THE SAVVY WOMAN'S

Homebuying Handbook

{RE}Think Real Estate ™

THE SAVVY WOMAN'S

Homebuying Handbook

Tara-Nicholle Nelson, Esq.

Real Estate Broker, Attorney & Accredited Buyer's Representative

The Savvy Woman's Homebuying Handbook: *150 Insider Secrets, Decision Making Guides and Online Resources – plus the one Action Plan You Need*
[Book One of the {RE}Think Real Estate Series] copyright©
2006 by Prosperity Way Enterprises LLC.

Visit our website at www.REThinkRealEstate.com more information, inspiration and other resources for homebuyers, homesellers, real estate investors and remodelers.

ISBN-13 978-0-9789828-0-5

ISBN-10 0-9789828-0-0

LCCN 2006934701

Edited by Linden Gross & Jean Cooper
Typesetting by Patricia Bruning Design
Cover design and layout by Ed Colmar at Green Graphics
Author cover photograph by Christina Shook Photography

The following trademarks appear throughout this book: Accredited Buyer's Representative, Ace Hardware, Amex, California Association of Realtors, Certified Residential Specialist, Consumer Reports, e-buyer, e-pro, Frette, Graduate, Realtor Institute, Home Depot, Lowe's, National Association of Realtors, Nordstrom, Pergo, Pottery Barn, The Holy Roman Catholic Church, Realtist, Senior Real Estate Specialist, Shabby Chic, Tony Robbins, Top Ramen, Trader Joe's, Trump Towers, Vanity Fair, Volkswagen, Whole Foods.

REALTOR is a registered trademark of the National Association of Realtors.

ATTENTION CORPORATIONS, UNIVERSITIES, COLLEGES AND PROFESSIONAL ORGANIZATIONS: Quantity discounts are available on bulk purchases of this book for educational or gift purposes, or to be used as client or magazine subscription/renewal premiums. Special books or book excerpts can also be created to fit specific needs. For information, please contact Prosperity Way Knowledge Systems LLC; 560 Vernon Street; Oakland, California 94610; tel. 510.910.6713.

TABLE OF CONTENTS

FOREWORD
by Kaira Sturdivant Rouda

Wow. A book for Savvy Women by a Savvy Woman about what has to be the number one method for lasting financial independence: buying a home. I was so excited to be asked to write this foreword. Not just because Tara herself is a savvy, inspiring woman. And not just because the topic is close to my heart as the COO and co-owner of Real Living, the country's 4th largest residential real estate company. Nope. It's because I find it exciting to read books by women for women. Period. We really do need to band together, share our talents, and inspire and mentor one another. OK, but enough about my reasons for believing in this book. Here's why you should be excited about buying your copy.

You, as a Savvy Woman, rule the world. It's true. Women make or influence 89 percent of all consumer purchasing decisions, and that includes, of course, the real estate industry. In fact, single women are the fastest-growing segment of homebuyers, a number that has doubled since 1989.

When it comes to homebuying and selling and all that goes with it – agent selection, neighborhood choice and home search – it's the woman's call, and the influence we wield will continue to grow in the future. At our company, Real Living, www.RealLiving.com, we recognized early on the power of marketing to women. We didn't have to look too far, since women represent 70 percent of the real estate work force. In 2002, we built the first women-focused brand in the real estate industry, from the font and logo treatment on up. We built Real Living with Savvy Women homebuyers in mind. And Tara has created this book with that same woman in mind. That woman is you.

Consider this: in the past, real estate brands were created by men to appeal to men. But women see things differently: Women are more likely to stick to a budget, while men are quick to negotiate a deal. Women prefer a cozy nest to call home; men tend to focus solely on the finances of the transaction. Women want to be engaged, inspired and communicated with – not to. We want a connection. We want information and the time to digest it. Our way.

At Real Living, we know women value community, location, house layouts, security and intimate spaces. We educate our agents about these wants and needs and provide them with the tools to offer what you are looking for: – superior service, convenience and control – during the home-buying and -selling process. We know this isn't just your largest financial transaction. It's also the largest emotional purchase you'll ever make. Tara recognizes this truth and provides an action plan to make your dreams of home ownership a reality. She's a living inspiration for Savvy Women everywhere.

The key to tackling the daunting task of homeownership is education. Education leads to empowerment. The Savvy Woman's Homebuying Handbook is a great first step. Finally, here's a book for women homebuyers, a second-to-none resource in a simple, easy-to-use format that works. Thanks to Tara's efforts, buying a home is no longer a process, but a fun adventure to realize your unique American dream.

What is great about Tara's writing is that she simplifies the complex financing and home-buying process, while sharing personal stories that make the book fun to read. Sure, you can go online and find some of the same information, in various forms, on many Web sites, including ours. But this book goes with you. It's yours, and it will become a permanent record of your hopes and dreams – and accomplishments. Chapter 1 explains how your mindset will determine your success – and helps you overcome hurdles, both real and imagined, that are common to even the most Savvy Woman. As Tara points out: "There are a lot of cultural and historical influences working against us – but with the right Realtor, a game plan and your dreams – you can do it. Your identity as a homeowner is waiting for you."

In Chapter 2, Tara guides you through the process of selecting the perfect Realtor. This partner in the process is key – she (or he) will make the process come together for you. You're in charge. You're "Madame CEO," as Tara says. Your Realtor is the one orchestrating the rest of the team. And, your Realtor is the one who helps sort through, quantify and qualify properties. Once you've discovered what you think is the perfect property, you'll grab this book to brush up on contracts and negotiations in Chapter 7.

This book, along with your Realtor, will make you feel completely empowered and in the know as you complete this transaction. That's the Savvy Woman way.

Throughout the book you'll find true stories about other Savvy Women and their homebuying experiences. Helpful charts and graphs bring some of the arcane and confusing factoids to life. And Tara's empowering and wise voice shines throughout. I know I always learn from other women's stories, and Tara shares anecdotes from her career as a lawyer and a real estate broker at just the right times.

Congratulations to you for buying this book and taking the first step toward becoming a Savvy Woman Homeowner. Read it, and then take action. As Chapter 9 advises, all the dreaming, thinking and learning in the world won't get you into your first home. You must take action. Tara's three-phase action plan will coach you through it. Commit, read the book, and then go for it!

All the best,

Kaira Sturdivant Rouda

Kaira Sturdivant Rouda is the chief operating officer and co-owner of Real Living, Inc., the fourth-largest real estate firm in the United States. The company is based in Columbus, Ohio, and has 4,000 agents and employees in more than 150 offices nationwide.

Introduction

You want to buy a home, but you're stuck at obsessively watching HGTV and plucking flyers from the For Sale signs you pass on the street. If you have been struggling with being overwhelmed and under-informed, shake it off and take heart in the fact that women just like you are now the biggest players in the market for homes.

Recently, some mind-blowing data was released on the numbers of women buying real estate. The headlines blared:

Single Women Buy One Out Of Every Five Homes— Twice the Rate of Single Men

and

Almost 20 Million Unmarried Women Own Homes

Then came unequivocal proof that women comprise the vast majority of real estate decision makers:

Married or Single, Women Make 91% of All Home Buying Decisions

File that under 'c' for 'contrary to popular belief', huh? This means that women wield two trillion dollars in real estate purchasing power every year. And this is no temporary spike in the charts. By 2010, nearly 31 million households—30 percent of all American households—will be headed by women.

Don't be too hard on yourself if you haven't yet become a member of this veritable movement of women homeowners. Frankly, the deck has been stacked against you. If you ask me, that's the real news flash, but it never made the papers. That headline would have read:

2.2 Trillion Dollar Industry Ignores 91% of Its Customers

Just to put the industry's underwhelming non-reaction in perspective, this is like Starbucks deciding they don't care so much about the wants and needs of coffee drinkers. It's like Wal-Mart deciding that penny-pinchers are an irrelevant demographic, or like Volkswagen deciding that passengers, not drivers, really matter. Incomprehensible? Not once you understand a few things about the real estate business.

First, let me just say that real estate is not the female-dominated, soccer-mom run industry people think it is. Women real estate agents and brokers outnumber men slightly, but like many fields, men predominate at the top. Most real estate company owners are men, and the heads of the large real estate companies, franchises and conglomerates are mostly male. In its 98-year history, the million-member National Association of Realtors has had exactly one woman president. (In all fairness, the President-elect for 2007 is also a woman.)

Some of these men at the top hold fundamental misconceptions which lead to a trickle-down practice of unwittingly under-serving women. As a result, you're not getting what you deserve.

What's behind this breach?

One – male brokers and company execs misunderstand the nature of the transaction of purchasing a home. These guys think it's strictly a business deal, so the husband is probably in the driver's seat. In reality, buying a home is as much of a lifestyle move—on a number of levels – as any transaction could ever be. Yes, a couple of those levels are financial, but certainly not most of them. These guys fail to understand that even if it was strictly business, women would likely be the ones handling it anyway. American women write 80 percent of all checks, pay 60 percent of all bills, and 48 percent of American wives bring home 50 percent or more of the household income!

Two – they believe the myth that the husband is the breadwinner in most families that own homes. Consider this: 22 percent of homebuyers are single women, and 72 percent are couples. In almost half of these couples, the wives are the primary breadwinners. Doing the math, women actually bring home most—if not all—of the money in about 58 percent of the households that buy homes. These women are bringing home the bacon that funds most home purchases.

Three – in the olden days (like, before the internet) real estate professionals' raison d'être was to provide clients exclusive access to information they could only get through an agent. Namely listings. Back then, the only people who had reliable lists of homes on the market were real estate agents. Real estate listings were not computerized or otherwise publicly available in any way, shape or form. This led to the subconscious belief in the industry that this was the real estate professional's sole function—to be the key-holders to the information that mattered the

most. This sentiment led many in the industry to horde information, so that they always had the upper hand over clients and the power to use their informational powers in a way that benefited them rather than you.

These days, in almost every locale (save NYC), the vast majority of properties for sale are listed on a Multiple Listing Service (MLS) which is publicly available—for free—on the web at www.Realtor.com and other sites. So, you don't necessarily need an agent to get the addresses of properties for sale, though an agent is indispensable in terms of navigating the process; helping you draft and interpret contracts, disclosures and inspection reports; educating you about the local market; connecting you with other legitimate and experienced professionals; negotiating with the seller, etc. However, too many real estate professionals, haven't caught on to the fact that their role has largely shifted to client education, professional advice, negotiation and facilitation, and are unintentionally neglecting to service the needs of their female clients.

> Women crave unbiased information and the power and control over their own affairs that comes only from knowing what to expect.

The big difference between women's and men's needs in terms of real estate is informational. Women crave unbiased information and the power and control over their own affairs that comes only from knowing what to expect. The guys who run the industry don't seem to understand that hording information doesn't make their agents any more expert, it just makes their women clients more wary and less trusting—a downside for everyone involved.

I'm not saying that the big real estate company web sites should be pink, that houses should be marketed with those buxom cartoon girls you see everywhere these days, or any of the other superficial schemes companies have used to give lip service to the priority they place on women customers. It is not the case that real estate agents or companies necessarily treat women badly as a rule. Rather, the industry simply fails to respond to the needs and concerns that are specific to women. I speak from both sides of this fence—as a woman who was a virgin home buyer and, now, as a real estate broker and attorney who has successfully coached hundreds of women into their own homes.

When I purchased my first home, I was a 25-year-old single mom of two young boys. I was fresh out of law school and had just started my first job in three years. As though that weren't enough of a challenge, I only had $3,000 in the bank, and I was trying to buy a home in the San Francisco Bay Area, one of the most expensive real estate markets anywhere. The professionals I worked with were all very nice, but they had no clue what my needs were or how to fulfill them. In fact, at times when they were ready to give up, I had to use my problem solving skills, suggest creative solutions and coach them to hang in there until the deal was closed. And they got paid at the end!

During that first home purchase, I was shocked at how easily these folks were ready to throw up their hands, but I wrote that off to a personality deficiency on their part. Cream puffs! Once the papers had been signed and the house was mine, however, I felt fairly satisfied with how things had gone down. I would later learn that my satisfaction had not been earned. I hadn't known enough to know what my real needs were at the time, so I didn't even know they weren't being met!

So, what were my needs? I wanted and deserved to be treated like I was spending almost $400,000 (which I was—for a house I sold four years later for about twice what I paid). Imagine how you would get treated if you walked into Nordstrom or Neiman and the salespeople knew you were about to spend that much money. Why should you—or I—be treated any differently, especially in the context of the most important transaction of your life, as opposed to buying jeans? We shouldn't.

What I really needed was:

- **Not to be stressed unnecessarily;**

- **No surprises (or no avoidable ones);**

- **A problem-solving orientation vs. a panic-and-freak-out session, if and when a surprise did arise;**

- **Someone to anticipate and propose things I might want or need or simply like, based on my life situation and their experience;**

- **Someone to anticipate issues I couldn't, and propose realistic solutions for them; and, finally**

- **To get the deal closed, get my keys, and move in!**

In my wildest dreams, I would not have imagined that it was even possible to have a transaction that went smoothly and harbored no surprises. Based on stories I had heard from others, I expected a rocky home-buying process. That was normal as far as I was concerned. And that's what I got.

Fast forward five years. I had left the practice of law to sell homes. I had built my clientele exclusively by referral, which means I ended up working with people I know and the people they know, most of whom happen to be very brilliant, very sophisticated, well educated and/or professional women. Maybe it's our age or something, but most people in my circle of friends and former colleagues seemed oriented toward buying vs. selling, so I did (and still do) a ton of purchase transactions. As a result, I began to specialize in working with buyers. I was working in the Bay Area, during an intense seller's market, and I used what I knew from having written complex contracts and negotiated settlements as an attorney to develop a system for choosing terms consistent with my clients' ideal lifestyle, educating my clients on the contract, and negotiating successfully with sellers.

Before too long, my psychology training kicked in. Early in my career working with homebuyers, I realized that about 90 percent of the purportedly "unavoidable" distress buyers experience during real estate transactions arises out of three sources:

> (1) Overload with the sheer volume of new information they receive and are expected to act on immediately in the context of a very high stakes transaction;

> (2) Lack of information, causing them to feel powerless relative to the agents and other professionals or a more experienced seller which, in turn, causes them to feel forced to rely on people who may not have their best interests at heart; and

> (3) Surprises arising at a point in the transaction where they feel forced to act differently than they would have if they had been given the accurate information when they had more options and more time or had less on the line.

In my opinion, all three of these stressors are unnecessary and can be largely avoided with (a) information, and (b) strategic expectation management, which is just another form of information. So over the years, I formulated a system of knowledge, expectation management, and solutions which led to success—with less stress—for many of my Savvy Women clients, who had been shunned as hard cases or patronized by other Realtors. Having helped hundreds of women in my personal practice and shared it with many more in my speaking and writing, I now offer this system to you as {RE}Think Real Estate.

What is {RE}Think Real Estate? It is a lattice of fear-exploding, action-inspiring resources which educate, support, and coach women into and through the action necessary to evolve their lifestyles through property ownership. {RE}Think solutions support and direct your progress on all things real estate—from buying and selling, to investing, to asset protection, to remodeling. Our raison d'être is to get you to {RE}Think the conventional view of real estate transactions as dry, tedious and even painful. Then, we {RE}Invent your interactions with real estate into opportunities to:

- **Experience style, beauty & humor;**
- **Shatter your fears & limiting thinking;**
- **Evolve and grow as a person, and ultimately;**
- **Seize control of your life, and exercise it boldly and joyfully!**

I saw such a glut of commission-driven, inaccurate, and impertinent real estate information out there in the world that, rather than eliminating stress, sifting through it added one more task to the Savvy Woman's already daunting 'To Do' list! {RE}Think Real Estate is a dimension beyond just 'information.' Rather, {RE}Think presents a complete set of *knowledge systems*: pre-filtered, unbiased, targeted and uber-usable solutions which specifically address and resolve your situations, concerns, questions and issues.

{RE}Think developed naturally out of my understanding of how women think about and shop for real estate, and how they analyze and interpret the documents and information they encounter during the process. As a result, each {RE}Think Real Estate solution works in its own way to feed and soothe the Savvy Woman's hungry, hypertext mind (that click-on-one-thought-and-fifteen-related-thought-windows-pop-open thing we do). And each {RE}Think knowledge system is delivered in a way which makes your life easier.

{RE}Think Real Estate presents a web wonderland and events (virtual and live) to chauffeur you through your lifelong relationship with real estate, but our premier resource is the {RE}Think Real Estate book series—and this is the first book of the series!

This book has two parallel aims. The first is to educate: to share with you the solution-oriented system of knowledge that has allowed me to help thousands of single women succeed in their quests to purchase homes. This aim would be in vain without the second, which is to coach you into action and through execution of your homebuying goals: to equip you with the concrete tools that will keep you accountable to your goals throughout the entire process and to provide the informational psychological, and decision-making support that will ensure your successful purchase of a home.

Let's start our first coaching session right now with a discussion about dreams and their action-inciting cousins, visions. "Home ownership is the cornerstone of the American dream," declared Senator Dianne Feinstein. One of my other favorite (but fictitious) folks, Carrie Bradshaw, expressed her own unique—and more personal—perspective on homeownership when she cried "Ooh! I forgot about the washer and dryer! I've been dreaming about that my whole New York life!" Maybe your personal Vision of Home invokes the grand aspirations referenced by the Senator from California. Or not. Like Carrie, the pragmatic image of yourself loading Your Very Own Washer and Dryer (or, better yet, of never dragging your clothes to the laundromat again!) might be more up your alley. Either way, virtually all of us could sit for a few moments and conjure up an image of life A.D.: After [we buy our own] Domicile.

Seriously, though, this sort of vision holds a power which we often undervalue. Any vision or goal or hope that you consistently envision and keep on your mental front burner will eventually find a way to manifest itself into reality—or realty, as the case may be. The fact that you ordered this book online or picked it up off the bookseller's shelf indicates that a house—a Home—is the object (or at least *an* object) of your desire. It also indicates that you are a woman, and a smart one. If this describes you, you are the Savvy Woman

> Vision holds a power which we often undervalue.

for whom I wrote this book—no matter what age, color or tax bracket you belong to. I call on you right this moment to sit down (if you're not already seated), set this book in your lap, lift your head, close your eyes and contemplate your life A.D. for few moments.

This brings us back to your vision of your life A.D. Now, it's important to note that I didn't ask you to visualize the house you buy, but rather the life you live after you buy your home. The vision of your home is a great starting place, but also visualize if you live with anyone else—a roommate who rents from you? A friend and co-owner? A parent or child? Do you spend your weekends walking to the yoga studio downtown or do you spend it working on your fixer upper? Do you live in a large sprawling place or someplace small and private? In a complex with a community center and a gym or in a solitary cottage off the beaten path somewhere? Does your vision feature stainless steel appliances or a large backyard? How much time do you spend at home? What sort of work are you doing, how much are you working, and for whom? We need for your vision to drill down into that level of detail.

Picture this book as a survival guide of sorts. Given that not many people actually die during the house hunting process, that may seem melodramatic. However, it is a survival guide in the truest sense of the term when you consider that many of those who don't die, don't come out of the process fully intact, either. Some lose a little dignity or self-respect at the hands of another party or professional involved in the transaction. Others have a great transaction, but end up completely enslaved to their "dream home," overextending themselves to the point that they must work 60 hours a week at a job they hate just to make the mortgage payment. See, the clearer your vision is on all these points, the more likely it is to survive the transaction, mostly intact.

This is not to say you won't have to make tradeoffs, like borrowing money from a parent to whom you'd rather not be indebted, or living in a condo in order to not have to take in a roommate. I tell my clients that the home-buying process requires compromises of virtually everyone who embarks upon it, whether they're spending $250,000 or $2.5 million. But being clear on your preferences allows you to get clear on your priorities and make clear and proactive choices as to your tradeoffs and compromises. It allows you to make these decisions knowing full well what the costs and benefits at issue are, and proceed from there boldly and without having the consequences of quick decisions sneak up on you later.

> Your home is an asset you can harness to propel you from financial solvency to stability, and beyond.

As you work your way through this book and the actual process of buying a home, you will almost certainly begin to sort the elements of your vision into mental file folders labeled "this house" and "the next house," and even "the house after next." Your first home is more than just a home, it's a springboard. Obviously, it's the springboard that takes you from renter to owner, from the land of white walls and security deposits to domestic goddess or real estate mogul – depending on your talents and inclinations.

However, buying your home can also serve as a springboard in at least two other key respects, each of which can help us set the intention with which you execute your homebuying process:

- **Your home is an asset you can harness to propel you from financial solvency to stability, and eventually from stability to prosperity. This path to prosperity is a process – one which cannot start until you break into the market. I wasn't surprised to hear that as many as 90 percent of American millionaires developed their wealth with real estate, but I was astounded to hear that the average net**

worth of a renter is $5,000, vs. $132,000 for the average homeowner. As property prices rise, breaking in becomes more and more difficult. My advice to you: buy as much house as you can as soon as you can, and move onward and upward when it makes sense for your lifestyle and your finances. Don't set your "this house" standards so high that you get priced out of the market while you search and search for a property that just doesn't exist in your price range. Leave something for "the next house," and the one after that;

- Successfully formulating, following and executing on a plan to purchase a home can include a number of those Grown-Up Moments—glimpses of the emotionally mature and powerful women we are becoming, moments of insight into your ability to create the life that you desire. When I was 20 years old, I lost 60 pounds. Then I stopped and thought—"if I did that, what else could I do?" Working through the {RE}Think Real Estate Homebuying system can wake you up to the transformational power of accomplishing one big thing outside the bounds of your comfort zone—what you now think of as your ability or skill or resource limits.

 In order to live to the edges of what is possible in our lives, most of us just need to go through the process of proving ourselves to ourselves. Executing on the goal of buying a home can be the springboard that propels you into strategic living in many other areas.

 I have been blessed to work with Savvy Women who have channeled the insights acquired in the process buying a house (against the odds) into career changes, starting their own business, adopting children without a partner, losing weight and making other huge and positive changes in their physical and emotional wellness.

- Finally, if you buy a home now and later end up in a committed relationship, you will forever possess a level of financial independence in your relationship. This prevents some of the power differentials which have traditionally deprived many women of voice and the ability to make choices going forward in their relationships, equalizing the playing field even for women who choose to later leave the workforceto raise their children.

Right this moment, we are declaring a moratorium on negative self-talk and limiting labels. We'll go into more detail in Chapter 2. For now, what you need to know is that you are a Savvy Woman, not an omniscient woman. Savvy Women are not born knowing arcane real estate verbiage they may use tentimes in their lives, at the outside. However, Savvy Women do learn what they need to know, and they also get coaching to get themselves in action or keep the momentum going, when they need to.

 True Story - No Idiots Here!

A client and friend of mine recently called me up to start the process of selling a home I sold her a while back. The next day, she rang me up to tell me that she had received a note in the mail from some guy who said he and his wife were interested in buying her house, which was months away from even being put up for sale. I said, "Sweets, he's an agent trying to get people to list their homes with him." She said, "But he doesn't say that, he just says he and his wife Caroline drove by my place and really liked it." I said, "He is a real estate agent." She said, "But the note is handwritten, and it says my first name on it." I replied, "I know—agents hire these services to handwrite these things for them, and he probably sent it to everyone in your neighborhood. But why don't you give me his name and number, and I'll check it out." She did, and I did. He was an agent, and I was able to show her his information on the state licensing web site.

The next day she went into work and noticed that a woman who lived a couple of streets over had the same exact handwritten note—except with *her* first name—out on her desk. My client was more than a little bit peeved, and said she would never list her home for sale with someone who had so falsely represented the nature of their interest in the home. "I'm such an idiot," she exclaimed. "I should have known better." I have heard innumerable women say those exact words in a real estate context, and it makes me angry every time.

She had laid down the gauntlet, so I took it up and hauled it with me onto my soapbox.

"You are absolutely not an idiot," I interrupted. "You are the director of marketing for a national company. You are responsible for a multi-million dollar advertising budget, and the numbers you proofread could make or break your company. The reason you couldn't spot this guy as an insider is that you simply don't do this every day—but I do. There is no way that in the normal course of your daily life you could have picked up the information that there is a contingent of real estate agents who go about hiring people to hand write notes purporting to be from a couple who has fallen in love with your house at first sight. This information is, however, within the scope of what I encounter in my daily work. If someone asked me to project response rates to a particular television campaign, I couldn't tell them that, I would call you – that's where you're the expert. You carried your responsibility for your own affairs when you hired me as your expert, and when you called me to ask me about the note."

This book was written from the same perspective as that sermon. It was written with the understanding that you are not a dummy, nor are you an idiot. In fact, you are a Savvy Woman who is probably quite brilliant at a number of things, including one or two things at which you

could rightfully be called an expert. So, why is it that you might be daunted or intimidated or overwhelmed at the prospect of buying a home? Because you haven't done it before, so you have not been exposed to the process, the jargon, the people involved, etc. Even if you have done it before, chances are you haven't done it enough to be really comfortable and familiar with these things. The processes and systems and verbiage involved in buying a home aren't taught in school, nor are they a normal and routine part of daily life for any but the most experienced real estate professionals or investors. So it would be insane for you to just know them—and not knowing them makes you no more a dummy than not knowing the formula for jet fuel.

The difference between the formula for jet fuel and real estate is that real estate is not rocket science. The terms are obscure, but they are certainly learn-able. You don't necessarily have to learn these things like the back of your hand; leave that for the experts—you can and will learn to strategically retain their services and harness their in-depth insider knowledge to your benefit. What you do need to do is develop a basic understanding of them and to have an accurate, unbiased and authoritative resource to which you can refer when you need to look some detail up or to get deeper into some topic or term. This book is that source.

You are on the road to having fulfilled your responsibility for your own real estate matters by having picked up this book. You may have even logged on to the {RE}Think site or attended a seminar. The next two steps to being a good steward of your own real estate life are exercising due care in selecting your team of professionals and then managing them well.

> The difference between the formula for jet fuel and real estate is that real estate is not rocket science.

Much of this book—and the {RE}Think Real Estate system—is about giving you unbiased and accurate information you can use to formulate your own objectives and vision and plan. You can then implement these to manage your team, so that your team doesn't manage you. You are the only person in this world who cares as much about your wellbeing—financial and otherwise—as you do; no matter how great or ethical your advisor is, they will always have additional considerations in their handling of you. The better advisors see their motives as aligned closely with yours; for example, professionals who operate by referral are very motivated for you to have a pleasant and successful experience, so that you will refer your friends and family members to them. However, other professionals are shortsighted, and may be more committed to getting you into something – anything – quickly than they are to the quality of your experience. In Chapter

2, we'll work out how to find the best professionals for your team; the rest of the book is about teaching you what to deliver to your team and what they should deliver to you.

The thing is, even the best advisor is not a mind reader. Unless you walk in the door with a clear understanding and, even better, a written summary of your wants and needs and guidelines and vision, there is no way that your professionals can help you fulfill them. For example, if you don't tell your mortgage broker the maximum amount you feel comfortable spending monthly on housing, she will do the math for you. And she won't know what your other priorities and preferences are. Unless you tell her. Just like any successful enterprise, a vision statement sent down from the top gives the team an endgame to aspire toward. This book is written to keep you mindful of the fact that you are at the top of this home buying "enterprise," and to give you the tools to manage your team.

My vision for you is that you not only successfully buy your home, but also that you leave this book with the knowledge to deactivate the intimidation and stress that is inherent in doing this big of a thing, that you return to it when you need that knowledge refreshed, and that you make full use of the resources available to you at www.REThinkRealEstate.com. Throughout this book you will find references to resources you can access at the website, including: inspirational tidbits and success stories, a calendar of live seminars and events; and, most importantly, referrals to service providers in your area, including Realtors and mortgage brokers, who have demonstrated their understanding of the {RE}Think Real Estate system and their desire and ability to meet the informational and inspirational needs of the Savvy Woman. You may also download every decision guide, comparison chart, worksheet and checklist in this book from the site–or email them to your friends.

Using this book involves a four-step process:

(1) First, read through the Action Plan in Chapter 9. It will prompt you to visit the member's area of www.REThinkRealEstate.com, where you will find a companion workbook you can purchase to help you stay committed and on track, as well as numerous free resources to coach you along the way;

(2) Second, calendar the items in the Action Plan, following the timelines and guidelines contained in the Plan;

(3) Read through the book – either straight through, or section-by-section while you

work through the phase of your homebuying odyssey covered by the relevant section of the book;

(4) Use the book and the website as a reference tool. When you have questions or concerns about some particular event or occurrence in your own homebuying experience, refer to the appropriate section of the book and see if you can get any guidance here. If you need more, visit the website, check out our blog, and see if your concern has been discussed by your fellow Savvy Women Homebuyers. If not, then Ask Tara or Ask An Expert, also at www.REThinkRealEstate.com.

I wish you well on your upcoming journey with a quotation which I keep in front of myself for constant reference on my Path to my goals, some of which seem outrageous to other people. It keeps me reminded that there is always space for growth, evolution and development – always the chance that life can be different than it is right now, even though it is already quite incredible! These three simple words serve the purpose of mental course correction at those times when fear, obstacles, and overwhelm rear their ugly heads – as a command, really, which keeps me mindful that in this life and on this Path, no limits exist except those which we create in our minds:

Dwell in possibility.
– Emily Dickinson

Part I: Setting Your Sights On Homebuying

Chapter 1

Estate of Mind: What's Been Stopping You & How to Develop the Mindset of a Homeowner

Everything I have been able to do in this life has been at least 80 percent due to the mindset I was raised with, the belief that with God's help, I can do anything or create anything that I desire. Though I had two children by the time I was seventeen years old, a series of incredible opportunities (of which I took full advantage) allowed me to graduate from high school early and continue my education, obtaining undergraduate, graduate and law degrees with no break. I literally gave birth to my youngest child over Winter Break from my first year at university, and went back to school two weeks later when spring session resumed. My kids are both boys, born 12 months and two weeks apart, and both have special needs. I sometimes joke that their early childhood was a great lesson in why repression is called a "coping" mechanism; I think having a daily session of forgetting the traumas of the day before was the only way I made it through those extremely trying times. Once my kids were much older, a friend of mine who was not yet a mom babysat her two godchildren, who were also almost exactly 12 months apart. After a nightmarish weekend, she called me and said, "How on earth did you raise those two boys? How did you keep from jumping off the Bay Bridge?" I replied, "I lived in Bakersfield then. We didn't have a bridge."

The bridge wasn't in my mental Rolodex of options for resolving my child rearing crises. So I set about the business of creating the life I wanted regardless of what happened, and conceived of myself as simply "course correcting" around unexpected developments, versus struggling with obstacles. As a result, by age 25, I had managed to pass the California Bar Exam and buy my first house. It was my mindset that energized me to continue school when everyone thought I was nuts, to leave my stagnant and abusive marriage and move my children to a new place where we knew no one in order to go to law school, buy a home, and leave the practice of law to be able to help people buy homes—against the conventional wisdom and the vocal opinions of many people around me.

In the course of my day-to-day work as a Realtor for many Savvy Women, I have grown to realize that many Savvy Women have:

(1) been technically able to buy a home for some time (or at least have been in the position to get themselves able), and

(2) wanted a house for some time, but

(3) for a number of "reasons," just haven't done it yet.

Surely you've heard of FAQs, those Frequently Asked Questions that are listed on every other website you come across. I have developed what I call the Mindset Matrix of FEQs—Frequently

The Mindset Matrix	
The Frequently Expressed Qualms Of Savvy Women	
Down Payment (1) I don't have any $, (2) I don't have 20 percent for a down payment.	**Credit** (1) My credit is terrible, (2) My credit is "okay," but if I do X, it'll get better.
Income (1) I only have one income, (2) I don't make enough $, (3) What if I can't make the payment?	**Lifestyle** (1) I'll have to "move down" (i.e., my house won't be as nice as my apartment is), (2) I'll have to cut my spending too much, (3) I'm not "there" yet (i.e., I don't have kids, etc.).

Expressed Qualms —the four categories of stories I hear from Savvy Women everywhere when I ask them why they haven't bought a home yet.

Some of us repeat our personal FEQs so often that they literally take on the quality of a story, a fable that we tell ourselves or others to excuse our inaction. I once had an attorney client who was very enthusiastic about buying, but worked for a non-profit and made very little money, especially for someone with her level of education. She did own an investment property out-of-state, which she was willing to sell for her down payment, but even with that, she was struggling to find something that she liked within her price range. After one in a string of fruitless and frustrating house hunt episodes, I mentioned in conversation that my nickname for my Dad used to be "The Bank of Randy," because I so often borrowed money from him when I was starting my family and my business. My client responded that her parents had offered to *give* her $100,000 toward her home purchase, but she didn't really want them to have to pay any gift taxes, so she had decided not to take it. Once I picked my lower jaw up off the ground, I gently informed her that there were plenty of ways we could structure a contribution from her parents so that it would be tax free, and urged her to consider exploring this option. She had been telling herself the story that she couldn't take this money without adversely impacting her parents, but this wasn't even true. In fact, it turned out that her parents were in a position to give painlessly even if they did incur the tax. But by telling herself this story, she was automatically and unnecessarily closing doors to a better lifestyle for herself.

These stories we tell ourselves only soothe the mental upset we feel when there is a loose end. They logically close the mental gap, a.k.a. cognitive dissonance, which widens when we contemplate why we are not where we say we want to be. Though this works temporarily, the cognitive dissonance will recur indefinitely until we actually are where we say we want to be, or until we stop saying that where we aren't is where we want to be.

After you've gained this awareness, the choice is three-fold. You can either:

- Continue renting, stay unhappy and keep telling yourself stories about why you don't have a home;

- Stop saying you want a home; or

- Buy a home.

That you have picked up this book and read this far indicates that—ding ding ding!—you've selected the "buy-a-home" option, the right answer in my humble opinion, especially given how do-able it is. As I've said to scads of Savvy Women, if your personal "story" falls

within the Mindset Matrix, I KNOW this is a do-able process for you. It may take time, but you can make it happen.

If you are a procrastinator, your FEQs can point you toward the specific areas you'll need to emphasize in the education and preparation phases, and the specific supports you'll need from your professional advisors. So let's re-conceptualize these FEQs, deactivate them as useless excuses, and convert them into rudders which guide us to the areas in which we need the most education or the most work.

Fear: The Invisible Fifth FEQ

There is one last FEQ. Funnily enough, this FEQ is rarely articulated by name; but when I talk with Savvy Women about why they haven't purchased homes I pick up on this particular FEQ in a number of ways. Sometimes it's in their body language, other times I detect it only after I realize that none of the basic FEQs pose legitimate challenges to the particular Savvy Woman before me.

The fifth FEQ is fear. Fear that if the bubble bursts, and real estate values drop, you'll be destitute because you've put all your financial resources into your home. Fear that if you lose your job, you'll lose your home, because you have no one to back you up. And fears of:

- Making such a huge decision on your own;
- Making a bad decision about something this huge;
- Not knowing anything about the process of buying a home;
- Not knowing who to trust;
- Being taken advantage of;
- Being asked to do things you don't know how to do;
- Being asked questions you can't answer;
- Being unsure when buying a house will fit into the calendar when you're already overwhelmed with your day-to-day obligations and most of all;
- Success – the fear that once you buy a home your life will change in ways that catapult you way outside your comfort zone.

My psychology studies and the life lessons I've learned have taught me two things you should know about fear.

What we fear, we create – This explains why we must overcome fear. If we allow the fear of becoming destitute and losing our home to prevent us from buying a home in the first place, then we have allowed fear to pigeonhole us in a lower, non-homeowner, socioeconomic bracket, keeping us from developing the true wealth that is available almost exclusively to property owners. The average American property owner has a net worth over 30 times greater than that of the average renter; which side of this equation do you want to be on?

We fear what we don't understand – This sheds light on how we will conquer our homebuying fears—with information. The information in this book, in conjunction with web resources and the resources provided by your team of professionals, will conquer the ignorance-based fears and calm the anxiety caused by the unknown. It will expose the seemingly scary process of buying a house for what it truly is: a project, like learning a foreign language or obtaining a degree—but much shorter, in most cases. And tackling a project just requires time, a plan, the appropriate personnel and the appropriate materials.

The thing about fear in the context of buying a home on your own is that it masquerades as a legitimate "reason" for not buying; again, this is why attacking the FEQs (and the unstated fears which often lie just beneath their surfaces) with information is the only effective way to deactivate these fears. It's a two-part equation: disprove or strategize to resolve the FEQs + demystify the process = obliterate your fears, the necessary first step of shifting into the mind of the homeowner.

Obliterating Limiting Thinking & Shifting Into the Mindset of a Homeowner

Experience has taught me that you already know what's been stopping you, whether your "story" is founded on legitimate challenges you need to work through or whether it is a pretext that justifies your fear-based paralysis. Many Savvy Women's FEQs are a mixture of both. Even if there are some legitimate challenges, thinking or verbalizing them over and over without formulating your strategy for resolving them simply wears a groove in your psyche. This might as well be a rope binding itself slowly but intricately around your Vision of Home, strangling it in the process. The alternative is to stretch your thoughts by visualizing—and then creating—the

Insight

TARA'S PRESCRIPTION

Q: What does this book have in common with Xanax?

A: Prescription-strength anxiety management. If you're like the average person, you'll only go through this process 4 or 5 times in your life. Younger Savvy Women tend move a little more frequently, say, every 3-7 years, so you might go through it several more times than that. If you end up being an investor, you might do this once or more a year. The point is you don't have to become an expert to buy your first home without making a bad decision along the way. Even savvy investors still maintain teams of professional advisors; these folks should be experts. You will never be in a position where you'll have to truly make a split second decision solely from the information in your head, without the opportunity to consult with your team, this book and your other reference resources.

- -

However, sometimes you will need to make quick decisions, so:

(1) Keep this book handy;

(2) Save www.REThinkRealEstate.com in your Favorites;

(3) Pick a Realtor early on from our Referral Network, and put them to work; and

(4) Make sure that you know the best way to reach your Realtor on a moment's notice from the time your offer is accepted to the time you have keys firmly in hand.

Taking these steps will relieve the feeling that you are totally alone and drastically minimize your stress and anxiety – no prescription necessary, and no side effects!

different reality that you crave, where you do your version of Mr. Rogers' sweater-and-shoe change in your own living room at the end of the workday.

Comfort is a Curse Word? – The fears we talked about earlier, the FEQs, the stories – these are all variations on a tired theme, the theme being limiting thinking. These thoughts and fables have the power to manifest that about which they purport to complain. This seems strange, but just as we create what we fear, we often continue to manifest our status quo in life, because we have been where we are so long that

we are *comfortable* here. Now, there is nothing inherently wrong with comfort, except when the situation that gives us comfort is different than we wish it was. Comfort becomes a dirty word when comfort means:

- We pay rent to some landlord who uses that money to fund his own tax breaks and retirement fund,
- We forgo those same benefits for ourselves,
- We live in a place we really don't like or feel ownership or stability in, and—most importantly
- We would be happier owning our own place.

These things that we wish were different create the motivational gap which keeps us energized to make change, even when it means we have to shatter our comfort zone.

If you rent now and you want to own, you need to get prepared to be uncomfortable for awhile. Not physically, but mentally—you will be gradually peeling away the layers of your comfort zone to think about yourself and your life and your capabilities in a different way. To declare a martial-law enforced moratorium on limiting thoughts or words or deeds of all sorts – no "I'm such an idiot!"s or "I am so poor"s or "I can't afford to buy a house"s. To minimize frivolous spending on low-priority items (and I don't mean $4.00 lattes, I mean more like $40 lunches, $100 dinners and $300 Manolos – but this is definitely a temporary ban I'm talking about).

Resources for the Spending-Challenged Among Us

Can you relate to the following quotes from Sex and the City's Carrie Bradshaw character on realizing that the contents of her closet could have funded a down payment on a home several times over?

> I've spent $40,000 on shoes and I have no place to live? I will literally be the old woman who lived in her shoes!

> I'm homeless! I'll be a bag lady! A Fendi bag lady, but a bag lady!!

If so, you need to check out:

> *Smart Women Finish Rich: 9 Steps to Achieving Financial Security and Finding Your Dreams*, by David Bach. Broadway (2002).

For quick access to these & other financial planning & spending plan resources, visit www.REThinkRealEstate.com and enter "baglady" in the Tara's Tips box.

Even those "little" things can really add up. I once realized that I was spending $900 a month at the smoothie bar! (In all fairness, that included smooothies for 4 and a good number of omelettes as well.) Imagine the horror of realizing that I was doing this at a time when I didn't own a home and was living paycheck to paycheck. A good strategy is to get real about what you are actually spending on by keeping a spending journal, then deciding what is a priority and what isn't. Make sure you follow through by actually cutting back on the low priority items, though; knowledge is only useful if you act on it. This doesn't mean no smoothies or lattes, it just means that you don't have to single-handedly cover the establishment's overhead with your house fund.

Three Steps to Obliterate Limiting Thinking

In order to break bad spending habits or limit thinking patterns, you will need to replace them with something else. Shopping online for houses at www.Realtor.com and for your eventual housewares (don't actually buy—just fill your shopping cart or your wish list for now), affirms your future as a homeowner mentally by replacing the "Story of your FEQs" with:

What to Expect When You Abolish your Limiting Thinking

It may have taken you years to get to where you were comfortable in your present situation. So, when you start to think and act differently in furtherance of your homeownership goals, you will be uncomfortable. A reaction I have seen many times is that once Savvy Women realize that their FEQs are irrational or able to be overcome, they begin to blame themselves for not having done it sooner. Judgment, self-blame, regret—thinking along these lines is just as limiting and paralyzing as the FEQs of fear and procrastination.

Right this moment, forgive yourself. Let go of what happened yesterday or last year or in the '80s (those of us over 30 all need forgiveness for something we did, or wore, in the '80s). Whatever decisions you made and actions you took – or inaction you were stuck in— was part of the path you were meant to take to get here, now, as you are. That's perfect. So get over it and let's keep on trucking.

- Accurate and powerful information about how you can succeed;

- Your "Vision of Home," which you should already be thinking about and will commit to writing later in this chapter; and

- Your calendar, complete with the tasks from your Action Plan (see Chapter 9), which you should keep at hand as a defense against limiting thoughts that are bound to arise.

Here is my 4.5 step formula for attaining—and maintaining—the mindset of a homeowner.

Step 1 – Commitment

You've already done this, but it bears repeating. On a day-to-day basis, until you're in your new home, you must make a psychological and emotional commitment to move forward on your plan and inch closer to homeownership. Right now, you are committing to writing your Vision, reading this book and following the Plan contained herein. Thirty days from now, you may be committing to devoting your Sunday afternoons to house hunting with your Realtor. The mindset of a homeowner is based on the never-waning, continually renewed commitment— the purposeful choice—to do whatever is necessary (within reason) to convert the dream of homeownership into reality. All the other steps flow from and support this commitment; without it, the rest is just an academic exercise.

Step 2 – What's Your Why?

I can give you reasons all day long why I think you should buy a home, but this book is about helping and coaching and inspiring you along a strategic path toward your Vision. Something must fuel you on this path, and that something is your "Why." When I ask you for your "Why," I'm asking you to soul search for the reason you want to buy a home. Your "Why" is that critical difference between the way things are in your life right now and the way you want them to be —the "gap" you believe will be closed when you own a home. Coaches call this difference a motivational gap, because it is the gap that motivates you to set the goal, pick up the book, go to the seminar and work the Action Plan. You can see why it is vital that you articulate your "Why" and write it down; it can get lost or forgotten in the work of closing the gap, and many of those who get discouraged and give up are those who forgot the "Why" that propelled them to want to buy a home in the first place.

Your "Why" is as personal to you as your fingerprints, and so long as you are honest with yourself about your motivation and purpose, there is no right or wrong answer; no reason too frivolous or weighty, nothing too altruistic or materialistic. Women generally state the reasons

"Why" they want to buy a home in terms of what they want to Be, Do, or Have that they aren't, can't do, or don't have in the status quo. Some people know right off the bat what their "Why" is, but if you have a harder time articulating it on paper, try completing these sentences:

- I want to buy a house because I want to be: (examples: less dependent, more stable, in more control of my living situation, a role model of power and responsibility for my children, etc.);

- I want to buy a house because I want to do: (examples: more entertaining, less communal living, more communal living, real estate investing using my home equity, own a dog, increase the standard of living for my family, etc.);

- I want to buy a house because I want to have: (more space, more assets to develop into wealth, a home in which to grow old, a place I can set up to meet my needs and whims and quirks, etc.).

Step 3 – Intention, Alignment, Identity & Flow

Intention – In Step 1, you committed to buying a home. When you did that, you set your intention for this process. Sounds New Age, but it's really not. I mean, think about it, the universe and the world – even in your neck of the woods – are abundant with resources, including all the resources you will need for your intention to buy a home to manifest into the reality of homeownership. So, now, our job is to proactively and strategically attract these resources into your life.

The principle of alignment illustrates the thinking woman's method to accomplish this – not in a haphazard, stress-filled struggle, but by strategically lining up the proper tools, like magnets attracting your new home into your life.

Alignment – Most of us have heard the highly technical home improvement mnemonic for remembering how to turn faucets, jar tops and screws: righty tighty, lefty loosey. Now, imagine if you tried to tighten a screw by turning right twice then left once, right a couple more times, then a few lefts. The opposing forces would largely cancel each other out, so it would take you a lot longer to get the screw all the way in, and might cause so much frustration that you stop trying and use a nail instead.

This same principle has been studied ad nauseum and applied in science and industry; it's called the principle of alignment. The principle of alignment says that in order to obtain maximal results from any effort, all forces must be working in the same direction toward the overall aim. The corollary is that the magnitude of all forces working toward a single aim is greater than the

sum of each individual force. The opposite is also true – when the individual forces being applied to a task work in opposite directions, struggle and failure often result.

In your quest for homeownership, your intention is just the first step, the first of the constellation of factors which must come together for you to successfully buy your home. In fact, it is the dizzying array of big things and little things, major issues and minute details that must all line up to make this happen that can overwhelm and intimidate even the savviest woman, causing discouragement, procrastination and plain old giving up.

In coaching people through all these details on a daily basis, I have realized that there really are just a few factors within your control that need to be working in unison to attain success at the enterprise of buying a home. The whole process can seem a lot less intimidating if you understand the task before you from a macro perspective, instead of starting out worrying about every 'i' which must be dotted and every 't' that needs crossing.

Keep in mind that this is an enterprise, like running a small business for a very short period of time. So let's think about your tools—the ducks you must put in a row, so to speak—in business terms.

The Savvy Woman's Homebuying Resource Alignment Quadrant

Alignment is that ideal state in which all these people, strategies, resources and processes work in concert to convert your intention to won a home into reality.

It follows that the #1 enemy of your intention is any and every thought, person, place, or thing which is not in alignment with your homebuying intention, vision, action plan, strategies, etc. You must be so consistently extreme in your commitment to your intention that it flows through and infects every area of your life. Simultaneously, you must ruthlessly, surgically excise from your existence any and everything that runs in any direction other than the course set by your intention.

The Intangibles	Financial & Lifestyle
o Vision	o Income/Career
o Mindset	o Credit
o Strategies	o Mortgage
	o Financial Plan
Human Resources	**Information & Technology**
o Homebuying Professionals	o This book & REThinkRealEstate.com
o Attorney	o Realtor.com
o Tax Advisor	o Multiple Listing Services
o Partner, Spouse, Parents, etc.	

Identity – The question is—how do you make this happen with relative ease? How can you escape the struggle that seems like an inescapable part of transforming your thinking, your habits, and your life to get them all in alignment with your intention to become a homeowner?

The answer: you harness the power of identity. You declare and claim your identity as that of a homeowner, transforming yourself into someone who would never think, say or do anything other than the thoughts, words, and actions of a thriving homeonwer. You choose—in this moment, as you read these words—to be:

- Assertive in expressing your wants and needs, questions and concerns;
- Responsible for your own finances;
- Organized in terms of your important documents;
- A leader with respect to your team of professional advisors;
- An on-time bill payer, and so on.

You can choose to become—in this instant—the sort of person who would never commit an action in opposition to your intention, even if you have committed such behavior in the past.

If the concept that you can just choose the kind of person you want to be and instantly create lasting change in your thoughts and your behavior strikes you as bizarrely over-simplistic, insane, or just impossible, I submit to you that you are already doing this in your life. I once heard Tony Robbins deliver an intensely powerful lesson on the power of the labels we impose on ourselves—both positive and negative—and how we "live into them" (his words). He spoke of drug addicts with whom he had worked who decided, in one moment, to become the sort of person who would never do drugs, and who remained drug free for life. He spoke of a chronic phobic who committed to being the sort of person who would never miss out on an opportunity for one of life's grand adventures due to fear—and whose actions and thoughts were forever changed.

Mr. Robbins challenged his audience to soul search for examples of the way in which we all live into the negative labels we impose on ourselves, often ignoring evidence of our positive past actions which prove the inaccuracy of the label. He pointed out that many of us dwell on instances in which we have procrastinated, or not followed through, or done something stupid. Then, we've confused those individual actions with who we are—labeling ourselves in perpetuity as "a procrastinator" or someone who "never follows through," or "stupid."

When we say these sorts of things to ourselves or out loud, we (a) prompt ourselves to live into these roles, perpetuating these sorts of actions, and (b) enroll the people around us in that concept of ourselves, causing them to expect us to behave consistently with the image we've created. This is nothing more than a manifestation of the age-old self fulfilling prophecy theory: if we expect the worst from ourselves that is what we'll get. And vice-versa. Yikes, huh?

The flip side of our ability to sabotage our aims with self-imposed labels is that we can wield the same power in the opposite direction, propelling ourselves into the person that we really truly could be, at our best. If you try, you can think of many instances in your life when you've acted wonderfully. Things you didn't procrastinate in doing, times when you planned and did follow through, really super freaking smart things you have done, etc. Though you may be choosing to live into a negative identity, you do have the power to deem yourself the sort of person who does those positive things, with parallel results. When you make that choice, you will live into and fulfill that prophecy. You will present yourself to the professionals you choose for your team as

> You can just choose the kind of person you want to be and instantly create lasting change in your thoughts and your behavior.

the sort of person who is responsible, organized, and success-prone enough to truly make this happen, which will cause them to fall into alignment with your intention.

So what do you do when a past bad habit—excessive spending, ignoring your bills, abdicating to your advisors rather than leading them—rears its ugly head? For most of us, the automatic mental response is to use that episode to confirm that, in fact, we really are flaky, or irresponsible or whatever. We must stop the thought path whereby we say to ourselves, "See, you really are [whatever your negative identity was]." Robbins urged us to stop the thought in its tracks by saying (aloud, if you're not likely to be thrown in the nuthouse by the people in the room), "That's not who I am, it's how I used to act."

You might have heard of the goal achievement strategy of "acting as if" your goal had already been accomplished. I challenge you to take this to the next dimension, not only acting as if you've bought a home, but being—living—the lifestyle of a successful homebuyer, living as if your life already is that life you envision after homeownership. I won't give you a bullet point to do list of how a successful homeowner should think or act or live; complicated rules

signify constriction and restriction and deprivation. That's the opposite of what we're shooting for here: the ability to make decisions and act with ease and comfort. The key to "living as if"—and with ease—is a deliberate decision-making process:

(1) first, pause and consider the consequences of every decision, thought or action;

(2) second, decide whether those consequences are in alignment with or in opposition to your commitment and intention to own a home;

(3) finally, move forward or stop the thought or action based on whether it flows from or against your intention.

This will be your decision rule for your life; if you diligently do this for several weeks, it will become second nature and you will quickly acquire an intuitive ability to align your choices and your identity with your intention.

Flow - Flow is that state in which you are able to move through life with ease while thinking, being, and acting in alignment with your commitment, your intention, your identity. My prayer in writing this book was that you would be able—with some introspection and discipline—to proceed through the homebuying process in a state of flow, rather than a state of distress and struggle. If your homebuying experience is characterized by flow, you will be much more likely to find it transformational and enjoyable, and to evolve personally during the process.

Step 4 – Draft Your Vision of Home

The term "Vision of Home" is somewhat of a misnomer. As we discussed earlier, the Vision statement I want you to put on paper is not simply a vision of a house or even of several houses, but a statement describing the desired state of your life after you buy your home – all elements of your life, including where, how and how much you live, work, play, rest, etc. We'll get even more concrete very shortly, but I want to emphasize this point, as doing some soul-searching at this point can have a huge impact on the endgame, which is a combination of (a) success at the enterprise of buying a home, and (b) wellness—financially and otherwise—throughout your career as a homeowner (which lasts way longer than the buying process itself).

Why Do You Need a Vision of Home—and How Will You Use It? – Before you've even started house hunting, you have already made a commitment. The Vision will help you maintain this commitment, through all the drudgery and detail work involved in getting your home. The idea is to paint such a vivid picture of the life you want that it excites you to action and keeps your commitment, energy and enthusiasm levels high—from start to finish.

Fully engaging in and completing this exercise during the house hunt will place you in an incredible position of power when it comes to communicating your needs and wants to your team of professionals, and staying on track throughout your process. In fact, depending on how specific your Vision statement is, you might be able to pull from it a subset of points to describe the place you're looking for to your agent. Having a written Vision will also help keep you accountable to yourself throughout—and long after—the process of buying a home, helping you make decisions about how much to spend and, in turn, how much house to buy, that are consistent with your lifestyle needs and preferences.

Finally, this Vision thing, used properly, can be a big-time stress manager even after you've found the house you want. I joke with my clients that the day everyone signs the purchase contract is the last day any of the parties are happy with the price. The seller calls their agent that night stressed that they took too little, and the buyer is remorseful that they paid too much! If, no, *when* you experience buyer's remorse, you'll have your Vision of Home there as a concrete reminder of what you wanted before you got mired in the detail of getting it. If the place you're in contract to buy (and the terms of the purchase contract) places you well on your path to your Vision – you're good to go. If not, you still have time to reexamine the decision making that led you there before your deposit money is forfeited—giving you the opportunity to back out of the contract at little or no cost if you feel your compromises have been too extreme.

How to Draft Your Vision of Home – There are definitely elements which must be covered, but the form of this document can be totally driven by your style; a one-page list of bullet points works for one Savvy Woman, while another might want to journal an epic 10 page narrative. Whatever works! You just need to get started. Here's how.

Think of your life as a little ecology, or pattern of interaction between an organism (i.e., you) and your environment (i.e., the people, places and things that populate your life). Every element is inextricably intertwined with every other element. To get a visual, think of those junior-high school food chain charts – if one fungus in the remote reaches of the Himalayas dies off, the price of Vanity Fair magazine goes up, through some intricate relationship involving the sun and herbivores in South America. Similarly, if you tweak one element of your Vision, the rest will change. For example, let's say that right now you are single, no kids, and are able to support your lifestyle working as a freelance graphic designer, and you have a vision of continuing to be able to do that. So you don't have to go work for a firm, you might incorporate the following elements into your Vision :

- Generating X number of additional projects per month, and working the extra hours to complete them (or implementing a referral generating system or otherwise increasing your profitability);

- Keeping your mortgage payment under X number of dollars a month (vs. the Y number of dollars you could afford if you went to work for a firm);

- Living in a smaller condo, a TIC (see Chapter 6) or having a roommate or tenant;

- Working mornings in your functional home office area, then walking to your favorite Wi-Fi coffee spot or library, in the afternoons;

- Having a preference for homes with CAT-5 wiring, DSL availability and updated electrical systems (to protect your equipment from sparks and surges);

- Living within driving distance of your parents or friends or favorite social haunts, so you don't have to spend a lot to visit;

- Walking to your yoga studio on Wednesday afternoons and driving a few minutes to Whole Foods to pick up lots of ready-to-eat stuff every other week;

- Meeting your book club at your favorite downtown bookstore, a short drive away;

- Pulling your car into a secure garage after you get home from visiting your parents, the rock climbing gym and your book club – I think you get the idea.

If you had changed your work, you can imagine how things would change – preferred locations would be driven more by your workplace than your leisure activities. If you had children, things would shift again – bigger space and income needs, maybe more cooking and more demands for your kitchen and eating areas, probably less time to walk to yoga, etc. Widen your thoughts beyond just the number of bedrooms and bathrooms you need to things about your house – and your lifestyle – that don't come immediately to mind. Craft a vision of your lifestyle, and from that we'll back into the specs of your house in a manner that is much more likely to see you happy a year or two down the road.

Now, if you have a need to share your Vision with someone, and there is no one in your life you can count on to support it, you need to trade up. Start flushing as many toxic people out of your life as possible and simply maintain your commitment and intention. Soon enough, your energy will attract similarly positively oriented people into your life.

An Eco-Friendly Vision

Like your favorite foods, your vision of home should be:

- **Organic** (it should grow naturally out of and be consistent with your personal values, life philosophy, life plan);

- **Holistic** (it must take account of all areas of your life); and

- **Sustainable** (you include a savings and emergency resource strategy which will allow it – and you – to survive a job change, a couple of months without work, a car breakdown, etc.).

Insight

YOUR VISION IS YOUR BABY

In three ways, you must treat your Vision like a newborn child.

Nourish It – Put yourself in a place and atmosphere that promotes creativity, and make sure you have a lovely notebook and comfortable pen, or your laptop, or whatever materials will be the most inviting to your thoughts. If you like, seclude yourself at home with music (they say baroque is the best for writing, but I like the hype and braggadocio in hip hop) or TV background noise or silence. Or maybe you prefer to work with some human bustle in the background; your kids or the patrons at your neighborhood coffee shop will be glad to oblige. Some of my clients have had delightful Vision-writing experiences in a group, retreat-like setting with like-minded pals.

Focus On It – Right now, decide when you are going to devote time to the care and feeding of your Vision , and set the time in your calendar or log it in your PDA. Without doing so, this whole project can quickly go from an absolute must to just another good idea that never actually happened.

Protect It – Protect your Vision from opposing forces – from without and within. UNDER NO CIRCUMSTANCES are you authorized to share your Vision , or even the fact that you plan to document it, with anyone who will be anything other than supportive. Throughout the ages they've been known variously as naysayers, malcontents, or haters, but you already know who they are in your life. Keep your Vision away from them.

Step 4.5 – Write It All Down

You want to leave this process with a written document that addresses each item in the following list. However long or short, take heed to the adage that a goal is just a dream until it is written down.

- **Commitment** – Mark down the date and time at which you made the commitment to become a homeowner.

- **Your Why** – Note the reason(s) underlying your intention.

- **Identity** – List the attributes of the sort of person you have decided to be.

- **Your Vision of Home** – Things you should definitely address and include in your Vision of Home:

 → Food;

 → Family;

 → Aesthetics;

 → Technology;

 → Finances;

 → Physical;

 → Pleasure;

 → Proximity;

 → Values (e.g.– integrity, ease, hard work, adventure, calm, status, independence, wisdom – whatever is important to you);

 → Work;

 → How your Vision is different from your current lifestyle.

Once you are done, check to make sure your Vision is consistent with the Values you hold dear.

Chapter 2

The Process & the People: A Primer

If I ruled the world, buying a house would be as clear and un-mysterious as baking a cake. Personally, I make it a point to cook as little as possible, but even I can manage to turn a box of mix into a confection that all but the most rabid sugar-busters would relish. You walk into the grocery store, go to the aisle with the big sign overhead screaming "CAKE MIX" in 200 point font, and you can pretty much pick the correct box of mix by the picture on the front. Then, you flip the box over and there you have pictures of the rest of your shopping list: eggs, water, oil (or butter). Once you get everything you need at the store, you pay for your goods, drive home, and follow the pictures. Step 1—preheat the oven. Step 2—dump the mix in the bowl. Eggs, water, etc. and so forth into the oven until the toothpick comes out clean.

Obviously, buying a home is much more complicated and involves many more steps and decision-making points than baking a cake. And, for most people, buying a home is just a tad bit more important, too. These are just more reasons why the process should be laid out in as simple and straightforward a manner as possible. Just think—someone once thought that baking a cake was important enough and difficult enough to warrant being broken down into numbered steps, then clarified with little pictures. Buying a home is about 100 times less familiar, 1,000 times more confusing, and 1 million times more impactful on our lives than the mix-to-cake process. How much more does homebuying justify clarification, a step-by-step breakdown, and pictures that pound in the point?

A lot more, if you ask me. To that end, I present the flowchart I use in my daily real estate practice when demystifying the homebuying process for my buyers-to-be. When we're learning new terms and processes like those involved in buying a home, most of us need to be exposed to the information in several modalities, and several times before we are familiar enough with it to, say, use it when communicating with our advisors and others during the process. This may be the first time you hear some of these terms in connection with a meaningful definition, but it certainly won't be the last. This chapter provides a general introduction to the major concepts, terms, processes, people and the overall sequence involved in the homebuying experience so that you will have some context for the rest of the book and the rest of your path to homeownership. The rest of the book then drills down deeply into each of the phases of homebuying, providing you with substantive insider insights and strategies on how to optimally handle each task and decision involved in each stage. By the time you've completed the book, through repeated and increasingly detailed exposure to these new ideas, you'll know your contingencies from your wood destroying organisms. Piece of cake!

Preparatory Phase

(1) Get Educated - Learn about:
- The process
- The players
- Your market
- Mortgages
- Attend seminars
- Internet research
- Read

(2) Determine Your Personal Statistics
- Credit
- Income
- Assets
- Monthly Spending Plan

(3) "Hire" Your Realtor
- Get referrals
- Meet Realtors® at seminars
- Find Realtors® at www.REThinkRealEstate.com

Phase One

(1) Initial Consultation with Your Realtor
- Discuss Agency relationship.
- Educate Realtor on your wants & needs.
- Get educated about your market and local homebuying practices.
- Review blank contract.
- Discuss your financial resources & limitations.

(2) Mortgage Pre-Approval
- Contact mortgage professional referred by Realtor.
- Submit information regarding credit, assets & income.
- Discuss & select loan type(s).
- Learn your max purchase price & corresponding payments.

(3) The House Hunt
- Arrange to receive automatic e-mail notification of new listings.
- Tour properties meeting your search criteria while learning
- about current market values.

(4) Find "Your" Home & Write an Offer
- Realtor researches seller's needs and fair market value.
- Discuss appropriate price and terms to offer with Realtor.
- Realtor prepares offer – you sign.
- Prepare earnest money deposit of 1-3%.

Phase Two

(1) Present Offer & Negotiate Contract
- Let your Realtor present your offer, including your earnest money deposit.
- If Seller accepts, move to next step.
- If Seller issues a counteroffer, you accept new terms, reject, or issue counteroffer. Counteroffers can go back and forth until one side accepts without changing terms.

(2) Open Escrow
- Escrow Officer/Agent orders Preliminary Title Report or conducts Title Search.

(3) Title Review
- Earnest money is deposited into Escrow Account or held in trust by Realtor or attorney.

(4) Inspections & Disclosures
- Review and sign Seller's disclosures &
- Preliminary Title Report.
- Attend Property, Pest & Roof inspections.
- Review inspectors' reports.
- Follow up w/ any additional inspections recommended, and obtain estimates for work you plan to do after closing.

(5) Resolve Condition Issues
- Depending on whether or not you made an as-is offer, renegotiate price, request repairs or credits, or make post-closing repair plans.

(6) Submit Home Information to Lender
- Mortgage professional submits property particulars to lender, including address, title information and contract details.

(7) Underwriting and Appraisal
- Mortgage professional orders appraisal.
- Appraiser reports opinion as to fair market value of property.
- Lender's underwriter reviews information regarding you and the property, and may request additional information to complete the loan process.

(8) Remove Contingencies/Option or Objection Period Expires
- After title search is clear, property appraises at purchase price, you are satisfied with condition of property and underwriter grants final loan approval, remove contingencies or allow objection/option period to expire. Increase earnest money deposit (in some areas).
- Deposit becomes subject to forfeiture if you back out after this point.

Phase Three

(1) Homeowners' Insurance & Home Warranty
- Select Homeowner's Insurance company and coverage.
- Give insurance agent escrow information so agent can submit proof of insurance coverage to escrow.
- Realtor or escrow agent orders home protection plan.

(2) Sign Documents
- Lender sends loan documents to escrow holder.
- Sign loan, title and closing documents.

(3) Down Payment & Funding
- Obtain a cashier's check or send a wire transfer of down payment and/or closing funds to escrow holder, if not covered by deposit.
- Lender sends mortgage loan funds to escrow holder.

(4) Record Transfer of Title and Close Escrow
- Escrow holder records transfer and deed with County Clerk/Recorder.

You get the keys to your new home!

The Homebuying Process

Now, let's walk through the flow chart, step by step.

Preparatory Phase

During the preparatory phase, you set yourself up for success. If you work through the items in this phase at all, you will embark on this path better equipped than probably 75-90 percent of wanna-be homeowners. If you complete all the work in this phase, you will almost certainly avoid the "Go Back Two Spaces" card that can be dealt by a mortgage bank who finds your qualifications to be lacking. Most importantly, you will buy yourself a direct route around a big chunk of the drama and stress most homebuyers experience.

(1) Educate Yourself – Get up to speed on how the homebuying process works, who the players are in the process, and the local market. You will need this information later in order to manage your team of professionals. Read this book, attend a seminar or course, start surfing MLS online to see what's available in your area at what price, and start reading the real estate section of your Sunday newspaper to keep your finger on the pulse of local market dynamics. (Keep in mind that everything those writers say is not gospel, but they are not always wrong, either. It will also help increase your facility with the jargon.)

(2) Know Your Numbers – I'll walk you through the process of gathering the needed ingredients and doing the math to determine "Your Numbers" in Chapter 3—The Money. This step involves:

- Figuring out your credit score (and increasing it, if needed);

- Developing a spending plan you can live with; and from that

- Deducing the maximum amount you can spend monthly on housing; and

- Narrowing down the general type(s) of mortgage loans which make sense for your life.

(3): Elect Your Representative – This phase is where you pick your Realtor. A tutorial later in this chapter will guide you through this process, which is by far the most critical Human Resources decision you will make along your homebuying odyssey, and one of the most important relationship decisions you will make in your lifelong career as the leader of your team of professional advisors.

Phase One

This phase involves communicating your wants, needs, vision, and priorities to your Realtor and mortgage broker, and working with them to translate these guidelines into an actual property.

(1) Initial Consultation – This is your first meeting with your Realtor. You learn about local standard practices and market dynamics. Also, you educate your Realtor. about your wants and needs, and the work that you have done in preparation for this process. You two work together to formulate a team action plan for success.

(2) Mortgage Pre-Approval – You get a referral to a mortgage professional (or two or three), preferably from your Realtor. You consult with your mortgage professional, who collects the necessary personal and financial information, including the maximum amount you would like to spend monthly on housing and other lifestyle issues which may impact your decision-making about what sort of mortgage will work best for you. See Chapters 3 and 4 for detail on the matter of mortgage types and how to align your loan choice with your life. Your mortgage pro then "shops" your loan application to various mortgage lenders, gets you "pre-approved" for a certain maximum purchase price, and gives you an estimate of the interest rate, monthly payment, and other terms of the mortgage loan(s) for which you are eligible.

(3) The House Hunt – You and your Realtor hop in the car and start looking at properties meeting your search criteria. As you learn how much different homes cost in your area, you may revise or massage your Vision of Home accordingly. You narrow your criteria over time and hone in on ideal properties.

(4) Find Your Home & Make an Offer – When you find a home that works for you on every level, you'll let your Realtor know that you'd like to make an offer to purchase it. A good Realtor will do some research into the market value of the property and the seller's priorities, then formulate a recommendation to you about a price (or price range) and other terms that will both achieve your aims and maximize the likelihood that your offer will be accepted by the seller. Your Realtor will document the price and terms you decide to offer in written contract format, and you will sign (and probably initial a bunch of times, too) the document, making it your official offer.

There are two elements of your offer which are important for you to start getting a handle on right now. The first—contingencies. A contingency is simply your right to bail out of the deal. Most states have a default set of contingencies that are standard in a real estate purchase offer—you can bail from the deal if your loan doesn't come through, if you are not satisfied with the results of your inspections into the condition of the property, etc., so long as you do so within a certain number of days after the seller accepts your offer. At the end of this time period, you are obligated to either "exercise" your contingencies (i.e., back out of the deal), renegotiate with the seller, or "remove" your contingencies and move forward to close the purchase. This time period is known as your contingency removal period, and you may alter it to make it longer or shorter or eliminate particular contingencies at the time you make your offer.

In a few states, the entire matter of contingencies has been replaced by an option period. You pay a small option fee (e.g., $100) for a 10- or 12-day period of time during which you can back out of the contract for any reason at all, with no questions asked.

The second element of your offer which bears discussion right now is your earnest money deposit—how much cash you are willing to deposit just to show the seller that you are serious, or "in earnest" about this transaction. The amount of your deposit is something that you will make clear in your written offer. (Note: this money has nothing to do with your down payment—keep them totally separate in your head. See Chapters 4 & 7 for details.) This cash does not go to the seller (yet); it goes into an account and is eventually applied toward your closing costs or down payment (if any), or refunded to you. Why does the seller care about this? A couple of reasons. First, if you don't deposit any money, a seller may think you don't have any money, which makes the prospect of you getting a mortgage and closing the deal less likely. This, in turn, can make a seller hesitate to pull her house off the market and forgo other prospective buyers. Second, in most areas, if you back out of the transaction after you have removed your contingencies or after your option period has expired, you forfeit your earnest money deposit to the seller. That's right; the seller gets to keep sometimes thousands of your dollars as compensation if you breach your promise, or contract, to buy the property after the contingency or option period is up.

For now, just be aware that at the time you make an offer on a property, you should be prepared to write an earnest money deposit check of up to about 1 percent of the purchase price of your property. For a $150,000 property, this would be $1,500; for a $500,000 home, 1 percent equals $5,000. A good agent will include a photocopy of this check when they present your offer to the seller or the seller's agent, but the check will not be deposited unless and until your offer is actually accepted by the seller.

Phase Two

(1) Present and Negotiate Offer – This process differs widely based on the standard practice in your local area. In my area, the agent presents the offer to the listing agent, and many times is only allowed to do so by fax. On rare occasions, we do what other areas do as a matter of course, and the buyer's agent verbally presents or explains the written offer to the listing agent and/or the seller in person. Either way, this step involves the seller's receipt and review of your offer. The seller either accepts it outright, rejects it outright, or issues a counteroffer specifying which parts of your offer are acceptable and proposing to modify other parts. If the latter, some negotiating back and forth may ensue, until everyone agrees on the price, when the transaction will close, when you can take possession of the property, and so on. When you and the seller agree on everything, you are said to be "in contract."

(2) Open Escrow – This process, too, is different in different areas. Generally speaking, the escrow holder is a third-party, neutral intermediary, which collects instructions from you, the seller, both agents, and your mortgage company as to who gets what in the context of this sale; collects all the stuff that needs to be exchanged before the transaction closes; and then gives everybody the stuff they are entitled to under the contract at the time the transaction closes. They make sure, for example, that the seller gets the money and you get the deed. We'll go into more detail later, but generally speaking, once you are in contract, your Realtor or the seller's Realtor will deliver the contract (and your earnest money deposit check) to the escrow holder to kick-start the process of the necessary exchanges, "opening escrow."

(3) Review Title – You receive a document called the preliminary title report, which allows the professionals involved to determine whether anything related to the seller's ownership of the property will make it difficult or impossible for the sale to occur. For example, if the property is involved in a bankruptcy or a divorce, the seller may not actually be able to legally sell it to you, and this kind of thing will show up on this title report. The report concludes with an offer to you, the new buyer, of a title insurance policy that protects the legal ownership that you are purchasing, and the terms of that policy. See Chapter 8 for what you need to know about title reports and title insurance policies.

(4) Inspections and Disclosures – At this phase, your Realtor will recommend the inspections that they feel you should obtain, based on the specifics of your property and your community. Your Realtor should also recommend inspectors, and may even call and schedule inspections for you. You should do your best to be present at some

of these inspections so you can visually see the items your inspectors discover—good and bad. Your inspectors will each issue written reports—often available via email or fax—which you and your Realtor will review to learn about the condition of your property. Sometimes your mortgage lender even wants some of this information to make sure they are making a loan secured by a property that is in good shape. Later in this chapter we go into more detail about your inspectors, and in Chapter 8, you'll learn the ins and outs of what to look for in their reports.

In every state, the sellers are required to disclose to you all material information about the property. Translation: they have to tell you anything—especially anything negative—which might impact a reasonable buyer's decision making about a property. Depending on your state, there are anywhere from three to about 40 legally mandated disclosure forms which a seller must complete and provide to you. These forms will tell you any manner of things, from whether anyone has died in the house recently, to any major home improvements the sellers conducted in the time they owned the property, to how many garage door openers you should expect to receive after closing! You will review these documents with your Realtor, who can help you pick out and assess the seriousness of any anomalies or concerns the sellers disclose.

(5) Resolve Condition Issues – This phase can unfold in a number of ways. After you receive and review the inspectors' reports, you can accept the property as-is. Alternatively, you can ask the seller to repair some items, to "credit" you some cash in lieu of repairs, or to reduce the purchase price given the condition of the property. You can also do some combination of these things—accept some items, but request that the seller repair others. The seller, in turn, can say yes or no to any of your requests. Which course of action you choose is highly situational—depending on the type and degree of the condition problem(s), the terms of your original contract with the seller, whether your market is a seller's market or a buyer's market, your ability to pay for work after you own the property, standard practices in your market, and the list goes on. In Chapter 8, we'll explore how to decide what to do about condition problems. In this phase you'll either back out of the deal because you and the seller cannot come to a meeting of the minds about how to resolve condition problems, or (more likely), you will resolve them and move forward with the process.

(6) Submit Home Information to Lender – Though by this phase the lender has already approved of you as a borrower, they will need to approve certain aspects of the specific property you buy before they can actually send funds to the escrow holder to release to the seller. Your Realtor and mortgage broker will work together to make sure that any information the lender requests about your property is submitted in a timely manner. This may mean sending information to the lender in appropriately-

timed installments. For example, you may want to send the address over immediately after you go into contract, in order to "lock" a favorable rate or terms, whereas you may want to wait to send information on the condition of the property until such time as you've been able to review the inspection reports, and resolve condition issues with the seller.

(7) Underwriting & Appraisal – A licensed appraiser will visit the property in person, measure it, compare it to other properties that have sold recently in the neighborhood, and prepare a written report expressing her opinion as to the fair market value of the property. During the underwriting process, the appraiser's report, updated information about your credit history and personal finances, and the requested information about the property are all reviewed by the lender against the lender's checklist of standards and requirements for the particular loan you are seeking. The underwriter will then issue a final loan approval with a list of final conditions that must be met for the lender to send funds to the escrow holder, including things like a phone call to your employer the day before closing to make sure you still have a job!

(8) Remove Contingencies or Option Period Expires – After—and only after—you and the professionals on your team have reviewed the inspection, title and appraisal reports, and are 100 percent satisfied that you do not need or want to back out of the deal, you will sign a form removing your contingencies. By signing, you might be putting some big bucks on the line, so you will sign the contingency removal only when you are comfortable that:

- **Your loan approval has been finalized;**
- **Your property has appraised at or above the price you have agreed to pay for it;**
- **You have read, understood, and accept the information contained in the seller's disclosures; and**
- **The property's condition is acceptable to you, or you have a written agreement from the sellers to put the property in acceptable condition prior to closing.**

This form communicates to the seller that (a) you are committed to moving forward with the transaction, and (b) if you back out after this point, they may be allowed to retain your deposit money.

Phase Three

(1) Secure Homeowners' Insurance – **At this phase, you purchase a policy of homeowners' insurance or, if you are buying a property in a Homeowner's Association which carries insurance on the building, you purchase a policy of insurance that covers your personal possessions. Your mortgage lender will not send the money to the escrow company until they are comfortable that the building is appropriately insured.**

(2) Sign Documents & Submit Down Payment – **You report to the escrow holder's office, and sign about a five-inch stack of papers for the mortgage, and about a quarter-inch stack of papers to actually transfer the home into your name on your local government's public records. If you are putting any money down or your earnest money deposit did not cover all of your closing costs, the escrow holder will do the math and let you know around the time of your signing what amount of money—to the penny—you need to bring to her in order to close the deal. Around the same time, but not necessarily in the same room or even on the same day, the seller will sign, too.**

There are some interesting logistics involved in signing. At these signing appointments, the escrow holder fulfills its mandate to make sure that the person who shows up and claims to be you and the person who shows up and claims to be the seller both are each who you claim to be. So, you'll generally need to bring your government-issued photo ID, your Social Security card (the original), and your thumb, since the escrow holder or a notary public she retains will often actually take your thumbprint as another form of proof of your identity!

(3) Mortgage Funds – **After you and the seller have both signed all the necessary paperwork, the escrow holder submits all the documents to the lender along with any last minute information the lender has requested. Within about one business day after signing, your mortgage loan will "fund," meaning that the lender will actually wire the money to pay for your home directly into the escrow holder's bank account, so that it can be disbursed to the seller (and/or the seller's mortgage lender).**

If there is anything that the seller has promised to do before closing, you will want to be sure that it is done, or that you are okay with it not being done, before the day of funding. The lender begins to charge you interest on your mortgage the same day the loan funds, not when the transaction closes, so the goal should always be to have as few days as possible between funding and closing. The ideal timing of this sequence is that you sign one day, fund the next day, and close the day following that.

(4) Record & Transfer Title, & Close Escrow – When the escrow holder has received all the necessary deposits—most importantly, the signed deed from the seller and their mortgage lender, the money from you and your lender, and the go-ahead from the Realtors on both sides—they will make a deposit or issue a check to the seller and her lender. Within a matter of an hour or so, she will have a courier physically deliver a copy of the new deed to your local city or county Clerk or Recorder's office, putting the world on notice that you are now the owner of this home! She will prepare a final accounting statement that shows every dollar and cent that you and the seller paid, or were charged, in connection with your purchase.

(5) Take Possession – This is where it starts to get fun again—you get the keys and get to move in! Most of the time, this happens the same day you close escrow. However, it is not at all strange for the seller to have a "rent-back," a period after you actually own the property, where they rent it back from you because they are not quite ready to move. The rent-back period can range from a day to two months. This is something that would have been negotiated between you and the seller quite a while before closing.

(6) Fête Accompli – You throw a housewarming part-tay.

The People

The path to homeownership is seldom traveled alone. Buying a home is very much a team endeavor, and may end up forcing you into management of the largest team you have ever led. In fact, most homebuyers end up retaining six or more professionals to work on their transaction before escrow is closed. Just like in the workplace, the only way you can effectively manage your team is to know their titles, their job descriptions, who pays them and how much, and how to select the best person for the job.

All these people are inextricably intertwined with the process—each person's job is to educate, advise or facilitate on your behalf through one or more phase of your homebuying experience. You can get a sense of what they each do just from the context of the chart, but I want to drill down deeper into who each of these people are and the nature of their relationship with you. Remember, one of my goals is to equip you to lead your team, rather than letting them lead you. In a corporate setting, you would never be able to effectively manage someone without knowing the details of their job description. So let's take a cue from the corporate HR folks and figure out which element(s) of the process are the province of which member(s) of your homebuying team.

Your Realtor

This is usually the first professional you will retain and always the most important hiring decision, as the person you pick will shape your experience and, in some instances, impact whether you successfully obtain a particular property (or a property at all)! First, some clarity on the different titles wielded by these folks is in order. Real estate agents and real estate brokers are individuals who are licensed by your state to represent buyers and sellers of homes, land and businesses. All agents must work under the supervision of a broker, and all brokers have demonstrated the years of experience and the advanced understanding of state real estate law required for the state to authorize them to supervise agents. Not all brokers choose to supervise other agents, though; a broker associate holds a broker's license but works at another broker's office instead of running her own. And a broker is not necessarily more experienced than an agent; many agents who have been in the business for years have opted not to get a broker's license because they have no desire to own an office or to supervise other agents.

The term Realtor refers to a licensed agent or broker who is a member of the local, state and national Associations of Realtors. About half of agents and brokers nationwide belong to these Associations—this narrows the field of folks from whom you choose to a measly million Realtors nationwide. Throughout the book, I will refer to your representative as your Realtor, because I urge you to only work with an agent or broker who is actually, uh, a Realtor. First of all, Realtors have agreed to adhere to a Code of Ethics and standards of practice above and beyond the minimums imposed by state law; and have volunteered to be subject to discipline by their peers for ethical violations. In my experience, this does not obliterate ethical violations, but it does decrease them and it also gives you an avenue for recourse if you have problems with your Realtor.

Who *Are* These People?

Real estate agents and brokers are notorious for giving themselves unique titles in an effort to stand apart from the competition. If you ever meet someone who says they are "in real estate," but you can't figure out what they do from their business card, check it against this list.

Realtist – A member of the National Association of Real Estate Brokers, a group of minority real estate professionals;

CRS – Certified Residential Specialist, a Realtor with additional education in residential sales;

GRI – Graduate, Realtor Institute, a Realtor who has completed 90 hours in advanced education in sales, legal, technological and ethics topics;

ABR – Accredited Buyer's Representative, a designation held by less than 1/2 of 1 percent of Realtors nationwide, who have demonstrated experience in buyer representation and have completed additional education on serving buyer clients;

e-pro, e-buyer, SRES (Senior Real Estate Specialist) – Additional designations that can be earned by Realtors to denote their above-average technological skill or education in serving a particular type of client.

Secondly, Realtors have made a significant financial investment in their careers, and generally take their professional growth, development and education more seriously than licensed agents and brokers who are not Realtors. (The Associations are the primary providers of agent and broker skills training and education nationwide.) Other brokers and agents know this, and will instantly see your representative as more professional by virtue of being a Realtor; this is critical in situations where your offer is competing with other offers. Finally, most reputable real estate brokerage companies require that licensees working with the company be Realtors. When your Realtor works with a reputable company, you stand to benefit from company resources such as advanced technology, sophisticated informational resources for you, and sometimes even in-house legal counsel to help keep your transaction from being derailed.

Real estate specialist, real estate consultant, sales associate, broker associate, real estate guru, real estate assassin (yes—assassin!)—These are various titles I have seen on the business cards and websites of various agents and brokers. These titles are neither good nor bad, but you

do want to make sure you are dealing with a licensed agent or broker, at the very least. If push comes to shove, most state Departments of Real Estate have websites where you can type in an individual's name and determine whether they are actually licensed or not.

What They Do – A good Realtor is to your transaction what an attorney is to a lawsuit. You, the client, provide the overall direction and vision for the outcome, but they actually facilitate and drive the transaction to get it to your desired destination. Your Realtor can:

- Help you determine your buying power, as well as select a reputable mortgage provider and financing options in light of your vision and your lifestyle;

- Provide resources to help you find properties to consider, and accompany you to view and evaluate properties;

- Provide expert knowledge and objective information about individual properties, resale considerations, neighborhoods and localities, schools, and other factors impacting whether a property will work for your life;

- Help you determine the price and terms you offer, present the offer, and negotiate on your behalf with the seller;

- Assist you in selecting a reputable mortgage broker and financing options that will work in light of the characteristics of your property and your life;

- Direct your finding and retaining other professionals—from an escrow officer or settlement attorney to the various inspectors and appraisers;

- Help you conduct due diligence and inspections on the property once you are in contract and review inspector reports and the seller's disclosures, to assist in your decision making about whether to re-negotiate, to proceed to closing or to back out;

- Guide you through the entire process, coordinating the exchange of documents during escrow and working with the escrow holder or attorney to make sure the transaction closes successfully.

Selecting Your Realtor – I'm not being melodramatic when I emphasize the importance of your relationship with your Realtor. In terms of your homebuying transaction and experience, there is no one—besides you—who will have more influence on the overall process and the outcome. However, your Realtor may also play more of a role in your personal life and family relationships than any other financial or professional advisor you ever work with. It is super important that you choose someone you trust and like, because you will reveal and discuss all of your

personal financial information with them, as well as many details about your lifestyle, your family, and how you live now vs. how you want to live. You may also spend many, many hours with this person in the car touring properties, either alone or with your family or other housemates.

Depending on your situation, this person may even be involved in your marital or relationship dynamics. I have worked with clients whose needs for a new home arose in the context of a divorce, but I have also worked with clients whose inability to work together in choosing a property was the straw that broke the camel's back, leading them to initiate a breakup! More often than not, though, a purchase may hold the promise of actually resolving a logistical relationship issue. A work-at-home couple sharing an office in their present home, for example, can get on each other's nerves as they trip over each other all day. If the new house has offices at opposite ends, these folks might actually look forward to seeing each other at the end of the day. The question, "How was your day, dear?" gains new interest when you don't already know the answer!

True Story – Closer Than Close

In the course of communicating about your ideal property for your life, you may end up developing an intimate relationship with Realtor. Last year, I had a couple of clients with whom the relationship grew so close that we developed our own private language for describing properties to each other – words and terms that instantly indicated both the substantive and emotional reaction to a feature or amenity or the overall property. These folks had very simple and elegant tastes, so when we saw a bathroom that was covered in marble from floor to ceiling and had faux gilt fixtures all over the place, one of them deemed it "ungapatz," her mother's faux-Yiddish term for all things in the style of the late great Liberace. They were looking at lots of Victorian duplexes, and many of the lower units were really just finished basements with ceilings I (at 5'4) could touch with a flat palm in my stocking feet. We learned how to detect these units from the exterior, and could tell from a drive-by whether the lower unit had "Hobbit potential." As in, only a Hobbit would feel comfortable living in a place with such a low ceiling. Homes with lovely old water towers in the backyard were asterisked as having "princess towers,"

Insider Secret

DON'T BELIEVE THE HYPE

Advertising is paid for by the individual agent or broker in the ad. The information contained in an ad doesn't necessarily reflect anything but how they are trying to position themselves in the market and how much they could afford to spend on their ad!

sorts of odors we encountered on the house hunt; there was the tolerable "old house funk," the dirty house "bio funk," the "someone-forgot-to-turn-off-the-gas funk," the "new paint/carpet funk," "the incontinent cat funk," and the list goes on.

The hybrid personal/professional nature of the relationship between you and your Realtor renders the selection process of utmost importance. I differ from those who say that you should approach this process with the Yellow Pages or the Real Estate Section of the Sunday paper, the phone, and a list of interview questions from a book or website. As a Realtor who has been approached in this way, I can tell you that [a] I shy away from working with total strangers, and [b] these question lists are well-known by every agent worth their salt, so almost every Realtor has good answers, which makes the questions less-than-useful at detecting a less-than-good Realtor. (In fact, at most new agent training courses, one of the first topics on the syllabus is how to answer these questions.) Your goal should really be to seek out a good fit—someone who is knowledgeable about the contracts and a skilled negotiator, someone whose personality jives with yours, someone who strikes a great balance of listening to your needs and providing their expertise and input, someone who is respected by other Realtors in the community, and someone who has the time and inclination to commit as much time and energy as is necessary to get you into the right place for your life and your resources.

Selection Strategy

I recommend a less formal, three-step approach to locating candidates and deciding who gets the coveted position as your Realtor.

> *Step 1: Find the Candidates* – Find your candidates from interpersonal relationships you already have, or ones that you create during the Preparatory Phase. Ask people you know who own or are shopping for homes in the same general geographic area where you want to live [a] who their Realtor was, [b] how their transaction went, [c] whether they keep in touch with the Realtor, and [d] whether they would work with the Realtor again. There is no arbitrary number of referrals you must get; if your best and most trusted friend is a raving fan of their Realtor, it may make sense to immediately follow up on that referral and create a relationship with that person. When you call that Realtor and mention the name of the referral source and your relationship to that person, you will automatically be perceived by that Realtor as being more credible, more serious, more qualified, and less mentally ill (i.e., more deserving of their

time and attention) than some random person off the street. If you are totally new to the area or know no one who can give you a referral to an appropriate candidate, check out the {RE}Think Real Estate referral resources at www.REThinkRealEstate.com. Besides referral, the only other method I advocate for meeting prospective Realtor candidates is attending homebuying seminars presented by local Realtors. The seminar will give you a chance to see the Realtor in action, gauge their comfort level with the material they are presenting, and start assessing the fit between their personality and yours. Public speaking ability is not a necessity in a great Realtor, but you will at least gain some idea of their professionalism and their ability to effectively present you and your offer to the seller in an articulate manner. Your Realtor's presentation to the listing agent or the seller might make or break your deal on the property you select.

Step 2: Check Them Out – Visit the websites of the Realtors to whom you were referred. Get a feel for the priority they place on technology, their business philosophy, etc. Type their name into the license status check box on your state Commission or Department of Real Estate website; it should read that the Realtor's license is Active and has no history of discipline. Give them a call, drop the name of the person who referred you, and let them know that you're looking to get started buying a home. Mention the geographic areas in which you are interested and ask whether the person works in those areas. Then make an appointment for a face-to-face meeting with the prospective Realtor. If their office is in an inconvenient location, feel free to suggest a coffee shop or restaurant, your place, or some other place where a private, unhurried conversation can be had. Again, don't feel that you have to make appointments with 15 different Realtors; make plans to meet with one or with five based on your comfort level during the phone conversation and the level of trust you place in the initial referral you were given.

Step 3: Initial Consultation – A good Realtor will have a set agenda or presentation for the meeting, which will involve many questions to assess your requirements and preferences. You can facilitate this process by providing the Realtor with your completed {RE}Think Real Estate Wants and Needs Checklist, from Chapter 6. If you just feel unprepared and empty-handed without a list of questions, here are a few you might want to cover during this session:

Insider Secret

A FRESH AGENT CAN BE A GOOD THING

Experience is important, but should not be a deal breaker. Ideally, you want someone who has done at least 10 or so transactions, but sometimes the newer agent will be more committed to you over the long haul, more willing and able to devote a greater deal of time to your house hunt, and more zealous about earning your lifelong business and referrals than the agent who has been in the business for 30 years. A newer agent can be totally acceptable, especially if she works at a company or with a mentor who provides consulting and support in the event something tricky comes up. But trust your gut as to her level of confidence and competence as she educates you about the contract and market dynamics. If she seems hesitant or unsure when just talking with you in the office, she might not be the best person to sell you or your offer to a seller.

- How much of your business is by referral?
- How much of your business is working for buyers?
- What areas do you work in?
- How long does it usually take for a new buyer client of yours to find their property?
- Can you refer me to a mortgage broker?

By the end of the conversation, you will want to do a gut-level assessment of whether you would trust this person with your closest confidences, and whether she exudes knowledge and professionalism. At the end of the meeting, if you would like to move forward and work with that Realtor as your representative, you will want to have a "loyalty" talk, discussing your level of commitment to working exclusively with that particular Realtor. The standard structure under which commissions are paid to buyers' agents sets up a dynamic which strongly discourages agents from investing much time or energy into buyer clients without some assurance of a loyal relationship. The basic dynamics of commissions and buyer-broker relationship can shed some light on how to inspire and secure a zealous commitment from your Realtor.

Commissions, Duties & Buyer-Broker Agreements

To understand how to get the most our of your Realtor relationship, it helps to know a little about her modus operandi: how her business works and how she gets paid. Once you know this, you can better understand—and influence—her motivations for doing the things you want her to do.

Commissions – In most cases, the commission payment structure is a trickle-down arrangement known as Buyer Representation, Single Agency, or Co-operation and Compensation. At the time a seller lists her property for sale with the listing agent, she agrees to pay that listing agent some percentage of the purchase price. When the listing agent places the property on MLS, she notes whether she and the seller are "co-operating" with Buyers' agents, and what commission they will pay to the successful Buyer's agent. Generally, the original commission is split 50/50 between the two agents; if the seller offered to pay a 6 percent commission, the listing agent offers Buyer's agents a 3 percent commission. Each of the agents then splits the commission further with their companies and pays their business expenses.

Duties – The fabulous moral of this story is that the seller pays for you to have a representative who owes you the duty of undivided loyalty to your needs above those of everyone else involved in the transaction. Your Realtor also owes you (and only you) the duties of:

- *Confidentiality* – She can't tell the sellers any of your personal information, without your consent. If you tell your agent that you really can go up an additional $10,000 on the price, she can't pass that on to the sellers;

- *Care and Diligence* – It is her job to protect you from harm that she, as a Realtor, should be able to predict. For example, she should recommend that you have the property inspected, as buying a home without inspections is a very predictable way to end up with a money pit on your hands;

- *Obedience* – She must follow your instructions and not do anything outside the scope of what you have authorized her to do. She can't make decisions for you;

- *Full Disclosure* – She has to proactively and honestly inform you of any- and everything she knows about the property and the transaction which will likely affect your decision-making;

- *Accounting* – She has to keep track of any money or property she receives or pays out in the course of your transaction, and must issue you a written accounting report if you request one.

Both Realtors involved in the transaction owe you and the seller the duties of:

- *Honesty* – They can't lie or defraud you;

- *Skill and Care* – They must comply with state licensing laws, and can't misrepresent the facts;

- *Disclosures* – They have to share with both parties to the transaction (i.e., the buyer and seller) all significant facts about a property, and they also have to disclose the details of the agent relationships. The agency relationship disclosure will include the names of both agents, their companies, which party each Realtor and company represents, and the duties each Realtor owes to the various parties.

Dual Agency and Subagency – When you work with the Realtor who is also representing the seller, the resulting relationship is called Dual Agency. You will avoid this in most cases by following the Realtor selection process laid out in this chapter, rather than just buying a home from the agent who is sitting at an Open House. Every once in awhile, though, your Realtor may list a home that turns out to be just right for you. This can present some opportunities for you, as in cases where the Realtor may take less than the previously agreed-upon commission if the seller accepts your offer, which makes your offer worth more to the seller than just your offer price.

However, dual agency presents some challenges, too. It is not humanly possible for one Realtor to fulfill her duty of undivided loyalty to two clients on opposite sides of a transaction; her loyalty is inherently divided by virtue of the situation. Also, the duty of confidentiality to one client is in direct conflict with the duty of full disclosure to the other client. If you ask me, this is quite undesirable, especially if you have worked with this agent and perhaps revealed a lot of personal and financial information to them over the weeks and months prior to selecting this property. However, if you simply have to have this particular property, there may be no other sensible alternative to dual agency. From the moment you realize your agent or broker also represents the seller, be very careful about what you reveal to your Realtor in terms of strategy and confidences.

On occasion, you may run into an archaic and unnatural practice called subagency. In subagency, the buyer's agent is forced to work as an agent for the seller's agent in order to collect a commission. In these situations, the very term "buyer's agent" is a misnomer; the

Insider Secret

BIGGEST IS NOT NECESSARILY BEST

The "biggest" agent in your area is not always the best agent to work for you as a first time buyer. These agents often focus on listings and representing sellers, as buyers are viewed as time-intensive, work-intensive, and not leading to a guaranteed commission.

structure is set up so that both agents actually work for the seller, and no one technically works for the buyer—not even the agent who drove the buyer around all those months and negotiated the offer with the seller! See what I mean by unnatural? I won't go into further detail about this, as the practice has been abolished by practice or law in most areas, but if this is the sort of representation proposed by the agents involved in the transaction, your Realtor will be able to tell from the MLS listing. This is an item which must be disclosed to you early on, so if it applies to you, you will know.

> **Buyer-Broker Agreements -** Traditionally, many agents and brokers strongly preferred working with sellers over buyers. When an agent signs a listing agreement, they are guaranteed to receive their commission when the property sells. Buyers had a bad rap for gobbling up dozens of hours of an agent's time, only to let their brother-in-law's pretend-cousin or the listing agent actually write the offer on the home, leaving "their agent" high and dry in terms of compensation. Plus, while a listing agent lists a house, markets it, and generally waits for a qualified buyer to appear, a buyer's agent may drive all over town showing homes every week for months or years with no guarantee that the buyer will actually find something they like, or buy it even if they do. It got so bad that seasoned agents routinely exhorted new agents that they must "list to last" in the business. In some regions, there were virtually no buyers' agents; buyers just drove around to Open Houses and had the listing agents write their contracts.

Over the past several years, buyers' agents have taken control of educating clients about how they must activate and protect their choice of Realtor, and the stigma attached with buyer representation has drastically diminished. This may be due, in part, to the increased popularity of Buyer-Broker Agreements. These contracts create a formal relationship between buyer and Realtor, and provide clarity as to the work the Realtor will do for the client and the loyalty and/or compensation that the client will guarantee in exchange. In the majority of cases, the seller will be offering a commission to the buyer's Realtor independent of what compensation provisions exist in the Buyer-Broker Agreement. These agreements, however, often include some type of clause in which you as a buyer commit to not inadvertently or intentionally screw your Realtor out of a commission.

True Story - You're Fired!

I fell victim to one such misunderstanding right out of the gate. On the transaction which would have been my very first ever, I was working with some friends, a married couple who were both attorneys. I was sending them materials from MLS, we had met and discussed their wants and

needs, and we were in the process of putting our first property tour on the calendar. One Sunday afternoon, I called them to see how they were doing, and they said they were going out to visit Open Houses. I asked if they wanted me to take them around, and they said no, that they were just going to mix some Open Houses into their errand schedule, and were just planning to play looky-loos that day.

The next morning, I awoke to an excited phone call from the husband of the pair, saying that they had found "the house" the prior day. He was so thrilled, and let me know that they wanted to meet with me ASAP so I could look over the contract. Contract—what contract? Oh, he said, just to make sure they didn't lose the place, they went ahead and asked the agent who was holding the Open House if he would write up the contract. But now he wanted me, "his Realtor," to check it and be sure it looked okay. Because I had not explained how commissions and agency relationships worked to him, "my client" had no idea that by allowing that agent to draft the contract, he had effectively fired me and hired him. That experience taught me that what agents think of as buyer disloyalty can really be an issue of education and information, and not always malicious intent on the buyer's part. Now my buyer clients carry a stack of my business cards with them into Open Houses, and hand them out when agents start soliciting them. And every client of mine understands that if they want me to be their representative, I need to be the person that drafts their contract for them. I'm only a cell phone call away!

People often ask me whether they should sign a Buyer-Broker Agreement, and my advice is that you certainly should be open to it. If your Realtor asks you to sign one, read it and determine whether the terms are acceptable to you, but ask to include a release clause so that you can change representatives if you later become dissatisfied or change direction. This is essentially a pre-nup for your Realtor relationship, making sure everyone is clear up front on what will happen if the relationship turns out to be functional (i.e., mutual loyalty) or dysfunctional (i.e., mutual release). This serves you by preventing the stress, suspicion, and guessing games that can happen on both sides of the relationship, and freeing that energy up so everyone can direct it toward getting you your home! Remember, Realtors are commissioned salespeople, and when you make your commitment to them clear, you not only demonstrate your respect and appreciation for their work, you also "incentivize" them to work harder and longer than they might have if your loyalty were in question.

As a buyer, you stand to benefit from a Buyer-Broker Agreement more than you generally stand to be harmed by it, and in most cases, the seller will still be the one to pay your Realtor's commission. The point of the compensation clause in the agreement can be one or more of the following:

- To express your commitment to your Realtor;

- To agree to make up the difference between a really low seller-paid commission and the minimum amount your Realtor agrees to work for (more about this later); or

- To evidence your agreement to pay your Realtor if they find you a home that is For Sale By Owner, or one where the seller has not authorized the listing agent to cooperate with other agents. This opens up the universe of properties that your agent will search on your behalf beyond just those that are listed on MLS. Most properties are listed, but having more properties to choose from is never a bad thing, and many times the non-MLS listed properties will pose the least competition among buyers!

Whether you should sign a particular Buyer-Broker Agreement is a harder question, because Buyer-Broker Agreements vary from state-to-state, and some states even have several different versions of the agreement. Complicating matters is that many Realtors just create their own informal letter of agreement between themselves and their buyer clients. These documents are usually no longer than two pages; if your Realtor asks you to sign one, read it and see how comfortable you are making the commitments it contains.

Most Buyer-Broker Agreements have some or all of the following provisions:

- Purpose of the agreement (i.e., the type of property you are looking for – residential condos and single family homes, for example);

- Scope of services you want the Realtor to perform (e.g., showing you MLS-listed houses in X cities meeting Y criteria);

- Exclusivity – this one is the kicker. Very few serious Realtors will agree to a non-exclusive relationship with a buyer. The rare instances in which this makes sense are when the buyer is looking in two widely disparate geographical areas, like Virginia and Oregon. Even then, though, your Virginia Realtor would probably ask you to sign an exclusive agreement with them for Virginia properties, but would of course provide in the agreement that you could also work with an out-of-state Realtor on your out-of-state house hunt. If you are uncomfortable agreeing to work exclusively with one Realtor you should:

 → Make sure you are working with the right Realtor for you;

 → Commit to the Buyer-Broker Agreement for a fairly short trial period (a weekend, a week, or a month), then extend it once you are comfortable that this Realtor and you are a good fit; or

→ Negotiate a 72-hour release clause from your Buyer-Broker Agreement, so that if relations with your Realtor should sour, you are not bound to her for the rest of your natural life. (No Realtor really wants to continue working with a client who has grown to despise them anyway.) Understand that if you exercise your release clause, but end up buying a property that the fired Realtor showed you while you were working together, you may still be obligated to pay a commission to that Realtor, depending on the terms of the agreement.

- **Duration** – How long will you commit to having this person as your Realtor? How long, relative to others, does it take you to select your choices from a menu at a good restaurant? If you know you are a slow and deliberate decision maker, consider that when determining duration. Are there lots of homes on the market or not? This should factor in, too. Some Realtors will not work with a buyer who does not commit to a certain minimum time period; if you really like a Realtor who insists on a three-month period, ask for a one-weekend trial first. If that works well, consider signing the Agreement, but press hard for a 72-hour release clause.

- **Compensation** – Here, you need to decide whether and how much you are willing to pay your Realtor. If you don't want to pay anything at all ,ever, you need to make sure that the contract states you only want to be shown MLS-listed properties where the seller is offering a commission acceptable to your Realtor as payment in full for services rendered to you. If you are a little more flexible, the Agreement can include clauses for cases where the property is a FSBO or a broker exclusive, and the seller refuses to pay your Realtor's commission. In any event, compensation is generally tied to the condition that you actually purchase a home; if you don't, you pay your Realtor nothing. Right now, sellers are experimenting with offering lower and lower commissions to their agents and the buyers' agents. Your Realtor may set a minimum flat fee or percentage rate that they will work for in the agreement. In these cases, the buyer agrees that if the co-operating agent commission offered on MLS to their Realtor is less than the Realtor's minimum compensation, the buyer will pay the difference. The idea is that you and your Realtor discuss the various scenarios that may arise during your house hunt and their impact on compensation, and resolve them in writing before you get started. Clarity is the key.

The Mortgage People

In some ways, shopping for a mortgage is just like shopping for other stuff. I've been so busy over the last few years that I've seriously looked into hiring a personal shopper to help out at Christmas and before traveling. It looks like they come in two flavors. One sort is a complimentary service of the high end department stores; you can report to certain areas of the store, let a shopper measure you, and they will bring out things for you to try on. I haven't tried this yet, as I

am an avid sale shopper and don't believe anyone else will hunt for that micro-pleated Ann Klein cocktail length skirt (regular price $199, marked down to $99, with an additional 30 percent discount) quite the way I will. Especially not someone who works for the store! I need someone who can look at 10 stores, not just one, and someone who is motivated to find me the best values—not just cheap stuff, but the best stuff at the best prices. On the other hand, those of my friends who have used these services have raved about the concierge style of service they've experienced with these shoppers, and the expertise these folks have in terms of the sizing and offerings in the store. So for those who have a favorite store, or are trying to take advantage of a particular store's good credit terms or sale, using a store-employed personal shopper might be a fabulous approach.

The other type of personal shopper is the freelance type—a personal shopping service that you can hire to go out to whatever stores you specify and look for anything and everything you specify, in whatever price range you specify. You're the boss, so you get to set the parameters: you can give them an overall budget, a per item budget, or a mix; you can get precise about what exact item or brand you want or describe what you need the item to do and let them select the best one they can find. You can be very specific about some things and very flexible about others, depending on your knowledge of the offerings out there in the marketplace, and how clear you are on what you want or need. If you find a shopper with some expertise on the sorts of things you're looking for, they can "interview" you to get more clarity as to what kind of clock will be best suited for you and they may know off the top of their head exactly which of the eight clock stores offers the best value on clocks, so they can go directly there. This is critical, because these services generally charge you an hourly rate for their work. If you can find personal shoppers who know where the best deals are on the products you need, they will be more efficient, you will pay less, and you'll be much more likely to actually get something that meets your needs.

Now, if you're really a comparison shopper, you might be inclined to take a third option which allows you to get your shopping done without leaving the house—shopping online. Depending on what you are looking for, you can compare the price of a single item, or the features of multiple items, at the website of a brick-and-mortar store (like Nordstrom or Target), at an outlet/discounter-type site (like Bluefly or Overstock), or at a non-discount portal site (like Amazon). You have to pay shipping, but you can do it in your sweats at 2 a.m. while you watch old Law and Order episodes, and you don't have to prepare an obsessive-compulsive list for your shopper—nor do you have to pay for a shopper. And, you can often find opinions or ratings by people who have already purchased and used the item, which can be quite useful. So, this is the route I usually take when I just can't muster the energy to drive out to the stores.

These are not random ramblings; the different types of personal shoppers have everything to do with the different types of mortgage professionals. After all, these people are the folks who "shop" for your mortgage loan, in every sense of the word. You'll need to choose one of these types of professionals to be your intermediary with your lender—the bank that loans you the money you use to buy your home:

Mortgage Representative

Who They Are & What They Do – If you walk into a bank off the street, and say you are interested in a mortgage, the person you'll meet is a mortgage representative. This person is like the department store employee who will shop the store's inventory for you; their job is to find the best mortgage program for you out of those offered by their bank, to collect and submit the necessary documents to support your loan application, and then (once you are in escrow) to serve as the middleman between you and the lender until your mortgage loan has funded, allowing escrow to close.

Who They Work For – A mortgage representative represents their employer, the lender.

Aliases – Mortgage Consultant, Home Loan Consultant.

The Problem Is – The problem with working with a mortgage representative who works for one lender is that lenders tend to offer loan programs with an underlying theme based on the risk tolerance of their corporate personality. For example, traditional banks tend to offer low rates to borrowers with relatively good credit who can document their income. Others specialize in making loans to less-than-perfect borrowers, but charge higher interest rates and have other, more burdensome terms. If you happen to walk into the right sort of bank for your situation, working with a mortgage representative can work out fine, but if you don't, you can end up being rejected for a loan or paying more than you would if you were working with a more appropriate lender.

How They Get Paid – Mortgage representatives work on a base salary plus commission structure, and generally charge you to work on your transaction as part of your loan closing costs. More often than not, the charge is about the same as what a mortgage broker (read on) will charge to shop for your loan.

A Mortgage Rep Might Be Your Best Bet If – Generally speaking, the more options the better, and working with a mortgage representative restricts your options to the mortgage programs offered by that particular lender. There are a couple of situations, though, in which working with a mortgage representative makes a lot of sense. Just as a Nordstrom cardholder might do well to use a Nordstrom personal shopper, if you:

- Work for a lending institution;

- Have other (e.g. checking, savings, investment or retirement) accounts with the lender;

- Are buying a new home (see New Home Mortgage Q&A, facing page);

- Belong to a credit union; or

- Belong to some organization (e.g. union or association) which has preferred status with a lender, you may be eligible for preferential mortgage rates or terms with that lender that are better than what you could get elsewhere.

Make Sure You're Getting the Best Deal

Once you receive a good faith estimate from a mortgage representative with the loan amount, interest rate and terms of the loan for which you have been pre-approved, you should consider contacting a mortgage broker (see next section) for a second opinion regarding whether the mortgage you have been offered truly is better than what you could get elsewhere, comparing fees and other terms than just interest rates. Also, if you are an A+ borrower (i.e., you have good credit, low debt, a large income, etc.), many of the traditional, big banks will offer you equally good rates and terms, so you might want to take advantage of the convenience connected with having your mortgage at the same institution as your other accounts.

 # New Home Mortgage Q & A

Q: Can a new home builder force me to use their lender?

A: No, but they can (and often do) require you to get pre-approved by a lender they specify. Often, that lender and the builder will be affiliated or have some sort of financial relationship; if this is the case, you are legally entitled to a disclosure as to the nature of their relationship.

Builders want to be sure that the buyers who are reserving lots and homes in their developments will actually be able to secure a mortgage, and the only way they can do this is to have buyers' credit and assets reviewed by the builder's own lender. The builders and their lenders also know that because getting pre-approved requires a little effort, the average buyer who obtains the required pre-approval will not go to the trouble of seeking a second opinion. However, the builder cannot force you to actually buy the house with a mortgage from their lender. If you are buying a new home and are required to get pre-approved by the builder's preferred lender, go ahead and do so, but make sure to get a duplicate set of your loan application and the supporting documents. Submit the second set to a mortgage broker and see if they can find you a better rate and/or terms.

May the best mortgage win!

If your situation requires anything unusual or exceptionally demanding from a mortgage perspective—like short escrow or contingency removal periods, or you have low credit scores/can't document income/and the property is difficult to appraise—a lender-employed mortgage representative may have some difficulty getting the loan funded and closed in a timely manner. Lenders' internal loan approval and funding personnel adhere strictly to bankers' hours, so they may take longer to get the same mortgage transaction completed than a mortgage broker, many of whom work evenings and weekends. If you have a challenging situation and are working with a mortgage representative, consider getting a back-up pre-approval by a mortgage broker who can commit to making it work within the framework of almost any challenge you throw their way!

Mortgage Broker

Who They Are & What They Do – Working with a mortgage broker parallels working with a freelance personal shopper. The better mortgage brokerages can access all the mortgage programs at anywhere from 40 to 400 different lenders on your behalf. There are only about 15 to 20 major lenders, so even a broker with 40 lenders will still be able to offer you most of what is out there; some of the larger and more established brokers have taken the idea of getting you as many specialty and "non-conforming" loan options as possible to the extreme—these are the ones who may offer programs from 300 or 400 lenders. Their job is to collect your application and documentation, then to "shop" your scenario among lenders, finding you the best loan program at the best rate and terms available.

Mortgage brokers excel at matchmaking between you, the right lender, and the right mortgage program. They can look at your application, ask you some questions and determine what lender and loan is best for you, whether you are a blue-chip borrower or have an off-the-grid situation.

Who They Work For – A broker works for you, and represents you to a number of different lenders. Also, they are usually paid 100 percent by commission, so they only get paid when they are successful at finding you a loan, getting you approved, and then closing the deal. Their commissions are paid partially by you, when you pay your closing costs, and partially by the lender whose loan program they chose for you.

Aliases – Mortgage Agent, Independent Mortgage Consultant. (I know—it can be hard to distinguish from a mortgage representative. Unless it's obvious. If the person's business card says the name of a well-known bank on it, for example, they are probably a lender-employed representative—just ask the person whether they are a broker or whether they work for a lender.)

Where You Find Them – The best way to find your mortgage broker is to ask your Realtor for a referral to someone they are comfortable working with. Your Realtor and mortgage broker will need to work closely as a team throughout your transaction, so finding a situation where the team dynamic is already organically occurring is ideal—they will already understand how each other works and have the necessary communication channels in place. Also, a mortgage broker who gets repeat business from the same Realtor has a built-in incentive to take extra special care of that Realtor's clients.

The happier the mortgage broker makes clients and the smoother the loan aspect of the transactions, the more likely that Realtor is to continue referring clients to that mortgage broker. You should definitely take advantage of the benefits of the repeat relationships your Realtor has, not only with a mortgage broker, but also with the other personnel you will need to complete your transaction.

They've Got Skills – Mortgage brokers keep their fingers on the daily changing pulse of which lenders are offering which rates on different programs for every type of buyer. So, just like hiring a personal shopper who knows where to go for the best value on clocks, working with a mortgage broker who knows where to go for the right mortgage for you is usually the most efficient and effective way to get the right loan for you. Most importantly, a skilled broker will do an intense troubleshoot of your application before it is submitted to the lender; will be able to anticipate, avoid and resolve issues the lender may have before they arise; and will be able to advocate for your application throughout the underwriting process in a way that a lender-employed representative is less likely to be able to do.

Caveat Borrower

The lender-paid share of a broker's commission is usually dependent upon the rates and terms of the loan: as a general rule, the higher the rate or more burdensome the loan is on the borrower, the more money the lender pays the broker. Sounds like this would cause all brokers to try to put as many people in "bad" loans as possible, but in fact, this reflects lenders' recognition that the "bad" loans usually go to difficult-to-approve borrowers. These loans can require a lot more work from a broker than a more conventional loan, so the increased pay is appropriate to compensate brokers for working on harder loans. Reputable brokers understand that buyers are often talking to multiple mortgage brokers and/or getting online quotes in order to comparison shop; the market competition makes good brokers know they need to bring their A game (i.e., best available rates and terms), no matter how much the lender is offering to pay them.

Insider Secret

SIZE DOES MATTER!

Most mortgage brokers work under the auspices of a brokerage company, with which they share their commissions in exchange for access to lenders, office space, etc. If your mortgage broker works for a very large and very reputable company, you might get some perks in terms of [1] the competitiveness of your offer (listing agents know which pre-approval letters mean what they say, and which ones mean nothing, in part by the letterhead on the paper) and [2] the responsiveness of the lender (my favorite mortgage broker's company does more loans with one blue-chip bank than any other brokerage—so when she calls the lender, they listen and respond quickly). These perks can translate into getting your purchase DONE, and done on time, so working with a broker at a large brokerage can be a great thing.

Broker/Lender Combos

Some mortgage brokerages have their own banking divisions, which actually make their own loans directly to buyers. These companies' brokers can compare their own companies' loans with external lenders' loans to find the best deal for you—and can combine internal and external loans for clients who need to make a small or no down payment. These companies' primary business is usually the matchmaking between buyers and external lenders, so they prefer to make loans in small amounts, or in niche situations where a smaller loan they make is the glue that holds a much larger transaction together. For instance, suppose a buyer gets approved for only 90 percent of the purchase price in mortgages from the lenders a broker works with, but doesn't have the remaining 10 percent in down payment money that is needed to close the deal. In this type of situation, a brokerage with an internal banking division may lend the buyer the 10 percent directly, allowing them to buy the home that otherwise might have slipped out of their grasp. Ask your mortgage broker if her company has its own banking division and, if so, whether they have any loan programs that make sense for your situation.

Online Mortgage Companies

In the world of personal shopping, it makes sense to log on and start shopping yourself, versus hiring a shopper to work for you. This is not always the case with mortgages.

Who They Are & What They Do – The online mortgage offerings are a somewhat confusing mix of sites of online lenders (e.g., QuickenLoans.com and Eloan.com), and sites that act as a referral network, which take your basic information and then get you loan quotes from several lenders who have paid to be members of the network,

like LendingTree.com. What is confusing is that the referral networks are not licensed brokers (i.e., they don't shepherd your application and file through closing), but they often do have internal lending subsidiaries. So, one of the four or five lenders who "competes" for your business on a network site may actually be the site's internal banking division. Whether you work with an online lender, a referral network's internal lending arm, or you select an external lender who belongs to a referral network, when you get a loan online you are effectively dealing with a mortgage representative who is employed by the lender, as discussed above, just online.

Pros & Cons – All the issues of working with a mortgage representative which we have already discussed apply to online mortgages. You have the advantage of being able to apply at your convenience, and without any in-person pressure, but these online arrangements are notorious for having customer service deficiencies when your transaction is actually in escrow. Once you are in escrow, getting your loan approved and funded in a timely matter is absolutely necessary for you to close the deal—buyers' failure to get loan funding on time is the number one reason home purchases fall through. It can be a crapshoot to choose a mortgage representative who works in a call center halfway across the country from you, and has no relationship to your local real estate community (read: no in-person accountability to your Realtor or to their reputation). I have heard both rave reviews and horror stories from buyers who have worked with all of these companies.

If I Were You – As much as I want you to take advantage of technology in the course of your homebuying process, I'd prefer that you worked with someone whose office you could walk into on this important of a transaction. Shopping for a mortgage is distinctly different than shopping for items which (a) are widely available to the general public directly from the suppliers, (b) require little or no expertise to select, and (c) do not require a complex approval process to purchase. You deserve and should take advantage of the expertise of either a mortgage representative or broker in matching your lifestyle and qualifications with the right loan and/or lender. Your likelihood of successfully closing your home purchase is dramatically increased when you have a skilled professional whose income depends on their success at preparing, submitting, and guiding your loan paperwork through the maze of lender guidelines until your mortgage has funded.

Appraiser

The appraiser's job is to do an in-person visit to your property, measure it and verify its features, and make an opinion as to its fair market value by comparing it to other, similar properties in the neighborhood that have sold recently. The appraiser then prepares a written report which the lender relies on as evidence of the fair market value of the home, i.e., the amount the lender could sell the house for on the open market if you defaulted on your mortgage. Pessimistic outlook, huh?

> **How to Pick One –** Your mortgage broker or lender will select an appraiser who is acceptable to the particular lender(s) funding your loan.

> **Who Pays Them & How Much –** The appraiser's fee—ranging from about $250 upwards, depending on the nature of the property—is paid by the buyer as part of the closing costs.

Escrow & Title

Here's another area that gets tricky due to the jumble of job titles people use, some geographical differences in who does what, and the fact that the same person or company often completes multiple escrow and title tasks. Let's get clear on the functions which are handled by escrow and title professionals, then we'll back into job titles and who does what in your area.

> **Escrow –** An escrow is an independent, neutral account, and the channel through which the major interests of all the parties involved in the transaction are protected. Think about it like this: if you met a stranger on the street, and they say they own the deed to a house worth a few hundred thousand dollars, and you agree to give them that sum—who hands the goods over first? Do you stand there with the money, have that stranger face you with the deed, and just try to grab stuff from the other at the same exact moment? No—you open an escrow account, and the neutral escrow holder conducts the exchange so that no one gets cheated. The person or entity which handles your escrow has three critical functions:

> o **Neutral, Third-party Intermediary –** The escrow agent has fiduciary duties to both the buyer and seller to follow instructions signed by both parties and to exhibit no preference or partiality to either side. Escrow agents are subject to state licensing and/or regulation, which helps ensure their neutrality. They serve as a liaison between the Realtors, the parties and the lenders, collecting instructions from everyone about conditions that need to be met before the deed can be exchanged for the purchase price.

Most transactions involve a complicated chain of instructions and conditions the escrow agent must navigate in sequence. For example, the seller instructs the escrow agent to deliver the deed to the buyer when the purchase price is deposited into the escrow account. The buyer instructs the escrow agent to deliver the money to the seller only after the deed has been recorded and a title insurance policy has been issued, showing that title to the property is now in the buyer's name. The buyer's lender instructs the escrow agent to collect the buyer's signature on about 97 different mortgage documents and send those documents to the lender before the lender will deposit the mortgage money into the escrow account—you get the picture. As the neutral liaison, the escrow agent is the one who takes all these orders from everyone and then makes sure that all the instructions have been completed before the property is transferred from Seller to Buyer.

○ **Deposits, Disbursements and Accounting –** The escrow agent collects money from the buyer and their lender, and disburses money to pay off the seller's mortgage(s), the seller, the buyer's loan closing costs, the appraiser, the inspectors, the insurance companies, the Realtors—and everyone else who must get paid in order for the property to be transferred. The escrow agent also collects signatures from everyone involved—being largely responsible for getting signatures on the documents required by the lenders and by the local governmental property and tax agencies—and then submits those documents back to the appropriate entity.

The escrow agent keeps a running balance sheet of the transaction from start to finish, showing who owes what to whom as deposits are collected; bills come in from inspectors, appraisers and repair companies; and disbursements are made. This accounting document is called a settlement statement.

○ **Verify Identity of Parties –** Before the deal is done, the escrow agent is responsible for making sure that the buyers and sellers actually are who they say they are—often the escrow agent will also be a notary public, or hire one for these purposes.

Aliases – The generic term for a person or company who performs the escrow function and manages the escrow account is an escrow agent or escrow holder. Most frequently, the escrow agent is an independent Escrow Company, and the contact person responsible for an individual transaction is referred to as the Escrow Officer. However, in some states, like New York, the standard of practice has been that the parties retain an attorney to serve as the escrow agents; hence, the title Escrow Attorney, which you might hear if you buy a property in one of these jurisdictions.

Who Pays Them – This varies by state, county and sometimes even city-by-city, based on the standard practices in the area and the terms negotiated into the contract.

Your Realtor will know. Generally, though, whoever pays the escrow company gets to pick the escrow company. Surprisingly, selection is not so much an issue of whether one is more or less neutral than another, but an issue of customer service. If you get to select the company, allow your Realtor to select one with whom they have a good working relationship and one with a track record of getting tasks ticked off the monster escrow checklist correctly and on time.

Title Insurer

Shortly after you open escrow, your title insurance company will search the public records on the history of title to the property to identify any rights others might have in the property you are planning to buy. They look at things like liens, legal actions, disputes as to who owns a property or even a sliver of land that is part of the property you think you're buying, and list any such items on the preliminary title report (known in the industry simply as "the prelim"), which also includes the legal description of the property you are buying. Before escrow closes, the title insurer works with the escrow company to eliminate any problems with the title—making sure that you take "clear" title to the property, and don't end up buying a property subject to liens or other "encumbrances" that you do not want to assume.

For example, if the seller failed to pay the contractor who built the addition onto her house, that contractor likely would have filed a lien with the county recorder's office. This lien would come up on the preliminary report, and the title insurer and escrow company would work together to make sure that the seller pays the contractor and the lien is released before your escrow closes.

> **The Title Insurance Policy –**The title insurer provides you a policy of insurance at close of escrow, which guarantees that the title is clear and properly in your name, and that you have the right to sell or give the property to someone else. If it later turned out that the seller didn't have the right to sell you the property in the first place, or that the description of the property was incorrect and you actually only own a 5,000 square foot lot, instead of the 6,000 square foot lot described in the preliminary title report, the title insurer would cover your damages for having been mislead—and the damages of your mortgage lender, literally cutting you and your lender checks for the value of the property you paid for but didn't actually receive.
>
> Why People Use "Escrow" and "Title" Interchangeably -Obviously, the title insurance company must work intimately with the escrow agent, and must completely trust that the escrow agent is doing the job of clearing title perfectly well. As such, the most efficient and most common business model is for title insurance companies

to have an internal escrow service. Today, most of the large "escrow companies" are actually title insurance companies that offer an escrow service. So your Title Officer is also your Escrow Officer—is usually one person at one company who gets called both these names because they fill both functions.

Who Pays Them – Again, this varies by state, city and individual contract. In some jurisdictions, the buyer pays for their own title insurance and the insurance policy that protects the interests of their mortgage company; in others, the seller customarily pays these costs. If the buyer pays, this cost is incorporated into the buyer's closing costs.

Escrow & Title: The Bottom Line

Escrow Officer, Escrow Agent, Escrow Attorney, Title Officer – These terms all refer to the same role, and usually to a single person—with one exception. If the escrow agent is an attorney, you will likely also have a separate title officer at a title insurance company. No matter what they're called, these folks are the i-dotters and t-crossers who make sure you get what you're paying those many thousands of dollars for.

Your Inspectors

The inspectors' collective job is to give you a body of knowledge about the condition of the property before you buy it. There are as many kinds of inspectors and inspections as there are things in a home to inspect; an average transaction will have anywhere from one to five different inspections before escrow closes. In fact, the California Association of Realtors has a two-page form comprised largely of a list of the various items a buyer could have professionally inspected prior to buying a home, including everything from soil stability to water and utility availability to subdivision factors. In Chapter 8, we list a number of the common and not-so-common inspections, so you can be aware of the breadth of information that is available to you in the course of your due diligence. Always keep in mind, however, that each inspection costs money, and there can be a law of diminishing returns to ordering unnecessary inspections.

We won't go into a detailed description of every single type of inspector and their area of expertise. Your Realtor will let you know what specific inspections are recommended or required in your area and for your type of property. For now, you should know that there are three basic types of inspectors:

- *Professional Home Inspectors* – Generalists whose only business is conducting property inspections for informational purposes;

- *Specialized Contractors* – Home improvement professionals who conduct specialized inspections for a fee, but who also are in the business of repairing the systems or components they inspect;

- *Engineers* – Structural, foundation, soil and other engineers who will inspect and prepare a report, then refer you to a contractor who can do any repairs or upgrades they deem necessary.

Professional Home Inspectors

Your home inspector should be a member of the American Society of Home Inspectors (ASHI), the National Association of Certified Home Inspectors (NACHI), or some other national certifying body. During your home inspection (a.k.a. property inspection), your inspector does an intense walk-through inspection of the entire property; tests things like the heater, water faucets, and electrical outlets; and points out issues, deficiencies, and any areas which might warrant further inspection by a specialist in a particular home system, like electrical or plumbing.

To preclude a conflict between your interests and your inspectors, many states require that home inspectors not be contractors-for-hire, and that they refrain from providing estimates as to how much they would charge to repair deficiencies they find. This way, the inspector is not tempted to fabricate problems with the property just so you will hire them to do the repairs. This sounds good in theory, but actually makes it harder for you to get a complete picture of your property. If your home inspector finds a legitimate problem with your property, you have no way to know if it is a $10 problem or a $1,000 problem without calling a contractor out to give you an estimate.

When you are there in person, you are much more likely to get your inspector to help you gauge how minor or serious each problem or deficiency is. Though they cannot give you a written quote, in person they are usually very helpful in letting you know whether something is more like a $10 weekend DIY fix or a $10,000 repair requiring a contractor and permits. Like every other industry, legalese reigns in the inspectors' written reports, with the result that fairly minor issues can sometimes be blown out of proportion. For example, if the hot and cold knobs on a water faucet are reversed, this will be declared a health and safety hazard in an inspector's report. When you are there in person, though, the inspector can help you gauge whether an item is actually a major repair or a half hour weekend project.

How You Find Them – Again, your Realtor will refer you to one or two or several, and may even schedule the appointment with them. Ideally, your Realtor will attend the property inspection and will also review their written report with you.

Who Pays Them & How Much – You pick—you pay. In some areas, sellers are having home inspections done before they even put the place on the market, so that buyers know what they are getting into if they make an "as-is" offer. If the seller ordered it prior to your offer, generally the seller will pay for that report. Unless (a) your Realtor is familiar and comfortable with the inspector that did the seller's report and (b) the seller's report was conducted no more than a month or so prior to the date of your offer, you should hire your own inspector. When you hire your own inspector, you have some recourse legally and under the inspector's insurance policy should the information in the report later turn out to be incorrect. Home inspections on a single family residence or condo start at about $200, and go upwards based on the size and number of units being inspected (e.g., a duplex inspection might run $600.)

Contractors

Certain inspections are usually conducted by the contractors who can actually fix any problems they find. These inspectors' reports have the opposite problem of the home inspection; they include an estimate, but the prospect of getting the job might "incentivize" a crooked contractor to fabricate needed repairs. Contractors are state-licensed, though, and in many areas home inspectors are not—this is the not-so-persuasive justification given for why contractors are allowed to give estimates on repairs indicated by their inspection reports, and not home inspectors.

The three most frequently ordered inspections are:

- The property ("home") inspection;
- The wood destroying organism inspection (often misleadingly called a "termite" inspection – they look for much more than termites); and
- The roof inspection.

Your "termite" and the roof inspections will be conducted by contractors who are state-licensed to control pest infestations, and repair and install roofs, respectively.

Should you elect to have any of the rarer drainage, foundation, electrical and HVAC (heating, ventilation and air conditioning) systems inspections conducted, the professionals who do the inspection will also likely be contractors who will not only inspect the system, but will also give you an estimate for what any repairs will cost should you hire them to do the work.

Who Pays Them & How Much – You do, unless the seller hired them before you made an offer on the property. Roof inspections are inexpensive, about $90-150. Wood destroying pest inspections run from $60 to $250, and can go significantly higher with a very large or multi-unit property.

Engineers

A structural engineer can conduct an overall inspection of the property, with recommendations for a general contractor to carry out. Or, a soil engineer might inspect the property and determine that it needs a special sort of drainage system which only a drainage company can complete, or an earthquake retrofit that is the job of a foundation contractor. These inspections are even rarer, but fulfill the purpose of getting specialized, expert information without the conflict-of-interest problem, if that's an issue for you. Your Realtor or other inspectors will often recommend these inspections, if needed, and will refer you to the competent, local engineers with reputations for quick responses when they are asked to do an inspection during escrow.

> **Who Pays Them & How Much –** You do, unless the seller hired them before you made an offer on the property. Engineers often charge $200-300 to inspect the property and give you a verbal report, and an extra $150 plus for a written report if you request it. If everything is fine, you may not need a written report. If not, the $150 or so you pay for the written may be well worth it if you can use it to negotiate a price reduction or credit from the seller!

Madame CEO. . .

Lest you begin to feel like you have an HR burden on your shoulders with all these people to hire and manage, relax and know that if you make the right choice on your first hiring decision—the person you select as your Realtor—the rest of this can unfold effortlessly, seamlessly, and you can still emerge from the transaction with information and keys! A good Realtor will already have relationships with skilled and reputable mortgage, escrow, and inspection professionals, and will even make most of the phone calls and appointments for you. These relationships can be critical to avoiding many of the stresses, mistakes, surprises and dilemmas that you might think are par for the course. When your Realtor has a team that clicks along like a well-oiled machine, your path to homeownership will feel like a smooth, chauffeured ride, not a bumpy bus commute with a bunch of screeching halts along the way.

Make it a Piece of Cake!

Remember, we're baking a cake here. Not a regular old cake from a box of mix, but one of those incredible multi-layered architectural numbers that looks like a stack of gift boxes iced with rolled fondant icing and Swarovski-esque sugar crystals. If you've spent any time watching cooking shows or those televised baking competitions, you know that it takes a village of pastry chefs to raise a worthy dessert. Similarly, it will take your team of professionals to get you successfully through the process of buying a home.

When you watch a team of chefs, you see that they understand their materials and their (literal) game plan so well that when they are actually working in the execution phase, actually erecting the cake, they don't even think about it. Each person does their assigned task, one chef is assigned to oversee and lead the team, and voilà! A cake is born. You are doing your part right now, by learning what everyone's role is and getting educated and prepared for success—financially and otherwise. This will pay off when you are executing your homebuying plan, by allowing you to flow through the process with less fear of the unknown, knowing what to expect, trusting your own decisions and leading your team with confidence. I used to think that a stress-free homebuying experience was just asking too much, but I can vouch that if you keep on doing what you are doing, you can have your cake and eat it too!**o**

Part II: The Money

Chapter 3

The Money

Nothing strikes fear in the hearts of otherwise competent and capable women like hard math and money. I'm not talking math as in multiplication or division; I'm talking more about fancy percentages of percentages. The fear of math is so strong that it even has a formal name, "math anxiety," which is defined as a learned emotional response to even the prospect of sitting in a math lecture or working through math problems. I believe there is a parallel affliction that we could call money anxiety, that hasn't been named or included in the DSM or anything, but is at least as prevalent, as potentially detrimental and (I submit) as learned as math anxiety is. Math anxiety is characterized by the symptoms of:

- Panic,
- Paranoia, and
- Passivity.

For many people, these symptoms drastically impede success in a math classroom setting. Can you see how the panic, paranoia and passivity caused by money anxiety might impede your and your family's financial success? It's a big deal, especially when you think about how financial assets are the access point to so many priceless life experiences, like travel, higher education, wellness and a comfortable retirement.

When I talk about the fear of money, I'm not talking about hundreds or thousands of dollars, I'm talking hundreds of thousands of dollars. Since those are the denominations thrown around in quarter-million dollar increments during discussions about real estate, the fear of money matters is particularly relevant – and prevalent – when buying a home. I've seen clients' facial expressions turn in a split second from exuberant delight at finding a property to sheer terror at the mention of the purchase price, as though I would be asking them for a briefcase containing 500,000 $1 bills before handing over the keys. My job is to give them and you some perspective on the money matters involved in buying a home, to recalibrate your mortgage/money mindset and help you proceed without the money-related paranoia or utter paralysis experienced by many would-be homebuyers.

> The fear of money matters is particularly relevant – and prevalent – when buying a home.

Not surprisingly, these two terror triggers – math and money – are somewhat related, but rest assured that since we're all adults here, you'll not be called on to do figures in front of the class. In fact, we've created calculators set up to do all the tricky math for you if you just plug in your basic numbers in the Buyer's Tool Shed at www.REThinkRealEstate.com.

Even though we can handle the actual math for you, and you will hire a mortgage professional to run the numbers and advise you on loan types, interest rates, closing costs, monthly payments and the like, a good leader delegates, not abdicates. Delegating is simply assigning a task to someone else and giving them the authority to act on your behalf, while abdicating is washing your hands of responsibility for the matter. To be an effective delegator, and to avoid feeling victimized by your mortgage and money advisors, you must understand the fundamental issues involved in their areas of responsibility.

Also, {RE}Thinking Real Estate is all about obliterating mindset obstacles to enhancing your lifestyle through property ownership. Fear in general and, more specifically, the fear of making decisions involving huge sums of money, is one of those mindset obstacles. The first step to shattering this obstacle is understanding where it comes from. A basic tenet of the {RE}Think Real Estate system is that, no matter the subject matter, we fear what we don't understand. An understanding of the money matters connected with real estate and home ownership is the antidote to the affliction of money anxiety.

At university, there was requirement that we take a course in statistics. There were two different courses that satisfied the requirement: one in the Math Department, and another in the Psychology Department – Statistics for the Social Sciences. Although I was studying Psychology, the Math Department course was offered first, so I took that one. At the end of the quarter, I earned an A in the course, but still had no idea whatsoever what on earth we had studied for 120 hours. I was quite dismayed that I had no better understanding of stats than I had possessed 10 weeks prior, so I enrolled in the Social Science version of the course.

What a difference a department makes. This second stats class was taught by a professor whose reputation for demystifying arcane mathematical processes had earned the cult-like devotion of students campus-wide. As she walked up to the blackboard on the first day of class, she was surrounded by an aura of learned gravitas, which filled the room like that smoke they make from dry ice in the theater. She introduced herself, confirmed the course she was there to teach, and announced that she was diving into the material. She drew two parallel, horizontal lines – one above the other, and proclaimed, "This is an equal sign." She continued, "It signifies that whatever is to the left of it is equal to, or the same as, whatever is on the right." I thought, mmm, am I missing something? Isn't this an upper-division, university statistics class? Isn't she the crème de la crème of the brain trust of the entire state university system? Turns out, she knew what she was doing. She proceeded to walk us through basic

> We fear what we don't understand.

mathematical functions, from kindergarten level on up, then into algebraic functions, and on through everything else we needed to understand the statistical analyses and research studies contained in scientific publications – all in just ten weeks.

Those of us who walked into the course feeling fairly comfortable with math were even more comfortable in that class, because we knew we'd be able to keep up once we saw where she was starting. (And along the way, we learned some good trivia and long-forgotten terms that might someday be the answer to a question on Jeopardy!) Those of us who had math anxiety, or who had missed a necessary lesson once in junior high and had forever after felt lost in math class, also were able to make it through the course with a sense that we could keep up and understand the fundamental concepts underlying the calculations we were learning. We even learned the party tricks of how to do the calculations themselves. And you know what? By going back to basics in such a very literal sense, every single person in that course emerged more confident about math, less anxious about math, and actually understanding statistics!

After that experience, what I know to be true is that there are no bad math students, and no people who are bad at math. There are simply people who haven't had a good math teacher yet. Same with money – people aren't bad with money, they just haven't been properly taught about money yet.

I tell this story to put in context the information contained in the next few pages. You may think – but we're not learning math, we just want to know what we need to buy a home. That is correct, but everybody was raised with a different level of financial education (or lack thereof), and real-estate related financial concepts are cumulative, in that they build upon one another. So if you miss a foundational concept, or never learned it, it is possible that for the rest of your life, you'll feel like you're faking your total understanding of real estate money matters, simply because a link is missing. Even people who have owned property before may have learned concepts under outdated or incorrect terms. If we go from the very most basic to the sophisticated, there will be no missing links, and everyone in the {RE}Think Real Estate community will be able to communicate with professionals and connect with other property owners from (a) a common vocabulary, and (b) a place of confident, though basic, comprehension – no matter what your present level of financial education or understanding. No Woman Left Behind. That's the intention behind this book, and behind the educational campaign this chapter represents.

So bear with me and buckle your seatbelt. Let's take a quick trip – conceptually speaking – through the fundamentals of money, credit, debt and mortgage, which comprise the foundations for all the higher-level financial issues involved in purchasing a home.

Money

Once upon a time, everyone just bartered with everyone else. If you gave me a pot, I'd give you some fish. The problem with that was maybe you didn't like fish, or maybe I didn't need a pot. So everyone in the village agreed that cows, let's say, would be an acceptable form of payment for everything else. This worked fine, but cows can be a little unwieldy, physically speaking. And there were lots of little things that people buy on a daily basis that weren't worth as much as a cow. To cut the cow up into pieces, however, obviously destroyed its value. So they needed something worth a fraction of a cow, that everyone valued, that was easy to carry around.

Because metals have always been universally prized for their beauty and utility, almost every society's earliest form of modern money was the coin. Coins got heavy, so every country

eventually developed a system of paper cash that was a token, or symbol, of the gold stored by the government in some remote warehouse. Eventually, how much gold was in the vault became much less important than the government's ability to force people – with military might, if necessary – to accept the paper cash, also known as legal tender, as payment. Whether backed by its intrinsic value as a desired commodity or by the threat of military force, the term money refers to any item which is accepted by general consent as a medium of exchange.

The money you earn at work, the balances in your checking and savings accounts, the cash in your wallet, the loans made by your bank – these are all forms of money. These days, electronic transactions, money substitutes, are more frequently used than actual money: checks, debit and credit cards, electronic funds transfer (EFT), and online bill payment services. With these money substitutes, we all move money (or blips representing dollars) around so effortlessly online or with the swipe of a card, that the line between cash and credit can seem to be a blur.

Credit

Credit takes two forms. In one sense, credit refers to the arrangement by which a lender loans money to a borrower. This is the case when a bank lends you money. In another sense, credit simply refers to a deferred payment arrangement: Joe Bob's Used Car Emporium lets you drive an '85 Kiyundaiolla off the lot as long as you pay him $500 per month for 92 months, or Visa extends you a credit card account, allowing you to defer payments for charges over a long period of time. The company making the loan or taking deferred payments is called the lender or creditor, and the person borrowing is called the borrower or debtor.

Either way, when people say "your credit" or "good credit" or "bad credit," they are talking about your track record of paying on your credit arrangements. The idea is that the best predictor of your future payment behavior is your past payment behavior. An entire industry has developed around keeping semi-public records of your payment history on credit accounts, evaluating your credit history and communicating that evaluation and information to prospective lenders on a need-to-know basis. We'll discuss this at much greater length in a moment when we get to credit scores.

Credit always costs you something. Creditors charge you for the privilege of using their money or for the privilege of getting to use their merchandise now without having to pay for it right away. The price the borrower pays for getting to take the loan is called interest. Interest is

usually expressed in terms of the percentage of the loan amount that the creditor will charge the debtor every year (or fraction thereof). A $100 loan at a 5 percent annual interest rate, for example, would cost $5 in interest every year.

The amount that is owed on a loan at any given point in time is called the principal. Whether the principal is greater than, equal to, or less than the original loan amount depends on the payment arrangements that have been made between the lender and the borrower.

Debt

When you, as the borrower, obtain credit, you are said to incur a debt – the obligation to repay the lender or merchant. Smaller cash loans and credit cards are typically unsecured debts, meaning that there is no item that the lender can automatically repossess in the event that you fail to pay as you agreed to. If you default, their only recourse is to sue you in court, but the litigation process is lengthy, costly, burdensome, and not guaranteed to result in recovery. Besides, if you stopped paying because you were flat broke, then getting a judgment against you doesn't really do the lender much good. It's that whole can't-squeeze-blood-out-of-a-turnip thing. As you might guess, these loans are granted or denied entirely based on your financial ability to repay and your credit history.

> Credit always costs you something.

On the other hand, large cash loans, or loans being used to purchase an expensive item like a car or a house, are often secured by the property being purchased. If you miss a few house payment or car payments, you'll get a not-so-nice note in the mail telling you to move your furniture or clean out your trunk because the lender is foreclosing on your house, or repossessing your car. When considering whether or not to grant you this sort of loan, the lenders are concerned about your personal information, but also about the value of the property, because their ability to stay in business depends on their ability to sell the security (i.e., house or car) and recoup their losses if they need to.

Secured loans arise from the philosophy that houses and cars are easy to sell, which makes a lender less hesitant to make such a large cash outlay. The flip side is that if you (the debtor) have financial problems that make it difficult to pay the secured loan, it is also fairly easy for you to sell the security and pay off the loan prior to defaulting on the loan.

Assets, Debt & Equity

Your assets are simply property or items that belong to you – anything you own that is of value. We categorize assets in terms of whether they appreciate (increase in value, like a house) or depreciate (decrease in value, like a car). When it comes to houses, the value of a house at any moment in time is more specifically referred to as its fair market value – the amount of money that a buyer on the open market would pay to purchase the property at that time.

When you own a home using a loan that is secured by the home, the value of the home can be analyzed on paper. For financial recordkeeping, the value is broken down into two components:

> *Debt* – This is the dollar amount you owe on the loan(s) secured by that property – if you sold the asset, you would have to pay this amount of money back to the lenders out of the proceeds from the sale.

> *Equity* – This is the portion of the asset's value above and beyond what you owe on it – if you sold the asset, and paid all the loans off, this would be the amount of money left over.

During your tenure as a homeowner, on a day-to-day basis, both "debt" and "equity" can seem somewhat abstract and intangible. Even though you technically "owe" whatever huge amount on your mortgage, you won't get a bill for that amount – your only responsibility is to pay the monthly payment. No matter how large it may seem, that $2,500 a month is a very far cry from the corresponding mortgage debt of, say, $400,000. However, when compared to equity, your total debt is real and you will always know what it is. If you gather up your mortgage statements, you can add up the principal amounts shown and know clearly the amount of your debt. Equity is more nebulous. The fair market value of your home at any given time is a range. Until you put the place on the market and see what price it fetches, any estimates as to its value are just that – only estimates.

Colloquialisms such as "building equity," "using home equity," and "pulling your equity out" create the misconception that equity is just another form of spendable cash. You may have even heard people say that home equity is especially desirable because it is liquid, which just means that it is relatively easy to turn into cash that you can spend for other things. College tuition, home improvements, and starting a business are some of the most popular uses of home equity.

The fact is, equity only exists on paper until you do one of two things to "pull it out" of your home: sell the house and pay the mortgage(s) off, or get a cash loan or credit line from the

bank that is secured by your home. Selling your house means that you have to find – and pay for – someplace else to live. Obtaining credit that is secured by your home equity increases the amount you'll have to pay on a monthly basis. As you can see, using home equity is by no means the free ride some folks make it out to be; as such, you should be very careful about how you use it.

The Multiple Personalities of Your Home

One of the most overwhelming issues in buying a home is the double-duty nature of a house as both home and financial asset. Your home is equal parts the environment for your day-to-day life and the largest financial investment you will probably ever make. Sometimes your home-related lifestyle and investing objectives are aligned; other times it seems like any house you'd actually like to live in is a pretty scary investment. With all the media hype about real estate bubbles bursting, the basic reasons why real estate – including your home – is a fundamentally safe financial investment bear repeating at this juncture.

Home Ownership is a Good Investment Because Real Estate is *Stable*

You'll be happy to hear that the fabled real estate "bubble" doesn't exist. For years now, thousands of news reports have said that American real estate is highly overvalued (hence, the "bubble"), and that the value of homes will plummet (burst) any minute. Many a would-be homebuyer has been stopped short on their path to homeownership by the fear of buying at the top of the bubble and getting caught in the burst.

The truth is that real estate values, like all markets, are cyclical, subject to periods of relative highs and lows. However, American real estate has NEVER had a nationwide "bubble," never a time in which there was a national loss in value across the country. Over the last few years, some (mostly urban, mostly coastal) markets have been appreciating at an unsustainably high rate. For instance, in the Bay Area, we have had a number of years where it was completely commonplace for a home to increase in value 25 to 35 percent – meaning that homes were doubling in value every three years! To the extent that this reflects a bubble, it is a bubble that is set to flatten out somewhat, but not burst. The basic economics of these areas – limited supply, a constant influx of people moving into the area, and a strong job market – prevent homes from actually losing value.

Insider Secret

SHOW ME THE MONEY

Most often, when people refer to "pulling equity out" or "using equity," they are referring to taking a cash loan (i.e., second mortgage) or a line of credit that is secured by their home equity (i.e., home equity line of credit or HELOC [pronounced he-lock]). A second mortgage is a cash loan that stands in second position to your first mortgage. It is secured by your home and if you fail to pay it, the lender can foreclose on your home, pay off the lender from the first mortgage, and keep whatever money is left. On a second (or third, or fourth) mortgage, you start paying interest immediately when you receive the loan money, but often the interest on these mortgages is fixed.

A HELOC is a line of credit, which operates more like an open credit card. You have a credit limit with the lender, and you may use the credit from the account by withdrawing cash, writing a check or using a debit card. HELOCs are also secured by your home, which subjects your home to foreclosure if you don't pay. HELOCs can be desirable because you don't pay interest unless and until you use the credit – and you only pay interest on the amount you actually use. However, HELOCs are often fully adjustable, meaning that the interest rate fluctuates on a monthly basis.

Because equity-based loans or lines of credit subject your home to foreclosure, you should use them with great discretion. A good rule of thumb is that borrowing against your equity is okay if you plan to use the borrowed funds for something that:

(1) Generates income (e.g., a rental property or a well-planned business);

(2) Is a good investment in maintaining or increasing the value of an appreciating asset (e.g., home repairs, remodeling or additions); or

(3) Is a big ticket, truly necessary item you would otherwise have had to take on a higher-interest loan to pay (e.g., education).

Conversely, it is NOT a good idea to use equity-based credit to pay off credit card debt or to buy a depreciating asset such as a car. When you do so, you basically convert unsecured debt into debt secured by the most important asset you have – your home. This puts you into a situation where (a) you'll be paying for 30 years for those shoes or that computer that ran up your credit card bill in the first place, or for the car that lost half its value when you drove it off the lot, and (b) you can lose your house if you fail to pay!

If interest rates are rising and you know you'll be using most or all of your equity-based credit, a fixed second mortgage might be right thing for you. If rates are low or going down, or you don't plan to use all your credit (e.g., you are securing the line of credit mostly to have an emergency fund), a HELOC might be best.

As I write this we are at what most learned commentators describe as the flat part of the bubble, or the bottom of the real estate cycle in many of these markets. At the bottom of the market in the "bubble" areas, appreciation has slowed to 6-10 percent per year. In many non-coastal and non-urban markets, 5-6 percent a year is normal, and some of these areas have seen an upswing to 10 percent plus at the same time as the bubble has flattened in larger areas.

Appreciation and home values are local issues. There certainly have been periods in which individual cities or areas have decreased in value due to local economic troubles or natural disasters. For example, after the 1989 earthquake, homes in San Francisco lost as much as 30 percent of their value – and values stayed depressed for three years. However, in the long term scheme of things, real estate everywhere keeps trucking ever upward in values; those folks who owed homes before the earthquake and still own them now have experienced an 300 percent plus increase in the value of their homes! Long story short, other than very short term, very localized, very occasional glitches, the value of homes rises consistently and stably, and is not subject to the ups and downs you see with other investments.

Back to the characteristics which distinguish your home as an investment from other assets.

Insider Secret

THERE'S NO TIME LIKE THE PRESENT

If you are one of those glass-half-empty type gals who just doesn't believe that real estate could go up in value much more than it already has, consider the case of a 75-year-old homeseller client I had a few years ago. She had purchased her home for $17,500 about 30 years before she asked me to sell it for her. I ended up selling it for $550,000. She told me that when she bought the house, her "Cadillac car" actually cost more than the house did! And if you had told her 30 years ago that the place would be worth $500,000, she would have offered to help check you into the nearest mental health facility. She said that when her house appraised for $50,000, she thought the appraiser was nuts. A few years later, when a house down the street sold for $100,000, she thought the whole world had gone mad.

The moral of the story is that no one ever predicts or truly believes that home values will go up as much as they do, but not believing doesn't stop home values from inflating (thank goodness!). So buy as much house as you can as soon as you can without overextending yourself. Unless you have truly terrible credit, or simply can't afford to make the monthly payment on a starter home in your town, don't try to wait for everything to be perfect, because waiting may cost you the ability to buy at all!

Home Ownership is a Good Investment Because Ownership has *Tax Advantages*

All the interest you pay on your mortgage loan is tax deductible. And for the first several years you own a home, most or all of your monthly payment is comprised of interest. This can mean from $8,000 to $40,000 plus per year of additional tax deductions, which basically is like taking money that you were paying for taxes and putting it directly into the appreciating asset of a home. They say that renters work from January to April just to pay Uncle Sam! You might be patriotic, but do you really like Uncle Sam enough to give him a quarter of your income every single year?

If you are employed at a job where you receive a W-2 form (vs. being a 1099 independent contractor or being self-employed), when you actually purchase your home, you should adjust your withholdings (the amount your employer withholds from your paychecks for taxes) to account for the enormous tax advantage you'll have at tax time. This way, you can bring more money home on a monthly basis to pay your mortgage payment, rather than struggling to pay it and then having a big tax refund at the end of the year. Visit the Buyer's Tool Shed at www. REThinkRealEstate.com for a link to the IRS' own withholdings calculator, which helps you project how much more you can bring home every month once you have the tax advantages of home ownership!

Home Ownership is a Good Investment Because Property is *Scarce*

Everyone from Will Rogers to Tony Soprano has made the observation that real estate is a good investment because "they ain't making any more of it." The fact that there is only so much land available, especially within livable distances from jobs and schools. This, in conjunction with the constant growth of the population, has created a permanent demand/supply imbalance. This imbalance is what keeps American real estate appreciating over time.

Home Ownership is a Good Investment Because Real Estate is *Secure*

The value of a home is mostly in the land, and land is extremely durable – it's almost never destroyed. For this reason, homeowner's insurance is readily available – and very affordable. (Unless you buy your home with all cash, your mortgage lender will actually require you to obtain

and maintain a homeowner's insurance policy.) So if your house burns down – you can easily replace it. In areas prone to flood, landslide or earthquake, it can be prohibitively expensive to insure against those risks; when natural disasters of these sorts destroy homes or the land they sit on, governmental entities virtually always offer some rebuilding assistance. Even with all the natural hazards, real estate is still a much more secure investment than almost any other asset you could buy.

Home Ownership is a Good Investment Because Real Estate can be *Bought Using Leverage*

Leverage is just the fancy way of saying that you can put down a tiny bit (or none!) of your own money and buy a house, because someone else (the bank) will let you use their money to make the purchase. (Real estate insiders talk about the upsides of using Other People's Money so frequently that they've actually assigned it an acronym – OPM). Precisely because real estate is such a stable, scarce and secure asset, banks know it is a safe bet to give you a loan secured by your home. And because you will actually be living in this asset, banks know you are likely to keep paying on your mortgage. They know that even people with some late credit card payments will do everything they can to pay the bill that keeps the roof over their heads. I guess they figure that shelter ranks higher on the hierarchy of human needs than, say, your Amex bill.

Leverage is probably the most critical feature that makes the investment in your home such an extraordinary opportunity for developing financial prosperity, because it literally makes each dollar that you invest into the property grow exponentially. Look at it in this (very oversimplified) way:

To Buy

STOCK | Worth $100,000 | TAKES | $ $ | $100,000

- -

10% annual appreciation rate ↓

- -

STOCK | $110,000 | $ $ | 10% return on your $100,000 investment

To Buy A

HOME | Worth $100,000 | TAKES | $ | $5,000

- -

10% annual appreciation rate ↓

- -

HOME | $110,000 | $ $ $ $ | 200% return on your $5,000 investment

Leverage is simply the flip side of the debt you incur to purchase your home. Yes, it is debt, but a really nice type of debt that is actually desirable because it magnifies the asset building impact of your dollars. Leverage is typically measured in terms of the ratio of debt owed in mortgages to the overall value of the home. The less money you put down, the less equity you have, and the higher the debt-to-value ratio, the more "highly leveraged" you are said to be. For example, someone who buys a home putting no money down (100 percent financing) is 100 percent leveraged on that property, while someone who puts a 20 percent down payment on their home is only 80 percent leveraged.

Home Ownership is a Good Investment Because
You Need a Place to Live

Compared to every other investment you could make, buying a home has the added bonus that you can live in it! (Try that with your stocks and bonds!) From a financial perspective, this means that you no longer have to pay rent. But from a common sense perspective, it means that this purchase is far more than an investment, it actually fills a basic need. You need a place to live. I submit that you should think of your home as a place to live that comes with a bunch of incredible financial bonuses.

Insider Secret

GOOD DEBT – IT'S NOT AN OXYMORON

Sometimes the most financially responsible among us are the ones who have the most mindset management to do around the idea of debt and leverage. There is bad debt (mostly unsecured, consumer debt – the debt you incur when you buy clothes and shoes and TVs and stuff) and good debt (secured debt you incur to purchase assets which grow in value). If you'd like to start shifting into the mindset of a mogul, or just free yourself up from the anxiety around taking on "debt" to buy a home, visit the {RE}Think Real Estate bookstore and invest in *Rich Dad, Poor Dad*, by Robert Kiyosaki. Warner Business Books (2000).

You don't worry about whether your car will depreciate when you buy it; actually, you buy it knowing full well that it absolutely will lose value. But you buy it anyway because you need it. If you are one of those types who has been stuck for a few years doing mental gymnastics about the real estate market and trying to figure out the best time to buy – stop trying to time the market and remind yourself that because it meets your need for a place to live, and replaces the rent you are paying now, with the mortgage interest deduction you get you, come out ahead when you buy vs. rent even if you have no appreciation at all! Then, you can stop fixating on bubbles and start seeing appreciation as gravy.

Mortgage

The specific name for the type of loan where the bank gives you money to purchase your home, or any loan secured by a home, is a mortgage. If leverage is a strategy for using OPM to buy real estate, then mortgage is the specific tactic of using the bank's money to buy your home.

Many people these days have multiple mortgages on their homes. When there is more than one loan on a home, we rank the loans in order of their priority: first, second, third, etc. Any bank with a mortgage on your home – no matter which mortgage – can foreclose on your home, evict you, and sell your house if you stop making your payments. In the event that your home is sold at foreclosure, the first mortgage gets paid off first, then the second, and so on until the bank holding the last mortgage gets whatever is left (if anything).

People sometimes get multiple mortgages by borrowing against their equity after they've been homeowners for a while. These days, though, many homeowning careers start off with multiple mortgages on the home. If you buy a home with less than a 20 percent down payment, your mortgage pro will likely advise you to use two (or even three) separate mortgages to purchase your home. Historically, when you bought your home using a single mortgage for greater than 80 percent of the value of a home, the lender charged you a monthly fee (usually several hundred dollars) for a private mortgage insurance (PMI) policy – insurance that covers the lender for the risk that you won't pay. Because you would have so little equity in the home in this situation, the lenders figured you might be less committed to paying the mortgage than someone who had put more money down on their home (i.e., someone who had personal money invested that they would lose if they defaulted). As real estate values ascended more rapidly and reliably over the last 10 years or so, though, many banks got into the business of lending buyers their down payment money, offering second or third mortgages that were also secured by the house. So, mortgage professionals have adopted a standard practice of almost always advising people purchasing homes with less than 20 percent down payment to only borrow up to 80 percent of the value of the home on a single mortgage, and to simply obtain a second mortgage, or even a third, to make up for the down payment that they won't be making. This allows buyers to get in with less than 20 percent down and avoid PMI!

For example, if you are putting 10 percent down, your mortgage professional might advise you to get one loan for 80 percent of the purchase price, and another mortgage for 10 percent. In the real estate business, we'd call this an 80/10. If you are getting 100 percent financing, the most common ways to purchase this are with two loans (80/20) or even three mortgages (80/10/10) totaling 100 percent of the purchase price of your home. As you go down the ranks of the mortgages from first to second and so on, the interest rates get progressively higher. Depending on the situation, the higher interest on a second or third mortgage can approximate the amount you would have had to pay for PMI. However PMI is not tax deductible, and the interest on all your mortgages is 100 percent tax deductible, so it makes much more sense to pay that money toward the interest on a second mortgage than to take out a single loan and pay PMI!

Amortization

Mortgages come in all different types, which we'll get to shortly. They are placed on what is called an amortization schedule, which is simply a calendar for how you will pay the loan off. Literally, the bank will show you a four or five page chart which will list every single payment you are scheduled to make on the mortgage over the next 30 years, and will break every payment down into how much of each of those 360 payments will be applied to the principal amount (the amount you originally borrowed) and how much will be applied to interest. Some loans are fully amortized, meaning that some portion of every payment goes to reduce your principal loan amount, from the very first payment you make. Others are partially amortized, which means that you have the option to pay only the interest for the first few years of the loan; these loans are also called interest-only loans. Still others have the potential to be negatively amortized. These loans require a very low payment of only partial interest for the first few years; if you make only the minimum required payment, you can actually end up owing more on the mortgage than you originally borrowed.

The amortization schedules are skewed so that the proportion of the payment that is applied toward principal increases over the years. So even if your mortgage is fully amortized, the lion's share of your monthly payment will be applied to interest during the early years of your mortgage. Also, the loans providing options for partial and negative amortization are packaged with a number of other features which prevent them from being as crazy as they seem. See the full description of loan types, below, to understand when these mortgages can present great opportunities for homebuyers.

Looking at amortization tables can be a freak-out moment for many homebuyers, because they often reveal the strange truth that if you pay off your mortgage as scheduled for the 30 or so year term, you will end up paying around 200% of the original purchase price of your home. These are the times that you must keep in mind that:

- Most wealth builders never do pay their mortgages all the way off; instead, they move, refinance or "pull equity" out every several years to invest in other appreciating assets;

- By the time you'd be scheduled to pay the mortgage off, the property will almost certainly be worth several times what you paid for it;

- All of the interest you pay is tax deductible; and

- If you didn't buy, you'd still be paying monthly rent and not getting either the massive tax deductions or the appreciation.

Most importantly, remember that the amortization tables are pretty irrelevant to your daily or monthly or even yearly life. They can be overwhelming, but the fact is that all you need to be concerned with going into this is your ability to make your monthly payments. If you can do that, you're good.

How Banks Work

When cops want to catch a crook, they get inside his mind by looking at his modus operandi – his criminal methods. As a prospective homebuyer, you'll soon be trying to catch a lender, so let's do a little profiling of our own and analyze their m.o. Once you understand how banks work you will be able to (a) quickly and easily compare loan types and programs, (b) choose a loan program that works for you, and (c) maximize how attractive your loan application is to the lender, eliminating the stress and worry most homebuyers experience while they wonder whether they will get approved for a mortgage.

The Business of the Banks

Banks (a.k.a. mortgage lenders) are not in the business of money, as you might think. Rather, banks are in the business of assessing risk. Did you ever see the film "Along Came Polly"? It starred Ben Stiller as an insurance actuary who used a software program to assess the level of risk posed by everything from his choice of girlfriends to eating the beer nuts on the counter at the neighborhood bar. If you ask me, he should have worked for a mortgage bank, because

his methods were right in line with their obsession for risk assessment. Banks have a much narrower scope than he did, though. The lenders' particular fascination involves analyzing the risks vis-à-vis their ability to collect interest on the money they lend.

In addition to being risk-obsessed, banks are very pessimistic. Their entire worldview is driven from a worst case scenario perspective – what are the chances that you'll flake and stop paying on your loan (a.k.a. default). By requiring an appraisal before they make the loan and securing the loan with the property, they have guaranteed that they won't lose their shirts if you stop paying. If you completely default, they can foreclose and sell the house to recover the vast majority of the principal, if not more. However, banks are not in business to own or foreclose on homes, they are in business to collect interest from you on a long-term basis. Industry studies have shown that lenders lose money when they have to foreclose, so they have gotten very sophisticated about determining the likelihood that they will have to, before they even approve you for the loan.

The process of assessing the risk you pose is conducted as part of your loan application process. You'll hear it called mortgage "pre-qualification" or "pre-approval." (The "pre" indicates that you are applying before you are actually in contract to purchase a home.) Your mortgage professional will run some standard analyses and collect a standard set of your personal information, combining these items into your actual loan application. A single, standard form loan application is used by all the lenders. Mortgage pros receive rate sheets daily or weekly from the bank. Unless your situation is really unusual, a mortgage professional can look at your scores on the different risk measures, glance at a bank's rate sheet, and tell (a) whether you qualify for a particular program, and (b) the interest rate and other terms of the particular program(s) for which you qualify.

The risk factors that lenders – and mortgage professionals – will consider when reviewing your mortgage application are:

> *Credit Scores & Report* – Your credit score is a number ranging from 400 to 850 that reflects how responsible you've been with past credit cards, loans, lines of credit, and deferred payment arrangements. The number that marks your spot on this continuum of responsibility is calculated based on a system created by Fair, Isaac & Co. Hence, industry insiders refer to your credit score as your FICO score. As you probably know, there are three national credit bureaus. Creditors report to these bureaus on a monthly basis with a snapshot of your accounts, providing information such as: how much you owe (account balance), your credit limit, whether you are

paying on time and in the amount you agreed to and, if not, how late your payments have been. (In Chapter 4 we'll discuss how to optimize your FICO score in detail.)

Each bureau will calculate its own version of your FICO score, based on the information they have received directly from your creditors. Lenders usually throw out the lowest and the highest of your three FICO scores, and qualify you for interest rate, programs, and other terms based on your middle score (a.k.a. "mid-FICO").

Lenders know that the best predictor of your future behavior (i.e., whether or not you'll pay your mortgage) is your past behavior, as reflected by your mid-FICO score. Overall, lenders tend not to be concerned with the specific items reported in your credit report, but rather with the mid-FICO score that was compiled on the basis of that information. There are two exceptions to this rule:

- **Mortgage Lates** – Having made even one late payment (late = over 30 days past due) on a mortgage in the past seven years can really impact your ability to qualify for a mortgage. The lenders' thought process is this – you could forget to pay a credit card, or have a really bad month financially and not be able to make your car payment. If you have paid your credit card or your car payment late, your mid-FICO will reflect this, and mortgage lenders may offer you a somewhat higher interest rate.

 But mortgage payments are a different story – making them on time ensures that you and your family keep a roof over their heads. Even people who lose their jobs and are totally broke will beg, borrow, steal or sell their homes before they will miss payments. Lenders see late mortgage payments as an indication of either financial ruin or extreme irresponsibility, and will often refuse to lend to people whose credit reports show "mortgage lates."

- **Bankruptcies** – We call these "BKs" for short. Times have changed since the day when a bankruptcy tolled the death knell for a mortgage application. Nowadays, there are lenders who tout their willingness to approve mortgages for folks with bankruptcies as recent as a day prior to their application! Lenders do look for bankruptcies on your credit report, though. Certainly, many of the traditional, more conservative banks do not offer mortgages to people with recent bankruptcies, and almost all of the banks who do will charge a significant premium interest rate and/or require special terms (e.g., automatic deduction of monthly payments from your checking account) of those buyers/borrowers with recent bankruptcies.

Income – Lenders want to know how much money you make on an annual basis so they can ascertain your financial ability to make your monthly mortgage payments, *and* cover the other financial obligations of home ownership, such as property taxes,

insurance and HOA dues (if applicable). There are two methods of communicating your income to your lender:

- **Full-Documentation –** "Full Doc" loan programs require that you document the income required to qualify for the mortgage you want with either a W-2 form, a 1099 form (for independent contractors), or two years of tax returns. Some lenders are now accepting a year's worth of bank statements – showing deposits adding up to your income – as documentation of the required income.

- **Stated Income –** "Stated" loan programs allow you to simply state what your income is, without documentation or verification. Why on earth would a lender simply take a borrower at their word? Two reasons: (a) self-employed buyers get no form at the end of the year, and are often so aggressive with their tax deductions that their tax returns show very little net income, and (b) many buyers have hard-to-document income, like folks whose income is largely cash (e.g., tips). To be approved for a stated income loan, the income you state must make sense based on your line of work; it wouldn't fly for a valet parking attendant to state an annual income of $200,000 just to qualify for a loan. Interest rates on these loans are generally higher than those charged on full-doc loans unless your credit scores are quite high, like over 720.

Liquid Assets – This is not about how many bottles of water are left in your Y2K stockpile. This is about how many dollars are in your rainy day stockpiles. Some loan programs have reserve requirements – a minimum dollar amount of liquid assets you must own in order to qualify for that particular program. Lenders want to know that you have an emergency fund to fall back on to make your mortgage payment in the event you become disabled, lose your job, or have some other disruption in your normal income and/or have to make a major, unexpected home repair.

On your loan application, there are spaces for you to list all your assets, including furniture, cars, and so forth. However, when lenders look at liquid assets, they are referring only to assets which could pretty easily be liquidated into cash at their face value. Your liquid assets include:

- Checking and savings accounts;

- Money market accounts;

- 401K and other retirement accounts which you can convert to cash;

- Stocks, bonds, and other publicly traded securities.

Seasoned reserves are liquid assets that have been in the bank for a certain period of time, usually about two months. Seasoning requirements were imposed to ensure that the liquid assets actually belong to you (i.e., are not borrowed), and will actually there if you need to draw from them to make your monthly payment or to fund an emergency home repair.

Lenders state reserve requirements in terms of multiples of the monthly payment, property taxes and insurance on the mortgage for which you are applying. For example, if the mortgage payment + property taxes + homeowner's insurance on your home would be $3,000, and the lender requires three months' reserves, then you must have at least $9,000 in verifiable liquid assets. If your loan program has a reserve requirement, your mortgage professional will ask you to provide account statements. If your lender requires that your reserves be seasoned, you'll be asked for the account statements from the two months (or the seasoning period required for that program) immediately prior to your loan application, and the lender will be looking to see no unusually large deposits during the seasoning period.

If you don't have a big chunk of cash in the bank, and have no IRA or 401K account – don't despair! Many lenders offer "No Reserve" or "No Seasoning" mortgage programs, some of which may be a little more expensive in terms of interest rates, but are available to help you literally get your foot in the door nonetheless. Also, if you have assets which are not easy to verify, there are "Stated Assets" programs as well.

 ## Insider Secret

LEAPING RESERVES HURDLES WITH A SINGLE HELPING HAND

If you meet all of the requirements to get "A paper" rates because of your sterling credit and stable income and job history, but you simply don't have sufficient seasoned reserves, generous parents, relatives or friends can help you out in a few different ways:

(1) They simply lend you funds, but you need to be able to keep them in your accounts for at least two months prior to going into contract if your loan requires "seasoning;"

(2) They can give you money to be used for down payment and/or closing costs, but they must be giving you at least 20 percent of the purchase price or you must put down at least 5 percent of the purchase price into the transaction from your own money; or finally

(3) They can add your name onto their bank or securities accounts that contain sufficient funds to meet the reserves requirements – for this to work, the funds should ideally have been in the account long enough to meet the lender's seasoning requirements, if any, and your generous relations must sign a document saying that you actually have full, unfettered access to funds.

Job – Lenders are looking for information about how stable and reliable your income has been in the past and, thus, will be in the future. They want to know what you do for a living and who your employer is, as well as how long you have worked for that employer. Historically, lenders wanted you to be with the same employer for a minimum of two years. Recently, most lenders have expanded their employment criteria to allow you to have changed employers over the last two years, so long as you have stayed within the same industry or line of work for at least that long. They figure that if you have demonstrated a commitment to working in the same industry, you will probably stay in that industry and have a similar level of income going forward.

Word to the wise – lenders will verify your employment (company and job title at minimum) by calling your company's HR Department, usually right after you apply for the loan and the day before they fund the loan, even if they don't verify your income. Make sure that whatever job title and tenure you have put on the application jives with what your HR rep will tell the lender when they call.

Debt-to-Income Ratio – Lenders want to know how much of your income will be committed to paying debts on a monthly basis after you have a mortgage payment to pay. You can calculate your debt-to-income ratio (a.k.a. DTI or debt ratio) the same way the lenders will in two steps:

(1) Add up all the minimum payments you are required to make on credit cards, department store cards, credit line, student loan, car, department store to get your minimum monthly debt payments;

(2) Minimum monthly debt payments by your gross income to get your DTI ratio.

For example- If these are the minimum payments you must make every month on your credit-related bills:

Auto Payment	**$ 300**
Visa	**$ 75**
Mastercard	**$ 75**
AmEx	**$ 100**
Macy's	**$ 50**
Student Loan	**$ 200**
Proposed Mortgage	**$2,000**

Total minimum monthly debt payments: **$2,800.**

If your gross monthly income is $7,000,
then your DTI $2,800 ÷ $7,000 = **40% DTI ratio**

This is really just a sophisticated way of telling whether or not you are overextended; the lower your DTI ratio, the more disposable income you have monthly to spend on things like food and utilities, and the more likely you are to have the money to pay your mortgage payment consistently. From the lenders' perspective, the lower the ratio of your debt to your income, the less risk you pose of defaulting on your loan.

Many moons ago, lenders required DTI ratios below 30 percent. As housing prices increased faster than incomes did, acceptable DTI's crept up to 35 percent and 40 percent. Now, 40 percent is acceptable to many lenders, and some will allow DTI's up to 50 percent higher!

The bigger revolution in acceptable DTI has been the advent of "No Ratio" mortgages. There is a whole universe of loan programs that do not even have a DTI requirement. Also, keep in mind that these ratios are driven by both debt and income—people who have difficulties in documenting their income often run into DTI problems. The stated income loans we discussed above make it possible for every cent of your income to be included in calculating your DTI, whether or not you can document it.

Loan-to-Value Ratio – Remember leverage? It sure stays on the lenders' minds. When you buy a home on the open market, the purchase price is usually equal to the fair market value of the home. At the time you first purchase your home, your down payment is the same as your equity—if you put 20 percent down, then you have 20 percent equity. What's the other 80 percent? Well, that is money you owe to the mortgage company. So, your loan-to-value ratio (a.k.a. LTV ratio) is 80 percent—you owe 80 percent of the value of your home.

Lenders view LTV ratio as an indicator of their risk. The lower the LTV ratio, the less likely you are to default. For example, if you have 70 percent equity in the home (i.e., a 30 percent LTV ratio), and you default on the mortgage, you face the risk of losing all of your equity if the lender forecloses. So chances are very good that you will do whatever you need to do to make that payment—no matter what.

As we discussed earlier, you'll virtually never want to take on a single mortgage for greater than 80 percent of the value of the property. This prevents you from paying for PMI. However, if you break up your purchase price and get, say, two mortgages, the lender on your second mortgage will calculate your CLTV (Combined Loan to Value) ratio based on all the mortgages on the property. So, if you are buying your home using an 80 percent mortgage and a 20 percent mortgage, then you have a 100 percent LTV ratio.

Insider Secret

THE APPRAISAL'S THE LIMIT!

For most lenders, the fair market value of the home, according to the appraiser, is the absolute ceiling for how much money they will lend to help you buy the home. It is also the "V" for Value in Loan-to-Value ratio. So it is important, especially if you are putting less than 10 percent down, to avoid offering to pay more than the home can be appraised for. See the discussion of Comparative Market Analysis, or CMA, in Chapter 7 for details on how to determine approximately what a property will appraise for before you even make an offer.

Position – As I mentioned earlier, if there are multiple mortgages on your property, the lender on the first mortgage has first priority for recovering if you stop paying. The second mortgage company gets what's left over until that loan is paid off, then comes the third mortgage. The further down a lender is on the food chain of mortgages, the greater the risk that the money will run out before they get paid off! (This is especially true once you get into a situation where there are four or five mortgages. It is pretty unusual to even have this many mortgages on a property unless the homeowner is in some sort of financial distress. Homeowners with financial problems are at the highest risk of over-mortgaging their homes and ending up "upside down" – owing more on mortgages than the property is even worth.)

The Level of Profit They Are Guaranteed to Make – Some people refinance frequently, paying their mortgage loans off every year by taking a new mortgage. Usually the new mortgage model comes with cash that can be used however the homeowner likes, or with a lower interest rate. Lenders' business model is set up for them to reap most of their profits by charging interest over a long period of time. At the time you apply for your particular mortgage, lenders know there is the risk that you will refinance anytime you'd like, which keeps them from making money in the long run.

There are two ways in which lenders can reduce their financial risk on your mortgage, by pinning down the minimum amount of profit they will make on your loan at the very beginning:

○ *Discount Points* – In money matters generally, a "point" is simply 1 percent of the amount you're talking about. In mortgage matters, a discount point is a 1 percent fee you can pay at the time you close your transaction in exchange for a discounted interest rate over the life of your loan. For example, if a lender offers you a mortgage at a 7 percent interest rate, they will also tell you up front that if you choose to "pay a point" up front, your rate will drop to, say, 6.875. You can pay

4 or 5 points if you want, and they are fully tax deductible for the year in which you buy your home. If you don't plan to be in your home – or in that mortgage – very long, it may not make sense to pay points. Your mortgage professional can help you calculate the cost of the discount points vs. the interest you'll save over the time you plan to keep the loan, to help you decide whether or not to pay points. If you do pay a point, the lender knows that even if you refinance the next day, they've made some money on your mortgage!

○ *Prepayment Penalties (a.k.a. Prepays)* – These are fees the lender will impose if you pay your loan off (or substantially off) within the first one to five years of the mortgage. The amount of a prepay is usually based on about six months' worth of interest – about the same as six months of mortgage payments! We call these "prepays" for short, and they are described in terms of how long they apply from the time you take out your mortgage. For example, if a mortgage broker says a particular mortgage comes with a two-year prepay, that means that if you pay your mortgage off within two years from the time you buy your home, then you will incur the penalty. With a hard prepay, you incur the penalty whether you pay off your home because you sell it or because you refinance it. With a soft prepay, the penalty is assessed only if you refinance the home. Lenders often impose prepays when they offer competitive terms to somewhat risky buyers. These same buyers often qualify for loans without prepays at a higher interest rate. If you take a mortgage with a prepayment penalty, the lender is guaranteed to make a minimum amount of money on your loan, either because you'll stay in the loan a minimum number of months, or because you'll pay the prepay penalty if you elect not to.

○ *The Level of Risk You Bear* – In any mortgage, either the bank or the owner must bear some level of uncertainty on a number of issues, including interest rates and monthly payments, among other things. For example, a fixed rate mortgage gives you complete certainty as to your rate and payments, but subjects the lender to losing out if interest rates rise. Thus, this type of loan is more expensive than one where the rate adjusts with the market. An adjustable rate, on the other hand, is less certain for you. During the mortgage application and approval process, the lender will determine the levels of uncertainty you assume relative to those they assume, based in large part on the type of mortgage you apply for.

Loan Options

The names of the various mortgage loan types are descriptive of their key characteristics:

- *Interest Rate* – Whether the interest rate stays the same (fixed) or varies (adjustable), or is fixed for awhile, then varies (hybrid);

- *Length of the Fixed Rate/Payment Period* – The period of time for which your rate and your payment are fixed;

- *Monthly Payments* – Whether your payment stays the same, changes, or you have options regarding how much to pay every month; and

- *Amortization (how the money you pay is allocated over time, whether to your principal or interest)* – Whether your balance owed will go down, stay the same, or even go up.

Tara's Two Ways Mortgages are Like Life Partners
(Boyfriends/Girlfriends/Husbands – Whatever Floats your Boat):

- No matter how many are out there, you only have to find one. (Or two, or realistically three – max – for mortgage loans *and* partners.)

- Your commitment is not a life sentence. What works for you now, may not work for you in the future, as your credit or income improve, rates go down, you move, or you decide you need to borrow against your equity. There's no law prohibiting you from deciding that your mortgage loan – or your life partner – is just not working out anymore, and refinancing.

Tara's One Way Mortgages are Not Like Life Partners:

You should go into a mortgage with your exit strategy in mind. Many savvy homebuyers take mortgages knowing when, why, and how they will get out of them. In Chapter 4, we'll explore how your life vision can and should impact your mortgage exit strategy.

Mortgage Types

There are only a few fundamental mortgage types. The thousands of programs out there are all variations on these basic programs. Once you understand the basic types and where lenders stand on the various risk analytics we've already discussed, it'll become a snap to compare mortgages and understand their similarities and differences.

Fixed Rate Mortgage

A Fixed Rate Mortgage is exactly what it sounds like. Your interest rate stays the same for the life of the loan, and so does your monthly payment. Fixed rate mortgages are generally fully amortized, meaning that from the very first payment you make, your payments are always allocated partly to paying off the principal, and partly toward interest. Mortgage amortization schedules are set so that in the early years of the loan, most of your payment is applied toward interest, and only a little toward the principal. Over time, the allocation shifts so that your payments are increasingly applied against the principal. The effect is that you pay more of your loan balance off at the end of the loan than at the beginning.

Fixed interest rate, fixed payments, loan balance always goes down - sounds great, huh? It depends. A fixed rate is desirable when rates are very low, or when rates are going up rapidly. The tradeoff is that fixed rate loans have the highest interest rates of all the loan types. Also, because these loans require payment on both principal and interest, the monthly payments are substantially higher than all the other loan types, when comparing payments on the same loan amount. Traditionally, these loans were always 15 or 30-year loans, hence the common names "15-year fixed" and "30-year fixed" to describe these types of mortgages. Over the last few years, more and more lenders are offering 40- and 50-year fixed rate mortgages, to create a lower payment option on a loan that is fully amortized.

Adjustable Rate Mortgage (ARM)

An Adjustable Rate Mortgage is a loan where the interest rate and, hence, the payment, adjusts, or changes. Occasionally, you'll hear of a "fully adjustable" loan, which simply means that the interest rate changes every month based on the movement of interest rates at large. When we're talking about first mortgages used to purchase a home these days though, we're usually talking about **Hybrid ARMs** – mortgages which have a fixed rate period after which the interest rate adjusts. When you see mortgage programs advertised as a "5/1 ARM" or a "7-year I/O ARM," for example, you are looking at a hybrid ARM (I/O=interest only). These loans are the most popular loans among my buyers, due to their basic features:

- The first number you see is the number of years after you buy the home for which your monthly payment and interest rate are fixed – this time period is called your Introductory Fixed Rate Period, and is usually one, three, five, seven or 10 years long;

- During your Fixed Rate Period, your loan is not amortized – you are only required to pay the interest on your loan during those initial years. You may pay toward your principal if you choose to, but you are not required to;

- Interest rates on these loans are substantially lower than the rates charged on fixed rate mortgages. The lower rate together with the interest only feature render the payment on any hybrid ARM is lower than on a fixed-rate mortgage of the same amount.

Interest[ing] Point: Counterpoint

Point: As much as homes cost, it doesn't seem like there would be that much of a difference between a fixed and an adjustable rate mortgage.

Counterpoint: These loans started to become popular precisely because home prices were skyrocketing. If you wanted a $400,000 home with 100 percent financing on a 30-year fixed mortgage with a 6.5 percent interest rate, your mortgage payment would be $2,528 a month. If you bought that same home on a 5/1 Interest-Only (I/O) ARM with 100 percent financing, your interest rate would probably be about 6.25 percent, and your mortgage payment would only be $2,083 a month. That's almost a $500 monthly difference, and can be the difference between being able to buy a house at all for some folks. For others, it can be the difference between buying a house with three bedrooms and buying a house where the kids have to sleep in the coat closet! If taking

an interest-only ARM allows you to buy a home when you wouldn't otherwise have been able to, then it is automatically a good choice in terms of getting your long-term prosperity building plan in motion, giving you a huge tax deduction, and making sure you don't get priced all the way out of the market by rising home prices.

Point: Not paying on the principal during your fixed rate period means that at the end of your first three, five seven, or 10 years, you owe just as much on your loan as you did at the beginning.

Counterpoint: The reality is that even if you have a fully amortized, 30 year fixed rate mortgage, for the first five to 10 years, the vast majority of your monthly payments will be directed to paying interest, and only a small amount is devoted to reducing your principal. In this millennium, true equity accrues through appreciation, not through paying your mortgage off. In fact, because most people refinance at least every three to five years in order to take advantage of low interest rates or to borrow cash against their equity, very few people actually pay off their mortgages anyway.

Point: A fixed rate mortgage seems stable and predictable. An ARM seems fraught with uncertainty as to what my mortgage payments could be. What if rates go up?

Counterpoint: This uncertainty is precisely why the banks charge less interest on ARMs than they do on fixed rate mortgages. But the fixed intro period feature of a hybrid can significantly reduce your uncertainty. A complete interest rate cycle from high to low takes somewhere between four and seven years. So, if you take a 10-year Hybrid ARM and watch the rates, you can actually catch the rates during a low phase of the cycle and refinance your mortgage then, taking a fixed rate loan if you'd like. Keep in mind that even when fixed rate mortgages are at 5 percent (very low), ARMs are still lower, at 4 or 4.5 percent, so you'll still have to justify spending those extra

Insider Secret

REFI ALERT

A great mortgage broker keeps tabs on when her clients' introductory fixed rate periods are coming due – even as much as a year or two ahead of time. They will alert you when rates drop, presenting a good opportunity for you to refinance and get a lower interest rate. Ask your mortgage professional if she can do this for you.

hundreds of dollars monthly for the security of a long-term fixed rate which you may not keep for the entire term. A fixed rate mortgage is basically the most expensive insurance policy you'll ever have, and may not be worth it given the many other ways you can calculate and protect yourself against the risk of rising rates.

Very, very few people who have bought homes in the last 20 or 30 years have actually kept the same 30-year fixed mortgage for 30 years, without refinancing. This is especially true if their interest rate is 7 percent or greater. On occasion, rates fall to extremely low levels (e.g., 4 to 6 percent). Almost everyone with a fixed rate mortgage refinances when rates get very low. The flip side of a fixed rate mortgage's security against rising rates is that they don't benefit when rates drop, so if rates drop below your rate and you have a fixed-rate mortgage, you have to refinance into another mortgage to take advantage of falling rates. ARMs adjust both to rising and falling rates. If you see rates falling a year or more before your Hybrid ARM will become adjustable, you can literally wait until rates get to a low spot and refinance then, without paying a high fixed rate while you wait.

> *Point:* It feels risky to have a potentially adjustable interest rate. No one has a crystal ball that can predict where rates will be at the end of the fixed rate period.

> *Counterpoint:* You are in a position to really calculate your risk here. First of all, you know at the very beginning exactly when your rate will begin to adjust. Truth be told, about 100 percent of my clients who take Hybrid ARMs refinance (i.e., pay off their Hybrid ARM and get a new mortgage) before their fixed rate period is even close to being up.

The interest rates on Hybrid ARMs go up as the fixed rate period gets longer; you can pay the bank for a longer period of predictability and certainty. This empowers you to select a fixed rate period that makes some sense for your life and for your risk tolerance. Knowing your life vision is essential to create your mortgage "exit strategy," which can drive the choice as to the type of mortgage you select in the first place. For example:

- Buyers who are students or early-career doctors, lawyers, teachers, professors, accountants or architects and can predict a major increase in their income in a fairly predictable number of years can align their fixed rate intro period with their partnership track, tenure track, or graduation schedule. If you are on track to make partner or be awarded tenure in five years, then you might take a five-year ARM or seven-year ARM;

- Many first-time buyers have a plan to move up to a bigger house or nicer neighborhood in three or five years; these folks should take a three- or five-year Hybrid ARM and not pay the extra interest on a fixed rate mortgage for 30-years' worth of interest rate stability that they won't even use;

- Families with new babies often break into the real estate market by buying a home in an area that they'll want to move out of when the kid turns five or six, in order to get into a better school district. These folks are also good candidates for a five- or seven-year I/O ARM.

If the first number is followed by a "/1," that simply indicates that after the Introductory Fixed Rate Period, the interest rate on that loan will adjust annually. Other loans become fully adjustable after the Fixed Rate Period, meaning they can adjust every month, within guidelines. It is critical to note that all ARMs have a cap on how much the interest rate and the payment can incease (a) every year, and (b) over the life of the loan.

How do the lenders decide when and how much to adjust the interest rate being charged on an ARM? Every ARM is tied to a specific published economic indicator called an index. This is why you hear people talking about the rate being paid to banks in London, and other seamingly arcane minutiae you'd think no one cares about – these indices form the basis for adjusting mortgage interest rates. Then, each ARM also has a margin, the bank's mark up. So, while one ARM might adjust based on Prime (an index) + 1 percentage point (a margin), another might adjust based on the one-month average of daily LIBOR (the London Interbank Offering Rates index) rates + 2 points (the margin).

Almost 80 percent of ARMs are based on one of three indexes: CMT (the Constant Maturity Treasury), COFI (the 11th District Cost of Funds Index), and LIBOR. You'll also hear a veritable alphabet soup of other indices thrown around, like T-Bills (Treasury Bills), MTA (Monthly Treasury Average), and COSI (the Cost of Savings Index). I want you to know that when you hear these acronyms, people are talking about the index, or basis for your interest rate.

Bear with me now – I know that we are verging on the pain point where eyes start glazing over, tongues hang out of mouths, and folks start twitching on the ground. It is not critically important that you understand how COSI is measured or the difference between the one-, three-, and 12-month LIBOR averages. What is important is that you understand that these indices fluctuate, some more rapidly than others. Let's talk specifically to the three most common indices:

CMT – The CMT is volatile, and moves quickly – up and down – with the economy. If your ARM is based on the CMT, you could end up with rapid fluctuations in interest rate and payment, with little warning.

COFI – The COFI index is much slower, and is said to "lag" the other indexes – it takes longer to react to market changes. This means that if rates are rising, yours will take longer to rise. However, if rates drop, yours will also take longer to fall.

LIBOR – LIBOR is more similar to CMT in that it closely follows economic conditions, but it follows international economic conditions, not just those here in America. So, if we have a nationwide recession when other countries are booming, LIBOR might stay high, keeping your interest rate high, and vice versa.

The whole discussion of indices is somewhat irrelevant to folks who never intend to keep their Hybrid ARM long enough for it to start adjusting. However, since some of the second and third mortgages you can use instead of a down payment are fully adjustable, buyers putting less than 20 percent down on your homes should know what you're getting yourself into on all of your mortgages. If you just ask your mortgage professional about the index to which your Hybrid ARM or second mortgage is tied, they are usually very helpful in educating you in more detail. Visit our bookstore at www.REThinkRealEstate.com to get *All About Mortgages: Insider Tips to Finance or Refinance Your Home* by Julie Garton-Good Kaplan Business (2004), which is chock full of information on indices.

Option ARM

You'll hear this type of mortgage also called by the names "Pay Option ARM," "Pick and Pay," "Flex-Pay," or any number of other names highlighting the unique feature of this mortgage – your ability to choose how much you pay in any given month. An Option ARM is similar to a Hybrid ARM; for a set number of years after you purchase your home, you are not required to pay down the principal during that initial fixed-rate period. After that introductory period, (a) you must start paying to reduce the principal loan balance. Also, option ARMs are fully adjustable, so the actual interest rate changes monthly from the start of the mortgage.

What is unique about the Option ARM is that during your introductory period, you are given the option – on a monthly basis – to pay less than the interest being charged in that month. Option ARMs are often described in terms of their "start rate" – usually 1 percent or 1.25 percent – which is the basis of your minimum monthly payment.

If you have an Option ARM, each month's statement will actually provide you four different options for what your mortgage payment will be that month – you get to choose from:

15-year Payment Option – The approximate amount you would need to pay to be on track to pay your mortgage off in 15 years;

30-year Payment Option – The approximate amount you would need to pay in order to pay your mortgage off in 30 years;

Interest-Only Option – The amount of interest charged that month on your loan; and, unique to the Option ARM

Minimum Payment Option – The monthly installment of the start rate (1 percent or 1.25 percent of your loan amount annually)—this is also called the **negative amortization** option, because if you consistently only made the minimum monthly payment, you would eventually owe more than you did when you bought the home. That is, your loan amount would increase, instead of decreasing (as with a fully amortized loan) or staying the same (as with an interest-only loan). Every year of your loan, the rate on which the minimum payment is based increases slightly until the end of your introductory period.

In order to prevent people from owing more than their houses are worth, lenders usually require a minimum down payment of 10 to 20 percent on Option ARMs. That is, Option ARMs are usually made only to a maximum 80 percent or 90 percent LTV ratio. This way, even if their loan amounts increase from negative amortization, they are likely to not owe more than the value of their homes. Like the other types of ARMs, Option ARMs also have a cap on how much the lender can increase the rate and the payment in any given year and over the life of the mortgage.

At the end of your introductory period (usually five years), an Option ARM recasts, meaning that the lender recalculates how much you owe and calculates a new minimum monthly payment that is based on a 25 year amortization schedule. The minimum payment amount will then significantly increase to an amount that would pay the mortgage off in 25 years—including

principal, interest, and any interest you've deferred over the first five years. If you suspect that this payment is a lot more than the initial minimum payment was, you are correct—the minimum payment after the five-year recast is as much as triple the original minimum payment. You can see why most Option ARM borrowers, like most ARM borrowers in general, have a plan for refinancing into a new mortgage before their fixed-rate introductory periods expire.

Yep, you heard me—you have the option in any given month to actually pay less than the interest that has accrued that month! Anytime you make the minimum payment, you actually defer paying some interest. If your interest rate is 6.5 percent and your start rate is 1.25 percent, and you were to make only the minimum payment every month of the first year of your mortgage, you would defer interest in the amount of 5.25 percent of the original loan amount of your home. This means that at the end of that first year, you would owe your original loan amount + 5.25 percent of that amount. In some areas, homes may appreciate at a rate of 10 percent, 15 percent, or more per year. You can see how if appreciation outpaces your deferred interest, this mortgage might not be quite so scary. Of course, this assumes appreciation is consistently high, and that is an assumption you might not want to bank your house on!

See the picture that's starting to develop? Let's assume you purchase a home for $600,000 in a market that appreciates approximately 12 percent per year, using an Option ARM with a 6.25 percent interest rate and a 1.25 percent start rate that goes up every year. If you made only the minimum payment for the first five years, you would have deferred a total of 25 percent interest for a total of about $150,000, so that at the end of the five years your total loan amount would be about $750,000. By the end of that same five years, though, that home would be worth over $1 million! Some investors and buyers who feel comfortable with a higher level of risk adopt the rationale that they will make only the minimum payment in order to afford a more expensive property because that property will appreciate faster (a) than the deferred interest will accrue, and (b) than the less expensive property they could afford if they used an interest-only ARM or a fixed-rate mortgage. This is a speculative position to take, based on a number of predictions, projections and assumptions about future market behavior. I certainly don't recommend it for a novice homebuyer, but I do want you to understand the rationale behind why certain buyers see this as a calculated risk they are willing to take.

Well, it's obvious from the buyer's perspective – that minimum payment is often much less than the interest-only payment. So if your interest only payment on a $350,000 mortgage at 6.5 percent interest is $1,895, the payment on that same loan amount and interest rate on an Option ARM with a 1.25 percent start rate would be a mind-bogglingly low $1,166.

From a lender's perspective, there are two sorts of buyers for whom this loan makes sense. The first are commissioned salespeople or other people whose income fluctuates seasonally. Many of these buyers will take advantage of the flexible payment options without ever allowing their loan to negatively amortize. For example, some teachers have income that is stable nine months of the year, then is reduced during the summer months. Real estate professionals have a boom in business in the spring and summer and a stable income during the fall, but business may slack off during the winter months. If a person with this type of income fluctuation had an Option ARM, she could elect to make the 30-year payment option in the spring and summer, the Interest-Only option in the fall, and then the minimum payment option in the winter months – without ever incurring any negative amortization.

The second sort of buyer for whom the Option ARM makes sense is an investor who might have fluctuations in the ability to make a full payment due to a vacancy or a major repair that needs to be handled one month. If you are looking to buy, say, a duplex where you live in one side and rent out the other, this loan might make sense for you. In the event your tenant move out and it takes you a month or two to find a replacement tenant, you might elect to make the minimum payment during those couple of months where you have no rental money coming in.

Option[al] Point : Counterpoint

Point: I could end up owing more on my house than I paid for it!

Counterpoint: Many people do this anyway, by refinancing and borrowing against their equity. Very few people actually keep one mortgage for the life of the loan. Of course, keep in mind that you can always make a payment greater than the minimum payment—this loan is about providing you options, but you don't always have to elect the minimum payment option. Your loan balance will not increase so long as you consistently pay at least the amount of the interest-only payment option, or offset your minimum payments with payments greater than the interest-only option.

Point: I could end up owing more on my house than it is worth!

Counterpoint: If appreciation in your area outpaces the rate at which you defer interest, and if you sell your home at a time when values are strong, then you shouldn't end up owing more than it is worth. But that's a lot of "ifs" to count on when you are talking about your financial position on your home! Again, what borrowers can control is how much interest they defer. Option ARM borrowers are well advised to keep the loan balance in check by using the minimum payment option sparingly or compensating for minimum payments with higher payments.

Remember, your lender doesn't want you to end up upside down on your home (i.e., owing more than it's worth) any more than you do. They are pessimistic – if you are upside down, you are more likely to go into foreclosure. If they have to foreclose and you owe more than they can sell it for, they lose money. For this reason, lenders typically implement at least three different controls to prevent what you owe from spinning completely out of control:

Down payment – Lenders require that buyers put 10 to 20 percent down in order to obtain an Option ARM.

Negative amortization ceiling – Lenders will not allow an Option ARM to negatively amortize beyond a certain point. For example, if the negative amortization ceiling is 125 percent, that means that if the loan balance reaches 125 percent of the original loan amount, the lender will recast the loan. This means they will begin requiring the borrower to make minimum payments large enough to begin reducing the loan amount. The recast minimum payments are significantly greater—sometimes two to three times the amount—than the original minimum payments. But the negative amortization ceiling and resulting recast won't sneak up on you; in order to hit the ceiling, an average Option ARM borrower would have to make only the minimum payment for the first four or five years of the loan. (And remember, even a borrower who only made the minimum payment for that much time could always refinance into a different mortgage if she needed to avoid the negative amortization ceiling, assuming the property could appraise for at least the new mortgage loan amount.)

Payment and rate ceilings – As with other types of ARMs, Option ARM lenders impose a cap on interest rate and payment hikes per year and for the life of the loan. The caps are generally quite high (like a lifetime rate cap of 12 percent on a mortgage that started at 6 percent interest), but they do provide some level of worst-case-scenario predictability.

Point: But if the minimum payment is all I have to make, then that's probably all I ever will make. Can't I get in trouble that way with an Option ARM?

Counterpoint: Depending on the circumstances, you absolutely can. If your home appreciates more slowly than you defer interest, you will end up in a situation where you owe more than your home is worth. If you were in that situation and needed to sell your home, you'd have to write a check to the mortgage company just to get your loan paid off, instead of receiving a check after the sale. If you know that you will only ever make the absolute minimum payment required of you, this loan probably isn't for you! This loan program is designed to benefit people who (a) really can afford the home but have cash flow fluctuations, (b) need some options and flexibility, and (c) are likely to overcompensate for deferring interest some months by paying more than the interest in other months. Bottom line? If you're not a financially disciplined individual, this is not a good mortgage for you.

Risk Factors Interactive

There are two sorts of mortgage loans and lenders. The traditional banks, which have fairly stringent acceptance—and rejection—criteria in accordance with their corporate culture of conservatism, are called prime lenders. Prime mortgages (a.k.a. A or A+ loans) are reserved for the most highly qualified borrowers, and typically offer the lowest interest rates and best terms. The last decade or so has seen the advent of subprime lending, where more aggressive lenders offer loans to higher-risk borrowers at a higher interest rate and on more burdensome terms. These days, the question is not so much whether you will get approved for a mortgage, but (a) how much risk you pose as a borrower, and (b) how much interest the lender that approves you will charge you as a result of that risk. Oh—I forgot—and (c) if you pose such a high risk that you get charged a very high interest rate, can you find a home you like that you can actually afford to make the monthly payment on?!

We've discussed each of the individual risk factors that lenders use to decide where you fall on the risk continuum. These risk factors are not considered in isolation, though. Rather, they are considered as a whole, as a snapshot of the total risk picture you present. It's a sort of global risk factor balancing test in terms of how the different factors affect the interest rate and terms for which you qualify.

The risk factors are both:

Interactive – if you rank very high on one risk factor and very low on another, they can balance each other out (though some factors, like credit scores and mortgage lates, carry more weight than others in the final risk analysis);

and

Cumulative – the more high risk factors you present, the higher your rate and tougher your terms will be.

Now, it's not an all-or-nothing deal. You are not either A+ or D-. There are many shades of gray, including A- and B loans. Lenders will rank your application on a scale of riskiness and offer you a corresponding loan program, rate and terms. This is precisely why there is such a multitude of mortgage loan programs out there these days!

If you understand how the different risk factors individually and in concert affect the rate and terms you are offered, you can fairly quickly begin to compare loan programs. For example, if you're a borrower with:

- A 740 credit score [very low-risk];

- With no ability to document her income (i.e., you need a stated income loan), [high-risk];

- With seasoned reserves equivalent to six months' payment on the mortgage you need (i.e., six months' seasoned assets) [low-risk]; but

- No cash to put down on the loan (i.e. 100 percent LTV ratio) [higher risk];

then you might be considered to present a low-moderate level of risk, which probably qualifies you for about an A- loan—you might have an interest rate similar to that of an A+ loan, but your mortgage might have a short prepayment penalty.

Check out the Risk Factor Balancing Chart below to get a quick picture of how each of the risk factors impacts your global risk snapshot and the terms you might be offered.

Risk Factor Balancing Chart

RISK FACTOR	A.K.A	RANGE	IMPACT ON RATES [LOWER IS BETTER!]
Credit Scores	FICO Score	400-850	Higher score =↓ rates
Liquid Assets	Reserves	Zero to six months' worth of payments, taxes and insurance.	More assets =↓ rates
Seasoning	N/A	Zero to two months.	Seasoning =↓ rates
Length of Employment	Time in industry or length of self-employment.	Two years minimum.	Longer =↓ rates
Debt-to-Income Ratio	DTI	0-55 percent.	Higher = ↑ rates
Loan-to-Value Ratio	LTV	80 percent max (to avoid PMI).	Higher =↑ rates
Combined Loan-to-Value Ratio	CLTV	103 percent max.	Higher =↑ rates
Position	1st, 2nd, 3rd	N/A	Higher =↑ rates
Prepayment Penalty	Prepays	Zero to three years.	Longer can↓ rates in some situations
Discount Points	Points	Zero to two points.	More = ↓ rates
Fixed interest rate	Fixed; 30-year fixed; 40-year fixed; 15-year fixed.	N/A	Longer fixed rate period =↑ rates
Adjustable rate	ARM, Hybrid ARM	N/A	Longer adjustable period =↓ rates

Opportunity Costs

Savvy Women often ask me whether they should wait until a certain season, year, or interest rate level to purchase a home. Others claim that they are waiting until they make a lot more money, save up hundreds of thousands for a down payment or drastically improve their credit. These folks fail to calculate that waiting to purchase has big costs, too—houses get more expensive faster than we can save money, get raises, or substantially change our credit.

I tell "the waiters" (and I'm not talking restaurants here) that I have met with real estate buyers, sellers, and investors worldwide and have never heard anyone say that they regretted buying at a particular time. By contrast, a couple of times a week I hear someone say they regret having sold at the wrong time, or not having bought when they could have. When you study and examine the American real estate market as a whole, prices move in one general direction—up (with few and temporary exceptions). Even when these so-called bubbles burst, appreciation may slow down from the astronomical increases seen in prior years, but even that doesn't roll home prices back so as to make housing significantly more affordable than it was in years past. So waiting for whatever you're waiting for is not going to put you in a position of more buying power. In fact, depending on how rapidly homes appreciate in your area, waiting is more likely to price you out of the market.

In my opinion, due to the opportunity costs of waiting there is rarely a situation in which it makes sense for you to wait if you can actually afford to buy a home right now. Houses rise in price so much, so fast, that buyers who wait can end up unable to afford anything decent at all. It might take you a year or two for your credit scores to get significantly better, or three years to save up three or six months' worth of mortgage payments. In that same three years, a $300,000 home might rise in price to $400,000 or more—meaning you'd have to pay an extra $1,000-plus in mortgage payment for the same house! If you buy sooner, you may pay a higher rate of interest, but that interest is tax deductible. You can estimate when your credit score will improve and refinance into a lower-rate mortgage with more favorable terms at that time. In the meantime, you'll have a big tax write-off and start building equity—and get to live in your own home—for several years. My rule? Buy as much house as you can as soon as you can, because waiting will cost you more than it will save you.

Well, ladies, that concludes the general educational portion of our discussion of money and mortgages. I hope you have been immersed in enough mortgage basics that the anxiety, if you had any in the first place, has started to subside. The most fabulous thing about money and mortgages is that you don't have to memorize this stuff; that's why you bought the book! If you need to, read and re-read this chapter, or consult it as needed while you move into a place of starting to get active about applying for a mortgage. Now that you know what you need to about mortgages and mortgage risk factors, let's tackle the more important issue of exactly how to select a mortgage that makes sense for your personality, your present lifestyle, and your vision for your future.

Chapter 4

Mortgage Matchmaking & Money Miscellany

Money is to homeownership as college is to a degree—it's the only way to get there. And preparing your finances for owning a home is similar to preparing to go to college, in many ways. You have one major decision to make, similar to choosing the college you'll attend: picking a mortgage. There are lots of good colleges out there, but your selection depends on which one is right for you: whether you prefer a girls' school to co-ed, religious to secular, or a technical institute to a school devoted to the arts. Mortgages are just like that—tons of different loan programs, and each of them is ideal for a certain Savvy Woman. The aim is making sure you choose one that fits nicely with your lifestyle, your personality, and your future plans.

Picking a mortgage—like picking a college—is only half the battle. Once the major decision has been made, there is a whole constellation of small details to arrange or prepare for when you arrive:

- Dorm room or apartment?
- Car or public transportation?
- Take on more student loans or take a part-time job?

Similarly, there are lots of money-related details of homeownership which you should be aware of, prepare for, and factor into your financial and lifestyle plans before you even commence your house hunt. These are the unexpected, relatively small costs which sometimes sneak up on new homeowners.

In this chapter, we'll work through your major money decision as a homebuyer—which type of mortgage to take—and the cumulatively major, but easy-to-overlook costs you'll bear as a homeowner

Mortgage Matchmaking

Everyone from astrologists to handwriting experts to online dating services has touted their expert ability to analyze you and come up with a compatibility profile targeting the romantic prospects most likely to be a good match for you. When it comes to mortgages, you are best equipped to start the process of plugging the data into a compatibility matrix, because you know yourself better than anyone else ever could.

The first step of mortgage matchmaking is to make sure you know the answers to a set of questions about yourself—some quantitative (numbers) and some qualitative (about your lifestyle). Once you pull these answers together, we'll make sure your scores are as high as they can be without incurring those nasty opportunity costs we talked about earlier. Then we'll polish up your risk picture to make it look as attractive to your prospective lender as it can, under the circumstances.

Next, you should know a little something about how different types of loans match up with different types of lifestyles. This will give you a head start during the process of selecting the mortgage you'll eventually choose. You can also start positioning yourself to understand what is involved in deciding whether you should pay discount points. Since rates and programs change constantly and rapidly, as do the perks you buy when you pay discount points, however, you won't be in a position to select your mortgage until you are actually house hunting.

Once you actually embark upon your homebuying experience, you will retain a professional matchmaker (i.e., mortgage broker or consultant) who will help you get concrete about what loan programs, rates, and terms are available to you at that specific moment in time, and will provide you the information you need to make your decision about what program to select. You will also have to make the final decision whether or not to pay discount points. Even then, the rates and terms you are offered are only estimated until you actually have an address, an accepted purchase contract, and your agreement to accept a particular mortgage—the things your mortgage professional needs to "lock" in your interest rate. No matter how preliminary, the matchmaking preparedness homework you do in the course of this chapter can dramatically boost your mortgage broker's ability to help you craft a sophisticated pairing of you and your mortgage, and your exit strategy into the next mortgage or home, too!

Now let's get the groundwork laid for you to connect with the love of your life—I mean, the mortgage of your next couple of years!

Step 1: Know Your Personal Stats

When it comes to getting ready to choose the mortgage that makes the most sense for you, there is a key set of numbers that is important for you to know—your personal statistics if you will. You can use my kids' friend, Hamilton, who is about 13 years old, for inspiration. Hamilton is a rabid basketball fan. We don't see him that often, so the last time I picked him up to hang out with my kids, I asked him how his parents are—he said, "Okay." I asked about his brother—he said, "Okay." I asked how school was going—he said (you guessed it), "Okay." Then, we got home, and he ran into my husband, John. John asked Hamilton who his favorite NBA player is this year. This child's eyes lit up and he literally morphed into his alter-ego, Sir Talks-a-Lot:

"SHAQ! He is off tha hook! I mean, he's 7-foot-1, weighs 325 pounds,

– and he's #1 in the league in field goal percentage with a 58.9 percent average;

– and he led last year, too with 60.1 percent!

Did you see that game where he scored 35 points against Charlotte? Did you know he wears a size 22 shoe?"

Now, I won't ask you your shoe size, but I do want you to know all of the following numbers before you even think about going in to meet with your mortgage broker or consultant. Use the Personal Statistics Worksheet, on page 123-124 or in the Buyer's Tool Shed at www.REThinkRealEstate.com to get your numbers on a single page that will be easy to fax or email to your mortgage professional when the time comes.

> *Approximately how long you plan to live in the place – Think about:*
>
> o School issues – how old are your children now and is there a time you'll need to move to be in a better school district? Or are you committed to private schooling?
>
> o Do you have short- or long-term marriage plans? When do you think you will get married? Will that affect where you live?
>
> o Do you anticipate changing jobs, transferring, or making a lot more income (e.g., when you make partner at the firm)?
>
> o Do you have short- or long- term retirement plans?

Your income – Know your:

- ° Gross – annually and monthly;

- ° Net – annually and monthly; and

- ° Adjusted Net - The net amount you will make monthly after you reduce the amount you have withheld from your paycheck to account for the big tax deduction you'll have after you buy your home (see the IRS withholding calculator link in the Mortgage Tool Shed at www.REThinkRealEstate.com, above).

The amount of your income that you are able to document – through documents like:

- ○ Bank statements showing deposits;

- ○ Tax returns;

- ○ W-2 forms;

- ○ 1099 (independent contractor) forms.

The amount of your income that you are not able to document – especiallyimportant if you are:

- ○ Self-employed; or

- ○ Compensated largely in cash (e.g., tips).

The total minimum monthly payments you are obligated to make on your debts – Gather up your account statements for all of your:

- ○ Credit cards;

- ○ Credit lines;

- ○ Auto loans;

- ○ Student loans; and

- ○ Any other loans or lines of credit.

The maximum amount you want to spend monthly on housing – including:

- ○ Property taxes;

- ○ Insurance; and

- ○ HOA Dues, if applicable, but not;

- ○ Utilities (e.g., water, gas, garbage, etc.).

Insider Secret

MORTGAGE YOGA

First, take a deep inhale. On the exhale, stttttrrreeeeeetch to make as big of a monthly payment as you can afford to.

Homes appreciate as a function of how much they are worth. If homes in your area appreciate 9 percent annually, then a $300,000 home will appreciate about $27,000 per year, but a $500,000 home will appreciate $45,000 per year. You can see why it makes sense to buy as much house as you can as soon as you can:

(a) taking all the incidental costs of homeownership into account, like property taxes, insurance, garbage collection, etc., and

(b) without overextending yourself.

If you have to scrimp somewhere, don't scrimp on your mortgage.

Cut back elsewhere. Do you really need cable? Private Pilates? Massages every other weekend? That many frappemochalattechinos? You pick and prioritize, but the house should be at the top of the priority list, because it will actually build wealth for you over the long haul.

Your FICO [Credit] Score – Check it at www.annualcreditreport.com. (This is not a commercial for www.annualcreditreport.com. This is a central, governmentally mandated website to allow you to take advantage of new laws that require the credit bureaus to give you one free copy of your credit report every year.) Make sure you order the reports and scores, and make sure you order them from all three bureaus. Contrary to popular misconception, it does not actually harm your credit score for you to order your own credit reports frequently (it does damage your score for others to order it a lot in a short period of time).

Your Liquid Assets – Collect the last two months' worth of statements from your:

- Checking and savings accounts;
- Money market accounts;
- 401K and other retirement accounts that you can convert to cash
- Stocks, bonds, and other publicly traded securities.

Add up the total cash value of the above items as of two months ago, and as of today. These are your seasoned and unseasoned reserves, respectively.

Length of Employment

- With your current employer;

- (If less than two years above) In your industry or line of work;

- (If self-employed) Number of years you have been self employed (e.g., how many tax returns you have filed reporting income from your own business).

Cash to Close – How much cash are you willing to spend to get into your house, including closing costs and down payment money? If this amount includes a windfall or large lump sum you are expecting that isn't currently in your accounts, like:

- An inheritance;

- A trust distribution;

- A legal settlement; or

- A bonus or large commission from work;

be sure to tell your mortgage professional how much you are expecting and when you expect to receive it.

Your Time Frame – When would you like to move into your home?

- One to three months from now;

- Three to six months from now; or

- Six-plus months from now.

Keep in mind issues that affect when you want to move, like:

- When school starts and ends, if you have kids;

- When you can take vacation time at work (to make the move easier); and

- The weather (if you live in a place with extreme winters).

Your Personal Statistics Worksheet

Each buyer should complete this worksheet before and after they do the quick work and the easy work, on pages 125-130.

How long do you plan to be in your new home? _____ years

Your income:

Gross: Annually $_____ Monthly $_____

Net: Annually $_____ Monthly $_____

Net monthly after you change withholdings per IRS calculator: $_____

Amount of income you can document:

Gross: Annually $_____ Monthly $_____

Net: Annually $_____ Monthly $_____

Amount of income you can not document:

Gross: Annually $_____ Monthly $_____

Net: Annually $_____ Monthly $_____

Total minimum monthly payments on all debts (list debts in order from least to greatest balance owed):

Creditor_____ Balance_____ Current Monthly Payment_____ Credit Limit_____ x.30_____ =
Goal Balance

Balance – Goal Balance = _____ Amount You Should Try to Pay Off

Creditor_____ Balance_____ Current Monthly Payment_____ Credit Limit_____ x.30_____ =
Goal Balance

Balance – Goal Balance = _____ Amount You Should Try to Pay Off

Creditor_____ Balance_____ Current Monthly Payment_____ Credit Limit_____ x.30_____ =
Goal Balance

Balance – Goal Balance = _____ Amount You Should Try to Pay Off

Creditor_____ Balance_____ Current Monthly Payment_____ Credit Limit_____ x.30_____ =
Goal Balance

Balance – Goal Balance = _____ Amount You Should Try to Pay Off

Total Current Monthly Payments: $_____

Maximum amount you want to spend monthly on housing: $_____

Your FICO (Credit) score (www.annualcreditreport.com):

Equifax_____ **Experian**_____ **TransUnion**_____

Your liquid assets (Type of Account, Bank or Company Name & Address, Account Number, Account Balance):
Checking and savings accounts

_____ _____ _____ _____
_____ _____ _____ _____
_____ _____ _____ _____
_____ _____ _____ _____

Money market and CD accounts

_____ _____ _____ _____
_____ _____ _____ _____
_____ _____ _____ _____
_____ _____ _____ _____

401K and other retirement accounts which you can convert to cash
(retirement accountswhich you could not draw cash from do not count)

_____ _____ _____ _____
_____ _____ _____ _____
_____ _____ _____ _____
_____ _____ _____ _____

Stocks, bonds, and other publicly traded securities

_____ _____ _____ _____
_____ _____ _____ _____
_____ _____ _____ _____
_____ _____ _____ _____

Length of employment:
With your current employer _____
(If less than two years above) In your industry or line of work _____
(If self-employed) Number of years you have filed tax returns reporting income from your own business?_____

Cash to close – $_____

Your time frame – When would you like to move in to your home?
____ 1-3 mos. ____ 3-6 mos. ____6-9 mos. ___9+ mos.

Qualitative Questions
Does your income fluctuate monthly or seasonally? Yes No Describe your income fluctuations._____

- ○ **What are your priorities for the financial side of this purchase? [number in order of importance]**

 Maximum Appreciation Buy as Much House as Possible
 Keep Payment as Low as Possible Buy Anything I can Afford
 Minimize Risk Maximize Tax Benefits

- ○ **Do you usually have to write a big check at tax time? Yes No**

- ○ **What is your exit strategy – why will you move when you move from this home?** _____

Step 2: Give Your Stats a Not-So-Extreme Makeover (a.k.a. How to Make Yourself Desirable to a Mortgage Lender, and When to Give it up and Take What You Can Get)

No matter what your numbers are, they can almost always be better. This is a double-edged sword. It's great because with a little bit of work, most of us can improve the snapshot of our finances seen by lenders. It's not so great because some prospective buyers—who could qualify for a mortgage—use the idea that they are "working" on their credit or saving up for a down payment as an excuse to procrastinate on actually buying the stinkin' house!

This "strategy" makes no sense, because even in a slow market, home prices rise much faster than you can raise your credit score or pay off a significant amount of debt. In the one to two years it takes to significantly improve your credit scores, home prices will rise so much that you either (a) can afford a much smaller or less nice home than you could have originally, or (b) can't afford to buy anything anymore at all. When you compare the potential interest rate savings corresponding to a higher credit score with the opportunity costs of waiting to buy until your score is higher, you quickly see that what you want to do is just a quick mini-makeover of your finances to make sure you display them in the best light possible, then go ahead and buy as much house as you can right now to get that equity building—even if the state of your finances means you can't qualify for A+ terms on your mortgage right now. Once you are in the home, you can start the more in-depth, long-term work on your credit scores, debt reduction, etc. so that a year or two down the road, you can refinance into a new mortgage with better rates and terms!

So, let's get going on that mini-makeover. Remember, the goal is just to spend a month or so making sure that your stats paint as pretty a picture of your financial resources—FICO scores, DTI ratios, reserves, and down payment money—as they can, not to do a Dr. 90210-style surgical reconstruction of your entire financial life.

Make Sure your Stats Are Accurate – Credit reports are notorious for containing erroneous information, due to incorrect reporting by creditors or fraud. I once had a client come in who should have had good credit, based on her history of paying her bills. When we pulled her credit report, though, many delinquent credit accounts that she had never even heard of were listed in her name and under her social security number. Her investigation revealed that her own brother had been committing identity fraud against her for years! She never would have known if she hadn't pulled her own reports in the process of preparing to buy a home. By filing a police report and aggressively disputing the fraudulent entries with the creditors and the credit bureaus, she was able to dramatically improve her FICO score.

The upshot? As soon as you get your credit reports from www.annualcreditreport.com, read them! Print them out or ask them to mail you a hard copy, and go through each report with a fine-toothed comb, marking it up when you see:

- Late payments that weren't actually late;

- Account balances listed that are higher than your actual balance;

- Credit limits that are lower than they actually are;

- Accounts that do not belong to you;

- Accounts you thought were open that are listed as closed;

- ANY other incorrect information.

Do the Quick Work

- If you have any credit lines that are over the credit limit, pay them down below the limit – immediately.

- If you have a surplus of cash in the bank available for discretionary use (e.g., more than 5 percent of the purchase price of the homes you're looking at) or your credit limits are fairly low, consider paying as many bills as possible down to 30 percent or less of their limits. For example, if you have a credit card with a $600 limit, pay it down to $180 or less.

Here's how to do this – rank all of your credit accounts from lowest to highest limit. Start at the top and work your way down the list, multiplying each credit limit (not the balance) by .3 to figure out what 30 percent of each credit account's limit is. Then go back up top, and list the current balances all the way down the list. Go through the list one last time, subtracting the 30 percent amount from each balance, to see how much cash it would take to bring each balance down to the 30 percent target. If there are any accounts you can afford to pay down to 30 percent without depleting your reserves—do it—today! Don't pay them all the way off—the 30 percent target is what FICO looks for to show that (a) you are not financially dependent on your credit cards, but (b) you are responsible enough to use credit and pay your bills as agreed. And don't worry about the really big bills. If you owe $19,000 on a student loan with a $20,000 limit, it would take you $13,000 to pay that loan down to 30 percent of the credit limit. If you have that much cash, paying that loan down is probably not the best use of it when you're considering buying a home. Plus, in the time it takes to save up to pay a really big bill off, the home of your dreams might be a whole lot more

expensive than if you had bought it before you paid the large debt off. Pay down the smaller ones and keep the rest in the bank for your down payment, closing costs, reserves, or your bill at Home Depot or Lowe's once you move in!

- If you happen to be one of those uber-responsible folks who uses credit cards for everything, then pays them off every month – STOP that practice until you are warmly ensconced in your new place. Credit scores are a snapshot—the creditors only report your account balances once a month. If your account picture is reported on the day of the month you have huge balances, rather than the day when you've paid them off, your report will look like you are living on your credit cards! The 30 percent of credit limit benchmark is an ideal account balance to maintain for purposes of maximizing your FICO score—not more and, surprisingly, not less. So, until you have actually secured your mortgage, stop running your cards up beyond that 30 percent, even if you plan to pay it off every month.

- If you have cards that have been unused at all for awhile, or lots of cards with no balances, go use a few of them, but refrain from going over that 30 percent of credit limit target. You want to show that you have the financial ability and the ethics to responsibly use credit.

Do the Easy Work

Reserves – If you don't have at least three months' worth of mortgage payments in liquid assets, your credit score is less than 700 and you have a relative or VERY close friend who has enough money in the bank to suffice for your reserves, consider asking her to add your name to her accounts. It takes a single trip to the bank, her willingness to sign a document attesting to the fact that she is giving you access to all the funds in their account, and a TON of trust (on her part) and responsibility (on yours). Most people can qualify with or without reserves, but many times the rate-reducing effect of having reserves can expand your purchase price limit. It is definitely worth doing if someone in your life can make her funds available to you. This is the new age alternative to getting a co-signer, allowing you to get some help without putting the co-signer's credit on the line or making her responsible for making your payment if you can't.

Anti-Checklist #1

WHAT NOT TO DO UNTIL YOU HAVE CLOSED ESCROW, IN ORDER TO MAXIMIZE YOUR PERSONAL STATS

✓ **Don't close any accounts –** it makes it look like you have less available credit. Pay accounts down to 30 percent, or pay them off if you insist, but DON'T close them!

✓ **Don't open new accounts or make new bills –** new accounts create a FICO-reducing triple whammy of a new account/inquiry, an account with a short length of repayment history plus a high balance-to-credit limit ratio. (When you first open an auto account or installment account, you are already at your credit limit – so it looks like you are maxed out.) The exception – if you have no credit accounts at all, you should open one or two secured credit cards at your bank, then use them (up to 30 percent of the limit) and pay the bills on time every time.

✓ **Don't buy a car –** see above. This also makes it harder for you to have a qualifying debt-to-income ratio, by increasing your debt without increasing your income. As a comedian once observed, "If you have a Land Rover and a landlord – it's time to reverse your priorities."

✓ **Don't pay your bills late!** You would not believe the number of people whose credit scores actually drop while they are house hunting because they make late payments. I've actually seen people who just barely got pre-approved have their FICO scores drop, find the house, make an offer, and then – SURPRISE!! – no longer qualify for the mortgage because they have paid their bills late.

Gift money – If you have "wealthy relations" or really nice parents who have indicated that they plan to give you money to help pay for your down payment or closing costs, get this money in the bank sooner rather than later. Unless your benefactors give you a full 20 percent down payment, most lenders are going to require the gift money to be seasoned (i.e., in your bank accounts) for at least two months prior to the time your mortgage professional submits your loan application to the lender (just to be sure this isn't a super short-term loan). So collect any promised gifts, put them in your bank accounts, and spend your waiting time writing really nice thank you notes.

Insider Secret

THE ONE GOOD DEED THAT CAN GO UNPUNISHED

- -

If you are hesitant to take gift money from your parents or grandparents because of the tax consequences to them, make a quick call to a tax or estate attorney. There are fairly simple, inexpensive ways to minimize or avoid taxation on these helping hand-type arrangements.

Student loans – Student loans seem like the warmest-and-fuzziest of all the sorts of debt you can occur. You only incur them if you've been proactive in improving your life, the interest is low and tax deductible, and they'll let you postpone paying them ad infinitum if you just call them up and whisper the magic word "forbearance." With a student loan, your "limit" is simply the loan amount you had when you graduated. During forbearance periods, the interest is tacked onto your account and your balance could grow beyond your "limit." If you've taken advantage of the forbearance process for any significant period of time, and you are less than 10 years out of college or graduate school, your student loan might very well show up on your credit report as being over the limit.

If you see on your credit reports that your student loans are designated both "Pays as Agreed" and the balance is reported as a greater amount than the credit limit, there are three ways you can fix this. All are worth considering because of the sheer size of most student loans, which have a proportionally large impact on your FICO scores:

(1) Pay your student loan down below the "limit" – this is only feasible if the amount over the limit is within reason;

(2) Call up your student loan company and ask them if they will adjust what they are reporting as your loan "limit" to match what your loan amount currently shows (if they agree, ask for a hard copy letter that documents the "new" loan limit in writing – you may need it to get your credit reports changed); or

(3) "Consolidate" your old student loan into a new one at the same interest rate or lower, which will reset the loan limit at whatever the loan amount is at the time.

Move On – As soon as you have finished doing all the paying down and student loan-type work that you are going to do from the list above, go through your credit report one last time and check off all the items that should be different now than they were when you originally pulled them. Now, you need to initiate the dispute process with each of the three credit bureaus for (a) all of the erroneous or fraudulent items, and (b) all of the items that you have caused to change while you were doing the quick work and the easy work, above. Once you dispute an item on your credit report, the credit bureaus immediately make a put up or shut up proposition to the creditor who was reporting the disputed item. If the creditor does not validate the disputed item within 30 days, the credit bureau erases it from your report.

It may take two or three rounds of disputes to get your report clear of all the incorrect items. I cannot impress enough the importance of moving forward with your homebuying process after the first round (while continuing to dispute errors until they are gone). As you improve your credit score through further rounds and through responsible use of your credit, your FICO scores will move up and your risk ratings will decrease, and you can refinance into progressively higher grade (i.e., lower interest & better terms) mortgages.

Do not wait for further rounds of credit report disputing to be complete unless:

o **Your credit score is still under 580** – FICO scores below this point qualify only for severely subprime loans. If errors or accurate delinquencies on your credit reports are placing you below this point, it may very well be worth waiting until they are gone or less recent.

 or

o **Your mortgage professional tells you to wait** – Every once in awhile, a client will have a credit score of 698 and the ideal loan program for them will require a mid-FICO of 700. There's no hard and fast rule for knowing when it's advisable to wait because your score is on the cusp of a hundred-point mark, except that once your score is over about 740, there's really no advantage to waiting (the best loans are offered to people with scores over 740—it makes no difference whether the score is 750 or 800). It totally depends on whether an increased score would make an improvement in the rate or terms for which you qualify—and that's a question for your mortgage professional.

Insider Secret

THE COMPANY YOU KEEP. . .

If you are buying a home jointly with someone else, your credit score may not be the one the lender looks at anyway! Make that person go through the Quick-and-Easy work process to maximize her score, too, then consult with your mortgage professional. Even if your score is below 580, you might not need to wait if your co-buyer's score is the one lenders want to see. Generally speaking, the buyer who makes the most money is the one whose score is of interest to lenders. (Of course, the person with the highest income is also often the person with the most bills and, accordingly, the lowest credit score.) Consult with your mortgage professional to see whose score is important.

When you've received your revised credit reports, recalculate your personal statistics, including your new FICO scores. Other than the numbers, there is a short list of qualitative questions to ask yourself to round out your personal profile before the real matchmaking can begin:

- *Fluctuations in income* – Is your income steady, or does it fluctuate monthly or seasonally?

- *Priorities* – What are your priorities for the financial side of this purchase? Are you trying to get maximum appreciation, get as low a payment as possible, or fit your five kids in as big a house as possible?

- *Your Tax Situation* – Do you usually have to write a big check at tax time?

- *Your Exit Strategy* – Why will you relocate when you move from this home? (Answers I've gotten to this question range from getting into a better school district to "they'll carry me out in a pine box.")

With this list in hand, you know enough about yourself to start weeding through the mortgage program types and start figuring out which of them might be compatible with your life!

Step 3: Narrow Down the Loan Types which Are Compatible with your Life and your Finances.

In Chapter 3, we learned all about loans. At the beginning of this chapter, you got clarity on your finances and the other characteristics of your lifestyle which are relevant to selecting the ideal mortgage for you. Now you can start to narrow down the universe of a gazillion mortgage programs down to a couple of mortgage types that might work for you.

Types of Loans & Types of Lives

TYPE OF LOAN	AKAs	SOUNDS RISKY BECAUSE	IT'S NOT REALLY THAT RISKY BECAUSE	MIGHT BE RIGHT FOR YOU IF	PROBABLY NOT THE RIGHT MORTGAGE FOR YOU IF
Fixed-rate	30-year fixed, 15-year fixed	Doesn't really sound risky, but there is the risk that rates will go lower than your fixed rate.	Fixed rates and payments minimize risk.	Rates are very low when you buy, or you are extremely risk averse.	You are a human being, because no matter how low the rate is, the rate on an ARM will always be lower, allowing you to buy more house or pay off the same house more quickly.
Adjustable rate mortgage	ARM	Can't predict whether interest rates will go up or down.	Most ARMs today are hybrid ARMs, with a fixed rate intro period. Interest rate on an ARM will always be lower than on a fixed rate. Rate & payment increases are capped.	You need a lower payment or want to buy more house than you could with a fixed-rate loan.	You are extremely risk averse.
Hybrid, Interest-only ARM	5/1 ARM, 7 year ARM, I/O ARM, 5 year interest-only.	You don't have to reduce your principal during the introductory period. You can't predict where rates will be when they begin to adjust.	You can totally predict when your rates will start to adjust, and can refinance prior to that. You can also pay toward the principal if you choose. In most areas, you will build equity faster through appreciation than paying toward the principal, anyway! Rate & payment increases are capped.	You need to be able to predict your rate and payments for a period of time. You know your exit strategy: you'll be moving in a few years (e.g., to get the kids in a better school), or make more money in a few years (you are a professional on track to partnership, in a career with step-up raises, or are a tenure-track educator)	Mmmm, can't think of anything.

TYPE OF LOAN	AKAs	SOUNDS RISKY BECAUSE	IT'S NOT REALLY THAT RISKY BECAUSE	MIGHT BE RIGHT FOR YOU IF	PROBABLY NOT THE RIGHT MORTGAGE FOR YOU IF
Pay Option ARM	Option ARM, Pick & Pay, Flex Pay ARM, Neg-Am	You could end up owing more than you paid for the house. You could even potentially end up owing more than the house is worth!	You only end up with an increasing loan amount if you consistently pay the minimum payment. You can always choose to pay more than the minimum, or to offset your minimum payments some months with much larger payments in other months. Rate & payment increases are capped.	You have tenants in the property, are a commissioned salesperson, or have seasonal fluctuations in income. You can make some higher payments, but need the flexibility of making a very low payment if you need to.	You aren't a financially disciplined person, or don't like to pay attention to financial details. Not great if rates are on the rise. Homes in your area don't appreciate strongly.
Stated Income	Stated	Interest rates might be a little higher.	You might not be able to qualify otherwise.	You are self-employed or make a lot of your income in cash or tips. You have DTI problems.	All your income comes from a "regular" job where you get a W-2 or a 1099 form, or you can document your income with bank statements.
Stated Income & Stated Assets	Stated/Stated	Interest rates might be a little higher.	You might not be able to qualify otherwise.	You have substantial assets and income that you have a hard time documenting.	You have account statements documenting 2-6 month's worth of mortgage payments in liquid assets.

Step 4: Engage a Mortgage Pro

With your Personal Stats in hand, and an idea of what type of loan might work for your type of life, you are well-equipped to have an educated conversation with a mortgage professional (See Chapter 2 for guidance on how to find your mortgage pro) and to get pre-approved for your mortgage.

Things to Bring to Your Mortgage Professional

Keep a file on your desk and as updated items on the list come in the mail, or you come across them, just stick them in there so you don't have to go on a scavenger hunt when the time comes!

Personal Information

(1) Full name of all persons applying for the loan along with their social security cards—the original blue card;

(2) Your home address, including zip code, for the last 24 months and the names and addresses of landlords and/or mortgage lenders.

Employment Information

(3) Name and complete address of employers (for all applicants) for the last 24 months;

(4) Last two (2) years' W-2 forms for all applicants;

(5) Most recent pay stubs covering one full month and year-to-date info for all applicants;

(6) Verification of any other income to be used for qualification purposes;

(7) If any applicant is self-employed, bring copies of your current profit and loss statement, a current balance sheet, and Income Tax Returns for the past two years, both personal and business.

Financial Information

(8) A list of account numbers, current balances, and complete bank/credit union addresses for all checking and/or savings accounts;

(9) Copies of your last two months' checking and savings account statements;

(10) Copies of most recent investment and retirement account statements, if applicable;

(11) If any buyer is obligated to pay alimony, child support, or separate maintenance, bring a copy of the recorded divorce decree and/or maintenance agreement;

(12) If any applicant owns other real estate, please provide a list of all income, copies of all leases and/or rental agreements, names and addresses of all lenders, loan numbers, loan balances, and monthly payments.

Feel free to email or hand them your Personal Statistics Worksheet(s), and to let them know what sorts of mortgage programs you are interested in or leaning towards. They'll ask you to complete the 1003 form and will almost universally ask you to give them the names, birthdates, and social security numbers for all mortgage applicants (you and whomever else you are buying the place with) over the phone, so they can run your credit reports. Not a big deal, so long as you selected this individual by referral or otherwise know that they are connected with a legitimate enterprise.

At some point in the near future, they will also ask you to bring or send them a list of paperwork (see Things to Bring to Your Mortgage Professional, previous page). Start gathering these things now, so that it's not a huge burden or rush to do it when you need to.

Insider Secret

A CLICK IN TIME SAVES NINE

You don't need to bring a detailed list of all your credit card accounts and other debts to your mortgage professional. She'll pull them into the loan application directly from her digital version of your credit report.

Step 5: To Pay Points or Not to Pay Points?

As I mentioned earlier, whether or not to pay points is really just a matter of figuring out (a) whether you can afford to pay 1 percent of the mortgage amount in addition to the rest of your closing costs, and (b) whether it is worthwhile to do so. If I were you, I'd ask your mortgage professional to tell you how much:

- The lender will reduce your interest rate if you pay a point; and

- How much money this will save you over the years you plan to be in the mortgage or over your introductory rate period, if you have an ARM—not over the life of your loan.

From there, deciding whether to pay points is a simple compare-and-contrast exercise—if it will save you more than it costs, it might be worth it. If you need the cash for closing costs or whatever else, though, it isn't worth it no matter how much it saves you. One caveat—if it's pretty near the end of the year, and you anticipate having to write a big check to Uncle Sam next April, you might think very seriously about paying points. If you do, the entire amount of the points you

pay is tax deductible the next time you file a tax return, and paying them can drastically improve your tax situation next year, while decreasing your monthly mortgage payments at the same time. Don't take my word for it—ask your CPA!

Insider Secret

MORTGAGE PRO COMMISSIONS

Mortgage brokers work on commission, which are paid by you, by the lender, or by both you and the lender. If you work with a mortgage broker, the industry norm is for them to charge you an origination fee equal to 1 percent of the loan amount.

The interest rate and loan terms you are quoted will usually be the rates and terms for which you qualify assuming you pay a 1 percent origination fee—this reduces what the lender will have to pay the mortgage broker. You have the option, though, of taking a loan at "par pricing"—this simply means that you pay no origination fee, and the lender assumes full responsibility for paying the mortgage broker. However, because par pricing puts the onus on the lender to compensate the mortgage broker, the par pricing interest rates are higher and terms might be more burdensome than those you would get if you paid an origination fee.

If you ask them to give you good faith estimates with (a) a 1 percent origination fee and (b) at par pricing, your mortgage broker can help you do the math to determine which is the most cost effective way for you to go. For example, assume that you are borrowing $900,000—1 percent of your loan amount is $9,000, and the interest rate differential between par pricing and pricing with a 1 percent origination fee will cost you $2,000 per year that you have the loan. If you are taking a 3/1 ARM, and know you will be refinancing before the 3 year introductory fixed rate period is up, then the interest rate increase "at par" is $6,000 max—it doesn't make sense to pay the $9,000 origination fee up front to save $6,000 over time. If you have a lower loan amount, or your lender sets very different interest rates for par and non-par mortgages, or you simply intend to keep your loan long enough to save more on the interest rate than you will by not paying the origination fee, it may make sense to pay your mortgage broker up front and save more on your interest rate over time.

Note – Subprime borrowers are often charged origination fees larger than 1 percent on grounds that it is harder for the broker to find a loan for which they will qualify. In any event, if you are being charged more than a 2 percent origination fee (or more than 3 percent total fees by your mortgage brokerage), you should definitely get a second opinion from a reputable mortgage professional.

Step 6: Find Your Big Number

The outcome of your pre-approval will be a letter that states Your Big Number—your maximum purchase price. You should make sure you are clear on what your monthly payment will be at Your Big Number, and on what sort of mortgage program (rate and terms) that monthly payment is based. That number will drive your house hunt and subsequent decision making, so make sure you understand the underlying details—you don't want to find a home priced at Your Big Number, and then realize that the payment you were quoted was the minimum payment on an Option ARM with a 5-year prepayment penalty, and not an interest-only payment on a hybrid 7/1 ARM with no prepay penalty.

Insider Secret

THE IMPORTANCE OF BEING EARNESTLY PRE-APPROVED BEFORE YOU GET IN THE CAR

Okay. So there are pre-qualifications, and there are pre-approvals. A pre-qualification is where you give a mortgage broker a hypothetical set of credit scores, income, etc., and they give you back an interest rate and terms that the hypothetical borrower you've described would qualify for. A pre-approval is where the mortgage pro reviews your credit, your income and your assets, and conditionally offers you a particular mortgage (or several), putting that offer in writing in letter form.

It is critical that you be pre-approved—not pre-qualified—before you get in the car to go house hunting with your Realtor:

- You can make an offer as soon as you see "the one"—Most sellers won't even look at an offer to purchase their home that is not accompanied by a pre-approval letter. If you see it, then have to wait a day to get a pre-approval letter, you could very well end up losing your new home or wind up in a bidding war over it.

- You won't see homes way above your price range – Once you are pre-approved, your mortgage pro will give you a purchase price limit. DO NOT go looking at homes that are outside of your limit. I promise you that after you see the million dollar house, the one that costs $300,000 doesn't look too good.

- You won't see homes that are way below your price range. People who erroneously assume they can only afford a $150,000 house might get really depressed, disgusted, and frustrated with what they can find in some markets.

With Your Big Number in hand, you're off to the races! You are ready to get in the car and start the house hunt. Seems like a lot of work to get to one number, huh? Well, everyone doesn't do that much work to get there—the only people who do are the savvy, strategic folks who make calculated decisions about their financial lives. Yep, just them. You do the homework, and you put yourself in that group. And you put yourself out of the group of people whose homebuying experiences are characterized by misery and distress.

Miscellaneous Money Matters

Surprises Are For Birthday Parties
– Mortgage Company Billboard

The number one source of chaos and distress in the course of buying or owning a home is surprise fees and expenses. Imagine the intensity: you've been house hunting for months, you're on day 25 of a 30 day escrow, you've given notice to your landlord and your stuff is boxed and sitting on the moving truck. Then you get a call from escrow saying that you can't get the keys to your new home until you write an unexpected check for thousands of dollars. It's like being held hostage! It's a totally avoidable problem, yet it occurs all the time, either because (a) one of the professionals involved made a math or timing miscalculation, (b) the buyer "forgot" to pay a bill on time and credit scores have plummeted since being initially pulled, or (c) the fees were mentioned before, but at a time or in a way that the buyer's mind didn't register what to expect.

The miscellaneous money matters discussed in this section are those that don't fit neatly anywhere else—so they often get glossed over or mentioned only hurriedly, if at all, once you are involved in a transaction. And speaking of glossed over, once you have a specific property in your sights, your eyes will glaze over and the professionals' "disclosures" of all the fees involved will sound very much like Charlie Brown's teacher in the background being drowned out by your mental recitations of how exactly you'll reconfigure your new living room and what you need to pick up at The Bombay Company or the paint store. So, there's no time like the present to demystify the miscellaneous money matters which otherwise might fall through the cracks.

"I Don't Have Enough Money to Buy A Home."

FEQ Shatter-er – There are two flavors of broke-ness people are talking about when they say this to me. Sometimes they have enough money coming in on a monthly basis to cover the mortgage payment, but they have no savings for closing costs or a down payment. Other folks have ample savings to get in, but don't have good cash flow.

I'll be brutally honest – there is a certain amount of cash flow you need to have on a monthly basis to buy a home. If you want to see what that is, look at entry level homes in your area on Realtor.com, take those purchase prices and start plugging various purchase price/down payment combinations into our mortgage calculators in the Mortgage Tool Shed at www.REThinkRealEstate.com to generate the corresponding monthly payment. As we've seen, there are tons of flexible loan programs (e.g., interest-only and Option ARM mortgages) that can bring monthly payments down to a manageable level. You can find some more creative—and co-operative—strategies for reducing your monthly payment burden in Chapter 5.

However, most of the people who say they can't afford to buy a home are talking about up-front money—they think that to buy a $500,000 house, they need $100,000—the 20 percent down payment that our parents and grandparents had to make. The real deal is that there are zero down payment loans, so that if your credit is okay, you may not need any down payment at all. You should try to save at least 3 percent of the purchase price in order to be a competitive buyer and to cover your closing costs—so that any little unexpected cost doesn't totally derail your transaction. With that said, I routinely sell $500,000 houses to people who put $15,000 or less into the transaction to get started. In fact, years ago I bought my first home for almost $400,000 with only $3,000 to get in. How? Sometimes, if market conditions, your lender, and the seller are all amenable, you can get closing cost credits from the seller that effectively allow you to finance your closing costs. Read on for more about closing cost credits later in this chapter.

If you're the methodical, mellow type who likes a life with minimal drama, save (or get a gift of) the closing cost money. If you're a scrapper with no savings who is committed to buying a home now by any means necessary, then go full speed ahead, sister. You may have to make some compromises, but it's worth it!

Double Duty – Earnest Money Deposit & Closing Costs

Again, the goal should be to start the homebuying process with at least 3 percent of the purchase price of your future home in the bank. This is not a hard and fast rule, and may vary in different states—in some areas, this might be an overestimate or an underestimate because of variations in closing costs or because the standard practice is for the seller to bear most closing costs. Ask your Realtor what you should expect in terms of the standard amount of closing costs in your

area. The same fund of money, the 3 percent I keep referring to, actually does double duty as your earnest money deposit and your closing cost funds:

Earnest Money Deposit – You might remember from Chapter 2 that your earnest money deposit is just a check that sits in the escrow company's account from the time your offer is first accepted. It is money that lets the seller know that you are "in earnest" about doing this transaction. In some areas, this deposit can be forfeited to the sellers if you back out of the deal after you remove contingencies or after your deadline for objecting to the condition of the property. The amount you should put into escrow for an earnest money deposit varies widely from market to market, and is always negotiable between you and the seller. It generally ranges from 1 percent of the purchase price up to 3 percent, depending on the market. Many sellers will simply refuse to take their houses off the market if you don't put up some deposit money or at least show that you have some cash in the bank, so if you want to have your pick of homes on the market, be prepared to put an earnest money deposit down in the amount that is standard for your area. A sellers' nightmare is to have the deal "fall out" of escrow because the buyer can't close their loan, and a buyer who doesn't have any cash in the bank is less likely to be able to get a final loan approval. To be competitive as a buyer, try to conserve your cash and stockpile as much as you can.

Insider Secret

THE CLOSING COST CASH CRUNCH

Occasionally, closing costs may exceed the 3% estimate. If your closing costs come to more than that, you're still on the hook. It can be terrible to lack the cash to cover these expenses, which sometimes seem to arise out of nowhere during a transaction. This is why having some cushion in the bank can make all the difference in the world.

The best way to prevent surprise costs at the end of the transaction is to read and understand your good faith estimate—a standard list of closing costs your mortgage broker or consultant will give you at the beginning of the transaction. For a sample good faith estimate, visit www.REThinkRealEstate.com, **go to our blog,** and enter "goodfaithestimate" in the Tara's Tips box.

If you do get surprised and can't cover some portion of your closing costs and you have an IRA or 401K or other retirement plan, you might be able to "borrow" some emergency cash from your retirement account. Usually, you can do this with no tax penalty if the borrowed funds are repaid within a fairly short period of time, like 60 days. Check with the administrator of your retirement plan to see if this is available to you.

Closing Costs – Most importantly, you need to have this fund of cash in the bank to cover your closing costs, a.k.a. transaction costs. These include all costs incurred as a result of doing the transaction, including:

- Inspector's fees;
- Appraisal fee;
- Escrow fee;
- HOA transfer and documentation fees;
- Realtor commissions;
- Title insurance policy costs;
- Home warranty fees;
- Lender's fees;
- Loan origination fees;
- Discount points, if you choose to pay them;
- City and/or county transfer taxes;
- Your prorated share of any property taxes the sellers have already paid;
- Prepayments of your own property taxes and insurance, if applicable; and
- Miscellaneous document drawing, courier, and wire fees.

Not all of these costs are incurred in every transaction, and each city, county or state has a different standard practice for which of these fees are paid by the seller and which are buyer-paid fees. Almost everywhere, the Realtor commissions (which are the largest of all these fees) are paid by the seller, unless you have agreed to pay your own agent. Your Realtor can help you early on to get an understanding of (a) how much these fees are in your area and at your price range, and (b) which of these fees you, the buyer, will be responsible for.

Closing Cost Credits

In some cases, the seller will agree to give the buyer "credits" at close of escrow with which the buyer can pay their closing costs. As I described earlier, you can add the amount of credit you want onto the amount you were going to offer for the property, then write into your offer that the seller will credit you a certain amount back for your closing costs. There are several things to keep in mind, should you get into a situation where you are asking for closing cost credits:

- The closing cost credits must be approved by the lender (lenders usually cap closing cost credits at 3-6%);

- The property must appraise at the purchase price including the credits;

- Some sellers simply won't agree to pay credits, or will require a earnest money deposit even if they do agree to pay credits;

- Asking for credits can make you look weak as a buyer if you are competing with other buyers;

- If at all possible, be prepared with a small cushion of cash in the bank or in other accounts, in case you underestimate how much you'll need for closing costs, end up competing with other buyers and decide not to request credits, or the Seller requires a deposit anyway.

If you simply don't have any money for closing costs, and you are only going to be able to buy a home where the seller agrees to give you closing cost credits, then you need to understand that you are putting yourself at the mercy of the seller to some degree. If you have no cash for closing costs, and the seller who owns your dream home refuses to pay credits, you are simply out of luck. If this is your situation, be prepared to compromise, and maybe even to settle for a home that is not exactly what you had in mind. If you are that type of gal who is just committed to breaking into the real estate market—period—then this level of sacrifice may seem like nothing in exchange for the blessing of being able to own a home with virtually no cash out of your pocket. It's all about your priorities!

Good Faith Estimate

When you submit a loan application and/or when you get into contract on a home, your lender will provide you with a good faith estimate. This is a standard form which:

- Offers you a concrete interest rate and the important terms of the mortgage program for which you have been approved; and

- Discloses all the anticipated closing costs of buying your home.

Remember—an estimate is only an estimate, especially when it comes to interest rates. Interest rates change on a daily basis—as soon as you are in contract on a home and you know that the rate and terms you have been offered will work for you, let your mortgage pro know so that she can lock your interest rate as soon as it makes sense. (Mortgage pros often also will let you know if some economic news that has just come out will lower rates in the next few days; this does actually happen on occasion.)

The list of closing costs contained in your good faith estimate is also just an estimate. Ask your mortgage broker to let you know what your maximum exposure is on closing costs, or at least to point out line items within the estimated closing costs that could fluctuate from what the quote, and to explain why.

Insight

COMPARING APPLES AND APPLES USING YOUR GOOD FAITH ESTIMATE

If you are comparing mortgage loans offered by more than one professional, do not make any decisions until you have seen good faith estimates for all the different quotes. You are comparing apples and oranges until you can put the good faith estimates, including all the terms and associated costs, side-by-side to make a decision. A million times, I have heard a buyer shortly before close of escrow say they wanted to change mortgage brokers because this other guy says he can beat the currently quoted rate. When they get the good faith estimate, they realize that the other guy didn't mention that it would cost two points—thousands of dollars—to get the "better" rate, and that without those two points, the rate he can offer is actually higher than the one they already had! If you work with a mortgage pro you met via referral from your Realtor®, you drastically diminish your chances of falling victim to the old switch-a-roo, but if you have to compare more than one mortgage quote, at least do it with all the facts—ask everyone for good faith estimates before you move forward.

Ask your Realtor to review your good faith estimate. She wrote the contract, including checking all the who-pays-what boxes, and can be a good second set of eyes to make sure no line items were left out.

HOA Dues

When you purchase a home that is located in a condominium development or a PUD, you almost always take on the obligation to pay Homeowners' Association dues on a monthly or annual basis. Most detached homes in a PUD have very low HOA dues, relative to the mortgage payment—some as low as $50 per year—that simply pay for your share of the community's insurance on the pool or clubhouse, landscaping the community park, and that sort of thing.

In condo and co-op housing, the HOA dues are likely to be as much as 10 to 15 percent plus of your monthly mortgage payment. These dues pay for common area maintenance. and

Insider Secret

THE MOST PREDICTABLY UNPREDICTABLE CLOSING COST

At close of escrow, you are required to pre-pay your mortgage interest for every day remaining in that month. So, if your home purchase closes on the 15th of the month, you'll pre-pay 15 days of interest. If it closes on the 1st, you'll pay a full month's worth of interest. For most people, a month's worth of interest is approximately the same as a month's mortgage payment! Here's where people get into trouble. If your contract calls for escrow to close on Thursday, August 30th, your mortgage broker will calculate only two or three days worth of prepaid interest into your estimated closing costs. Well, things run a little late, and instead of the mortgage funding on Thursday, it funds on Friday. But the county offices aren't open Saturday or Sunday, and Monday is Labor Day, so the earliest your escrow officer can get your deed recorded and close the deal is actually Tuesday, the 5th of September.

The $300 you were supposed to prepay in interest has just turned into a $2,900 line item closing cost that you must come up with before closing. You can prevent this sort of thing from creating drama by:

- Setting close of escrow for the middle of the week, so that the weekend doesn't stop you from closing escrow;

- Not planning to close escrow on the very last day of the month – allow a little room for error(!);

- Getting continuous status reports from your mortgage broker throughout your escrow; and

- Making sure you have some cushion, some cash leeway in case your closing costs do exceed estimates.

landscaping, but may also pay for the maintenance of your building's roof and exterior walls; fire and hazard insurance on your building; water, gas, garbage collection service; and other items which owners of detached single family residences are required to cover on their own. In some buildings, your HOA fees may even cover cable and DSL service, security systems or personnel and other perks offered by the complex or building.

The existence and amount of HOA dues will virtually always appear in the MLS listing and/or on the property flyer. In virtually every state, the seller is required to disclose the amount of HOA dues and the items included therein within a week of the day you go into contract. If you know you're going to be looking for a condo or townhouse or for a newer home in a planned subdivision, you should make the questions "How much are the HOA dues?" and "What do they cover?" part of your script for each and every property you look at. Then incorporate the answers into your spending plan for after you get into the property.

County, City, & Special Property Taxes

If you're a lifelong renter, you're probably most familiar with governmental taxation in the form of sales taxes and income taxes. Well, go figure, when you own real estate (a.k.a. real property), the state and/or county and/or city within which your property is located have the power to tax your property, and they often exercise that power in the form of imposing property taxes.

There is a set tax rate in your county, called an ad valorem tax, which is an annual tax in the amount of a percentage of the market value of each home in the county. When you buy your home, the escrow company provides your county government with information about the sale, including the sales price. Most counties consider the price you paid to be the fair market value of your home, and apply the ad valorem tax rate to that price to determine your annual property taxes. So, for example, if the ad valorem tax rate is 1 percent per year, and you paid $500,000 for your home, then the annual property tax on your home will be $5,000 for the first year you own your home.

In many states, cities or even neighborhoods within a city can have various add-on taxes or assessments in addition to the county ad valorem tax, that pay for local improvements such as school enhancements, street lights, sewer improvements, or sidewalk construction. Some newer PUD-type subdivisions may also have special taxes for the additional fire or police services the subdivision requires of the city or county. Sometimes these special taxes or special assessments are flat-rate taxes (e.g., $1,500 per house per year), and sometimes they are determined by a percentage of the fair market value (e.g., .001 percent of the assessed value of the home). Special taxes or special assessments are often collected by the county tax collector along with the ad valorem tax.

Many county tax assessors have put their records online; you can often go to your county's website, click on the link for the department of the tax assessor an enter an address or parcel number to find out the precise annual tax rate and any special taxes or assessments that are applicable to that address. Your Realtor can assist you in creating a projected tax rate for purposes of your spending plan before you find your home; after you have a specific address, your Realtor, your mortgage professional and/or your escrow officer can all help you determine the precise property tax obligations you'll have once your own the home.

Also, you'll need to either (a) decide to allow your mortgage company to collect a prorated monthly installment toward your annual property taxes in an impound account (see Impound Accounts, below) and pay them to the County on your behalf, or (b) learn how they are billed and collected, and how often they are due in your area. Most county tax collectors bill property

owners once annually for their property taxes (usually months before they are due), and collect them in two equal installments six months apart. There is usually a month or so grace period between the "due by" date and the "late after" date (the date on which late fees are added to the bill). These bills and due dates are always on a set schedule that has existed since time eternal, making these very predictable bills that are easy to anticipate and budget for. For example, in California, property tax bills go out in mid-July, and are paid in two installments due on November 1st and February 1st, each of which is late after December 10th and April 10th, respectively. In Texas, however, bills go out and are due in October and November, are late on February 1st, and are considered seriously delinquent in July. Again, your county website or your transaction professionals can help you find the specific billing dates, due dates, and late by dates for real property taxes in your county.

The best thing about property taxes? They are fully deductible on your federal tax return. Another way in which Uncle Sam "encourages" home ownership by taking some of the sting out of the expenses involved.

Homeowner's Insurance

We won't here go into the details of the different types of homeowners' insurance, and the various items it covers. We'll save that for Chapter 8. It is important, though, to include this as a line item in your monthly spending plan as a home-related expense. Fortunately, homeowner's insurance is very inexpensive compared to all the other expenses of homeownership. As a very rough estimate, your homeowner's insurance policy will cost approximately 75 to 90 percent of your square footage every year—if your new home will be 1,500 square feet, then your homeowner's insurance policy will cost roughly 1,500 x .75 = $1,125 to $1,350 per year. Divide that by 12 months to get a monthly insurance cost of $93.75 to $112.50. The actual expense could range far below or above this estimate, depending on the level, type and amount of coverage you select.

Make sure to get a quote from either (a) an insurance company referred by your Realtor or mortgage broker, or (b) the company which currently carries your auto or renter's insurance policy. You should actually get insurance policy quotes twice: first, before you start house hunting when you get a very rough estimate, and again when you are in contract to actually start the process of obtaining coverage. Your lender will require that a policy meeting the lender's minimum coverage requirement is in place before escrow can close, so the sooner you start shopping the better.

Keep in mind that if you purchase a condominium or co-op, your unit's fire and hazard insurance is provided by the HOA and charged through your HOA dues. Still, you should obtain condo owner's insurance coverage to protect your personal property, among other things—this is extremely cheap to buy and, so, should not be a big unexpected expense.

Insurance policies are priced by the year, but may be paid either annually or monthly directly to your insurance company or through an escrow/impound account maintained by your mortgage company.

Impound Accounts

When I hear "impound," I visualize a truck towing some poor, frazzled soul's car behind it turning into the city impound yard, where a sweaty guy with a bad comb-over will hold it hostage for $300 a minute. If that's what comes to mind for you, too, it's time to rethink your concept of the word "impound." An impound account is an optional, automatic savings plan that makes it easier for you to pay your big annual expenses—namely, property taxes and insurance—in monthly installments, instead of large lump sums once or twice a year. Instead of you paying your property taxes to the County tax collector twice a year and your insurance to your insurance company, you can elect to have your mortgage company collect one month's worth of your annual taxes and insurance every month when you pay your mortgage payment. The mortgage company funnels these funds into an account called an "impound account" or an "escrow account"—the two terms refer to the same thing. Then, when your property taxes come due, the mortgage company pays them out of your escrow account—once or twice a year, whenever your tax collector requires. Your mortgage company also makes the payments on your homeowner's insurance.

This is an all or nothing set up—if you choose to "have impounds" (i.e., to have your mortgage company make these payments for you) then you must choose to have them collect monthly pro-rations for both property taxes and insurance—you can't pick one or the other.

Why choose to have impounds? Well, if you have a fixed income, if you know you will have a hard time (discipline-wise or financially) setting aside a monthly amount to go toward your annual property taxes, or if you know you would struggle to be able to pay your property taxes in twice-yearly installments—you are probably a good candidate for impounds.

Why not choose impounds? Obviously, impounds can increase your monthly payment by several hundred dollars or more, depending on the property tax rate and the assessed value of your home. Also, when you choose to have impounds at the beginning of your mortgage, your lender will take tack on anywhere from two to 14 months' worth of the monthly tax installments and an extra two months' worth of insurance installments onto your closing costs in order to

be sure they have sufficient funds to make a tax or insurance payment if it happens to become due before they have collected enough monthly installments from you. This can increase your closing costs by as much as 1 percent of the purchase price of your home, so if cash is tight at closing time, you might elect not to have impounds. (The calculation of how much your closing costs will increase if you choose to have impounds is very specific to your closing date, when taxes are due in your area, and whether taxes are collected annually or bi-annually—ask your escrow officer to estimate it for you after your offer is accepted by the seller.)

Also, buyers who have a large amount of discretionary income, or who can elect to work lots of overtime or otherwise increase their income sometimes choose not to have impounds knowing that they can work extra hours or divert their spending money to pay their tax bills twice a year, or however often they come due.

Keep in mind that you can choose to start an impound account at any point during the time you have the mortgage—you don't have to choose them at the beginning. Many buyers elect not to have them at first because cash flow is tight right when they get into the home, but then start an escrow account later on as they settle into the groove of homeownership. If you choose not to have impounds, consider setting up an automatic transfer from your checking account to a separate savings account you set up specifically to pay your taxes and insurance. At the very least, plan to save ahead for your property taxes so you don't run into problems paying them when they are due.

Extra Utilities & Costs

If you are a lifelong renter, you might forget that your landlord takes care of some monthly bills for you. Garbage collection and water are two costs that are usually taken care of by the landlord, not the tenant. Similarly, landscaping (e.g., fees to maintain the lawn and garden) is often provided by the landlord. Keep in mind that when you buy your own home, you will need to incorporate line items for landscaping, maintenance and garbage collection into your monthly budget, unless you are buying a property in an HOA or PUD that handles these things. If you are buying a new home, you may actually need to pay to have landscaping installed—most new homes come with a dirt lot for front and back yards unless and until you hire a landscaper.

Also, you should understand that when the sink leaks or the roof leaks or the water heater breaks, you are responsible to fix it, usually at some expense. If you can set a few bucks aside for a home improvement fund, you certainly should! To mitigate the potential cost of unexpected repairs, make sure that you have a home warranty in place before close of escrow; for a few hundred bucks a year, these folks will come out and fix many of the major malfunctions that

Insider Secret

WHAT A PITI

When you get mortgage quotes, you'll often see the monthly payment broken down as follows, using the acronym PITI (which people say in letters, P-I-T-I, not like the word "pity"):

P for Principal – the portion of your monthly payment that goes toward paying off the principal loan balance;

I for Interest – the portion that goes to pay interest charged by the lender;

T for Property Taxes – this is 1/12th of your annual property tax charged by the county; and

I for Homeowner's Insurance – again, a 1/12th fraction of your annual homeowner's insurance premium.

Things You Need to Know About Your PITI Mortgage Payment:

- If you have an interest-only loan, the payment quoted is only ITI;

- If you are not getting impounds, the minimum payment required on your monthly statement will not include T or the second I;

- You should go ahead and ask your mortgage professional to give you a PITI quote or an ITI quote (if you're getting an interest-only loan), even if you are not going to have impounds, because the T amount will be what you should save every month toward your property taxes, and the I amount will be the amount of your monthly insurance bill;

- After you do your spending plan and decide how much you can afford to spend monthly for housing, make sure you tell your mortgage professional whether or not your budget's max monthly housing payment includes taxes and insurance, so they can know to set your maximum purchase price accordingly. It should include taxes and insurance, unless you have generous parents or the ability to pay your tax bill from some source of funds other than those accounted for in your normal monthly budget;

- You should make sure you know whether the monthly payment you are being quoted is with or without taxes and insurance, and plan your budget accordingly. As with everything, if it isn't clear – ASK: "Does this payment include taxes and insurance?"

can happen in your home. New home builders often place their own warranties on their homes for as many as 10 years to protect buyers from defects in the construction or materials used in their new homes.

The One Pleasant Surprise

When you pay rent, you pay in advance—the payment you make at the beginning of January is for January's rent, and so forth. When you own a home, you pay in arrears, meaning that the payment you make in January is for the mortgage payment you incurred in December. Mortgage payments are always due on the 1st of every month, but not late until the 15th of the month.

But remember, when you close escrow, you actually pre-pay your mortgage interest from the date of closing through the end of that month. Then, because you pay in arrears, there is no payment due at all in the month after you close escrow. Your first mortgage payment is not late until the 15th of the following month. So, if you close escrow in April, your first payment is not due until June. If you close in November, your first payment won't be due until January – you always get to skip a month! You can count on this, so it may make it a little bit easier to find your closing cost money knowing that you won't have a rent or mortgage payment you have to make for at least 45 days—or more!—after closing.

Math, Money & Mortgage

The twin fears of math and money are inextricably intertwined with the topic of mortgages. Maybe that's what places mortgage at the pinnacle of fear-based drama in homebuying transactions. Well, maybe it's that, or maybe it's the fact that unless someone specifically sets out to teach it to you, you would probably never have any reason to know any of the mortgage stuff we've covered in Chapters 3 and 4—from jargon like indices and amortization to the alphabet soup acronyms of FICO, LTV and DTI, and COFI. It should make you nervous to put large sums of money or debt on the line without understanding what the heck everyone around you is talking about!

You probably don't feel like an expert on mortgages right now, and you don't need to be one. Remember, you're going to hire your own personal mortgage concierge to guide you through the process. What I hope you do feel is that (a) you understand the basic concepts at a fundamental level, (b) you know what questions might be important to ask the professional you do hire, and (c) you have a reference guide to come back to as you do your homework and select your mortgage.

I also hope that you've grown to appreciate the importance of the process that culminates in your choice of mortgage—you start by plugging hypothetical numbers into our mortgage calculators, you run your personal stats, do The Easy Work and The Quick Work, then hire someone to give you expert advice and do the ultimate matchmaking between you and your eventual lender. You will not be forced to make a rush decision, and even if you qualify for a less-than-fabulous mortgage, you can continue to trade up into higher grades of mortgage as you evolve your credit and other financial qualifications over time. That should take a lot of the pressure off.

Insider Secret

YOU HAVE CONNECTIONS IN THE MORTGAGE BIZ

No matter how many times you've read this chapter and other books, no matter how many charts and tips you read, situations always arise where you'll want to ask questions of someone you can trust. You have connections! Visit www.REthinkRealEstate.com, and Ask Tara, Ask the Expert, or check out the message boards and ask your fellow Savvy Women who are successful homebuyers and owners!

The stuff of this chapter is neither the sexiest nor the most fun subject involved in the homebuying process. Topics like amortization and the interest rate indices have rarely, if ever, been described as "juicy." Not exactly the most prime opportunity to experience freedom and fabulosity, right? Maybe, maybe not. Let's {RE}Think this. It's like my mother said when she came home from her 25th high school reunion: all the "cool" girls who never did their homework were morbidly obese, on their fifth marriages, and addicted to painkillers to anesthetize them from the reality of their lives; all the "nerdy" girls who had been in math club were Fortune 500 execs, thin-with-no-stretchmarks after four kids, world travelers, or otherwise living fabulous lives. The moral of the story was that homework may not seem fun when it's time to do it, but it is VERY necessary if the fabulous life is your end goal. That's also the moral of this chapter: if digging in your old handbags for change to come up with closing cost money the day before close of escrow is your idea of style, then don't do your homework. If your idea of being a fabulous homebuyer and home owner is to be calm, cool, collected and in control, then a little bit of mortgage-and-money homework will go a very long way..

Chapter 5

Creative Homebuying:
Best Practices When Buying Your Home With Your
Parents, Lovers, Friends & Associates—or Just
Getting Their Help to Buy on Your Own!

Once upon a time, favorable family relations were encouraged or, rather, enforced with the oft-heard adage that "you don't get to choose your family." That was way back before Oprah blessed us with the epiphany that, in fact, you can decide who does and doesn't get to be in your household and your life. That was also before we started marrying later, making more money, and experiencing singlehood several times in the average lady's lifetime through divorce and widowhood. We women are the ultimate connection brokers, and these sociological phenomena inspired us to pioneer the "chosen family," crafting our families out of the parents, siblings, friends, lovers, children (biologically ours or not), and even pets of our choice.

Though millions of women buy their homes on their own, many—single or not—approach the homebuying process as a co-operative endeavor with members of their biological family, their chosen family, or both. Increasingly, women have become more and more open to homebuying "teams" comprised of strangers—well, people who were strangers to one another before their interests (and the stars) became aligned. Buying your home with other people—or with their help—has emotional, financial, legal and lifestyle impacts which vary with the nature of the relationships and the intentions of everyone involved.

This chapter presents a quick guide to the creative ways people are buying homes with a little help from their parents, lovers, friends and even former strangers, and some basic strategies for handling these arrangements strategically to minimize your legal and financial risk. Then we'll explore the various types of homebuying assistance programs that are out there. As you read this chapter, keep in mind that:

All aspects of these creative homebuying arrangements are negotiable – Even though the most frequent ones are listed here, there are really almost an infinite number of creative arrangements possible – you can always tweak the details of the listed arrangements a little or a lot to meet the needs of the folks involved. To do this safely, though, you should consult a real estate attorney; it'll cost a few bucks, but will be much less expensive than the potential fallout from an improperly negotiated co-ownership or assistance arrangement;

Any of these arrangements can be done with anyone – The programs that are listed here as most often done between friends, for example, could just as easily be set up between mother and daughter or cousins. I've grouped the arrangements by the most common relationships between the homebuying 'team' members in hopes that it might create a spark of inspiration that your mom or your salsa lesson buddy Robin might be a good partner. Nothing prohibits you from teaming up to buy property—but do pay careful attention to the legal and logistical notes listed under the different arrangements; the implications of buying with a stranger and buying with your lover are very different.

If you've been planning on buying your home completely solo—bravo! I applaud you for stepping up and taking control. On the other hand, creative homebuying may be the answer for you if:

- You have been pre-approved for financing, but the payments are too high;

- You have been pre-approved for financing, but the purchase price you qualify for is too low to get the size, type or location of home you need;

- You have qualified for financing with a 5 percent, 10 percent or 20 percent down payment, but you don't have the cash to make the down payment;

- You already own a home, and want to move up, but you can't afford the higher payments;

- You don't mind compromising with other people on the type of home or financing you choose; and

- You don't mind living in fairly close contact with other people.

On to the nitty-gritty of the creative homebuying arrangements you can strike with the people in your life. Family first—let's explore the most common ways parents everywhere are assisting their progeny purchase homes, and the best practices for effecting such an arrangement.

Parents

They already gave you life—what else do you want from them? Well (as my kids so often remind me) you didn't ask to be born, so that whole gave-you-life thing shouldn't stop you from asking for help from your parents in the course of buying your home. The assistance you request could range from referrals to professionals all the way to cold, hard cash.

There are two particularly popular ways in which many parents are helping their Savvy Women offspring—married or not, Generation Y'ers to Boomers (and beyond!)—to purchase homes.

Legacy Homes

When it comes to real estate, the age-old nature vs. nurture battle is no contest—nurture wins every time. Buyers' tastes in homes are formed similarly to our tastes in foods: our childhood experiences and exposures have a huge formative impact. I once had a 45-year-old friend who hated corn flakes because she once got sick after eating them as a 6-year old (and hadn't eaten them since). Conversely, how many of us define "comfort food" as whatever our moms and grandmas baked up for us as kids? Similarly, some homebuyers hate the style of home in which they grew up, and want no part of any house that reminds them of that particular style in any way, shape or form. On the other extreme are folks who love their childhood home and seek to buy a dwelling as similar to that as possible.

Some particularly fortunate members of the loved-my-childhood-home set have made the most of the socioeconomic context of our times—parents downsizing into amenity-packed over-55 communities, high home prices, and low cash savings—(and their parents' generosity) via a lovely little trend called the Legacy Home.

The Legacy Home phenomenon is where parents sell their home to their child at a significant family discount or on other favorable terms. The extent of the discount is often relative to the real estate market in which the home is located and the value of the home—a friend of mine saved hundreds of thousands on her estate outside of San Francisco (which was her husband's childhood home) while a Midwestern Legacy Home might be passed on at a discount of $5,000 or $10,000, and still pose a significant benefit to the descendant/buyer. Some legacy homes

aren't discounted, but are sweetheart deals for other reasons. Perhaps, for example, the parents finance the property or some chunk of the purchase price (so you make payments to your parents, instead of the mortgage company and hopefully don't have to work as hard to qualify or pay as much interest).

In terms of the transaction, the sale of a legacy home is just like the sale of homes between strangers—the same contracts, same required disclosures, same escrow process, and the same financing issues apply. However, there can be dramatic tax advantages for either, or both, the parents and the progeny in a legacy home situation:

(1) *Tax Benefits for Parents* – Parents can get some relief from the capital gains taxes they would experience if they had sold the property at a higher price. Also, if the parents are over 55 and downsizing, some areas will allow them to transfer their old, lower tax base to their new property if certain requirements are met—allowing them to keep paying really low property taxes on their new home.

(2) *Tax Benefits for Kids* – Many counties will not reassess the property for property tax purposes when a parent sells to a child—this can mean that your ongoing property taxes are a fraction of what they would be on any other home you purchase for the same price. Even if parent-child transfers are not exempt from reassessment in your area, a discounted purchase price usually translates into a lower property tax rate simply by virtue of the lower price.

(3) *Tax Benefits for Both* – Many counties waive the transfer taxes which are due on sale when the sale is between parent and child—reducing the closing costs for both parent/seller and child/buyer.

Of course, a Legacy Home scenario simply doesn't work for everyone. For this type of setup to make sense for every party involved, some or all of the following factors should exist:

o Parents want to move, preferably downsizing to a home of a lower value than the prospective Legacy Home;

o Parents have a very low amount of debt on the property relative to the equity they have in it (low loan-to-value ratio), or own it outright;

o Parents are financially solvent or thriving, or will be after they sell the Legacy Home and purchase their next home;

- The Legacy Home meets most or all of the needs of the child—or is bigger and better than the home they would otherwise have purchased;

- The geographic jurisdictions involved offer some or all of the tax benefits described above.

From an emotional perspective, the Legacy Home scenario works out best when it's a win-win for both parent(s) and child—and when both the parent(s) and the child are aware of how much they each stand to benefit from the situation. From the parent's perspective, the biggest benefit is probably the "legacy" part of the equation—the feeling of knowing that they have contributed on a lasting, lifelong basis to the creation of family wealth that could potentially last in their family for generations. Now, that's a win, if you ask me!

Gift Money

When I Googled the phrase "the gift that keeps on giving," I got results ranging from fruitcake to sperm to John Kerry to depleted uranium. The only answer I didn't see was gift money for a down payment or closing costs on a home—a gift that truly does keep on giving. This is, of course, my opinion, and may represent a subconscious bias from my own family values. When I announced to my dad that I was planning to get married the second time (just as I was in the midst of buying a home), he graciously offered to write me a nice sized check as a gift. Then he deadpanned, "And if you spend that on a wedding, that'll be the last check I ever write you." Dad-speak translation: Use that money towards your house if you know what's good for you. So I did. And that gift has kept on giving in terms of equity that I was able to parlay into all the properties I've bought since, as well as my business ventures. It was a foundational building block for my lifestyle and my net worth.

> *How To Get It* – From one daughter to another, you know best how to ask for things from your parents. However, it is critical that your parents (a) have it, and (b) can afford to give it to you without struggle. I suggest that if you are approaching an occasion that is often accompanied by a big gift (e.g., college or grad school graduation, wedding, baby's birth, etc.), and if you are asked what you want for a gift—take advantage of the opportunity to express that what you really, really want is a cash gift that would help get you into a home.
>
> *How to Use It* – **There are about three different ways you can use gift money in the course of your homebuying adventure:**

- *Closing Costs* – You can use the money toward your closing costs—maybe making you able to pick your property instead of having to limit yourself to properties whose sellers will provide closing cost credits;

- *Down Payment* – You can use the money toward your down payment, allowing you to either:

 → Buy the same sort of home that you would have bought without the gift, but have a lower monthly payment;

 → Buy a more expensive house (more bedrooms, more square feet, nicer condition or better neighborhood); or

 → Buy a home – period—when you otherwise wouldn't qualify for or be able to afford the monthly payment on a 100 percent financed, entry level home in your area.

- *Cash Cushion/Reserves* – You can simply put the cash in the bank and apply it to the ongoing expenses of homeownership, including property taxes, insurance, repairs, the garbage collection bill, your Pottery Barn tab (!), etc.

How to Avoid Problems with Gift Money

"Problems with gift money" sounds like an oxymoron, doesn't it? The deal is that lenders actually place guidelines on how you can use gift money in your transaction, and running afoul of those guidelines can really cause problems when it's time for your transaction to close.

- You will need to produce a "gift letter" from your parents (or whoever is giving you the money) to the effect that the cash gift does not have to be repaid. Let your mortgage broker or consultant draft the letter to your lender's specifications;

- If you are using your gift money to make a full 20 percent down payment on your home—you're good. No further strategy necessary;

- If you are using gift money for down payment purposes, and are making less than the full 20 percent down payment, many lenders will want you to match the gift money with money of your own. So, if your parents are giving you 5 percent, the lender will want to see an additional 5 percent in down payment that comes from your personal accounts. If the gift money is all the down payment money you have, or you don't have enough money of your own to match it, you need to season the gift money and make it your own. If the gift money is in your personal bank accounts for at least two months prior to the time you go into contract on your home, then it is no longer considered gift money and you can use it toward your transaction as you please, without any "gift money" limitations, and without even using a gift letter!

Co-Ownership: Buying with Lovers, Friends or Associates

For the first years of our lives, no one loves us more than our parents—and most often, that feeling is mutual. As we grow older, our parents may remain our biggest fans, but we develop many other relationships—with our romantic interests, our friends, and even sometimes with strangers who have similar or complementary needs to ours. Many Savvy Women choose to purchase and own homes with their lovers, friends and associates, and there are special considerations and cautions that apply to these co-ownership arrangements.

There are only a few legal relationships possible between two or more people who co-own real property. These relationships are known collectively as methods of "taking title." The various methods of taking title each represent a set of answers to a set of basic questions, including (but not always limited to):

- What happens to the property if one owner dies?
- Can one owner sell their interest without the whole property being sold, and what happens if he or she does?
- Do the owners possess equal or unequal ownership interests in the property?

Methods of Taking Title

When you purchase a home by yourself, there are only three possible ways to take title—and they are pretty much dictated by your life situation:

- Beatrix Buyer, a single woman (if Beatrix has never been legally married);
- Beatrix Buyer, an unmarried woman (if Beatrix was previously married); or
- Beatrix Buyer, a married woman as her sole and separate property (if Beatrix wants to take title in her name and her name alone. Note—In order to do this, the title company will require Mr. Buyer, Beatrix's hubby, to sign a document giving up any and all rights and interest in the property.).

When you purchase a property with others, the escrow company will ask you to choose how you would like to "take title" or "hold title," or how you want title to "vest." They are looking for the legal description of your relationship to each other as co-owners of the property. Literally, the deed they record at the county office to create a public record might read:

- Beatrix Buyer, a single woman, and Christina Co-Buyer, a single woman, <u>as Tenants in Common</u>; or
- Beatrix Buyer and Christopher Co-Buyer, <u>husband and wife, as Community Property</u>; or

- Beatrix Buyer and Christina Co-Buyer, as <u>Domestic Partners, as Joint Tenants with the Right of Survivorship;</u>

whatever you tell them to use to fill in the blank.

Insider Secret

DO GOOD DEEDS

A deed—or title—is a living, evolving document. Marriage, divorce, refinancing, having children—any or all of these life events can affect the way you want to hold title. For example, if you hold title with your buddy as Joint Tenants with the right of survivorship, but then have or adopt a child, you might want to break the joint tenancy so that you can bequeath your interest in the property to your child, if you should pass away. Or if you own a home with your love interest as Tenants in Common, then you two get married, you might consider revising the deed into your names as Community Property.

Let's look at the basic characteristics of the various relationships possible between co-owners.

Tenancy in Common (a.k.a. "TIC")

- The deed would read: Beatrix Buyer and Christina Co-Buyer, as <u>Tenants in Common;</u>

- Owners can be married, unmarried, or a combination (e.g., a married couple and an unmarried friend can all be co-owners);

- Owners can own fractional and unequal interests (e.g., Beatrix Buyer, a single woman, owns an undivided 2/3 interest and Christina Co-Buyer, an unmarried woman, owns an undivided 1/3 interest);

- Owners are entitled to income from the property and are obligated to pay expenses from the property proportionate to their ownership share;

- Ownership interests can be created at different times and can last for different lengths of time;

- Each owner can sell, lease or will to her heir(s) the share of the property which belongs to her—with or without the consent of her co-owners.

Joint Tenancy

- The deed would read: Beatrix Buyer and Christopher Co-Buyer, as <u>Joint Tenants;</u>

- Owners can be married, unmarried, or a combination;

- All owners own equal interests (e.g., 50 percent interests for two owners, 33 1/3 percent interests for three owners, etc.);

- Right of survivorship—if one owner dies, his or her interest automatically goes to the surviving owners in equal shares—you can't will your ownership interest to someone else;

- Ownership interests must have been acquired at the same time;

- If any owner transfers his or her ownership interest, the Joint Tenancy is destroyed and the person replacing that owner takes title as Tenants in Common with the remaining owners;

- In non-community property states, married couples can hold title as Tenants by the Entireties—identical to Joint Tenancy except that neither spouse can sell his or her interest separately from the other.

Community Property

- The deed would read: Beatrix Buyer and Christopher Co-Buyer, as <u>Husband and Wife, as Community Property;</u>

- Only applicable in community property states;

- Owners must be a married couple who intend to own the property together;

- Ownership is 50/50;

- Ownership interests cannot be sold separately; both parties must agree in order to sell property;

- An owner can will 1/2 of his or her share to their heirs, the surviving spouse keeps the other half;

- In some states, owners can elect to take title as Community Property with Right of Survivorship, meaning that when one owner dies, his or her interest automatically passes to the surviving spouse, without a will, court or taxation.

Methods of Taking Title in Joint Ownership

	TENANCY IN COMMON (A.K.A. TIC)	JOINT TENANCY	COMMUNITY PROPERTY
Who can be co-owners?	Any number of people, including a married couple.	Any number of people, including a married couple.	Only husband and wife.
How can ownership be divided?	Ownership can be divided into any number of interests and any fractions of ownership.	Ownership interests must be equal.	Ownership interests are equal.
How many "titles" are there?	Each owner has a separate legal title to their interest.	Only one title exists to the whole property.	Title is held by the "community" – separate interests but unified management.
Who has the right to possess the property?	All owners have equal right of possession.	All owners have equal right of possession.	All owners have equal right of possession.
How do owners sell or transfer interest in the property?	Any owner can sell their interest separately, without co-owners' consent.	Any owner can sell their interest separately, but such a sale breaks the Joint Tenancy & owners then become Tenants in Common.	Both owners must consent to sell or transfer of property – interests cannot be sold separately.
If an owner sells their interest, what is the ownership status of the person who buys it?	New owner is Tenant in Common with other owners.	New owner is Tenant in Common with other owners.	New owner can only buy the entire title of the community.
What happens if a co-owner dies?	The deceased owner's interest passes to her heirs.	The deceased owner's interest ends, and the surviving owner(s) automatically own the property via survivorship.	½ of the deceased owner's interest goes to the surviving owner – the other ½ goes to the deceased owner's heirs (which may or may not include the other spouse).
If a co-owner dies, what is the ownership status of the person who obtains their ownership interest?	Tenants in Common with the other owner(s).	If only two original owners, the survivor owns the property as the sole owner. If more than two original owners, the surviving Joint Tenants become Tenants in Common with each other.	Survivor and heir(s) become Tenants in Common. If survivor is heir, survivor owns the entire property as the sole owner.
Can the property be sold by a creditor of one co-owner?	The debtor/owner's interest may be sold (with a court order) to satisfy a debt, and the creditor becomes a Tenant in Common with the other owner(s).	The debtor/owner's interest may be sold (with a court order) to satisfy a debt. The sale breaks the Joint Tenancy, and the creditor becomes a Tenant in Common with the other owner(s).	Individual spouses' interests cannot be sold separately, but the entire property may be sold (with a court order) to satisfy the debts of either husband or wife.

Insider Secret

MONEY PARTNERS

Homes purchased under any of the above forms of joint ownership must almost always be bought using a single mortgage, with the co-owners as co-borrowers. If one or more buyer(s) cannot qualify for the mortgage, it is possible for less than all of the buyers to take out the mortgage and simply put the non-borrowing owner on title. However, this means that if the person not on the mortgage fails to pay their share, the mortgage lender is coming after only the owners whose names are on the mortgage.

A Note About TICs

The Tenancy in Common (TIC) form of ownership is used by co-owners to structure a mutually agreeable co-owner relationship outside of the few legal default co-ownership structures. There are very few TIC characteristics which are mandated by law. Rather, the TIC owners are able to negotiate and craft agreements on all the various issues of co-ownership to reflect their mutual intentions. Increasingly, TICs are used by friends and even strangers to buy a multi-unit property, where each co-owner will have the right to exclusively use a particular space or unit within the property (e.g. a duplex where you own and live in Unit A and your best friend owns and lives in Unit B). Because the TIC format can be used across such a wide range of situations and relationships to fashion a custom co-ownership, the legal description of your Tenancy in Common contained in the deed to your property is just the tip of the iceberg involved in documenting your TIC.

If you choose to own a property in a TIC, you and your co-owners are effectively taking on a mini business enterprise—the business of maintaining and owning a property. Accordingly, you will all need to enter into a contract called a TIC Agreement. This is a written contract (prepared by real estate attorneys for a fee ranging from $1,000 to about $3,000) which should document the co-owners' agreements on the following issues, at the very least:

- Which parts of the property will be used and maintained by individual owners, and which will be common or group areas;

- Each owner's financial obligations, including earnest money deposits, down payment, impound accounts (if any), reserve accounts for major repairs or improvements (if any), maintenance of the common areas, mortgage payments, taxes, utilities, and other expenses;

- How each owner's monthly payment will be determined (a formula), and how the property will be managed, including all bills, income (if any), annual accounting, and ongoing maintenance and clean-up;

- Usage rules and how they will be enforced (including rules regarding pets, parking, noise, etc.);

- Rules governing meetings and decision-making by the co-owners;

- Definition of when an owner has defaulted on the TIC Agreement, and consequences of default/remedies for non-defaulting co-owners;

- Insurance, logistics, and policies to be activated when an owner dies or is declared bankrupt;

- The sale of interests in the TIC, including any rights of first refusal and provisions for the non-selling co-owners to approve of prospective purchasers; and

- How disputes between co-owners will be resolved.

At first glance, none of this seems too controversial. However, in the process of putting pen to paper, disputes often emerge. It is critical to have the hard discussions and resolve all the above-listed issues in advance—if you just can't, or you simply reach an unresolvable impasse, reconsider whether you should be in a TIC with that individual. Part of the benefit of the TIC agreement lies in its nature as an excercise in group problem resolution and decision making! While the stakes are low, it reveals who you can and cannot live—and own—with.

In the best TICs, you won't ever even have to pull the TIC agreement out of the safe deposit box. If a problem or dispute arises over the course of your co-ownership, don't automatically start waving the paperwork around and yelling, "I have it in writing!" Instead, discuss the issue and try to sort out an informal resolution. All the while, every owner involved will know that the Agreement is there and will govern just in case you can't resolve the problem informally. I guarantee you—a well-drafted TIC agreement is a long-term drama avoidance tool. So don't skimp and try to DIY; find a good attorney who will draft it for a flat fee and rest assured that your interests have been documented.

It's Not Just How You Own, It's With Whom You Own

While there are some small variances state-to-state in the specifics of each form of ownership, these characteristics will apply by and large pretty much wherever you are. As you might guess, the legalities and logistics critical to a smooth co-ownership experience vary widely depending on the nature of your interpersonal relationship with your co-owners. The questions you need to ask—and answer—before you purchase the home will vary depending on whether you are buying with your lover, your friend(s), or your associate(s).

Lovers

Boyfriends, girlfriends, husbands, fiancés, life partners—whatever you call yours, they are the most likely people to be your homebuying partners. There are some general considerations that apply when you buy a home with your sweet baboo, regardless of whether you are married, engaged, domestic partners, or otherwise.

If you choose to go into a co-ownership arrangement, approach your house hunt knowing that you will need to make some compromises, and that your Vision of Home will be a shared one. You should start your discussions with your partner by ascertaining his or her Vision of Home and trying to detect where your visions are aligned and where they are not, as well as figuring out what areas are non-negotiable for each of you (if any), and which ones you feel less strongly about. From this exercise you should be able to get a feel for how smooth the house hunt is going to be. Don't be scared—about eight times out of 10, one of you will care strongly

Insider Secret

THE "RESTROOM" CONVERSATION

As a high-touch Realtor in the high-end Bay Area real estate market, I developed a super-sophisticated client needs assessment technique called The Restroom Conversation. (I say this TIC, which in this case stands for Tongue-In-Cheek rather than Tenants in Common!) I'd sit in the conference room with my married clients and interview them on what they both wanted. Six times out of 10, the guy of the couple would say he was specifically interested in a fixer. As soon as I heard the word "fixer," my eyes would dart over to catch the expression on his wife or girlfriend's face. Sometimes, I'd see agreement, sometimes neutrality, sometimes dismay, but often incredulity or even terror. Depending on the expression, as soon as the guy stepped out to go to the restroom, I'd ask her nonchalantly, "So, what do you think about the idea of buying a fixer?" At least 50 percent of the time, she'd blurt out "Please do not show us fixers. He will never finish the projects and we'll be living in a half-done house for the next five years." So, I'd show them lots of houses that needed some paint, or maybe some carpet, but would try hard not to show them houses that required multiple, long-term projects. And I would always try to at least throw in one or two homes in move-in condition, just to expose him to the other side of the fence – it's amazing how compelling Pottery Barn accents, custom color schemes, refinished hardwood floors, and the "vortex of cuteness" (in the words of a favorite client) can be, even to the most die hard DIY-er. Compromise achieved. Almost always.

The moral of this story is that when you are buying with someone else, it is wise to develop an open line of communication directly with your Realtor – outside of the discussions you have in the presence of your co-buyer(s). Your Realtor may have some effective strategies or suggestions for how to resolve your differences.

about different things than the other does, so that one property can satisfy both of your needs. For example, you might prioritize a certain neighborhood, while your partner's most pressing desire is a three-car garage.

There may be one or two bones of contention—price, condition (e.g. fixer or not), and house style tend to be areas where partners conflict the most frequently. Even these are surmountable. What is important is that you both detect and resolve as many of these issues as possible before you meet with your Realtor so that you can present as united a front as possible. You may have a negotiation that looks like:

You Get:
Neighborhood
Room for a home office
Victorian or Tudor

You Give Up:
Insistence on move-in condition
Big, open backyard

Your Partner Gets:
3 car garage
Backyard workshop or studio
RV Parking
Cosmetic Fixer

Your Partner Gives Up:
Choice of neighborhood
Major Fixer

If your Realtor only ever hears a bunch of wants and needs that are diametrically opposed, they may end up showing you "compromise" properties which you both hate! If you can resolve almost all of your differences, and present your Realtor with just a couple of conflicting needs, then he or she can show you some houses that meet your wants and some others that meet your partners'. Your negotiation on the last few points of contention will be much easier with brick-and-mortar options before you. And your Realtor will then be able to weigh in on whether either of your preferences will impact resale, property maintenance or long-term appreciation to help you make your final decision.

The Questions You Need to Ask

From here on, most of the process of putting the appropriate legal and logistical structure into place around your co-buying process is simply a matter of asking the right questions, getting the answers, and making decisions based on those answers. The questions you need to ask in your specific situation will depend on the type of relationship you already have with your co-buyer.

Married

Are you legally married?

Or are you *common-law* husband and wife or domestic partners?

If the latter, go to the question list for unmarried lovers, unless you get legal advice that says that your state's marital property laws apply to you.

Do you plan to own the home together?

Do you plan to live in it together? Would you prefer for just one of you to own the home?

Some bi-coastal couples, for example, elect to each own one home separately. Couples who keep their finances separate, where one partner alone will be paying for the home, also sometimes decide to own the home separately.

In order to effect a separate ownership even though you are married, the owner spouse must (a) take title in his or her name alone, (b) make sure the deed specifies that she or he is married and that the property is separate property, and (c) have the non-owner spouse execute a quitclaim grant deed, which expressly waives all legal rights or claims to the property. Your title company can help you execute your intention to own a home as your sole property, even if you are married.

If you want to own the property together (as do the vast majority of married couples), you will elect to hold title as a married couple as either Community Property, Joint Tenancy, or Tenancy in Common. The overwhelming majority of married couples elect Community Property or Joint Tenancy, depending on whether or not they live in a community property state.

Do you live in a community property state?

Just say yes if you reside in Arizona, California, Idaho, Louisiana, Nevada, New Mexico, Texas, Washington and Wisconsin. In addition, Puerto Rico is a community property jurisdiction, and married couples in Alaska can elect to be treated under community property rules.

If you do live in a community property state and you want anything other than:

(a) 50/50 ownership;

and

(b) 50/50 split of the value of the home if you break up – no matter how much or how little you each contributed financially during your marriage, then you will have to own your home as Joint Tenants or Tenants in Common.

Insider Secret

LOVE THE ONE YOU'RE WITH?

Buying a single family home in a TIC with your lover can be treacherous. If you break up, you could end up living with a stranger, if you're not careful in negotiating the terms of your TIC agreement. Make sure you obtain the right to (a) have a first shot at buying your love's share yourself, or (b) screen and approve of anyone who buys their interest.

If you don't live in a community property state, you may elect to hold your home as Joint Tenants or as Tenants in Common. In some states, when a married couple elects to take title to their "marital home" (i.e., the home they will live in together during their marriage) as Joint Tenants, it is called a Tenancy by the Entireties. If you intend to own your home 50/50 with your spouse and you choose a Tenancy by the Entireties, all the characteristics of a Joint Tenancy will apply except that neither spouse can sell their interest without the agreement of the other spouse.

What percentage of the property will you each own? 50/50? 60/40? Some other fractional arrangement?

If your answer is anything other than 50/50, you must select a TIC as your ownership choice.

What do you want to happen with the house if you break up? Who gets what?

If you want to split your home 50/50 if you break up, then your best bet is:

- Community Property (if you're in a community property state); or
- Either Joint Tenancy or Tenancy by the Entireties;

and

- A pre- or post-nuptial agreement expressing your agreement to split the house 50/50 in the event that you break up.

If you are not in a community property state, you are in an equitable division state, which simply means that even if you own your home 50/50 as Joint Tenants, a divorce court will look at all your marital assets and both of your financial contributions during the marriage, and distribute them equitably. Equitably means fairly, not equally. Holding your home as Joint Tenants or as a Tenancy by the Entireties creates a strong presumption that you intended to split it 50/50. However, the court will have the power to find that a 50/50 split is unfair, depending

on the circumstances of your marriage. So, the only way to be sure that the value of your home will be split equally should you divorce in an equitable division state is to have a simple agreement between the two spouses that states that you have agreed to split the value of your home 50/50 in the event you ever get divorced.

What do you want to happen with the house if one of you dies?

If you want your spouse to automatically receive it without having to go to court, elect:

- Community Property with the right of survivorship (if available in your state);

- Joint Tenancy with the right of survivorship; or

- Tenancy by the Entireties, with the right of survivorship.

In a community property state, if you don't specify the right of survivorship, each spouse is able to will their 50 percent interest in the home to whomever they want. Most often, this is the other spouse, but they could also give their interest to their parents, siblings, kids, dog, ferret, etc.

If you don't want your spouse to automatically receive the house if and when you pass away, you should own it as:

- Community Property without the right to survivorship (and have a will or other estate plan in place specifying the person or entity who should receive your interest in the home);

or

- Tenants in Common (and have a will or other estate plan in place specifying the person or entity who should receive your interest in the home).

Long story short—if you don't have an estate plan in place that expresses who you want to receive what when you pass away, the laws of most states would place your spouse as your next of kin, and he would receive your property (or a large chunk of it)—regardless of your selected legal form of title.

As soon as you have purchased your home, you should definitely meet with an estate planner and talk to her about owning your home in a living trust. This has about 75 million benefits (tax-wise, privacy-wise, and otherwise) and will allow your heirs to easily and seamlessly receive title to your property on your death. See the conclusion for more detail on the advantages of placing your home in a living trust.

Not Married

If you aren't married, but are buying a home with your partner, your choices are dramatically simplified, because you don't have that legal entry of the marriage to contend with. You pretty much have only two choices: Joint Tenancy or Tenancy in Common.

Your decision as to whether to own your home in Joint Tenancy or as Tenants in Common will depend, in large part, on your answers to the following two questions:

What do you want to happen to the property if one of you dies? If you want the surviving owner to automatically own the deceased owner's share, without any other estate planning documents or any court proceedings, then you should hold the property as Joint Tenants. If you want to be able to pass on your ownership share in the property—or any part of it—to anyone other than your co-owner, then you need to own the property as Tenants in Common.

Note – even if you own the property as Tenants in Common for some other reason, you can always have a will or, preferably, a trust drawn up so that your partner inherits your share of the property. But under these default rules, Joint Tenancy is the only form of joint ownership where an unmarried joint owner will automatically be given the deceased owner's interest when he or she passes away.

What percentage of ownership will each owner have? 50/50? 60/40? Some other percentage? If your answer is anything other than 50/50, you must own the property as Tenants in Common.

If You Plan To Get Married – If you plan to get married prior to buying your home together, then read the above section on buying with your spouse. If you plan to get married after you buy a home together, understand that the legal nature of your co-ownership may change by operation of law, automatically, when you get married. If, for example, you own the property together as Joint Tenants or as Tenants in Common, and you live in a community property state, the home (and its increase in value during your marriage) might convert automatically into community property as of your wedding day. This is especially the case in situations where the post-marriage mortgage payments are made with community property funds (i.e., monies earned during the marriage). Even if you own the property as TIC or Joint Tenancy in an equitable

distribution state, the nature of the property might convert upon your marriage. The upshot? If you want to keep your property and your assets separate in any way after you get married, you need to obtain a pre-nuptial agreement to that effect. See Chapter 9 for more details on how to know when you should consider a pre-nup.

A Word about Domestic Partnerships – Many jurisdictions have enacted Domestic Partnership laws, which allow same-sex and heterosexual couples to register with the city or state and obtain an official, legal status as a couple, without being married. Often, corporate employers' health benefits and the so-called "widow's benefits" offered by governmental employers are on the list of items made available to domestic partners which would not otherwise be available to members of an unmarried couple. Be on notice that domestic partnership registration has very little or no impact on the legal title you take to real property. In some states, the local tax benefits of marriage are now being extended to registered domestic partners, but it will still be many moons—if ever—before domestic partnership is universally considered legally identical to marriage.

If you are in a domestic partnership and would like to create a 50/50 co-ownership situation as similar as possible to a marital one, consider Joint Tenancy with the right of survivorship, which will at least prevent your partner from having to go through court or other legal proceedings to become 100 percent owner after you pass away. Whether you end up choosing Joint Tenancy or Tenancy in Common, consult an attorney to craft an co-ownership agreement and an estate plan to effect your wishes and to protect your interests and effect your intentions (and the interests and intentions of your partner) in the event anything should happen to either of you, or should the relationship dissolve.

Friends

In my experience, there are basically two different factual scenarios into which women co-buying with friends can be categorized: "The Compound Fantasy" and the "Two Purses Are Better than One Reality."

> *The Compound Fantasy –* In my set of gal pals, there's this discussion that almost inevitably comes up whenever any of us has a major annoyance or problem in our relationship. I call it "The Compound Fantasy." And it goes a little something like this:

Beatrix (into her Bluetooth headset while she's on the elliptical trainer):
I'm so sick of him! I swear, we need two master bedroom suites so I can have my own room. He leaves these nasty little hairs in the sink, his sweaty gym clothes on the floor, and the empty dog food cans on the kitchen counter.

Elle (into her own Bluetooth while she types away at the office):
You are preaching to the choir, sister. This is exactly why I'm still single. Oh. My. Goodness. Wouldn't it be awesome if you, Lucy and I all chipped in and bought one big house?!?!? We could all live there, all pitch in to the mortgage payment and the chores, we could take turns cooking, drive each other's kids around—just help each other out. It'd be, like, a compound.

Beatrix: *Yeah, a compound...*
(Fade to black as Beatrix and Elle both smile and stare dreamily into space.)

For my pals and me, this fantasy is simply that—an exaggerated case of "grass is greener" thinking. But single moms and single businesswomen everywhere are deciding to convert this fantasy into reality, by buying homes and living with other women who have similar lifestyle dilemmas and needs, as well as complementary financial and other resources.

The Two Purses Are Better Than One Reality – This scenario is just what it sounds like. Two (or more) friends start casually looking—each on her own—for homes in their area, maybe get pre-approved and visit some Open Houses. They leave the Open Houses in a state of clinical depression at the sort of home they can afford to buy on their own. They see each other and over the course of the conversation it comes up that they both would love to buy a home, but really can't seem to afford anything that resembles their idea of a real home. The light bulb comes on, and they realize that perhaps together they could afford big house or a duplex, and each live in one unit. They combine the prices for which they are pre-approved, go check out some Open Houses and realize that the individual units of the duplexes they can afford together are way nicer than the single family homes or condos they could each afford on their own. So they decide to buy a two- or three-family home together!

Questions You Need to Ask

Both of these scenarios sound awesome in the conception, but can be tough in the execution. Many women are bringing these co-ownership-with-friends scenarios to life—successfully— but it takes some work. Buying a home with a friend is different than buying a home with a lover in that:

- You might not necessarily want to live in same living space with each other,

- You probably haven't had to make any major decisions of this magnitude (like getting married or having children) together before now, and

○ **You are not as likely to have the same tastes and habits as you are with someone who already lives with you.**

These differences will drive most of the questions you need to ask before deciding to purchase a home with a friend (or friends):

What is your Vision of Home? – Ask anyone you're considering teaming up with for a house purchase to complete the Vision of Home exercise from Chapter 1 and the Wants & Needs Checklist from Chapter 6, then discuss the differences and similarities between theirs and yours. Especially discuss what you want your living space to be like, physically speaking—everything from location, to the type of building, to the architectural style, to cute/old/charming vs. cool/new/modern. EVERYTHING. And make sure you know each other's must-haves and deal-breakers.

Will you be sharing a single family home or buying a multi-family home? Said differently, will you be living together or will you each get your own unit?—Are you really committed to making a roommate-type relationship work over a long-term period of time, or do you each want your own private residence (complete with your own kitchens, bathrooms, and front doors—which you can close and lock if you need to be alone!);

Do you prefer to make decisions slowly and deliberately after lots of investigation or do you prefer to trust your intuition and act when you "feel" it is right? – Nothing is more frustrating than for one person to be ready to buy the third or fourth property they see, when the other person has no intentions of buying anything until they've seen at least 40 or 50 properties. Get clear up front on how you both envision your house hunting process, so you are not unpleasantly surprised when you find the place of your dreams and your pal is not ready to buy, or when your buddy pressures you to buy a place way before you are ready. If you are a more intuitive buyer and your co-buyer is more deliberate, then you might want to have them do a lot of Open House looky-loo-ing before you go out and get serious about looking with your Realtor and vice versa. If you are a significantly slower decision maker than your friend, consider going out to lots of Open Houses to build up your comfort level with the commitment involved in actually buying before you, your co-buyer and your Realtor begin the formal house hunt.

Do you have a Realtor or mortgage lender? – If either of you has a Realtor or lender, you should calendar a meeting with all buyers and all professionals to give every buyer a chance to meet and question the professionals, and choose with whom they would like to work.

Have you been pre-approved for a mortgage? If so, for what purchase price were

you pre-approved and on what terms? – The good faith estimate will show all this information. At the beginning stages of your discussion, you can roughly combine your approval amounts to get a general sense for (a) how much you can spend on your home together, and (b) what the monthly payment on that amount will be. Nine times out of ten, though, you will need to jointly qualify as co-borrowers on a single mortgage in order to purchase a property held in TIC or Joint Tenancy. You should do so as soon as possible to uncover and iron out any potential glitches before you get too deep into the house hunting process.

What is your career situation (i.e., stability, earnings, future plans, etc.)? – I know this seems strange, but you really do need and want to know where the money for your friend's share of the mortgage payments is going to come from, and how stable that source of funds is. You actually should find out how much she (or they) makes. I've literally had best friends get deep into the homebuying process prior to realizing that they each assumed the other made way more money than she actually did! This information empowers you to do a reality check on the amount for which you collectively have been pre-approved. It is impossible to plan to spend almost every cent of your income on mortgage—and it might raise a red (read: preventive) flag if you realize that your friend is planning to do so.

How to Hold Title When You Buy a Home with Your Friend(s)

For the most part, you'll want to take title as TIC when you own a home with one or more friends. (Your only other option is to own it as Joint Tenants, which would prevent you from bequeathing your ownership interests to your own children, family members, or other heirs. Remember that in Joint Tenancy, the surviving joint tenant automatically receives the interest of her co-owner when the co-owner passes away.) If you hope to maintain a long-term friendship or co-owner relationship with your buddy, you should take extra special care to negotiate a detailed TIC Agreement which addresses all of the issues discussed earlier. If you are buying a single family home with a friend and taking title as Tenants in Common, ask your attorney to pay special attention to the provisions for sale of an ownership interest—you definitely want the right of first refusal before your co-owner(s) can sell their interests and the right to approve of any prospective purchasers, so that you aren't forced to live with a stranger without any advance veto power. Talking out the tough issues up front, and evidencing your agreements in writing, can be essential to avoiding and resolving disputes years down the road.

Insider Secret

SURPRISE PREVENTION

If you are buying with someone else, make sure they don't have any tax liens, owe back child support, or have outstanding court judgments against them. Right before escrow closes, the title company will search to make sure there's nothing out there, because any of those things can be recorded as a lien against your home, impacting your lender's interest in the property. Your lender will refuse to fund your mortgage until they've all been paid off. If they are large debts, this can mean that you'll have to either (a) buy the place alone, or (b) figure out how to come up with a bunch of cash to pay them off before you can get into your house. Prevent surprises, and check with your co-buyer on these things before you get into escrow.

Associates

The old saying goes, "Politics makes for strange bedfellows." I submit that real estate makes for even stranger bedfellows than politics! And I'm being pretty literal here. The most common way Savvy Women end up living with strangers is via the popular, wealth-building strategy of buying a multi-family home and living in one unit while renting out the other(s). Over the last decade, the high price and rapid appreciation of housing has increasingly prompted complete strangers to get into bed (or at least into houses) with each others in two common, mutually beneficial co-ownership arrangements: the "Stranger" TIC and Equity Shares.

Insider Secret

FAMILY AS FRIENDS

When it comes to co-buying and co-owning a home, your siblings and parents fall into the category of "friends" for legal purposes. The same questions and title considerations apply, so address them. Don't assume your mom must be flush, so you don't need to inquire about her finances, or that you don't need a right of first refusal to prevent your brother from selling his interest to a stranger without your approval. Ask the questions now—and insist on getting acceptable answers before you move forward—so you won't be sorry later.

Unit-arianism: Live in One & Rent the Other(s)

A few years ago, a hilarious film came out called "Duplex". Ben Stiller and Drew Barrymore star as a young professional couple who buys their dream home, a Brooklyn brownstone duplex with a rent-controlled apartment upstairs. The seemingly sedate, elderly tenant turns out to be an energetic senior who plays in a brass band (which practices at her apartment, of course), blasts her television 24 hours a day, and makes incessant and bizarre requests of her new landlords—even though she pays only $80 a month in rent!

The issues Ben and Drew had with their tenant are pretty far out compared to the typical issues faced by homebuyers who purchase a multifamily home, live in one unit, then rent out the rest. However, this creative homebuying strategy does have major impacts on your finances and your lifestyle before, during and after you purchase and own your home. As with everything else in life, buying more house means taking on a correspondingly greater amount of responsibility. Here are some of the things you should consider and incorporate into your homebuying planning and decision making if you think you might be interested in living in one unit and renting the other(s).

Before:

Is It Worth It to You?

If you buy a multifamily home in an area where multi-family homes are expensive compared to the rental income received on the individual apartments, the extra unit(s) may not help you pay the mortgage nearly as much as you think! In fact, you may end up paying much more than your unit's share of the mortgage on the property. For example, if you pay $800,000 for a duplex with two identical units, and you can only get $1,600 for the rental unit, then you are going to be responsible for well over half the monthly mortgage payment –$3,500 or more per month. However, if you live in a town where you can buy a duplex for $100,000 and you can charge $800 for the rental, then you come much closer to getting some significant help with the mortgage.

Now, even if you are in the first situation, there are also tax considerations (the ability to deduct more mortgage interest, property taxes, depreciation and other expenses than you would if you bought a smaller, single family home) that may render it logical and economically feasible to go ahead and buy the duplex, despite the disproportionate contribution you'll have to make into it monthly. Also, if you are interested in investing in real estate to take advantage of

appreciation, buying and living in a small multi-family property can be a great way to launch your career as an investor, while you have maximum ability to control and manage the property—and learn about what's involved.

The only way to figure out if it really makes sense for you to buy a multi-family home instead of a single family is to make sure that you understand all the costs, benefits and implications of owning a multi-family home in your area—consult with your CPA, your Realtor, your mortgage broker, and square all the information you receive with your personal finances and life vision.

Do the Extra Math and Know Your Extra Numbers

Just like when you buy a single family home, when you buy a multi-unit property, you need to know how much you can afford to buy—but if you're buying units, you must take into consideration both the rental income and the additional expenses.

Know the Flow

For every property you look at, you'll need to do a cash flow analysis—a fairly simple math calculation that takes the rental income that comes in every month, minus the expenses that you (as the landlord) must cover, including the mortgage, to determine how much money you'll have to put into the property on a monthly basis.

Rental Income

In order to figure out how much you'll have to pay every month toward your multi-family home, you must know how much each unit rents for right now, or how much you can expect to get for it. Unlike homes that have sold, rental comparables are a little harder to find; if you need to project the rents on a vacant unit, check your local Craigslist site and the websites of local property management companies to find out what similar, nearby units are renting for.

Additional Expenses

When you're the landlord, you may have to pay more than you otherwise would have for:

- *Utilities* - Depending on the rental market in your area, you may pay your tenant's water and garbage fees, plus things like snow removal and even heat, depending on whether the units have separate furnaces;

- *Property Taxes* - Property taxes are determined by the price/value of your home, which is usually greater if you buy units than it would be if you were just buying a single family home for yourself;

- *Maintenance and Repairs* – You'll be responsible for maintaining your tenants' homes, not just yours, so you should tuck at least 3 percent of the rent you receive away every month into a reserve fund just for that extra expense.

House Hunting for Two (Plus!)

Articulating what you want and need in a single family home—to yourself and to your Realtor—is mostly about describing the home you're looking for and a maximum price you can pay. Matters get a little more complicated when you are looking for a multi-family property. In addition to all the basic characteristic of a home (beds, baths, etc.) multi-unit properties vary dramatically on many other items:

- How many of the units are currently rented, to whom, for how much, for how long, etc.;

- Whether rent control or tenant's rights apply to one or more tenants;

- The amount of owner-paid utilities and costs, etc.

These factors, combined, create a different set of financial obligations that every individual multi-family property places on their owner-to-be (read: you). For example, one duplex at $350,000 may come with two long-term tenants paying $1,100 in rent per month plus their own utilities, while another at the same price may come with one tenant who is about to leave, a vacant unit, and a single set of electric, gas, and water meters—so that the owner either will have to pay the utilities or pay to install separate utilities meters. It is impossible to create a completely black-and-white vision of the property you are looking for when you're shopping for a multi-family. Rather, you'll need to state a list of preferences and priorities, and stay flexible.

Some multi-family property characteristics you should discuss with your Realtor include:

Rent Controlled Properties

Make sure you know if the prospective property is subject to any rent control laws. If so, get very familiar with them. Rent control ordinances can prevent you from moving into an already occupied unit, raising the rent or evicting tenants that come with the place, and otherwise severely restrict what you can do with your own property;

Vacant vs. Occupied Properties

If you live in a rent-controlled area, you may not want to buy a property with a long-term tenant who is paying low rent. Likewise, if all units are rented, the law in your area might impact whether, and how easily, you can evict one so you can live in that unit. Alternatively, if you are

buying a duplex, you might prioritize properties that have only one tenant, where the tenant is paying a rent amount that is close to fair market rents.

Owner-Paid vs. Fully Separate Utilities

When a multi-family property doesn't have fully separate utility meters (gas, water, electric), it's usually up to the landlord to pay for the utilities that are shared. Hopefully, the costs can be incorporated into the rent you charge the tenants.

Rental History & Rentability

You can often get a good idea of how many vacancies the property has had over time from the seller. Also, when you are hunting for a multi-family home, you definitely should take into consideration how "rentable" the property and the rental unit(s) are, i.e., how desirable the place will be in the eyes of future prospective tenants.

Think about factors such as:

- Whether the property is close to any major employers, colleges, popular shopping districts or other attractions;

- Whether the property is conveniently located to public transportation; and

- Whether the rental unit(s) has (have) conveniences renters prefer (dishwashers, garbage disposals, off-street parking, yard/patio/balcony space).

Properties that are highly rentable should be high on your priority list; these places will minimize the time you'll have to spend with a vacant unit (i.e., time you'll have to pay the full mortgage all on your own).

Special Financing Considerations for Multi-Unit Homes

Lenders see mortgages on multi-unit properties as slightly riskier than mortgages on single family homes, though they won't penalize you nearly as much if you plan to occupy your multi-unit property as they would if you were strictly an investor buying units you never intended to live in. If you decide to buy a multi-family property, when you are lining your mortgage financing up, you'll need to consider:

- *Size Does Matter* – Mortgage rates and terms for duplexes

> Properties that are highly rentable should be high on your priority list.

are very close to those for single family homes. When you move to purchasing triplexes (three units) or fourplexes (four units), you move into income property lending, where the mortgages are more restrictive and more expensive. More than four units is considered a commercial property, and the buyer would be required to show detailed financial reports and the history of the property. If this purchase will be your first foray into landlording and real estate investing, staying with a duplex or triplex is advisable. Use this property to gain the experience, knowledge and financial resources to be able to qualify for and support a commercial mortgage and multiple vacant units on your next, larger property;

- *More Money Down Required & Higher Interest Rates* – In order to get the best rates on a multi-family property, some lenders may require you to put more money down. While 100 percent financing is often available on duplexes for a slightly higher rate than on a single family home, on three-plus unit properties, you must put 5 percent, 10 percent or more money down in order to qualify for reasonably similar rates to those you'd get on a single family residence;

- *Rental History* – Some lenders will actually do a rent survey, asking all the current tenants how much they pay for rent. Usually, the lender will give you credit for some portion of the rental income from a property (75 percent is an industry norm), adding it to your income for purposes of qualifying you for the mortgage. The lender won't consider 100 percent of the rental income because vacancies and missed rents pose the risk of interrupting that flow of cash.

During:

Things that come up while you are living in a multi-family property as the owner-occupant with tenants on the property are:

Landlord-Tenant Issues

Choosing a multi-unit property means you are willing to live in fairly close quarters—upstairs, side-by-side, or on the same lot with someone, usually someone you don't know. There might be noise, pet, cleanliness or other standards of living on which you and your tenants(s) disagree. There is a whole body of local and state landlord tenant law with which you should become familiar. This will include things like how and on what grounds you can evict someone; whether, when and how much you can raise your tenant's rent; and your responsibilities in terms of caring for the property and accounting for security deposits, etc. Most cities now have some sort of association or organization of landlords; consider joining up and/or attending their seminars or meetings to get educated on the law and standard practices in your area;

Property Maintenance & Repair

When a tenant lives on your property, you will need to react to requests for maintenance and repairs even more quickly than you would necessarily do for yourself—even though some of the repairs might be due to damage the tenants themselves caused! Having a trusted handyperson on call and having a good home warranty plan are absolute musts. And you should budget to replace the carpet and paint in the rental unit much more frequently than you would if you lived there. On average, every time a tenant vacates, you should evaluate the carpet and paint to see whether they need to be redone;

Vacancies

Speaking of vacancies, as a landlord you will definitely want to maintain a reserve account of funds you can draw on to make the mortgage payment in the event your rental unit is vacant for a (hopefully) short period of time. Also, take into account that you may need to devote some hours and dollars toward finding a tenant, when vacancies arise. Finally, many of the landlord associations also offer resources to help you locate and screen tenants in the event you have a vacancy.

After:

You know how I feel about exit strategies. So even before buying a multi-unit property, you should know that a couple of issues will affect your ability to re-sell your property when it's time.

Rent Control

It pays to be strategic about selling a property in a rent control jurisdiction. If you're at or near a life place when you'll be ready to move up yourself and/or sell the property, you should see a tenant vacancy as a real opportunity to attract new buyers. Remember, when you house hunt for a multifamily, rent-controlled properties that are tenant-occupied are a lot less desirable than vacant ones. Keep this in mind over the years you own your multi-unit home, and strike while the iron is hot (a.k.a. vacant);

Capital Gains

Technically speaking, you may only take your capital gains tax exemption on your personal residence. So, if you live in one unit of a four-plex that you own, when you sell you may not be able to use all of your profit on a new single family home for yourself without paying capital gains

tax on the portions of the profit attributable to the three units you didn't live in. At least a year prior to the time you'll want to sell your multi-unit home, talk with your CPA about projecting your capital gains taxes, and possibly deferring them through a 1031 like-kind exchange.

You Might be a Good Unit-arian If...

If you don't want to be a co-owner with someone else, and you are not freaked out by what you have just read, you might be a great candidate for buying a multi-family property and living in one portion while renting the rest. You might also be a good candidate for "unit-arianism" if any or all of the following describes you:

- You are willing to sacrifice privacy or comfort for the ability to buy at all or buy a larger property;

- You don't mind living in close quarters with someone you don't know;

- You don't mind taking on landlording responsibilities for maintaining the property and its expenses—but also the tax and appreciation benefits – singlehandedly;

- You are not living paycheck-to-paycheck, and can afford to make your mortgage payment and property taxes on your own for at least a few months of the year without the help of the rental income;

- You are strongly interested in investing in real estate;

- You tend to be organized with respect to your finances or you have (or are willing to retain) a bookkeeper.

If you are not so interested in being a landlord, but don't mind the idea of sharing the space— and the expenses—of a multi-family property with someone, consider the Stranger TIC.

Stranger TICs

This co-ownership of a multi-family property by strangers as Tenants in Common comes in two flavors: new or existing. A "new" stranger TIC scenario usually involves one would-be buyer advertising or actively looking for another buyer to go in with on a property that is up for sale. You'll see these sorts of postings on Craiglist.com and similar sites—"Seeking Buyer for TIC to buy Berkeley Duplex." If you are considering a new stranger TIC, the questions you need to ask are essentially the same ones you'd ask a friend, but you should approach a stranger TIC with much more caution. Some of the details of the property, like soundproofing between units, will be more critical than with a friend TIC, as you don't really know the lifestyle your prospective co-owner leads.

Also, all prospective owners of the TIC will need to apply for, qualify for, secure and pay a single mortgage on the property. And if one owner misses a payment or defaults on the mortgage, the mortgage company will look to the other owner(s) to pay the whole thing or risk foreclosure. As such it is vitally important for all TIC owners to be certain of the other prospective owners' financial ability to make the payments. There are two things you can do to make sure that the mortgage gets paid if one owner has a temporary interruption in income:

(1) *Each owner can contribute to a reserve account* – putting a month or two of mortgage payments in the account that is drawn on only if someone can't make her payment for a month; and/or

(2) *Mortgage disability insurance* – **each owner can secure an insurance policy which will pay their share of the mortgage payment in the event the owner is temporarily disabled (i.e., out of work for six months or less due to injury).**

If all owners agree to implement either or both of these strategies, the details of how they will be implemented should be documented in the TIC Agreement.

Finally, certain TIC Agreement provisions take on a new significance when negotiating co-ownership with strangers, because (a) their behavior is less predictable, since you have no history to go on and (b) you have no emotional relationship with them, so they don't necessarily have an inherent concern for your well-being or enjoyment which would motivate them to do right by you. The TIC Agreement clauses to which you should pay special attention when entering a new stranger TIC include:

- A reserve bank account (to ensure a cash cushion exists to cover missed payments and/or unexpected maintenance and repairs);

- Pet and noise rules, including prohibitions on certain hard flooring materials in an upstairs unit (a sound issue for the downstairs occupant);

- A schedule for major improvements and maintenance over time;

- The precise description and distinction between individual units and common areas;

- Accounting and dispute resolution provisions;

- Rules governing any owner's sale of their interest.

Existing TICs

When you buy into an existing TIC, you are simply purchasing the ownership interest of one co-owner. Buying a TIC is pretty similar to buying a condo or co-op, except there are far fewer governmentally mandated legal requirements of a TIC. That means that the onus is on you to do your due diligence, investigate the financial and maintenance history of the property, and make sure there is an acceptable TIC Agreement in place which addresses all of the same issues that you would handle if negotiating a new TIC Agreement.

(1) READ and UNDERSTAND the TIC Agreement,

(2) Have your attorney read and discuss it with you, and

(3) If you or your attorney has any questions or concerns, get them answered and/or resolved before you buy.

It is acceptable to propose revisions to the TIC Agreement of an existing TIC if that's what it takes to cover all the bases.

Understand that the existing owners will do their due diligence on you. You might have to undergo an interview and approval process at least as extensive as the one you would go through to buy into a co-op. The non-selling TIC owners might ask you extensive questions about your family, your lifestyle—even your personal finances. Because the property was probably purchased using a single mortgage taken by all the co-owners, when you purchase the interest of one of them, the mortgage will need to be refinanced in the names of you and the non-selling owner(s). This means that if you fail to make your mortgage payment for whatever reason, the remaining co-owners will be forced to either pay your share or lose their home, just as you would be should they default. So don't be offended if they pry. They just want to know all the things you would want to know about someone before agreeing to live in close quarters with them, and allowing them to have a major influence on the stability of your home and your financial wellbeing!

Getting By With a Little Help From Your Friends & Country(wo)men

The TIC is the most popular and safe way to purchase a property with someone other than a friend or relative. However many homebuyers don't necessarily want to co-buy or co-own with anyone, they simply need a little help in order to purchase their home, and their relatives and

friends aren't the best source of that help (for whatever reason). There are two popular methods of relying on the kindness of strangers when it comes to homebuying—the Equity Share (which can be arranged with relatives and friends, too) and Homebuyers' Assistance Programs.

The Equity Share

You may see the house you eventually purchase as a home first and an investment second—a move that will have huge impacts on your lifestyle, and also on your finances. In some communities, however, there are a number of folks who see real estate—including your home—as a potentially lucrative investment, and so are willing to help you get into your home in exchange for a cut of the appreciation. These arrangements are called Equity Shares, and here's how they work:

- An investor who has cash is matched with a homebuyer with stable income who doesn't have as much down payment money as she would like;

- The investor contributes cash for the buyer's down payment and/or to supplement the buyer's monthly payments, depending on the buyer's particular needs;

- The homebuyer covers her own closing costs, the mortgage payment, maintenance, taxes, insurance, HOA dues, etc.;

- At close of escrow, the buyer signs an Equity Share Agreement with the investor, and both the note (i.e., IOU) and Deed of Trust are recorded with the County recorder's office, securing the investor's "loan" with the house. This officially documents the repayment agreement between the homebuyer and the investor, and places the investor in the position to foreclose on the home to collect the money owed in the event the homebuyer fails to repay the investor in accordance with the Agreement;

- After owning the home for several years (usually three to seven years—whatever the Equity Share Agreement specifies), a neutral appraiser is retained to determine how much the home has increased in value (i.e., how much equity has accrued). Then, the homebuyer effects a "cash-out refinance"—refinancing the mortgage and pulling cash out in the process. The homebuyer uses that cash to repay the investor's initial investment, and gives the investor a share of the increased value of the home.

In a typical Equity Share Agreement, (a) the investor makes a 10 percent down payment on the buyer's home, (b) the homebuyer agrees to do a cash-out refi three years after the purchase, and (c) at the three-year mark, the buyer repays the initial investment and buys the investor's interest out with 50 percent of the equity that has accrued in the three years of ownership. To see a sample Equity Share Agreement, visit the Buyer's Tool Shed at www.REThinkRealEstate. com.

For example:

2007 Purchase Price	Initial 10% Equity Share Investment	8 percent appreciation/ year x 3	2010 Value of Property
$300,000	$30,000	$78,000	$378,000

Repayment of Initial Equity Share Investmen	+	Appreciation Split	=	2010 Equity Share Buyout
$30,000		$78,000 ÷ 2 = $39,000		$69,000

HOWEVER, remember that with Equity Shares, as with all other real estate relationships, almost everything is negotiable. You can negotiate:

- For the investment to be larger or smaller;

- To repay the investor on a monthly basis in exchange for a smaller buyout amount later;

- For a larger or smaller equity split;

- For a longer or shorter pre-buyout period;

- For the investor to make a monthly contribution toward your mortgage payment, if that's something you need.

Some Equity Share Agreements even call for a renegotiation of terms if a minimum amount of equity hasn't accrued by the time set for buyout—usually, in these cases, the buyer and investor simply agree to postpone the buyout. Whether or not your Equity Share Agreement calls for a renegotiation, you can always propose terms that would work for you—both up front and during the Equity Share—just remember that the investor always has the right to say no. For this reason, keep in mind the number one rule of negotiation: you are much more likely to get what you want if you propose a win-win arrangement in the first place!

True Story - Creative Is as Creative Does

When I say everything about an Equity Share is negotiable, I mean it! One woman I know did an Equity Share with her father as the investor. He put up $100,000 in total down payment/investment, and she repaid the first $50,000 as an Equity Share (translation: she refinanced after a few years and he got back his $50,000 + a portion of the equity she had built), and the second $50,000 as a loan with interest due on sale (translation: when she sold the home, she repaid the $50,000 + 7 percent annual interest). She didn't have to give up so much equity, and he still made a higher return on his investment than he would have with another investment!

How do you put this kind of thing together? Figure out the needs of everyone involved and then talk to a real estate attorney to see how you can resolve them all!

Equity Share FAQs

How do I find an Equity Share Investor to help me buy my home?
Some women find their own Equity Share investors amongst their relatives and friends; simply tell folks you know about what you are trying to do and prospective investors will make their interest known. If you do an Equity Share with a relative, make sure that you retain a real estate attorney or other real estate professional to draw up the necessary documentation of the arrangement. That way you won't end up with Aunt Bess as your mortal enemy because you both remember "the arrangement" very differently two years down the road. There are also companies out there– usually real estate brokerages - with rosters of investors who are perpetually interested in helping folks like you buy homes. Do a Yahoo! or Google search for "equity share real estate _____ your city _____" to find a company that might have a bunch of investors who are ready, willing and able to help you buy your home. If you can't find a corporate equity-share finder in your area, try to find your own investor by posting on Craigslist. org, or a similar site.

What are the pros and cons of buying my home with the help of an Equity Share?
Pro: Down payment assistance means lower monthly payments or being able to afford a bigger, nicer, or better located (read: more expensive) house.

Con: You give up a large portion of your equity from the first several years—if appreciation and wealth-building were a large part of your reason for buying in the first place, or if you will need that appreciation to move up around the same time as your buyout date, this could be a problem. Also, your investor might not agree to the arrangement if you take a certain type of mortgage, so you might limit your financing options by participating in an Equity Share.

Isn't 50 percent a lot of money for me to give up?

It's all relative. It is a big chunk, but it may make sense if you can't get a home, or couldn't afford anything that meets your needs, without an investor's help.

Beyond that, it all boils down to doing the math—how much are you're saving monthly x the number of months before buyout vs. how much you will have to pay out in equity.

And remember, you can always negotiate for a different equity split—if your investor is particularly motivated or your local market is rapidly appreciating, you might just be able to get an equity share where you don't have to give up quite so much of your home equity.

Is the investor a co-owner with me?

Not usually, but it does depend on the specifics of your arrangement. Normally, the arrangement is documented by:

(1) the Equity Share Agreement—a detailed contract between you and the investor,

(2) a Note—a very simple, one-page loan agreement, and

(3) a Deed of Trust—another very simple document that is recorded with the County offices, to secure the loan with your home.

Some investors insist on having co-ownership—for tax reasons (i.e., to share in your mortgage interest deduction) or because they perceive it as increasing the security of their investment. If you have a prospective investor who insists on being a co-owner with you, definitely seek the advice of a real estate attorney.

What if my house was a fixer when I bought it, but I fixed it up? A lot of the increase in my home's value was due to my hard work. Does the investor get to share in my "sweat equity"?

Nope. Your Equity Share Agreement should specify that the investor shares only in market appreciation, not in extraordinary appreciation due to your improvements to the property. The appraiser who makes the determination of value for purposes of determining the buyout amount will be able to project what appreciation would have accrued had you not done any work to your home.

How much do I have to pay the investor every month?

Usually nothing. A typical equity share does not require any monthly payments to the investor.

To Share or Not to Share?

Whether your situation is appropriate for an Equity Share depends on the terms and relationships involved. An Equity Share with a relative can be a completely different experience than an Equity Share with a stranger-investor—for better or for worse. Like any homebuying assistance arrangement, the details contained in the documentation of your Equity Share will set the tenor for the relationship and prevent later disputes, as well as helping you determine if this sort of "assistance" is sufficiently beneficial or excessively costly for your specific situation. You know enough now, though, to add Equity Shares to your arsenal of creative homebuying arrangements you can pull out of your hat (just in case you need a little help).

Publicly Available Homebuyers' Assistance Programs

Equity Shares are private affairs—individualized down payment assistance arrangements negotiated directly between a single homebuyer and a single investor. In contrast, there are a multitude of homebuying assistance programs that are offered and available to members of the public who meet the criteria for receiving help. There are literally tens of thousands of such programs available nationwide, far too many to attempt to catalogue here. Their criteria are often complex and ever-evolving, but are generally publicized via the web; we maintain an index of programs in your area in the Buyer's Tool Shed at www.REThinkRealEstate.com. Here, we'll just break down the different types of programs and the basics involved in obtaining their assistance, to put them on your general radar screen of options you should explore and exhaust before moving ahead on your own.

Assistance Programs – Who & How They Help

Homebuyers' Assistance programs can be broken into two general categories: those that offer help only to First Time Homebuyers, and those that offer help to non-First Timers who fall into some other qualifying criterion, usually based on career profession or age.

Independent of the beneficiaries they serve, there are three major categories of assistance offered by the various programs.

Down Payment Assistance

For the buyer with little or no cash available for a down payment, some programs will actually provide some down payment money, including:

- *Grants* – Cash contributions that do not have to be repaid (very rare);

- *Down Payment Loans* – The Assistance Program loans you the down payment money at a very low interest rate, to be repaid monthly, or after you've been in the property for a certain number of years, or even only if and when you sell the property. Sometimes, the due-on-sale types of down payment loans are actually forgiven entirely (i.e., do not have to be repaid) if you own and live in the property for a long (say 30 years) period of time;

- *Equity Sharing Assistance Programs* – The Assistance Program contributes the down payment on the condition that you repay it and share the built-up equity. Unlike with private individual Equity Shares, the buyout is usually not required until you sell the property.

Favorable Financing Terms

Many of these programs will offer qualified participants better financing terms than they could get elsewhere, such as:

- Below market rate interest, or lower interest than you would qualify for ordinarily. Often, these programs will offer very low, fixed interest rates for a 30-year term. (Keep in mind that the monthly payment on a fixed rate, low interest loan may still be higher than the payment on an interest-only, market rate loan—this is sometimes a large factor in swaying qualified homebuyers away from mortgages offered by assistance programs. If you qualify for a mortgage assistance program, get pre-approved elsewhere, too, and compare the mortgages offered to you on down payment, interest rate, origination fees, and monthly payment.);

- No or low origination fees and closing costs;

- Flexible ratios, credit, and other qualification criteria;

- No reserve requirement, without raising your interest rate like a regular mortgage lender would if you had no reserves.

The Intangible Necessities

In addition to (or instead of) the above-listed, concrete financial aids, many of the publicly available homebuyers' assistance programs also offer some or all of the following:

- *Education* – Homebuyers' seminars and the like;

- *One-on-one counseling* – A non-commissioned, non-sales oriented professional will sit down and talk with you about your specific situation and help you strategize, troubleshoot, and problem solve;

- *Credit counseling & repair* – Many of these agencies will actually pull your credit report and help you clean it up, if necessary, using many of the same strategies we discussed in Chapter 4.

First Time Homebuyers' Programs

Am I a first time buyer? This seems like a simple yes or no question, but it's not! You might still qualify for one of these assistance programs if it's been awhile—two or three years—since you've owned a home. Also, some programs make exceptions for women who owned a home with a former spouse, and for folks who formerly owned a mobile home or trailer.

There are three types of entities who offer first time homebuyers assistance in buying their "first" homes:

Insider Secret

DIVORCÉES CAN BE BORN-AGAIN VIRGIN HOMEBUYERS

Divorced women who owned homes with their husbands can sometimes qualify as first time homebuyers. If you are in this situation, check with the agency offering the particular program you're interested in to see if you can qualify under this exception.

Government Programs

You would be hard pressed to find a city, county, or state government of any size that doesn't offer some sort of down payment or mortgage assistance program.

Why? Governmental agencies often have a mandate to increase the number of homeowners in certain populations, like moderate- or low-income households, or to increase the percentage of residents in certain neighborhoods who own their homes.

What do they offer? Governmental First Time Homebuyers' Programs most often offer down payment assistance and favorable financing terms, as described above.

How do I get in? Usually there is a rigorous approval process during which you must meet strict qualifications, including:

- *Income Limits* – There is often a maximum income you can make to qualify, though the programs do allow for a greater household income the more people live in the home;

- *Purchase Price Limits* – There is generally a maximum amount you can spend on your home;

- *Credit, Debt and Personal Finance Reviews* – Similar to a standard bank loan qualification process;

- *Property Types* – Often, these programs will only help buyers purchasing single family residences;

- *Usage Limitations* – These programs look to help buyers who plan to live in, not rent out, the property they are buying;

- *Geographic Limitations* – These programs virtually always limit the recipients of their assistance to properties within their jurisdictions – so a state program will require that you buy a place within the state; a city-run program will only help you buy a home in the city limits. Some programs provide certain incentives to people buying homes within certain districts, neighborhoods or even zip codes!

- *Educational Requirement* – Often, these programs will require that you attend a seminar or course they offer as a prerequisite to moving forward in the approval process.

What Should I Watch Out For? Many a woman has gotten excited about such a program, only to find out that there are simply no properties on the market in her area that fall within the purchase price limits, or that the income maximum is so low that she could never qualify for this program and actually afford to make a monthly mortgage payment.

Also, many of these programs will require you to select your mortgage lender/ professional from a very short list of preferred providers. This limitation doesn't often deprive you of good rates and terms, like you would expect when you lose lending options, but it may mean you don't receive the same level of customer service you would expect to receive from a broker who is more driven to earn your business.

Further, many of these programs do not offer the low-payment, interest-only loans that a lender might offer you outside of the program. If you are trying to take advantage of favorable financing terms, make sure you get pre-approved by a "regular" bank as well, so you can choose what's best for your life.

How Do I Find Them? Go to your city, county and state websites—they will usually have a button for "Living in [Your Town]" or "Housing"—that's where you will usually find information and even an application for these programs. Also, visit our Buyer's Tool Shed at www.REThinkRealEstate.com, and click on Homebuyers' Assistance Programs.

Non-Profit Organizations (NPOs)

Many local and national NPOs have been created for the sole purpose of providing assistance to homebuyers.

Why? They are non-profits! Serving the community is their raison d'être, and extensive research has shown that the economy and the community are benefited by increased homeownership rates. As well, some of these groups exist specifically to combat the predatory lending (the extension of mortgages on very oppressive terms to folks who are qualified for better loan terms) that has become prevalent among demographics known to be undereducated as to financial matters, including ethnic minorities and women.

What Do They Offer? Down payment assistance; favorable financing terms; and extensive education, counseling, and credit counseling. Some also offer refinancing and advocacy for home owners who have fallen victim to predatory lending.

How Do I Get In? NPOs offering assistance to homebuyers usually have criteria similar to government programs (see above), but may not have quite as stringent maximums on income and purchase price. (They may not have quite as much assistance money to spread around, though, either.)

What Should I Look Out For? The restrictions on lenders and loan programs might be even tighter with NPOs, because they often have negotiated directly with a single lender or two to make these preferential mortgages available to their clients.

And, again, "regular" banks now offer such aggressive and attractive loan programs that they might offer you a lower monthly payment on a mortgage, even if the interest rate is higher. Get pre-approved within and outside of the program, and compare.

How do I find them? There are three major nationwide NPOs doing this work:

- Acorn Housing Corp. – www.acornhousing.org;

- NACA (Neighborhood Assistance Corporation of America) – www.naca.com;

- Nehemiah Corporation of America – www.getdownpayment.com.

Many, many more NPOs are out there and willing to help—to find them, do a Yahoo! or Google search for "non-profit homebuyer assistance program" and see what comes up. Also, visit our site and click on Homebuyer's Assistance Programs in the Buyer's Tool Shed.

Private Builders & Developers

Private builders who have developed new condo developments and multi-family housing may offer assistance or preference to first time buyers.

Why? Especially in urban settings, many local governments have started requiring big builders to offer these programs in order to get their building permits. Also, there are sometimes big tax advantages for developers who create entire developments or buildings specifically for folks who qualify for these programs.

What Do They Offer? Usually, favorable financing terms, help with closing costs (not down payment), and preferential pricing—yes, lower prices on the homes which fall under this program.

How Do I Get In? Builders' affordable housing programs usually have similar qualification requirements as those for governmental or non-profit assistance programs, but are less tough to meet. Usually you can make a little more money and still qualify.

- *Location Limitation* – You do have to be buying a home within the specific development or complex or building;

- *Workplace Location Preferences* – Many programs give priority to folks who work in the same city or general area as the property;

- *Other preferences* – Some programs will give priorities to people over the age of 55, disabled people, etc.;

- *Lottery* – There are usually a limited number of homes available under these programs—and usually, demand exceeds supply. Many developers have resorted to conducting lotteries to select the victorious buyers under these programs. You essentially have to put your entire application together showing that you meet the qualification criteria, put some minimal deposit down ($500 to $3,000) and then wait for a drawing to see if your application was chosen. If the developer is giving any preferences, each preference-qualifying characteristic you possess may garner you an additional entry in the hopper.

What Should I Watch Out For? Builders may want you to get pre-approved by their preferred lender, but will allow you to work with whomever you choose. They may make some of their assistance—often closing cost credits—contingent upon your working with their preferred mortgage lender.

How Do I Find Them? This is very tough, because these often are not well-publicized. If you are looking at new condos or townhouses, or even at condo conversions (complexes which used to be rental apartments and have been rehabbed, and legally subdivided to be sold as condos), just ask the folks at the sales office whether they are offering any "below market rate" units—they'll know. You might also post on the REThinkRealEstate.com message boards, asking other Savvy Women in your area whether anyone can point you to a local affordable or below market rate housing development.

Assistance Programs For Non First-Timers

These programs usually offer down payment assistance and/or favorable financing terms to people who fall within a specific population—usually a group of people that is underpaid and that conducts work of some inherent value to the larger community. If you belong to any of these groups, contact your HR Department at work to see if there are any homebuyer's assistance programs available to you—they'll know. You can also usually search Yahoo! or Google for "[___your profession___] [___your city___] homebuyer assistance" and get things that your HR Department might not even be aware of. Those professions with homebuyer assistance programs include:

- Teachers;
- Police or Sheriff Personnel;

- University Faculty & Staff;

- Union members.

Also, if you work for a very large employer, you may have preferential lending options available to you through a mortgage bank or credit union that has worked with your employer to create a sort of assistance program as an employee benefit.

Seniors can often take advantage of governmental, builder/developer, and mortgage lender assistance programs, as well as having access to tax advantages upon buying and/or selling. Ask your Realtor and mortgage lender.

Finally, some banks offer preferential mortgage terms to people who are buying homes in certain neighborhoods or zip codes—ask your Realtor and mortgage professional if anything like that might apply to your case.

Assistance, Madam?

If you can qualify for an assistance program and still buy the sort of home you would have otherwise, you absolutely should. It can be like free money—really—if you can meet the requirements. However, many women start investigating programs available in their area and realize that they don't even come close to qualifying, or that any home they want would exceed the program's purchase price limits. This might simply be because these programs lag behind the prices of homes in the more expensive markets. Nevertheless, millions of women and families all over our nation have had the door to homeownership opened by these sorts of programs, so it's definitely worth a couple of hours of research into whether you might qualify.

Creative Homebuying – The Ultimate Mix & Match

As with mortgages and with homes, deciding whether and how to include others in your homebuying experience is all about knowing what works for you, your lifestyle, and your vision first. Only you can know whether you are up for making the compromises that are necessary to buy and own with someone else, or to jump through the hoops required to get help from a person or program. A solitude-lover who would like a lower monthly payment but doesn't want to live with someone might select an Equity Share, getting some down payment assistance but living in and managing her property alone. A single mom with a "compound fantasy" might choose a TIC with some single mom pals. You might mix and match; buying a Legacy Home as Joint Tenants with your life partner. Even though you're contemplating involving others in your home purchase, for it to work well in the long run, it has to be all about you at the start .

PART III: Finding & Getting Your Home

Chapter **6**

Master The Art Of
The House Hunt

Taken literally, the term "house hunting" evokes the image of a furtive Mediterranean-style bungalow with windows-for-eyes darting about wildly as it tries to elude a shotgun-toting, Annie Oakley-type character in khakis and safari jacket. As difficult as it can be to get clarity on your wants and needs and to end up with a home that works for your life, at least the houses don't actually try to run away from us!

However, the 'hunted house' image is useful in at least one respect—it gets you thinking about the house as a living, growing entity. Houses do actually breathe. They also creak, settle, contract when it's cold and expand when it's hot, and generally cry out for constant maintenance, periodic repair and the occasional upgrade. Roof shingles erode and fly off, gutters age and crack, paint fades, lawns grow shaggy and flowerbeds succumb to invasions of weeds. The plumbing, climate control, and electrical systems either function properly—making our daily living tasks easier and more convenient—or they malfunction, adding another item to our project lists.

Just as houses live and breathe, they also speak to us—kind of. When I am preparing to show houses to my buyer clients, I work intensely and meticulously to select prospective houses and make arrangements so that the house hunting expeditions—which I call "Buyers' Tours"—go smoothly. Then I back all the way off when my buyer and I pull up in front of the house. In my experience, people know what a bathroom is and what a kitchen is, so there's no real need for me

to pull a Vanna and present a room with a flourish. (I do point out any hidden features—like closet organizers, and neat details—like glass doorknobs—which might otherwise go unnoticed.)

The thing is, when buyers find the house they will buy, they just know. As soon as we arrive at the curb in front of the place, and again when we walk into the house, they sense, groove or feel as much as think, "I could live here." People don't usually articulate that at first; rather, a super-slow nod of the head and raised eyebrows is my indicator that the house has spoken to them. The well manicured neighborhood or urban exterior has said something to my buyer which inspired the sense that they could see themselves driving or walking up to this house at the end of the day. The cozy living room with wood floors, dated—but spacious—'70s styling, original 1920s crown moldings, or cutting edge kitchen has whispered to my client a warm "welcome home." When this happens, it doesn't necessarily mean that what you've seen is exactly what you thought you wanted. In the same way that houses age and develop, your priorities and desires may substantially evolve as the house hunt takes place. It is not at all bizarre for a condo to sing to a single girl who was committed to a detached, single family residence, or for a duplex to speak to a buyer who thought she was only looking at lofts.

Because my buyer—in this case you, my reader—will have followed the {RE}Think Real Estate program laid out in this book and only visited prospective homes which would work for you logistically and numerically, once the house has spoken very little else must happen before you decide to make an offer to purchase the home. By following this process, you, too, can find a house which speaks to you.

Doing Your Homework Helps You Manifest Your Vision of Home

A thorough analysis of your wants and needs—in terms of the physical structure, location and amenities of your future home—is the most critical factor in maximizing your chances of manifesting your Vision of Home. You wrote up your Vision in Chapter 1, but that may be more personal and confidential than you want to share with your Realtor. The Wants and Needs Checklist at the end of this chapter is designed to help you extract a less confidential and more concrete subset of information about the house you are looking for, which you can simply hand (or email) to your Realtor to jump start the process of finding the right home for you. This information, in tandem with your "Numbers" from Chapter 2, must be clear in your own head in order for you to:

- Make your own decisions as to tradeoffs and priorities based on how much house and how much mortgage you are prepared to handle;

- Manage your Realtor and empower her to show you prime prospective properties, while still using her skill and experience to drill down into the essential nature of your needs, sometimes opening your eyes to options you would not otherwise have considered; and

- Ensure that your Vision and voice are not drowned by the voices of Realtors, lenders, family members and friends, all of whom will freely opine as to what you "should" buy in the chaotic process of the house hunt.

This chapter is full of information on the nuts and bolts—or brick and mortar, if you will—of building types, ownership types, interior and exterior architecture, and the jargon and terms real estate insiders use to describe a house. The {RE}Think Real Estate Wants and Needs Checklist is a document intended to communicate to your Realtor a mix of your vision and values, along with concrete details about the sort of house you prefer, so it is important that you understand the lingo and terms that describe what you're looking for before you complete it.

The process of developing detailed clarity on the type of house you want to see and physically getting in the car and going out to the particular place you will buy, is a process involving discipline, skill, decisiveness, a little alchemy and sometimes even a soupçon of magic. The bulk of this chapter reflects my effort to pass insider knowledge down to you. This skill part will provide much of what you'll need to generate alchemy and empower yourself to make strong decisions swiftly and boldly. I'll share a few tips about the magic component of house hunting as well, the two basic ingredients of which are (a) your commitment, and (b) prayer!

Timing is Everything

You should get pre-approved for your mortgage at or around the same time as you assess your Wants & Needs, working with a Realtor and mortgage broker who have a pre-existing working relationship with one another.

They will work with you and with each other to try to get you pre-approved for the sort of home you want and/or to manage your excessive desires for the property based on your financials. See Chapters 3 and 4 for detailed instructions on how to get pre-approved and how to make the numbers work for you.

Cracking the Property Description Code

There are two basic avenues through which you will be introduced to a property—online (via a feed from the MLS—the most used online database for Realtors) into a company or agent's site, or in hard copy (via the property flyers you pick up at an Open House or out of the flyer box on the sign in the yard). Both of these items will contain the listing agent's description of the property—these are essentially marketing methods by which the seller's agent exposes the property to you, the qualified prospective buyer.

Insider Secret

USE THE WEB!

If you want to make your life easier while you're house hunting, check out properties in your area on your agent's website or at www.Realtor.com. The California Association of Realtors' recent Internet Buyers Survey found that buyers who used the net to kick off their house hunt spent HALF the time out house hunting with their Realtor before finding the property they bought!

If you don't know the Code, a property's description on the flyer or the listing service can look like hieroglyphics. For example, most people could guess that TLC indicates a property that needs some work. But you might not guess as easily that a FSBO with S/S and MPL CABS where the SLR=LA and Buyer takes occ. at COE means that the home is for sale by the owner, who is a licensed real estate agent and can move out at close of escrow, and has a kitchen with stainless steel appliances and maple cabinets.

Beyond simply interpreting the code, there are certain code words and phrases you should definitely watch out for. A property with "upside potential" sounds a lot better than a fixer-upper, but usually means the same exact thing. "Usually" is the operative word, though. From the face of the listing, you can't always tell whether these code words are being used as they were intended or whether you should interpret them as a tip-off to a fatal flaw. Equipping yourself with an insider's understanding can provide you with a healthy skepticism so that you don't end up consistently disappointed by some of the more ubiquitous misrepresentations. On the other hand, be sure to not dismiss properties too quickly either. I have had more than one client get a great deal on their dream home because the listing was poorly written, had a bad photo, or otherwise turned other buyers off.

Insider Secret

DON'T NIX PICS

Bad photos can lead to good deals. Every once in awhile, the photo is bad because of technical difficulties, weather problems, or a tree, car or other item obstructing the house. For example, horizontal siding often shows up badly in digital images, appearing to be cracked and worn even when it's in brand new condition. Because buyers screen properties online and by photos, these properties can stay on the market longer than they ought to, making the seller more willing to negotiate on price and terms. If you need a bargain, or are in a strong seller's market, ask your Realtor to point these properties out, and give them a chance—you might be pleasantly surprised when you drive up!

True Story - Plus, or Minus?

Last year, two Savvy Women I was working with teamed up to buy a duplex. We were really looking for a property with two two-bedroom units, but in our effort to keep within their monthly payment comfort zone, we expanded our search to units listed as having "1+" bedrooms. Technically, an area designated as a "+" or almost-bedroom is supposed to be a real room, with four walls and a door—though it's not a true bedroom (i.e., it lacks a closet), it hasn't been designed for another specific purpose. Well, we only had to look at a couple of these 1+ units to realize that agents in this area had started calling any room in which the sellers had put a bed a "+" room. In one day, we saw two different listing agents open up formal dining rooms—complete with fireplaces, see-through glass doors, and built-in china cabinets – and deem them suitable for use as an extra bedroom. Not only did both of these places actually have beds in the dining rooms, one of them still had people—sleeping—in the bed! No wonder the listing agent wanted to be present at the showing. He wanted to make sure we didn't awaken his clients!

Cracking The Code Part I: The Anatomy Of A Listing

There are no hard and fast rules to which agents adhere when they are writing listings for inclusion in the MLS or for a property's flyer. Nevertheless, there is a sort of recipe of informational ingredients you should expect to see when you pick up a flyer or see a listing. Generally, the listing agent's description of the property will include the following basic information:

- A photo and/or a map. (Some agents don't manage to get a photo onto the listing. This may dissuade you from seeing it, but if it otherwise meets your criteria, ask your agent to check it out for you. Some of the best deals I've gotten for clients were in cases where the lack of a picture kept the competition down);

- The property address;

- The list price—the price the seller is asking;

- The property type (see below);

- The number of bedrooms and bathrooms;

- The building's size and the lot size, both expressed in square feet;

- Major, unusual terms—good and bad (e.g., Seller needs to stay in the property for two months after close of escrow, Seller will include all appliances);

- Major, unusual disclosures (e.g., a $50,000 termite repair estimate, a recent death on the property);

- A general description of the property's amenities and features—in most areas, the MLS will require that agents complete fields relating to certain features in an effort to guarantee some minimum level of information across the board. These will differ by area, though, and some agents still manage to check "Other" or "None" for every field! When they do, the listing will look like a whole bunch of nothing, and if you want to learn about it, your agent will have to call and get the details from the listing agent by telephone;

- Selling points, or anything that the listing agent knows will make the property more attractive to buyers, including:

 → Upgrades and updating that have been done to the property's roof, flooring, paint, climate control, plumbing or electrical systems, kitchen or bathrooms (these are so reliably included in the description that you can generally assume that they don't exist if they are not listed);

 → Neighborhood or community amenities (e.g., near public transportation, near popular shopping district, school district is top-rated, etc.);

 → Favorable lot characteristics (e.g., views, yard size, etc.);

 → Whether property is in a homeowners' association (HOA) or other planned unit development, and applicable dues, if any.

The rest of this chapter will introduce you to some of the abbreviations, descriptions, euphemisms and jargon you might come across as you try to decipher a listing or flyer. To download of a copy of this glossary which you can print out for your reference while you review MLS listings and carry along with you while you go house hunting, visit www.REThinkRealEstate.com, go to our blog, click on Tara's Tips and enter: "decoder."

Cracking the Code Part II: What you Need to Know About Building & Ownership Types

Counter intuitively, once you are on the house hunt, the term "house" stops being sufficiently precise to describe the object of your pursuit. Property flyers and listings swap the general notion of a home for several categories which specify either the type of building or unit being sold, the nature of the legal ownership interest for sale, or both. Whether you already have absolute clarity about which types of buildings and ownership do and don't work for you, or you remain open until the end of your house hunt, you should at least know what these various designations mean. It might save you from summarily rejecting—or not even looking at—the property of your dreams because you weren't clear on the difference between a detached home and a PUD.

Building & Ownership Types – Four Degrees of Separation

When you think of a condominium, you might think of an uber-modern, metropolitan high-rise a la Trump Towers. However, the common interest development (of which condos are one sort) was one of the first forms of property ownership respected in ancient Roman civilization, and was even written into the Napoleonic Code of 1804.

The Common Interest Continuum
Four Degrees of Separation

INCREASING SHARED OWNERSHIP INTERESTS →

| Detached Single Family Residence | Planned Unit Development | Condominium | Co-operative |

In all of America, all housing units are classified as either single family or multi-family*, and there are only four different ownership boxes into which single family residences can be classified. These are based on the degree of "common interest" you share with your neighbors, if any. (Not interest as in hobbies, but interest as in legal ownership rights.) Every building you run into will fall into one of these four boxes, and the classification of the unit you choose will have a major impact on your rights and obligations, as well as your monthly budget. Once you understand the degrees of separation—or common interest—the building types make a lot more sense.

* A number of my Savvy Women clients over the years have elected to buy a home with two or more units, either teaming up with a friend or relative to buy the building or buying it themselves so they can live in one unit and rent the others(s). You can learn more about this strategy in Chapter 5, and at the Investing Center at www. {RE}ThinkRealEstate.com

The Two Extremes: Detached and Co-Ops

At the far ends of the continuum are detached single family residences and co-operatives. Consistent with their extreme natures, detached homes are found everywhere and co-ops are found infrequently except in NYC and the District of Columbia.

Detached Single Family Home

A detached single family home is exactly what it sounds like—a single building with everything within the four exterior walls intended for one family on a lot separate from other homes. When you purchase a detached home, you are solely responsible for paying your mortgage, property taxes, and utilities. You also bear all responsibility for insuring, maintaining and repairing your property—the home and the lot and everything on it. Other than local laws and building codes, nothing stops you from doing whatever you want to your place, inside and out. If you want to paint your home fluorescent green with purple stars, nothing but the boundaries of good taste (and the cries of outrage from your neighbors) will stop you. Same with having pets and renting your place out to a roommate or a tenant—you are the mistress of the entire domain, so you may do as you please.

> *Pros:* It's all you. You have the freedom to do as you choose with your property and have more privacy and fewer neighbor issues than if you shared walls with someone.

> *Cons:* It's all you. If the pipes burst, the roof leaks, or the tree's roots grow into your septic system, there is no property manager or association to which you can turn for help. (There are inexpensive home warranty plans, though, that can minimize some of the risks of big repair costs; we'll cover home warranties in Chapter 8.)

Co-operatives

In a co-operative, or "co-op," a corporation owns the entire property, which is usually a building of apartments (also called "co-op"s) and the land beneath them. (Co-ops can actually be made up of any type of building, but nine times out of ten, a co-op is a high-rise building.) This corporation's members are the owners of the individual apartments or units, hence, the company is known as a "co-operative corporation" and the building and units are called co-operatives. Instead of "buying" a residential unit in the "co-op," an individual must buy shares of stock or membership shares in the corporation. When you buy shares in a co-op, you obtain the

exclusive right to use your particular living unit through a co-operative ownership contract. This contract—between the buyer and the corporation—binds the owner to comply with the bylaws of the co-operative, to pay the co-op's monthly fees for operating and maintaining the building, and to pay the buyer's proportional share of the building's property taxes.

Each co-op has an elected board of directors, comprised of owners who reside in the building. The board is responsible for managing the affairs of the co-operative, supervising the property management company and, most importantly, for reviewing the applications of new owner/residents. The requirement of board or owner approval is one of the most unique characteristics of a co-operative. Even if the seller has agreed to sell you the unit, the board must review and approve your application and your financial ability to handle the responsibilities of membership in the co-operative in order for you to be allowed to buy a co-op unit.

Also, co-ops generally have rules governing uses of common areas like elevators and hallways, and governing your ability to do things which might affect your neighbors, like playing music, altering your unit, keeping pets, and renting out your unit.

> *Pros:* Many of the most coveted, classic buildings in urban locales are co-ops. Think Fifth Avenue, NYC. This is a remnant of the owners' desire, historically, to have control over who can and can't buy and live in the building. Closing costs are usually lower than for the sale of other forms of property, because co-op sales don't generally incur government real estate transfer taxes or require full title searches of the public records.

> *Cons:* The Board approval requirement can restrict your ability to buy and sell. Less privacy and a somewhat communal living atmosphere with rules and regulations impact how you live and use your property.

The In-Betweens: PUDs and Condos

No, Virginia, a Homeowner's Association (HOA) is not a support group. It is, though, a group into which you'll be drafted if you purchase a home that is part of a condominium development or a planned unit development. The term Homeowners' Association, or HOA, simply refers to the people who own units in a particular condominium development.

Condominiums

First, for clarity's sake, understand that the term condominium or "condo" refers to both a single unit you might buy and the legal form of ownership you acquire when you buy a unit.

Condos are similar to co-ops in that they are generally comprised of a number of attached residential homes in a building or a complex of buildings. However, the condo as a legal form can technically be applied even to detached residences on a single lot. Condos are most often stacked vertically, on top of one another, but this form of ownership is also frequently applied to townhouses, which are stacked next door to each other, sharing side walls but not ceilings or floors.

When you buy a condo, you become the exclusive owner of your living space—usually called a unit—and your parking space(s), while at the same time obtaining shared ownership with your neighbors of portions of the property called the "common area." Most often, the common area includes laundry areas (though some condos have in-unit laundry), community parking spaces, hallways or outdoor walkways, and recreational areas like greenbelts, clubhouses, pools, tennis courts, and gyms. In newer, larger and/or more progressive condo communities, you might even see an on-site business center with access to fax machines and the Internet, a DVD library with free popcorn and cookies, or the entire ground floor devoted to a public gym or supermarket. The common area also may include the four exterior walls, ceiling/roof, and sometimes the floor of an upstairs unit; maintenance problems in the walls or the roof are usually the homeowners Association's responsibility to repair.

When you pay dues to the HOA, you pay for:

- Your homeowner's insurance (the HOA obtains insurance on the whole building, and just charges you for your share);
- Common area maintenance (landscaping, cleaning, repairs, improvements);
- Gas (sometimes - if gas lines are shared between units);
- Water (sometimes - if water heaters are shared between units).

The property flyer or MLS listing will generally specify the amount to be paid monthly to the HOA by the buyer of a particular unit, though these amounts do increase every year or so. Often, the property description will give a brief, bullet point explanation of costs covered or amenities paid for by the HOA dues.

Like co-ops, condo HOAs also elect boards of directors, but there are usually no provisions for the board to have input into who can buy a unit. Also, like co-ops, condos are usually managed by a property manager, and condo owners are subject to permanent covenants, codes and restrictions (CC&Rs) governing things like pets, alterations to units, items you may have on your balcony or porch, noise, and so on—basically, anything that might impact your neighbors' ability to enjoy their units.

Pros: You write fewer checks monthly, as many of your monthly costs are rolled into your HOA dues. Also, lots of potentially major unexpected repair costs are liable to be covered by your HOA. Between the HOA and a home warranty (see Chapter 8), you can drastically reduce your risk of big repair costs. Access to on-site recreational facilities and convenience amenities can be a big plus—if you use them.

Cons: Your HOA dues might be more expensive than the total of your water, gas, maintenance and insurance costs would be otherwise; the overage usually goes to pay the management company and to create a reserve fund for repairs and maintenance. Some HOAs don't manage money well, or are involved in major litigation that threatens the Association's ability to actually cover large dollar repairs and maintenance items. Your strategy for investigating the financial health of an HOA is covered in Chapter 8. Other HOAs have deferred maintenance on the property, which can lead to expensive repairs down the line which you, as a member of the HOA, will have to help fund. If the reserves aren't healthy enough to finance a large repair, you could wind up being assessed a significant sum of money (translation: thousands of dollars) in addition to your monthly dues. Communal living is inherently less private, and condos that were converted from rental apartments often lack soundproofing. It's no fun to have to hear the guy upstairs flush the toilet or handle other unmentionables. You may need to seek approval for some interior upgrades or alterations.

Precious Cargo

When you own a home, your homeowner's insurance policy covers both the building and the personal property inside the building, like furniture, computers, clothes, etc. When you buy a condo, though, the insurance protection provided by your homeowners' association only protects the structure—and not the contents of your home. Make sure to get an insurance policy to protect the contents of your home, similar to a renter's insurance policy, to be sure that in case of theft, etc., you're not stuck with a nice new, but empty, home. These contents policies are quite inexpensive, and can prevent you from losing everything you own other than your home. Not sure who to call? Ask your mortgage broker for a referral or call your car insurance company—they often provide multiple policy discounts.

Planned Unit Developments (PUDs)

PUDs are basically detached single family homes in a subdivision or other "master planned" community which offers amenities and benefits above and beyond those made available by the local municipal government. Similar to single family homes, the owner of a home in a PUD possesses exclusive ownership of the lot of land on which the building sits, the actual building, and everything within the four walls. The common areas in a PUD are generally streets and parking areas, community centers or clubhouses, parks and open spaces, and other recreational facilities. The Homeowners' Association in a PUD usually does little more than hold title to these areas and retain a property manager to maintain and repair them. Individual owners are responsible for insuring and maintaining their homes and yards (though front yard maintenance can sometimes be an HOA responsibility), but are bound by relatively non-restrictive CC&Rs. Common examples of CC&Rs binding PUD home owners include limitations on exterior paint color, putting up basketball hoops over the garage, and prohibitions on vehicle parking in driveways and on streets. While HOA dues for PUDs are proportionally much lower than those for condos and co-ops, they generally cover nothing but common area maintenance. It is important to note that in many states, subdivisions less than 10 years old are generally PUDs, and owners therein are often required to pay special taxes or assessments intended to fund the increased burden the subdivision created on police, fire and other municipal services. If such a special tax applies, it will often be disclosed up front in the property listing or flyer. If you do not see it there, it is legally required to be disclosed within days after you make an offer.

> *Pros:* This is just as private as living in a detached family home, but may have lower maintenance responsibilities. Communities have a uniform standard for aesthetics and maintenance, and contain no weird purple-and-orange-and-yellow houses. HOA dues are generally quite low.

> *Cons:* Restrictions on paint colors and parking can be annoying. Uniform appearance standards can give the neighborhood a Stepford feel. HOA dues don't really substitute for any other costs you would have to pay if your home were not in a PUD.

Deciphering the Code – Building/Ownership Types

As you can see, often the form of ownership and the type of building are expressed in a single term in the listing or flyer; you will frequently see homes referred to as "condos," "co-ops," and "single family homes," which will clue you in to both the sort of brick-and-mortar structure and the form of ownership you should expect. However, you'll see lots of other terms in the "building type" slot, too.

Here's what those different terms signify:

Tri-Level – Distinct from a three-story house in that at least one of the levels is not a full floor apart, but is rather a step-down type configuration. For example, the living room may be two steps down from the first floor, which is separated by a full flight of stairs from the second floor;

Duet – A two-family home where the units are a mirror image of each other; identical, but reversed in floor plan. Often, these units are sold separately to separate owners as units in a tiny, two-unit PUD or condo development;

Duplex – A two-family home, meaning two separate units with separate entrances, each of which has its own kitchen. A duplex can be a duet, but many aren't (e.g., a three bedroom, two bath unit with an "in-law" unit in the backyard is a duplex, but not a duet). Duplexes are normally sold at the same time to a single owner or family, like a single family residence;

Flat – A one story condo or co-op unit;

Townhouse – A two or three story condo or co-op unit, where the units are attached side by side—or even detached—rather than stacked on top of each other. These properties are appreciated for the fact that residents generally don't share water heating units, and so can't hear their neighbor's toilet flush above their head. Also, overhead footsteps and general noise aren't as big of an issue in a side-by-side configuration;

Zero Lot Line – A single family residence in a PUD where the lot extends very little beyond the four walls of the house, usually just enough for a wall or fence separating your place from your neighbors' homes. The result is no front, back or side yards, i.e., almost a townhouse-type configuration, but with detached walls.

Cracking the Code Part III: What You Need To Know About Architecture

Architecture – Exterior

Properties are not described in terms of their architectural style 100 percent of the time. Descriptions of exterior architecture are generally only included in a listing or flyer when the listing agent knows that the style at issue is popular and, if mentioned, will be a selling point. Just in case you haven't paid much attention to the names of the styles of those houses which

tend to strike your fancy aesthetically, here is a quick guide that will help you distinguish your Tudors from your Bungalows.

Just as dogs have breed-specific health issues, so do houses. Certain architectural styles are notorious among home repair professionals for having characteristic troubles ranging from the minor to the critical. Use the information noted at the end of each list of architectural details to pinpoint areas that you will want to really check out when you see homes of this style during the house hunt. Consult it again during the inspection phase should you make an offer on a house built in that style.

Bungalow

- One or one-and-a-half stories;

- Wood, brick or stone exterior finishes;

- Rectangular building with low profile;

- Simple façade with few decorative details;

- Projecting, covered front porch with entryway set off to one side;

- Interior Characteristics: Kitchen, bedrooms and bathrooms laid around central living room;

- Breed-specific issues: Dry rot/damage to wood exterior, damage to stained and leaded glass in windows and built-in doors, damaged masonry.

Colonial

- Brick or wood exterior;

- Small front porch with white rectangular columns topped by a triangular gable or pediment leading up to the front door;

- Rectangular building;

- Symmetrical façade – same number of windows on either side of the front door, etc.;

- Two or more stories;

- Relatively steep roof pitch;

- Interior Characteristics: Living rooms on first floor and bedrooms on higher floors;

- Breed-specific issues: Damaged timber foundation sills, weather damaged columns, damage to historic interior plaster walls and ceilings.

Craftsman

○ Exterior or natural materials, like wood or stone;

○ Assymetrical façade;

○ Large porch with square pillars or columns holding up the corners;

○ Ornamental braces;

○ Stone chimney;

○ One story;

○ Relatively low-pitched (flat) roof;

○ Interior Characteristics: Built-in china cabinets, nooks, desks, etc.;

○ Breed-specific issues: Front porch or back steps with interior water damage or that are separating from main foundation. Because Craftsmans are so popular and inexpensive to build, new home developments in a faux/nouveau Craftsman style are springing up across the country. In some areas, these homes are being built so quickly and poorly that insiders have taken to describing them as "Crapsman."

Ranch Style/Rancher

○ Exterior finished in stucco, wood, brick or some combination thereof;

○ Low-pitched roof with medium to wide overhanging eaves;

○ Side or rear glass doors which slide open to a porch or patio area;

○ Attached garage;

○ Breed-specific issues: Asbestos tiles (may be under carpeting) and other asbestos-containing building materials (not a health hazard unless they are disturbed or damaged, as is possible during remodel or removal).

Spanish/Mediterranean

○ Stucco exterior finish (usually in earthy, cream, or pinkish tones);

○ Flat, red-tiled roof;

○ Small, circular accent windows;

○ Wide, square pillars on front façade;

○ Arches over doors, large windows and porch;

○ Square or polygonal towers;

○ Interior Characteristics: Tile floors, arches, wrought iron light fixtures;

- Breed-specific issues: "Pooling" and water damage to flat roof and ceiling underneath, moss growing on tiles, damaged/destroyed tiles, damaged/broken custom shaped windows, damaged/deteriorated historic stucco.

Tudor

- Patterned brick or stone exterior, or plaster with half-timbers;

- Decorative exposed wood framing known as "half-timbered" construction;

- Asymmetrical façade;

- Front door of vertical wood planks;

- Tall or narrow windows with small panes;

- Steeply pitched roof, sometimes with mock thatch;

- Large rectangular chimney with an ornate, cylindrical pipe—or "chimney pot"—on top;

- Breed-specific issues: Dry rot and other damage to half-timbers, damage to decorative exterior elements, damaged custom-size windows.

Victorian Queen Anne (Note: the term Victorian actually refers to an era (mid-1800s through about 1915), and not a style. Accordingly, there are about eight styles commonly referred to as Victorian, but the Victorian Queen Anne is what most of us think of when we think of a Victorian.)

- Any and all exterior finishes, from brick to shingles to terra cotta;

- Different exterior wall textures or materials on the same façade;

- Assymetrical façade with extensive wood or brick patterning or detailing;

- Extensive ornamental and decorative accents, usually in one of the following themes: delicate posts and spindles, raised classical columns, fancy half-timbering, or intricately patterned stone or brick;

- Front entryway and significant part (or all) of front façade covered by a porch;

- Breed-specific issues: Damaged or missing decorative accents which are no longer available, soil contamination and other lead-based paint environmental hazards, damage to historic interior plaster walls and ceilings.

Modern/Contemporary

- Extensive use of large, tall, or odd-shaped windows to create a feel of openness to the outdoors;

- Minimalist exteriors without ornamentation;

- Shed roof (steeply sloped single flat inclined planes) with exposed beams or flat roof;

- A mix of exterior finish materials, usually including glass, concrete, stone, wood and/or brick;

- Subtle, unobtrusive front entryway;

- Designed to blend with or take advantage of the surrounding natural environment;

- Interior Features: open and flexible floor plan, with large spaces for entertaining and common use, relatively smaller bedrooms, use of commercial-type building materials throughout home (e.g., concrete, glass);

- Breed-specific issues: Custom-sized windows can be expensive to upgrade; flat-roofs require yearly maintenance to prevent leaks caused by the unavoidable pooling of water; when considering resale, some designs can be perceived as cold and dated by buyers.

Architecture — Interior

Built-Ins (code: Blt Ins) — Furniture-like amenities which are built into the house, (e.g., china cabinets with glass doors and drawers, bookshelves, desks, etc.);

Eat in Kitchen (code: eat-in kit.) — A kitchen containing a small dining area;

Nook — Less than a room, a doorless area usually intended to house a piece of furniture or artwork. A breakfast nook is large enough to fit a small dining table and chairs; older houses may contain smaller nooks for a headboard, china cabinet or lamp to fit into;

Open Kitchen or Pass Through Kitchen — Spatial arrangement where the wall between the kitchen and dining room has a large hole and counter, through which platters of food can be passed and conversations can be conducted, or where there is no wall between kitchen and dining room;

Split Level or 1.5 Stories — One section of the home—usually above the garage or the master bedroom suite—is two stories or elevated by just a few stairs, rather than a full staircase;

Tri-Level — Distinct from a three-story house in that at least one of the levels is not a full floor apart, but is rather a step-down type configuration. For example, the living room may be two steps down from the first floor, which is separated by a full flight of stairs from the second floor;

Vaulted Ceilings, Cathedral Ceilings (code: Vault., Cath.) — Ceilings over about 12 feet high.

Amenities & Features

Cabs — Cabinets;

Central Air — Central air conditioning;

DP Windows — Dual pane windows, an upgrade for any house over 10 years old, offer significant advantages in insulation (i.e., energy cost savings and fewer cold air drafts) and soundproofing;

Elect. Hkups. or 220 — Dryer hookups use electric, so an electric dryer is needed;

Exp.d Bm. Clg — Exposed beam ceiling;

Finished Basement (code: Fin. Bsmt.) — Indicates a basement where the framing has been covered with sheet rock and flooring has been installed, so that the space is suitable for use as a room (though it may not be as well insulated against cold and heat as the rest of the house);

Gas Hkups — Dryer hookups use gas, so a gas dryer is needed;

Gourmet — Describes a kitchen with commercial or extremely high end appliances and/or other amenities suitable for intensive or sophisticated cooking (e.g., islands, warming lamps, etc.);

In-Law Unit (code: MIL) — Indicates that the property has a separate living unit with its own kitchen, like the sort that was traditionally used when a widowed mother in-law came to live with the family;

Kit. — Kitchen;

More or Less (code: MOL) — Indicates that the measurement mentioned is approximate, not exact;

Pergo or Laminate Floors — Pressed wood slat flooring systems which are meant to duplicate the look of hardwood floors, but are able to be cleaned with soap and water. These systems vary widely in quality of materials and installation, look and noisiness;

Plus Room — A room that has no distinguishing feature which would designate it for a particular use, i.e., it is neither a formal living room, dining room, kitchen, bathroom or bedroom. These rooms are most frequently used as a den/rumpus room, office or bedroom without a closet, depending on size and the occupants' needs. Unpermitted bedrooms (those converted from a basement, added without permits, with no closet or that have access directly to furnace, water heater or crawl space) are often called plus bedrooms, as in 3+ bedrooms;

S/S Apps — Stainless steel kitchen appliances, usually dishwasher and stove/oven and hood, if applicable;

W/D — Washer and dryer, usually refers to availability of hookups for these appliances and not the machines themselves.

Descriptive & Miscellaneous

Back on Market (code: BOM) – Refers to a property that was in escrow with another buyer and accordingly withdrawn from the market, then had to be placed back on the market because the previous buyer did not follow through on the transaction. This can be due to the previous buyer not being able to resolve a condition issue with the seller or a job transfer or divorce on the part of the buyer, but most often is because the previous buyer's financing fell through (usually because they were not appropriately pre-approved by a reputable lender). When the previous escrow fell through due to something out of the seller's control, these properties will often be listed as being "back on market" with "no fault of seller;"

Cozy — Small;

Condo Conversion — Refers to a condo building or complex that was formerly used as rental apartments. Might indicate need for updating, soundproofing issues. The worst of these buildings are notorious for the pervasive smell of stale cigarette smoke and outdated carpeting, paint, wallpaper, etc. in the common areas. The best of these buildings are indistinguishable from other condo developments;

Detached Gar. — A garage that is detached from the main house building;

Elevation — In architecture, any geometric projection of a vertical wall. New home builders often offer a menu of front or façade elevations — simple pictures of the available options for what the front of the house will look like from the street. Each

elevation option usually has its own name and can even sometimes be mixed and matched with selections from the floor plan menu; for example, you might be able to choose a "Tudoresque" front elevation with the "Entertainer" floor plan;

Ext. — Exterior;

Floor Plan – A detailed drawing of the layout of a house to scale, mapping out the relative locations of rooms and utility features, including closets, sinks, toilets, washer/dryer connections, etc. The term floor plan also refers to the actual layout of the house, as in "open and spacious floor plan;"

Frpl. — Fireplace;

Gar. — Garage;

Int. — Interior;

Low Maintenance Yards — Usually refers to hardscape (e.g. cement, cobblestone, pavers, etc. which take the place of living landscaping) or landscaping which does not require mowing (e.g., bushes, shrubbery, tall grasses, ground cover). Or a tiny outdoor space;

Mature Landscaping — Trees, shrubs, etc. have been there for some years, might be overgrown/poorly tended, but maximize privacy;

No Mention of Upgrades or Updating — Usually means no upgrades or updating have taken place;

#/# (code: 3/1, 2/2, 4/3) — Number of bedrooms/number of bathrooms, e.g., 3/2 means the home has three bedrooms and two bathrooms;

Per Seller (code: per slr) — According to the seller. Simplified legalese for something that is impossible for the Realtor to actually verify, but is deemed reliable because the Seller has provided the information. For example, sometimes the public records do not list the square footage of a property, but the Seller knows what they were told by the former owners or appraiser, and passes that information to you. You should presume these sorts of things are not exactly precise, but are a good approximation;

Pottery Barn-Style — Refers to a style of paint and decorating in sophisticated, classic manner with lots of neutrals;

Public Records — Records of the Tax Assessor, which usually include basic details about the property, such as number of bedrooms and baths, square footage of home and lot, zoning, number of fireplaces, and owners' names—often cited as source of information for specifications of house as listed on the flyer or the MLS listing;

Quaint — Usually refers to a small, older place in original condition, which may need upgrades;

S/b — Should be

Shabby Chic — Refers to a style of paint and decorating in a style that is inexpensive, but focuses on whites, light colors and creatively re-using classic furniture;

S.F., ft² —Square feet;

T/b — To be;

Views — Signifies that something pleasant can (allegedly) be seen from somewhere on the property. Should specify how much (e.g., panoramic, partial) of what (e.g., mountain, bay, ocean, lake, forest) can be seen from where (e.g., the entire house, the back windows, standing on your tiptoes in the basement bathroom);

W/o — Without.

Condition

Contractor's Special — A fixer-upper in which the work required is major in scope, and includes projects for which municipal permits and a contractor's license are required;

Cosmetic Fixer — A fixer-upper where the work needed is very minor and aesthetic (e.g., needs new paint and flooring);

Furn.d — Furnished;

Handyman's Special — See fixer-upper. Usually means work needed is cosmetic (e.g., paint, carpet) to minor in scope;

Needs TLC — A fixer-upper; will require some work to bring it to the standard condition of the average property on the market;

Newer, Nwr — Refers to remodeling projects which have been completed within the last few years, but not immediately prior to the sale of the property;

Non-conforming — Describes a feature, upgrade or expansion which does not meet the governing building standards or codes;

Open Floor Plan (code: Open Flr. Pln.) — A minimal number of walls divide the rooms;

Pride of Ownership — A property or a neighborhood characterized by exteriors and landscaping which appear to have been well-maintained by homeowner(s);

Smart — The home's lighting, heat, cooling, alarm, and/or appliance systems are controlled by computer/remote control;

Upside Potential — Fixer-upper, probably a major one;

Without Permits, Unpermitted, Unwarranted — A feature, upgrade or expansion built without required government building permit(s). The lack of permits may or may not be acceptable; for some tips on evaluating unpermitted items, visit www.REThinkRealEstate.com, click on Tara's Tips and enter "unpermitted."

Terms

Appliances Stay or Appliances Included — Refrigerator, washer and dryer are included – against the normal standard of practice and usually without warranty from the seller;

Broker Co-op or Will Co-operate with Brokers — The seller or new home builder/ developer has agreed to pay the commission of the agent representing the successful buyer. (Usually not stated, just understood with existing homes. Often expressly stated with new homes.);

CC&Rs — Covenants, Codes and Restrictions, the rules which govern what you can do with your property in a common interest development (i.e., condos, PUDs, etc.);

COE — Close of Escrow;

DND — Do Not Disturb occupants (i.e., don't knock on the door and ask to see the place, or ask if it is for sale). This instruction is often applicable when the occupants are tenants who are not co-operative with the sale, or when the owner-occupants are elderly, infirm, work at night (sleep during the day), etc.;

Dual/Variable — A dual representation is one in which the seller's agent represents both the seller and the buyer. A dual/variable representation is one where the seller's agent has agreed to take a lower total commission from the seller's proceeds if she represents the buyer, compared to the total commission the seller would have to pay if another agent brings the buyer. If the seller's agent has agreed to do this, it must be disclosed in the listing. If you see this in a listing on a property you're interested in, you'll want your agent to find out if the listing agent is presenting any offers from buyers they represent. Because their clients' offer will automatically net the seller more money than if you made the identical offer, you may need to strategize with your agent about how to be competitive against any offers made by the seller's agent's buyer clients;

Excl. — Excluded

Furn.d — Furnished. Furniture is included, often because the seller needs to move quickly and far away, or because the former occupant has moved into a household that is already furnished (or has died);

HOA Dues — Monthly dues payable to the Homeowner's Association. Usually these include homeowner's insurance, complex amenities (pool, gym, etc.), and sometimes common water and gas;

Offers Subject to Inspection — The seller is not willing or able to let you see the interior of the property until after you make an offer. This is sometimes the case where there is an elderly or infirm occupant, or a tenant who is less than co-operative. Generally speaking these properties can be a great deal, because many people disregard them. The offer that you make can always be written with a contingency for a satisfactory visual inspection by you, so that it is very easy to withdraw your offer to purchase it if the property is not up to par once you see the inside;

OWC or Owner Will Carry — The seller is offering to finance at least part of the purchase price. With seller financing, you make your payment to the owner, not the bank. Often you will see OWC 2nd, which means the owner is offering to carry a second mortgage on the property, replacing the down payment you would otherwise have to make. These deals can be attractive to buyers who cannot qualify for a bank mortgage for credit or other reasons, or to buyers who are able to negotiate great payment terms with the seller;

Neg — Negotiable;

Possession (code: Poss.) — Refers to the time frame in which the home will be available for the buyer to actually move in. Can be prior to close of escrow, the same day escrow closes, or as much as 60 days after close of escrow;

Rent Back, Lease Back — A possession arrangement in which the buyer closes escrow, but the seller still occupies the property for a time, "renting" their former home "back" from its new owner. A listing may say "Seller needs 30 day rent back," which means that as a buyer, you must be willing to wait 30 days after escrow closes to move into your new home. Generally, a buyer would charge the seller rent in the same amount as the mortgage payment for which the buyer will be liable during the rent-back period;

Rent Control Applies — If the property is not occupied by tenants, the seller is giving you notice that if you buy the property and rent it out, your relationship with your tenants will be subject to local rent control law. More importantly, if the property is occupied by tenants at the time the seller has it on the market for sale, the seller

is letting you know that (a) the property will not be delivered to the buyer vacant, because rent control laws prohibit the seller from evicting the tenant, (b) if you buy the property and want to live in it, your ability to evict the tenant and the procedures necessary will be governed by local rent control law, and (c) you might be in for a fight from any tenant you try to evict, because they are likely paying lower than fair market rent. Your best bet? Avoid these properties if they are tenant-occupied, or ask the seller to deliver it vacant. If you write an offer on one, try to negotiate a "move out payment" and agreement with the tenant while you are still in escrow to make sure you don't have the trial of the century on your hands after you buy the place;

Slr Fin.g Avail — See OWC just above;

Tenant's Rights — Tenants living in the property may have a legal right to 24 hours' notice prior to prospective buyers being able to see the interior of the property. Also, in rent control jurisdictions, the seller may not be able to deliver the property to the buyer vacant. The buyer may have to purchase the property, then evict the tenant if permissible under local law. See "Rent Control Applies" just above.

A Three-Hour Tour: What to Expect & What to Demand

Logistically, the house hunt is a three-step process. First, you will work with your Realtor to determine your search criteria—the characteristics and features you are looking for in a place. That will give you enough insider knowledge to meaningfully complete the Wants and Needs Checklist. Next, your Realtor, and sometimes you yourself, will find prospective properties that are up for sale which come close to your description of the property you are looking for. The most common place to find such properties is on the local Multiple Listing Service (MLS), an online database in which Realtors place their listings in order to make properties known to other Realtors and their buyer clients. Finally, you will get in the car (or on the bus, or subway, as the case may be) and go out and do an in-person visit of the properties that have been identified as potentially meeting your criteria. This is the phase I call your Buyer's Tour.

Great Expectations

On average, Buyers look at five to 25 properties before locating one that speaks to them enough to make an offer on it. Some buyers see one place and buy it, while others look at 50 before making an offer on one. The clearer YOU are about your wants and needs, the more efficient and less painful your house hunt will be. Also, changing your priorities drastically and repeatedly

can result in a house hunt so long that homes in your area actually rise in price while you sort yourself out. Make sure you tell your Realtor if and when your priorities change. They're professionals, not mind-readers!

- As a general rule, you should try to see no more than six or seven properties on any given Buyer's Tour—more than that, and the features of one place will start to blur with another. A full tour like this will take in the range of two-three hours, and sometimes longer depending on the types of properties you're seeing (condos can take a long time, especially if you look at all the complex amenities too, including community gyms and pools), how many of them interest you, and the distance between the properties.

- View the first Buyer's Tour as a purely educational exchange of information between you and your Realtor:

 → On the first tour, your Realtor will show you properties meeting as many of your criteria as possible, and should provide a representative sampling of such properties that are presently on the market in your price range;

 → Your Realtor should not censor the first tour much based on aesthetic or subjective details. (In cases where there are a large number of properties on the market in your price range, your Realtor can exercise a little bit more discretion.) I like to use red carpet as an example; on the first tour, I won't rule out showing a house because it has red carpet, because my client may like red carpet—even though I don't;

 → Your job for the first tour is to provide your Realtor as much feedback as possible about the features and characteristics you like, dislike, or REALLY dislike. If you communicate your feedback effectively to your Realtor, then on subsequent tours, your Realtor should show her respect for your time by not showing you houses with characteristics you have already designated as deal breakers (without some incredibly redeeming quality). Feel free to use my Good, Bad & Ugly Feedback Sheet, available for download from the Buyer's Tool Shed at www.REThinkRealEstate.com

What You Should Expect from the Realtors & the Seller. . .

On a Buyer's Tour, your Realtor will have arranged for you to visit the properties ahead of time. Usually, your Realtor will use an electronic key or code only available to Realtors to operate a lockbox on the property, a little safe that holds the keys which provide access to the house. The key and lockbox will have been put there by the listing agent. The beauty of this system is that it allows properties to be shown when the seller is not even at home. Indeed, savvy listing agents will often have advised the seller to leave the property and allow your Realtor to show you the property alone.

On occasion, the seller will not be able to leave the house and will remain on the property as you tour it. In these instances, it is appropriate for your Realtor to introduce herself and you, and to let the seller know that you will walk through the place and check in with the seller at the end of the tour with any questions you might have.

A GREAT Realtor will make every effort to have "previewed" the properties she shows you, actually visiting the properties in order to exercise her knowledge of your preferences to rule prospective properties in or out of a Buyer's Tour. This is not always possible; sometimes last minute scheduling of a tour, a quick response to a hot or newly listed property, or access limitations will prevent even the most dedicated Realtor from being able preview a listing. Also, on the first tour, the Realtor may not know enough about your likes and dislikes to meaningfully sift through the properties. For the most part, though, once you've gone out with a Realtor once or twice, she should make an effort to avoid showing you homes she has not seen first.

True Story–The Dog House

Even the best prepared Realtor, however, is sometimes faced with unexpected, ahem, challenges. Once, a married couple and I were out looking at homes, and found one which looked interesting. The listing, I had noticed, had an instruction not to let the dogs out. Cool. Um, until a little wet black nose, followed by the tiny little terrier attached to it, wedged itself out as I cracked open the door. He had obviously heard me unlocking the door and just sat poised to dart through the three-inch crevice between the door and the wall the moment I opened the door an iota. That little mutt (and I am a dog lover, believe it or not) ran and ran and ran. He ran down the street and hung a left, and was nowhere to be seen. The neighbors all stood outside clucking about how those dogs ALWAYS get out, even when the owner is home, and how even the owner can never get them back in. Now, I had only let one of the pack out, but all I could see in my mind's eye was the dog getting hit by a car, and me being placed in the Realtor version of the stockades for disregarding the instruction on the listing.

The next thing I know, my clients—who are not athletic folk—are chasing after the dog. Then they hung a left and disappeared from view. I hopped in the car and slowly, so as not to hit Fido, drove in the general westerly direction my clients had gone. I caught up with them as they were engaged in deep negotiations with the runaway dog, trying to convince him to come with them. Now, my legal training kicked in and my mind's eye saw myself in court with my clients,

who on my watch had been savagely mauled by this seemingly harmless pooch. To make a long story somewhat shorter, we opened the car door and managed to persuade the dog to hop in, picked him up and took him in the house. Which, by the way, turned out to be not even worth the trouble. But the neighbors did raise a cheer as we drove off.

You Should Request From Your Realtor. . .

(You can download a printable version of this list from the Buyer's Tool Shed at www.REThinkRealEstate.com, and just hand it to your Realtor at your first meeting.)

- That she read and call you to discuss your Wants and Needs Checklist BEFORE she starts previewing properties for your first Buyer's Tour. This will give you the opportunity to clarify and elaborate your vision in time to affect the fate of that initial tour;

- That she give you the first cut. Ask her to email you the MLS listings of 10 to 15 properties she's thinking of showing you a Buyer's Tour about four to five days prior to the scheduled tour. Then, YOU pick the top eight you'd like to see and email their addresses back to your Realtor. You've undoubtedly just improved your chances of seeing properties you like by about 75 percent;

- That she drive you on the tour in her car;

- That she preview—actually go and see in person—as many of the properties she plans to show you as she can prior to your scheduled tour;

- That she be on time for your tour appointments;

- That she be willing to make a weekly standing appointment for your tours until you are in contract. (Now, if you need to go out more than five tours or she is not going to be in town on a certain weekend, you shouldn't expect her to adhere strictly to this one. You just don't want there to be huge gaps of a month's time between your tours.);

- That she discuss your impressions of properties with you, give her professional opinions of whether you will be able to find properties with the features you like and without the deal-breaker characteristics in your price range, and suggest alternatives;

Insider Secret

MID-WEEK SHOPPING

Weekdays are freer times for many Realtors and tend to be better times to see properties while the sellers are away. If you can get away from work, the weekdays can be great times to house hunt.

○ That she commit to honoring your wants and needs, and avoid repeatedly showing you properties with characteristics you have deemed bad or ugly, unless such a property also features some quality your Realtor believes YOU will find redeeming.

Two Tips for Getting Your Realtor to Show You the Right Properties

Immediately start going to Open Houses – Right now, even way before you're ready to buy. When you see one you like—or dislike, take the flyer for it and make notes on the back as to the features of the property which evoked a strong emotional response for you. Keep a file with these flyers. Once you have selected your Realtor, show her these flyers and use them to deepen and illustrate the discussion of your wants and needs;

Have your Realtor register you in her system for automatic email notifications when

Anti-Checklist #2

WHAT NOT TO DO WHILE HOUSE HUNTING

✓ **Don't just pick up the phone, call the number on the sign, and go by yourself** – First, it's unsafe. Second, you can end up looking at a bunch of properties that don't meet your search criteria or price range, wasting your time. Third, it can make sellers think you are unrepresented and, thus, that they have the greater bargaining leverage from the get-go. Let your Realtor do her job; if you drive by an interesting property your Realtor hasn't mentioned to you, call your Realtor with the property address and phone number from the sign, and let her research the asking price and property details—nine times out of 10, your Realtor hasn't sent it to you because the property doesn't meet one or more of your search criteria. The 10th time out of 10—your Realtor can escort you there and show it to you while the seller is out of the house, and out of your hair;

✓ **Don't plan something for two hours later** – You don't want to rush, you want to linger where necessary. Plus, if you find one you really like, you might spend more time there. And, with drive time, etc., it can easily take three hours to see seven houses—not to mention that you may find one you want to immediately write an offer on, which will take another hour or so;

✓ **Avoid taking separate cars on your Buyer's Tours** – Every once in awhile a hot property will come up, your Realtor will call you from work, and you can meet her there. If you are going to be driving from house to house, get in the car with your Realtor—even if it means you have to put the baby seat in your Realtor's car. This way, you don't get separated, no one gets lost, and you can spend the time between houses debriefing and providing your Realtor with the feedback she needs to narrow your search and hone in on your home;

✓ **Don't bring a triple Venti mocha frap with you on your Buyer's Tour –** How can I say this? Uh, you don't want to be using everyone's bathroom, if you know what I mean—especially if people still live in the house. Vacant houses are the best ones for pit stops, but because everyone knows that, they are also the most likely to have nothing in the way of toilet paper except a cardboard roll with a couple of spots of paper still stuck to the glue.

Plus, coffeehouse drinks usually have coffee and milk—not the most gastro-friendly substances. If you need to, plan ahead to stop in the middle of the tour for a snack and a pit stop, and do feel free to bring a bottle of water;

✓ **Don't wear lace-up shoes –** Slip-ons, flip flops, etc. are ideal. Many well-prepared homes will have new carpet, and often the listing agent will have posted a "please remove shoes" sign to help keep the flooring clean. Having to untie and tie your shoes at every house can be a huge waste of time—and really anti-climatic when you get to the front door of a house you really want to see. Note—those paper booties some "shoes off, please" agents provide can be slippery. Avoid them; if you can't stand the idea of walking barefoot through a house, make sure you wear socks with your slip on shoes;

✓ **Don't hesitate to look in drawers, cupboards and closets –** If you really dislike a place, you needn't get really detailed in your viewing of a property. But if you don't hate it, you should open every door. I've had clients miss whole rooms and large storage areas by not opening a door they assumed went to a closet. Besides, you need to know how wide and deep the real closets are, which you can't find out without opening the door and having a look. If you really like a place, you should also open kitchen and bathroom drawers, cupboards and cabinets—you're not being nosy, you're gathering information. Rest assured that the sellers have had ample notice to straighten up those spaces in anticipation of your poking around;

✓ **Hold the trash talk –** Sellers may be listening. I wish I was kidding, but often the seller just steps outside or next door. (I once represented a kooky seller who walked around with her purse on during the Open House "ooh"ing and "aah"ing like she was a prospective buyer.) And they don't always understand that it's the most interested buyers who pick the place apart to figure out exactly what they will need to do to it to make it theirs. If you end up in a multiple offer situation, you don't want to have an uphill battle because you badmouthed the sequined butterfly "artwork" the seller had hanging in the hallway. So, if you can't say something nice, don't say anything at all. Until you get in the car, and roll up the windows—then you need to let it rip so your agent can learn your likes and dislikes;

✓ **Don't think you can offend your Realtor –** I always remind my clients that the house I'm showing them is not my house. So, if you like it, that's great. But if you hate anything about it, don't hesitate to say so. Don't be timid or polite and omit a criticism or concern you have. Doing so can result in you seeing more of the same, which is a waste of everybody's time.

properties meeting your search criteria come onto the market – Then, diligently go through them and email any listings you want to see to your Realtor. As she prepares for your tour, there'll be no guesswork involved for her to decide which properties she should take you to that weekend.

It's Your Prerogative

My first official real estate client was a 73-year-old lady who had decided to move to a single-story home after living in a three-story for over 25 years. And she was picky: She wanted a home that was not in the flatlands nor in the hills; she wanted it near the freeway, but didn't want to hear the freeway; she wanted it to be newer but didn't want a new house; and she wanted a one-story house in an area where over 80 percent of the homes have at least two. So. For our first tour, I actually found seven houses which met her search criteria. (I previewed 32 houses to find these seven—took me three days.) Then I put her in the car, and we drove to the first house. I put the car in park, turned off the ignition, unbuckled my seatbelt and started gathering my lockbox key and the listing. She simply turned her head to the right, looked out the window at the house, turned her head back to the front and said, "no." To every single place on the tour.

I use this client as an example when I train new agents. And every single time, they moan and groan about how awful it would be for a client to summarily reject every single house on the tour without even getting out of the car once. After all that preparation, no less. And I say, "Wrong answer! It was awesome." Look—this client did me the HUGE favor of making very clear very early on what wouldn't work for her and, by process of elimination, what might work for her. And yes, it took me nine months (!) to find a property that met her approval, but at least she didn't shine me on, grin and say "mm-hmm" to a whole bunch of places she really hated, wasting my time and hers. Instead, I only took her out maybe once a month, when something REALLY promising came on the market. And maybe I'd only show her two or three properties per tour instead of the seven I would have shown a typical client. Because of her clarity, as we zeroed in on a couple of places at the end of the house hunt, we were very certain that (a) we weren't missing out on anything and (b) any compromises we did make were necessary ones. The place we eventually found was by far the best on the market for her needs. The moral of the story? Be honest, and give copious feedback to your agent, even if it means not getting out of the car.

Work Your Magic!

When my youngest son, Clayton, was about 10 years old, I was driving him and some friends home from school. At the same time, my cell phone started to ring off the hook. First, an agent called, to negotiate some terms. I called another agent, to pitch my client's offer, and then another to refuse some bizarre last-minute request from the seller. My mortgage broker rang to do our daily status and troubleshooting review of the five or six transactions we were working on that moment, and to update me on the several mortgage applications my clients had pending. While I'm rapidly scanning my mental Rolodex from deal to deal and client to client the whole time, the kids in the backseat are yelling, "No, Clayton's mom. Turn here!" I turned to look at my kid in the passenger's seat, and he says—totally straight-faced—"Mom, work your magic."

By "my magic," Clayton meant to encourage me to keep on doing what I normally do, which is to work with lots of deals and lots of details and negotiate from memory, if necessary, and doing it really well. So, the question is, "what's your magic"? And how can you harness "your magic" to the benefit of your house hunt?

Maybe your magic is team-building, getting people to care about and work toward a common goal. If so, you might generate some alchemy for your house hunt by letting your friends, family members and colleagues know what type of property you are looking for, and asking them to let you know if they learn of anything like that. Maybe you are a natural born organizer. So, you may work some magic by providing your Realtor with a meticulous matrix of the factors you liked at Open House properties, and then again by keeping track of the factors you respond to during your house hunt—down to the zip code—and consistently narrowing your search based on these factors (and making sure that you keep your Realtor updated as you weed out properties and gradually add in more Must-Haves and more Deal-Breakers) until you find that home that speaks to you.

One thing I know about you right now, is that at least part of your personal magic has been getting where you are in life at this moment as a Savvy Woman. Take the uncommonly "common sense" you have, and apply it to every step of your house hunt. You know what will work for your life and your family, and what will not. And don't be afraid to act boldly and say "this is it" when, well, this is it. Makes no difference whether you've seen one or one hundred homes. There are no rush decisions in real estate these days. My average client signs her name and

initials over 200 times—no joke—before they close escrow. You will have, on average, 15 to 30 days to back out of a deal at no cost after the sellers accept your offer to buy their home. That's at least 15 days in which you (and your family or housemates) can learn the ins-and-outs of the house, the neighborhood, the loan specifics, etc., and still back out without losing anything but your time and maybe a few hundred dollars of money you paid your inspectors to give you the information you need to make this life-changing decision. Even after the first 15 days, you often still have the right to back out, though it may cost you some deposit money (a small cost when compared with the cost of moving forward with a home purchase that truly won't work for you). So don't hesitate to express yourself when you really truly like something—you will have plenty of opportunities to change your mind if you really need to, for whatever reason.

My Number One Tool for promoting the magic is to keep your search as broad as possible in the beginning, within reason. Don't send your Realtor a Checklist with so many dealbreakers that no property on the MLS actually falls within the scope of properties you'll agree to go see. A dealbreaker is a characteristic of a property you don't even want your Realtor to email you about; a dealbreaker is a two bedroom condo, when you have four kids and three dogs. Give your Realtor the ability to show you a wide range of properties that "might" work for you, until you have been out enough to be crystal clear on what you absolutely must have and absolutely can't stand. Keep in mind that many of the "deal-breaker" and "must-haves" will be entered as hard search criteria by your Realtor in some sort of computer system, be it the MLS or some other program. When these items are entered as a required field or as a rule-out search term, the search results will absolutely screen out everything not meeting these criteria. Every time you want to check the "deal-breaker" box or the "must have" box, think twice, and try to see if you might really want to check "like" or "dislike" instead. The computer doesn't know if you might be able to deal with a 3 bedroom place with an office if you enter a minimum of four.

I have had clients see three houses and buy the third one. Alternatively, I have had those who looked for about a year before they found "The One." The honest-to-goodness truth of the matter is that there is no magic. There is only preparation. There is only a commitment to learning about enough houses and about ownership to be able to articulate what you want and

need in a manner that a real estate professional will understand. Once you have done that, all you can do—and all you need to do—is to use a tool to communicate this to the professional whose expertise and exposure you will want to leverage so she finds the best home out there for you. So, you have already waved the wand and stirred the pot. Keep waving and stirring and before you know it, you will take that fated step in to the house that responds in a whisper or a shout—"You're Home."

The Savvy Woman's Homebuying Wants & Needs Checklist

Name(s):_____

Name(s):_____

Street Address:_____

City:_____ State:_____ Zip:_____

Home Phone:_____ Cell:_____

Fax:_____ Call prior to sending fax ☐

Email Address:_____ Okay to send listings ☐

Email Address:_____ Okay to send listings ☐

I have decided to move because:_____

I would like to move into my new home by:_____

I am ☐ am not ☐ working with a mortgage broker. My mortgage broker's contact information is:

Name:_____ Phone:_____

I have ☐ have not ☐ been pre-approved for a mortgage loan up to $_____

I rent ☐ own ☐ my present home.

If renting: My monthly rent is:_____. My lease expires:_____

If owning: I do ☐ do not ☐ need to sell my home prior to purchasing my new home.

I do ☐ do not ☐ need to refinance my home prior to purchasing my new home.

My house is ☐ is not ☐ presently on the market / in contract.

My house is listed with:

Agent:_____ Company:_____

Phone Number:_____ List Price:_____

The only thing(s) that would prevent me from buying a home today is:_____

I would describe my present home as:_____

What I like the most about where I live now is:_____

What I like the least about where I live now is:_____

In my spare time I like to:_____

I would describe the home I am looking for as:_____

I will consider living in the following cities/counties/parishes:_____

I will consider (check all that apply):

☐ Condos ☐ Townhouses ☐ Single-family ☐ Co-Op ☐ Multi-family ____# of units maximum

The Numbers:

The maximum monthly PITI payment acceptable to me is: $_____ per month.

I have $_____ cash available for down payment and closing costs. I would like to
use $_____ toward down payment and closing costs.

I will ☐ will not ☐ be interested in properties with HOA's.
The maximum HOA dues I can pay monthly are:

☐ Under $150 ☐ $150-250 ☐ $250-350 ☐ $350-500 ☐ $500-750 ☐ $750+

I think☐ know☐ I would like to look at homes in the following price range: $_____ to $_____

No. of Bedrooms: _____ Min. _____ Preferred No. of Bathrooms: _____ Min. _____ Preferred

Square Footage (Home): _____ Min. _____ Preferred_____ Unknown

Square Footage (Lot): _____ Min._____ Preferred _____ Unknown

Location:

Close to work (max. _____ minute commute)

Work address:_____

Nearby shopping
City(ies):_____

In School District: ☐ N/A ☐ _____(District)

Home Interior Features:

	Must Have	Like	Dislike	Deal-Breaker
Updated Kitchen	☐	☐	☐	☐
Eat-in Kitchen	☐	☐	☐	☐
Stainless Steel Appliances	☐	☐	☐	☐
Granite Kitchen Countertops [or _____ (surface)]	☐	☐	☐	☐
Master Bedroom Suite (with in room bathroom)	☐	☐	☐	☐
Double Sinks in Master Bath	☐	☐	☐	☐
Bathtub	☐	☐	☐	☐
Walk-in Bedroom Closets	☐	☐	☐	☐
Formal Dining Room	☐	☐	☐	☐
Formal Living Room	☐	☐	☐	☐
Family/Rumpus Room/Den	☐	☐	☐	☐
Separate Mud Room/Laundry Room	☐	☐	☐	☐
Fireplace	☐	☐	☐	☐
Hardwood Floors	☐	☐	☐	☐
Air Conditioning	☐	☐	☐	☐
Central Heat	☐	☐	☐	☐
CAT-5 Wiring	☐	☐	☐	☐
Great Room	☐	☐	☐	☐
DSL Availability	☐	☐	☐	☐
Basement	☐	☐	☐	☐
High or Vaulted Ceilings	☐	☐	☐	☐
Garage: _____ car minimum; _____ car preferred	☐	☐	☐	☐
2+ stories or 1 story / flat (circle one)	☐	☐	☐	☐

Home Exterior Features:

Architectural style(s):_____

	Must Have	Like	Dislike	Deal-Breaker
Large yard/no yard to maintain (circle one)	☐	☐	☐	☐
Fenced front yard	☐	☐	☐	☐
Front yard	☐	☐	☐	☐
Back yard	☐	☐	☐	☐
Privacy from neighbors	☐	☐	☐	☐
Patio or deck	☐	☐	☐	☐
Outdoor spa/hot tub	☐	☐	☐	☐
Pool	☐	☐	☐	☐
View:_____(describe)	☐	☐	☐	☐

I entertain often: ☐ yes ☐ no:_____

Things I can **ABSOLUTELY NOT** stand in my home—that I want you to never show me in
a prospective property—are:

Information I will need about a prospective property before making an offer (e.g., distance to subway/
bus, school buses, special educational needs, city taxes, etc.):_____

The five most important features I want in my home—in order of their importance to me—are:

(1) _____

(2) _____

(3) _____

(4) _____

(5) _____

The following children will be living in the home being purchased:

Child's Name:_____ Age:_____ M F

Child's Name:_____ Age:_____ M F

Child's Name:_____ Age:_____ M F

Child's Name:_____ Age:_____ M F

The following pets will be living in the home being purchased:

Name:_____ Type:_____ ☐ Indoor ☐ Outdoor

Name:_____ Type:_____ ☐ Indoor ☐ Outdoor

Name:_____ Type:_____ ☐ Indoor ☐ Outdoor

Name:_____ Type:_____ ☐ Indoor ☐ Outdoor

The following number & types of vehicles will have space requirements:

(1) ☐ Car ☐ Truck ☐ RV ☐ Boat

 Parking Required: ☐ Garage ☐ Carport ☐ Driveway ☐ Street

(2) ☐ Car ☐ Truck ☐ RV ☐ Boat

 Parking Required: ☐ Garage ☐ Carport ☐ Driveway ☐ Street

(3) ☐ Car ☐ Truck ☐ RV ☐ Boat

 Parking Required: ☐ Garage ☐ Carport ☐ Driveway ☐ Street

The following ADA-type accommodations (e.g., ramp, wide doorways, etc.) are preferred/required
(circle one):_____

Chapter 7

Contracts & Negotiations: How to Get Into Contract Without Losing Your Mind—or Your Shirt

In real estate, everything is negotiable. Everything. A mentor of mine ("Mentor") used to tell a story which perfectly illustrates this point, about a buyer-client ("Buyer") who was shopping for a tract home in San Diego some years ago, in what was then a strong buyer's market, created by tons of homes on the market and 14 percent-plus interest rates. Mentor showed Buyer four or five virtually identical homes—same model, same subdivision, very cookie cutter. Buyer dismissed one after the other until the last one, which was not customized or upgraded or distinguishable in any meaningful way from the rest. About 10 minutes after walking in, Buyer declared, "I want this one."

Mentor asked, quizzically, "What is it that you like about this one compared with all the others?" Completely straight-faced, Buyer answered, "I like the dog." Mentor said, "Errrrm, uh, okay, but you know the dog doesn't come with the house." In an instant, Buyer's facial expression shifted from surfer-dude ennui to laser-beam intensity, furrowed brow and all. Peering at Mentor through squinted eyes, Buyer slowly stated, "I. Want. That. Dog. Write the dog into my offer." In a bizarre demonstration of the mind-bending effect that real estate market forces can exert on otherwise normal humans, the sellers agreed to sell the house to Buyer, dog included.

While the mere idea of reading (much less drawing up and negotiating) an intimidating

contract where hundreds of thousands of dollars are at stake can cause palpitations in even the savviest of folk, the dog story illustrates the essence of the contract and negotiation phase of your homebuying experience. It's not just about "whereas"-es and "the party of the first part" and all that legalese nonsense (which, thankfully, has pretty much been obliterated from most states' standard homebuying contract forms anyway). What contracts and negotiations are all is about a meeting of the minds—both sides coming to an agreement as to the terms on which the transaction will take place and documenting that agreement in writing.

Once you have a contract, the escrow and closing process flows simply and naturally from the meeting of the minds. "Escrow" refers to both a period of time and a sequential process of multiple acts by you and the seller, across which both sides deliver on the promises they made to each other in the contract. As the buyer, there are also a number of logistical items you will handle during the escrow time frame to get ready to own your home. And closing is that final exchange envisioned by the contract—the deed and the keys (from Seller to you) for the money (from you and your lender to the seller). All your work, from creating your Vision, to shifting into the mindset of a homeowner, to mastering money matters and the house hunt—culminates in closing. But to get to closing, you've got to get the house.

Legal-Ease

Ideally, you'll review your state's form contract before you find the property of your dreams. Most buyers' eyes glaze over and the printed words mean very little once they've already found their home. Reading it before making an offer gives you a chance to ask questions and get answers from your Realtor when you're not in the heat of the moment. Ask your Realtor for a copy of your state's form purchase contract, and review it while you're in a cool, calm and collected state of mind.

A Contract by Any Other Name

Making an offer. Writing the contract. Placing a bid. There are as many ways to say it as there are house hunters and Realtors. Making an offer is as simple (hah!) as (a) putting the price, terms and conditions on which you are willing to buy a particular property on paper, and (b) communicating that price and terms (a.k.a. your "offer") to the seller.

Your Realtor will handle the actual putting of pen (or printer ink) to paper, to document the offer you want to make. Almost everywhere nowadays, your offer to purchase will be made on a standard, computerized purchase agreement form also known as the contract. In most states, these forms contain lots of standard, boilerplate verbiage that is built in to protect the legal rights of you, the seller and the Realtors, and lots of places where your Realtor will need to fill in the blanks—those are usually the most important terms, because those are the ones which reflect your particular wishes regarding that particular property. You'll hear me (and your Realtor) interchangeably call this single document your offer and the contract. Your Realtor putting your intentions on the form and you signing it creates your offer. Once the seller agrees to your terms and signs your offer (or a counteroffer incorporating your offer), the same document we once called your offer magically morphs into the contract—the agreement between you and the seller. Voila!

Insider Secret

DON'T ASK, DON'T TELL

While staying aware of what people are talking about when it comes to real estate in your area, you should stay away from relying on the advice and opinions of your Aunt Barb, your buddy Pam, and even the non-real estate professionals in the media who so freely express their opinions on all things real estate. If you have any lurking fears, it is very easy for negative opinions ("you're paying how much for that?!??!") and seeds of doubt ("personally, I'd never buy in this market/that subdivision/that neighborhood/that town/this day and age, but good for you!") planted by others to blossom into the sort of self-doubt, excuse-making, and procrastination that has kept many a Savvy Woman from enhancing her life and wealth through property ownership.

Your best bet is to simply not tell people what you're paying, or the price range you're looking in, or anything like that unless you know that they will support you 110 percent. A particularly Savvy Woman buyer of mine recently asked if I could email her the exterior photo of her home by itself (i.e., separate from the listing), because she wanted to share her excitement at buying with her family, but avoid the drama that she knew sending the listing to her family–complete with price, etc.—would create.

What to Expect When Making an Offer – The Sequence

Homebuying is too major of a transaction—for both buyer and seller—to be a cookie cutter-type deal. Every single homebuying transaction progresses a little differently, but there is a basic sequence of events you can expect to occur, more or less, when you make an offer to purchase a home. Just keep in mind that there may be some variations in the order and substance of the sequence based on your individual situation and/or the standard practices in your local area. For example, items 1-8 might get mushed together, all occurring in a two-hour period in person at your Realtor's office, or in absentia over a weeklong series of phone calls, emails and faxes. Once you get an overall picture of the process involved in making an offer, we'll break the offer process apart and drill deeper into what you need to know for some of the individual offer negotiation steps.

(1) You will tell your Realtor that you'd like to make an offer to purchase the home;

(2) Your Realtor will interview the listing agent to ascertain the seller's motivation level, particular needs or special issues;

(3) Your Realtor will prepare and provide you with a Comparative Market Analysis, (CMA) checking the most recent available market data specific to "your" property;

Insider Secret

MORE MONEY (IN YOUR PRE-APPROVAL LETTER) = MORE PROBLEMS

If you are pre-approved for more than the amount you are offering to pay for the property, you should ask your mortgage professional to provide you a new pre-approval letter that states you are pre-approved for exactly the amount you are offering. A higher pre-approval amount can "inspire" the seller to ask you for more money. And, no, they won't assume that you can't really afford the property if your letter states the exact amount of the price offered. The listing agent will let them know that your professionals knew what they were doing!

(4) Using information from the listing agent interview and the CMA, your Realtor will formulate, present and explain to you a recommendation as to the price and terms you should offer;

(5) You make the ultimate decision as to the details of your offer and communicate them to your Realtor;

(6) You review the seller's disclosures, including pre-contract inspection reports, if any disclosures or reports are available. Depending on standard practices in your area, you might actually sign the disclosures at this time. You'll learn all about inspection reports and disclosures in the next chapter;

(7) Your Realtor may request a custom pre-approval letter from your mortgage professional, specific to the address of the property and the purchase price you are offering.

(8) Your Realtor prepares the paperwork, and you sign the offer and accompanying papers;

(9) You write a check (usually payable to your escrow company or closing attorney) for your earnest money deposit for inclusion with your offer;

(10) Your Realtor presents the offer, in whatever manner specified by the listing agent: in person to the seller and the listing agent, in person directly to the listing agent, or to the listing agent via email or fax;

(11) You await—and receive—the Seller's response: counteroffer, acceptance, or rejection;

(12) **OPTIONAL** Should the seller's response be a counteroffer, then you formulate and communicate your response—counteroffer, acceptance or (unlikely) rejection. The counteroffers can continue back and forth indefinitely until either you or the seller accepts or rejects a counteroffer outright.

True Story - Gone in 60 Minutes

Different markets move at different speeds, and your Realtor will set the pace for your transaction. If you live in a major metro area, or you are looking to purchase a hot property, you may need to kick things up a notch. When you make an offer to purchase a home, take charge of the transaction and shorten your nail biting period by putting the seller on a tight time frame.

Unless there's a good reason he or she can't get an answer back to you quickly (e.g., Seller lives out of state, Seller is elderly or sellers are a corporate or large family group), you should give the seller four to eight business hours max to respond to your offer. [Note—Small town or rural markets may not bear such a short time frame.] Why so little time? Well,

(1) You want to create a sense of urgency, the feeling that if the seller doesn't give you an answer soon, you'll be moving on to other properties;

(2) The longer they have to mull it over, the more likely sellers are to talk themselves into pushing back with a counteroffer for more money or a shorter escrow or whatever; and

(3) Listing agents with one offer in hand have been known to call all the other buyers' agents who have shown the property and let them know that an offer has been made, in an effort to generate multiple offers from fence-sitting prospective buyers. The less time your offer is open, the more likely the seller's agent will be to spend her time trying to sell the seller on your offer—the bird in the hand—and the less likely she'll be to spend that time tyring to flush out that elusive bird in the bush.

One of my Savvy Woman clients had worked with me to create a very compelling offer on a property. The market had just softened on its way from a seller's to a buyer's market, and the average number of days that properties were sitting on the market had tripled over the year prior to her house hunt. However, the property she chose was in pristine condition and in a very desirable district of town. I knew we were up against one other offer, so we made a very nice offer, about 10 percent over the asking price. The seller made a counteroffer, and we accepted, but we still lost out to the other buyer.

About three days later, I got a call from the listing agent letting me know that the victorious buyer had already backed out of the deal, due to no fault of the property or the seller! So we seized the chance, verbally re-negotiated terms, and sent our offer on over—at the same price, even though we were the only offer at that time, simply to prevent the seller from balking long enough for others to figure out the peachy property was back on the market. The seller stalled and issued a counteroffer on price and some other minor details. We agreed to everything but price. The seller came up with some other penny-ante demand, and in that counteroffer again tried to ratchet the price up. We were already at my client's max, so we refused, but verbally

agreed to all the other term changes, and I let the seller's agent know we'd be sending our counteroffer back at the same price. While I was relaying faxes to and from my client to get her signature on the counteroffer, I got yet another call from the listing agent claiming that several other Realtors were showing the property, and one was promising (threatening!) to write an offer that day. It was 11 am when I got that call. I called my client up and told her to speed that signed counteroffer back to me—we were going to keep our counteroffer open only until 12 noon.

At 11:50, I received the signed counteroffer back from the listing agent. We were in contract at the price my client agreed to pay—above asking, but within my client's zone of affordability, monthly payment-wise. A few days later the listing agent informed me that there was a backup offer in place, but couldn't ethically disclose the price or terms of that offer. When we closed the deal 21 days later, the listing agent pulled me aside and confided that the other Realtor who had threatened to write an offer the day ours was accepted, had actually made the backup offer. At 2 pm—just two hours after our offer would have expired—the seller received another offer to purchase the property for $30,000 more than our offer!

If we hadn't put the seller on such a short time frame, she would have hemmed and hawed until the other offer was made, a bidding war would have ensued, and my client probably would have lost her dream home, because she was already at the top price she could pay. Setting a short time frame for the seller to consider your offer can save you thousands of dollars, and may even be the difference between being the sole offer and getting outbid and losing the home entirely!

What Should I Offer?

A purchase offer is not just about price, it is a constellation of connected factors. Before you can start figuring out what you should offer per se, you need to know about the factors which make up an offer. The forms and the terms offers call for vary widely from state to state, but virtually every state's form residential purchase agreement will contain the following terms, at a minimum. We call them material terms because an offer to buy a home, without any one of these terms, would not present the seller a complete picture of the transaction you propose:

Universal Material Offer Terms

Address – Obviously, you'll want the seller to know what property you'd like to buy;

Purchase Price Offered – How much you are offering to pay the seller, and how you plan to finance that amount (e.g., mortgage or seller financing, etc.);

Earnest Money Deposit Offered – The seller can tell how serious (and how well qualified to secure financing) you are, in part, based on how much cash you are willing to deposit up front;

Close of Escrow Date (a.k.a. COE) – When do you plan to close escrow? This can range anywhere from 15 days to 60 days+ if you need a mortgage in order to close the deal. Lots more about this in the next chapter;

Occupancy – When will you need the seller to be out of the property? The same day you close escrow? Or will you allow a slower seller to do a rent-back, moving out a few days or weeks after COE and paying your prorated mortgage payment for every day they stay in after closing;

Personal Property Included/Excluded – Are you asking the seller to throw in anything that's not attached to the property? Furniture, appliances, plants, cars, children, etc.? Are you asking them to take anything that is attached? See the section on Personal Property, below;

Allocation of Closing Costs – Most contracts have a column or row of checkboxes that lists the various closing costs, inspections, reports, and governmental requirements (e.g., low-flow plumbing retrofits, termite fumigations—whatever, if anything, is required in your area) and designates which party to the contract—buyer or seller—will pay which costs. All these details and costs involved in closing the sale of your house will be addressed in the next chapter about escrow procedures;

Insider Secret

WHAT'S UP WITH ALL THE 8s?

If the list price of your property ends in 888, chances are that the home's seller or the listing agent is of Asian descent (or adheres to an Eastern belief system). The number 8 is very auspicious (i.e., good) in some Asian spiritual traditions; even if you are not offering the full asking price, try to fashion your offer to end in 8s as well—demonstrating your respect for the seller's culture and values is a brilliant way to get the relationship off on the right foot!

Contingency, Objection or Option Period – You will have a period of time during which you can investigate the property and finalize your financing before the deal becomes final and your deposit money is subject to forfeiture. In some areas, you have to proactively remove contingencies—telling the seller your investigations are done, financing is secure, and you are waiving your right to back out and get your deposit money back. In other areas, the standard is an objection or option period. If you don't object to something about the property or tell the seller that you can't get financing within a certain period of time, you are presumed to be moving forward and your deposit money is forfeited to the seller if you back out after that time. In your offer, you can select the length of this contingency removal or objection/option period;

Dispute Resolution Provisions – You will have the opportunity to elect, in advance, some alternatives to litigation in the event a dispute should later arise between you and the seller. The most frequent alternative dispute resolution methods offered are:

- **Mediation** – Agreeing to have your dispute heard by a mediator, usually a lawyer who has been trained to help folks resolve their problems informally;

- **Binding Arbitration** – Agreeing to have a retired judge hear and decide your dispute. Arbitration is less costly and less-time consuming than going to court. However, some people think it's slightly harder to predict how an arbitrator will decide. By agreeing to binding arbitration, you also give up some of your legal rights to discovery. There is no appeal from a binding arbitrator's decision like the appeal rights you would have if you litigated in a traditional court;

- **Liquidated Damages** – Agreeing that if you breach the contract (i.e., you back out of the deal after you've removed contingencies or your objection period has expired), the seller will accept your deposit money to cover her losses due to your breach (vs. taking you to court and having to prove how much her losses were).

Personal Property

The standard rule is that when you buy a home, the building is presumed to come with all fixtures—items that are attached to the building. Then there are other items that are presumed to come with the property, because they are necessary for the property to function they way it did when you saw it. There are items which you might think would come with the property, but don't, unless you specify them in the contract as personal property you would like to keep. And, finally, there are items which are often left behind by sellers which you may not want—things you should consider expressly excluding in your offer.

Just So You Know – Any appliances, furnishings, etc. that you ask the seller to leave behind will transfer to you without any warranty by the seller—only still-valid manufacturers' and retailers' warranties, if any, will apply.

Drama-Prevention Strategy – If you are asking the seller to leave behind items of personal property that have a high monetary value, like cars, snowblowers, etc., make sure you check with your mortgage professional before you submit your offer. Some lenders will later refuse to extend a mortgage when the purchase price was intended by the parties to cover the home plus something other than real estate.

Personal Property – Would You Like Speakers With That?

FIXTURES & NON-FIXTURES THAT ARE PRESUMED TO BE INCLUDED*	ITEMS YOU SHOULD EXPRESSLY INCLUDE, IF YOU WANT THEM (EVEN IF THE SELLER OFFERED THEM IN THE LISTING!)	ITEMS YOU SHOULD EXPRESSLY EXCLUDE, IF YOU DON'T WANT THEM
Lighting, plumbing, electrical fixtures (e.g., faucet handles).	Surround sound speakers wired to house (wires are fixtures, speakers are not).	Debris in house, garage, backyard (if there's a lot of stuff, just say "debris" – if there are particularly troublesome items, like oil drums or oil cans – name them item-by-item).
Ceiling fans & their remote controls, if any.	Furniture (indoor and outdoor).	Full or partially full paint cans (unless you want some paint for touchups). These items are hazardous materials and can be hard to dispose of later.
Fireplace inserts, gas logs & grates & their remote controls, if any	Outdoor benches, statuary, pottery, potted plants.	Old cars that are parked on the grounds but appear not to function.
Built-in appliances (including SubZero-type refrigerators, non-portable dishwashers, water softeners and purifiers).	Non-built-in appliances (e.g., refrigerator, plasma or big screen TV, washer & dryer, commercial/free-standing oven/stove range).	ANYTHING and EVERYTHING – furniture, clothing, dishes – whatever is still on the premises if the property is unoccupied when you go see it.
Window coverings (e.g., shutters, blinds, awnings, curtains).	Snowblowers, pool & spa equipment, and other property maintenance tools.	
Floor coverings.	IKEA-ish or Rubbermaid-type storage units.	
Stuff that is screwed into the roof, like satellite dishes, TV antennas and solar energy systems.	Outdoor storage sheds and portable buildings.	
Garage door openers & remote controls.	Window or portable air cooling/conditioning units.	
Mailboxes	*Special* window treatments & hardware (they should be left, but often aren't, so make sure you list them if you want them).	
Security systems & alarms.	*Special* lighting fixtures, like chandeliers (they should be left, but often aren't, so make sure you list them if you want them).	
Built-in air conditioners or coolers.		

Use this guide to help you make sure you get what you want, and only what you want.

Tara's Five Things Every Homebuyer Should Know about Contracts

(1) *It Ain't Over 'Til Both the Buyer & Seller Sign* – There are only three possible sequences in the whole wide world that can unfold between the time you make an offer on a home and the time you get "into contract" with the Seller:

(2) *Offer – Acceptance* – You make an offer and the seller accepts your offer, exactly as you made it. This is called the mirror image rule, because the terms of the offer and the acceptance must be precisely identical. If the seller's response includes even a single change to your offer, then the seller's response is a counteroffer (see below), and you are not in contract.

(3) *Offer – Counteroffer(s) – Acceptance* – You make an offer and the seller agrees to some, but not all, of your terms. So the seller sends you another document called a Counteroffer, which is the equivalent of the seller saying, "Buyer, I don't accept your offer, but I will if we can make the following changes to it: X, Y, and Z." That counteroffer is, really, just a new offer from the seller to you. You can either accept the mix of terms from your original offer and the seller's counteroffer, or you can propose changes to some of the seller's counteroffer terms with your own counteroffer. There is really no limit to the number of counteroffers that could go back and forth between buyer and seller. Whichever party receives a given counteroffer is in the position to accept that counteroffer at any time before it expires or is revoked or another counteroffer is issued. As soon as the receiving party accepts the last counteroffer, the "contract" has been "ratified" (meaning that you are in contract to buy the home, and no one else can buy it).

For example, you might offer to pay $350,000 for a home, with escrow to close in 45 days and, among other terms, the plasma screen television over the fireplace to be included in the sale. The seller could issue a counteroffer agreeing to all other terms but price (countering at $375,000) and length of escrow (countering at 30 days). In turn, you could either agree to the seller's counteroffer, or issue another counteroffer at $365,500, but excluding the plasma TV from the sale. The seller can either accept these latest terms or issue a counteroffer, and so on, ad infinitum.

(4) *Offer – Rejection or Expiration:* The seller can flat out say "no" to your offer, without countering back any different terms. (This usually happens when the seller has accepted another offer, decided not to sell at all, or views your offer as so far off-

base or insulting that they don't care to even attempt to revise it into acceptability.) Your offer will include some sort of expiration date—either a standard pre-printed time frame during which your offer will remain open (usually about three to seven days from the time the offer is made), or your Realtor will insert a time frame ranging from several hours to several days. The seller can simply allow that time frame to lapse, so that your offer expires—it's pretty rare, but it is possible. (If the seller plans to let time lapse on your offer, the seller's agent will usually call your agent and let them know that no response is forthcoming.)

True Story - Our Lady of Perpetual Negotiation

Some sellers just like to feel like they are hard bargainers. They can turn an offer you thought they couldn't refuse into a back-and-forth the likes of which you haven't seen since the last time Venus played Serena. No matter how much you offer, they want more. Or they want to pay fewer closing costs or to have a shorter or longer escrow, a legitimate reason for feeling like they are in a superior position of bargaining power.

With these types of people, you'll want to pick your battles and stick to your guns. By this I mean, know what your absolute deal breakers are—and aren't—and don't fuss over penny ante items, but also don't bend beyond the boundaries of what works for you. If you do, you're very likely to see them just keep on pushing. And unless there is hot competition for the property, if you give a little to them before you put your foot down, chances are good that you'll end up victorious!

A while back I represented a Savvy Woman who wanted to go see a very luxe duplex in a super chic part of town. The market, however, was in the middle of transitioning from a strong seller's market to a moderate buyer's market. The place was listed at $769,000, but because of the company with whom it was listed, I knew that we should expect to pay at least three to five percent more than that if we wanted the place. It was the very first place my client looked at, but it was perfect, so she elected to move forward and make an offer. We made an offer of $800,000 with $10,000 closing cost credits to my buyer, and a 14-day contingency removal period. When the listing agent informed me—and my spies in her office confirmed—that there was another, strong offer, we increased our offer to $800,000 with no closing cost credits and shortened our contingency removal period to eight days. The seller countered back at $830,000 and asked for no loan contingency and only five days to remove all other contingencies.

Well, now, my client was maxed out monthly-payment wise at $800,000. And, as we'll discuss later, I think it's crazy to make an offer with no loan contingencies unless you're paying cash,

which my client wasn't. And both my lender and appraiser said there was no way they could get final answers in five days, because two of those days would be the weekend. So, we countered at $800,000, with a loan contingency, but shortened the contingency removal period to six days, and expressed that this was our final offer. A half hour later, the listing agent called saying that her client agreed to all our terms, except the $500 home warranty—she didn't want to pay for that. Well, then I knew that this negotiation was more about principle than about money. This particular seller just had a need to feel like she was getting a good bargain—whether her negotiations got her an extra $30,000 or saved her $500. So, in the name of picking our battles wisely and creating a win-win, the listing agent and I agreed to split the cost of the home warranty, so neither the seller nor the buyer had to come up with it.

Bottom Line: You have to be like the protagonist of that Kenny Rogers song. Know when to hold 'em, when to fold 'em, when to walk away and when to run. And always refuse to overextend yourself (Kenny didn't mention that in the song). Everything is not worth fighting over, but you should draw the line at paying more than you can afford. You might just call the seller's bluff, and end up with your dream home anyway!

Acceptance Defined

In order for an acceptance (of an offer or counteroffer) to be valid, the person accepting the offer must communicate the acceptance to the other person. The seller can't just sign the offer and put you in contract; he or she must sign and either fax or email or mail or courier or somehow deliver the signed contract back to you (or your Realtor). There are lots of picky little arcane legal rules about exactly when acceptance has been communicated, but in practice, the two Realtors will have made an advance arrangement about how acceptance will be communicated at the time the offer was sent over to the seller's Realtor. 99.9 percent of the time, the seller's agent will simply pick up the phone and call your agent to let her know as soon as your offer has been accepted; your agent will do the same once you have accepted a counteroffer.

Until your offer (or a counteroffer) is accepted and acceptance has been communicated to the other side:

- The seller may continue to keep the place on the market, and another buyer could make an offer;

- The seller could make a counteroffer;

- You may revoke your offer;

- You may revoke your offer and make an offer on another property;

- You may revoke your offer and make another, different offer on the same property; or

- You may submit an Addendum to the seller that supplements or changes the terms of your original offer (e.g., increasing the price).

Insider Secret

BE QUICK ON THE UPTAKE

It is critical to respond to counteroffers as soon as possible, and to avoid making a counteroffer as to any term that is not truly a deal breaker. Delays in responding leave space open for another buyer to step in and create a bidding war, or even more likely, for the seller to perceive that other, serious buyers might be out there—a seller's mere perception of a hint of a whiff of the scent of a potential bidding war is a homebuyer's number one nemesis, ratcheting up the possible sales price in the seller's head on an exponential basis.

The same real estate "logic" that made the sellers in Mentor's transaction think it was perfectly okay to throw the beloved family pooch into the deal can make Sellers do crazy things like counter the only offer they received to increase the offered price by $50,000, or reject great offers out of hand so they can wait to see what happens after the Sunday Open House. Spare yourself some drama and:

- *Don't let your offer stay open very long* – one business day is more than enough time, unless your Realtor says that it is bizarrely short in your market (or unless the listing agent specifies that they need more time than that to respond, because the seller is a company, a large group of people, elderly, ill, or located out of the area);

- *Respond ASAP to any counteroffer(s) you receive;* **and**

- *Don't make counteroffers to change petty terms* – if you can live with the deal created by the seller's counteroffer, accept it and get on with the purchase of your new home.

A Contract by Any Other Name. . .

In a state like California or New York, you may sign anywhere from 40 to 140 different documents in the course of buying your home. In other states, like Alaska, you might get through a whole transaction with only a few documents. However, only a small number are actually part of the contract between you and the seller:

- The contract itself;
- All counteroffers; and
- Addendum (plural: addenda) – An addendum is simply a piece of paper which documents changes you and the seller agree upon after you strike the original agreement. These most often take the form of price reductions, extensions of time for you or the seller to fulfill an obligation, credits to you to cover needed repairs your inspectors discover, or changes in the timeline (extensions of escrow, etc.).

The 95 million other forms exchanged back and forth with the seller during escrow are disclosures that the seller and both Realtors use to communicate who's who, your legal rights and obligations, and material facts about property. Later in this chapter, you'll learn what to look for when you receive disclosures.

It Takes Two

Even after you get into contract, EVERY document needs to be signed by both you and the seller. Every counter, every addendum, every disclosure, every EVERYTHING gets signed by everyone.

The No Handshake Rule

There's no such thing as a "verbal" agreement when it comes to real estate. No matter how small the item being discussed—a couple of extra days to close escrow, the seller's agreement to replace a window, whatever—get it in writing or don't count on it!

Everything Is Negotiable

Remember the dog story? You can ask for anything. By the same account, the seller can always say no to anything you ask for. The more you ask for, and the more outrageous your requests, the more likely you are to upset the seller and negatively impact your working relationship with him or her. Keep your requests reasonable in nature and few in number, and you'll have much more co-operative and less stressful transaction!

Insider Secret

CUTTING IN THE MIDDLE(WO)MAN

When you want to ask or tell the seller something, always always always go through your Realtor, who will communicate your request or concern to the seller's agent. I know it seems inefficient, but it is truly a rookie move to contact the seller directly—it's just not done, mostly because the terminology is tough to master and legally sensitive. Also, some seemingly innocent and minor changes to your agreement with the seller might create problems with your lender; your Realtor is better equipped than you to see these red flags. You hired your agent, so use her! It will prevent the catastrophic misunderstandings (read: drama) that can result when you or the seller says something even slightly different than what you each actually mean!

Insider Secret

DEALING WITH A BUILDER/SELLER

A lot of this talk about negotiating and price and terms, etc. is moot when you're buying a newly built home. By and large, the builder/developer dictates the terms on which they will sell you a home in their community, and you either take it or leave it. The list price is the price you pay (but the flip side is, you don't have to pay more or compete with other buyers). The builder will have a standard contract with a standard required deposit, standard contingency removal or objection periods, and a standard set of disclosures that they make to every buyer. The larger the builder, the more set they will be in their ways and to their price. The upside is that builders hate getting sued, so they generally try to create a standard contract that affords you most or all of the same protections your Realtor would build into a contract for you.

Making an Offer – The How To's Examined

Having previewed the lay of the land and with some of the "What to Expect" under your belt, the time has come to drill down into the more detailed "How To"s of the individual phases of making and negotiating your offer to buy a home.

Formulating an offer is not a precision endeavor. Unless you are buying a new home, or a home or unit in a development where identical units have sold very recently, there is definitely an element of crystal ball-style prognostication involved in trying to make an offer the seller is likely to accept without paying more than you have to for your home. It's not a total guessing game, though; there are some basic steps you and your Realtor can take to arrive at a price range and other terms that make sense.

Step 1: Comparative Market Analysis

A CMA is the most widely used, reliable, and mathematical method of estimating the true value of "your" property, and works just like comparison shopping. A CMA distills your property into its essential characteristics—namely, bedrooms, bathrooms, home and lot square footage—and compares it with nearby homes that have similar characteristics which are currently on the market or have recently sold. Specifically, your Realtor will get into MLS and search for properties with:

- With a similar number of beds, baths and square feet (give or take a little);

- Which are currently on the market (status: active), currently in escrow (status: pending), or have closed escrow (status: sold) within about the last 6 months; and

- Which are located within a ½ to 1 mile radius around the property you're considering buying.

The CMA report your Realtor prepares will list the status and specs of each of the comparable properties (comps), the list price, the sales price, and the number of days the property was on the market (DOM), and will probably also provide some calculations such as high and low sales price, average sales price, and price per square foot ($/ft2).

Look for:

Sold Price, Not List Price – Pay special attention to the difference between the list prices and sold prices. Active and pending properties can provide interesting insights, but these properties' MLS entries will only contain their list price (the sales price of pending properties is not reported on MLS until the property actually closes escrow).

Remember, the list price is merely an asking price, while the sold price is the price a buyer actually paid for a property that actually closed escrow. For that reason, the sold comparables have the most informational value and relevance of all the comps in your CMA.

Insider Secret

THERE'S NO PATENT ON PENDINGS

When the sold comps aren't that similar or sold a long time ago, or there is a very similar pending comp, you can go nuts wondering what price the buyer of that pending comp agreed to pay for the place. Sometimes the listing agents of pending comps can be sweet-talked into giving up the dirt. Your Realtor can call them up, explain the situation, and ask—obliquely—for contract price hints, like "Did it sell for over (or under) asking? About how far over (or under)? What was the list price to sales price ratio? And how much competition was there—did you have multiple offers?" And you can also make some educated guesses; the longer it was on the market, the less likely it sold for the asking price. The opposite is true, too—if it went off the market really quickly, it probably sold at or over the asking price..

Adjusted Average Sales Price – The most basic way to use a CMA to gauge what you should offer on your house is a three-step process. First, you get the outer limits of a range of prices by throwing out any extreme comparables in each direction (e.g., the homes that are overly upgraded or waaaaaay nicer than your place and the total tear-downs) and taking the highest and lowest sales prices. (As an aside, that highest sales price is probably pretty close to the maximum value that your home will appraise for.) To narrow the range, your second step is to average the sales prices of the comparable properties—add them all up, divide the sum by the number of comparables, and the result is the average.

Then, the average sales price needs to be adjusted upwards and/or downwards based on how the comparable properties compare with the property you want to buy on each of the following items:

- Are the units or lots smaller or larger?
- Same number of beds and baths?
- Are they similarly upgraded with similar features?
- Are they similarly located?
- Were the sales recent, or were they quite awhile ago?

In real life, your Realtor will conduct this analysis for you. And they will have the expertise to gauge how much—and in which direction—to adjust the average for square footage location, or the recency of the sale. But I want you to understand the rationale behind it, so you can walk through the numbers yourself and have some basis for that subconscious reality check we all like to do. If the numbers don't make sense to you, see if you can locate the logical problem in the CMA. If you don't find any inconsistencies or mistakes in the CMA, that's your clue that you're probably just freaking out because of the momentous purchase you're considering. This is normal, so sit with your freak out for a moment—take a deep inhale and exhale, then keep on truckin'.

Degree of Similarity between Your House and the Comps - All these averages don't matter much if the properties are not really that similar to yours. This is the biggest drawback to rough-and-dirty web CMA sites like Zillow.com—they get their essential specs for your property and the comps from the public records, which are often incorrect, and so they can't adjust for a house that has a huge addition, or is in an inferior location (e.g., on top of the railroad tracks), or is simply very different from neighboring homes. Also, if your market took a major upswing or downturn three months ago, the six-month-old sales won't be nearly as strongly predictive of the value of "your" home. Your Realtor will have adjusted the averaged sales prices of less similar comps in order to approximate the value of your home and the purchase price you should offer to pay, and adjustments can be imprecise.

On the other hand, the sales price of even one recent very similar comparable property can be highly predictive of the market value of the home you're considering. A highly similar comparable is one which lines up closely with the home you're looking at on the following criteria:

- *The Basics* – Beds, baths, square feet of living space and lot size;

- *Features & Upgrades* – Garages, gourmet kitchens, additions, backyards, etc.;

- *Condition* – Total fixers aren't comps for homes in undisputed move-in condition;

- *Location* – If one abuts a greenbelt and the other borders a 24-hour multi-cine-plex parking lot, they aren't that similar.

The outcome of your CMA should be to narrow the infinite world of potential prices to:

(1) A definite range of prices, with clear upper and lower limits, which reflects the realm of realistic prices an average buyer would pay for the home and realistic appraisal values for the home; and

(2) A tentative target price within that range, provided by your adjusted average sales price.

Insider Secret

THAT'S NOT A COMP!

The more money you offer, the more likely the seller will accept. Your Realtor only gets paid if the seller accepts, so you can see why some Realtors tend to include or emphasize the highest priced comparables, even if they aren't the most similar comps for your property. Ask your Realtor for a copy of your CMA, and ask for the full MLS listing details of the several most similar comparables. That way, you can decide for yourself how similar they really are!

Step 2: Market Trends

Getting a feel for the fair market value of your potential home-to-be from a comparables approach is the critical first step to determining the purchase price to offer for the place. From there, you'll need to take into consideration the trends affecting the real estate market in your region, city and even neighborhood, in order to narrow the offer price range even further.

Buyer's Market vs. Seller's Market – Whether your area is currently in a buyer's market or a seller's market can have a great impact on the price and other terms you offer. How can you tell whether your home is in a buyer's market or a seller's market? The short answer—you'll know. Real estate now rivals weight loss, Brangelina, and Suri Cruise as an obsession for Americans, and you'll hear everyone around you—from national and local journalists and pundits to the watercooler crowd and your book club buddies telling stories of their real estate experiences. Though this is a very unscientific and anecdotal method of market analysis, hearing multiple people spin similar tales can accurately indicate the direction in which the market is leaning. For example:

○ Stories about buyers who had to make 10 or 12 offers before getting one accepted → seller's market;

- Stories about homes for sale which received five or nine or 81 offers (yes—I once represented a buyer who had to compete with 80 other buyers to buy a property, and it was a fixer-upper, no less) → seller's market;

- Stories about buyers getting great deals on homes that had been on the market for a long time → buyer's market;

- Stories about buyers having a ton of fabulous homes in fabulous condition, right in their price range, to choose from → buyer's market;

- Stories about buyers getting sellers to do a lot of work to the property after contract → buyer's market;

- News stories reporting a sharp increase in previously low foreclosure rates may indicate a seller's market that is transitioning into a buyer's market (sellers who were expecting to be able to sell their homes very quickly waited until they were in too deep and then couldn't get the home sold before the bank foreclosed).

However, anecdotal evidence is seen as unreliable for a reason, um, because it is. First, the stories you hear are always filtered through the teller's screen of their own biases and often limited understanding of market dynamics. Second, what may be true in your overall market may not be true for the particular neighborhood, district or the price segment in which you are house hunting. Plus, many of our markets are in transition right now—lots of coastal markets are changing from seller's market to buyer's market, and many previously undervalued, heartland and southern towns are experiencing an unprecedented shift into a seller's market. When these sorts of transitions happen, it can be tough for the average Joe on the street (and the stories they tell!) to catch up with the new reality of the market.

In order to get a more accurate picture of what is going on in your market right now, and how that might affect the price and terms you offer, ask your Realtor to walk you through the following, less obvious stats that are available on MLS, in your CMA and sometimes on your local Association of Realtor website. You'll want to know them for both your entire town and for the immediate one-mile radius immediately surrounding the property's address:

Competition – How many active homes are presently on the market? How many meet your search criteria? Look at your CMA and see how many active comparables there are. Lots of homes mean lots of supply, an indicator of a buyer's market. Of course, the number of homes that constitutes "a lot" in any area is relative to the historical norm, so you may need to ask for your Realtor's experienced opinion as to whether the current supply of homes on the market is plentiful or scarce compared to normal;

Average Number of Days on the Market (DOM) – If homes in your area routinely sell within a week or two, your area is likely a seller's market. If they often stay on 60 days or more, you are most likely in a buyer's market. The longer homes stay on the market, the less power sellers have in that market. Definitely check this number specifically for the one mile radius surrounding your property—different neighborhoods in the same town or towns in the same metro area can have drastically different DOM averages

Seasonal Issues – The general rule is that the better the weather gets—especially in areas with extreme winters—the more buyers are out there house hunting, driving up demand. Conversely, no one really wants to sell or move during the winter holidays, so the sellers whose homes are on the market usually have to move for some reason. High seller motivation can present great opportunities for buyers.

Higher Interest Rates – Rising interest rates don't really indicate a buyer's market, but they can create a buyer's market by causing other buyers to (unwisely) delay purchasing. Since the two sometimes go hand in hand, higher interest rates, along with some of the other indicators of a buyer's market, may indicate that you have pretty good bargaining power;

Average List Price to Sales Price Ratio – This is just a fancy schmancy way of figuring out whether homes sell for above or below the asking price. If a home sells at exactly the list price, then the list price to sales price ratio (LP:SP) is 100 percent. Average LP:SP ratios below 100 percent indicate that homes usually sell for below the asking price. LP:SP ratios above 100 percent means that homes are selling for above the asking price;

In addition to helping you understand whether your area is currently experiencing a buyer's market or a seller's market, this number is the most clear-cut, mathematical method of projecting how much over (or under) the asking price a home—including your home—should sell for. Take the average LP:SP ratio from the three to five CMA comps that are the most similar to the property you're considering, and multiply the ratio by the list price on your property. So, if the average LP:SP ratio of your comps is 105 percent, and your soon-to-be home is listed at $400,000, then you would multiply the two to predict the price at which "your" home is likely to sell—and, perhaps also your offer price: $400,000 x 105 percent = $420,000;

Step 3: Facts Specific to This Property and This Seller

DOM (Number of Days on the Market) – Savvy homebuyers often get in the habit of asking their Realtors how long each and every property they see has been on the market. This information is much more useful once you know the average number of days on the market from your CMA. If the home you are preparing to offer on has been on the market any more than a couple of weeks beyond the average DOM in your area, the seller's motivation level is likely to be higher, and the market has begun to "educate" the seller that the list price might just be too high. Whether you are buying in a buyer's or seller's market, a much longer-than-average DOM is a signal that there may be an opportunity for you to purchase the property at or below the list price. This is not always a slam dunk; some sellers will refuse to lower the price on an overpriced home for two or three times the average DOM out of stubbornness or desperation. If, for example, the average DOM is 35 and the listing has been on the market for 150 days, you might make a lower offer knowing that the seller is simply unreasonable. On the other hand, your offer might be the first thing that has come to them in a long time, so it might just be worth a shot!

Seller's Priorities & Motivation – Every once in awhile, it turns out that some other thing is more important to the seller than just money. If that is the case, your Realtor will be able to learn that from their pre-offer interview of the listing agent. For example, if the seller has already bought another house and is presently making mortgage payments on both, a $400,000 offer that can close in 15 days might be more attractive than a $410,000 offer that closes in 45—really! Or if the home is being sold by the out-of-state family of a person who has passed away, offering to take the home in as-is condition (including all the furniture, etc. they don't want to move) and to close escrow really fast can be a strong incentive for the sellers to accept a lower offer. And a seller who needs the money from this sale to close escrow on a home they are building may not be able to move out until three or four weeks after you close escrow on their present home. Folks like these are much more likely to accept an offer that includes a period of time after you close escrow where they can rent their home back from you, usually at the same price as your mortgage payment, prorated for every day after COE (Close of Escrow) they stay in the home.

Now, don't get carried away with this; sellers aren't going to drop the price $100,000 because you make it easy for them not to have to move Aunt Fanny's furniture. But you might make it a lot easier for them to accept an offer $5,000 less than what they were hoping for, or to accept your offer over an equal or slightly higher priced one that doesn't have such desirable terms, and that can be a wonderful thing!

Competition – Yours & the seller's—Look at that CMA (Comparative Market Analysis) one last time. How many Active, closely similar comparables are there within that ½ mile radius? In addition to tipping you off to whether your market is a buyer's or a seller's market, the number of active comps also indicates how much competition the seller has. The more active comps there are, the more your seller will be anxious to get an offer, period, and be open to your offer around or below the list price.

Probably the single most important thing to know when you're making your final decision as to how much to offer on a property is whether you have any competition—whether the seller will be considering any other offers at the same time as yours. When you are competing in a multiple offer situation, many (but not quite all) bets are off, and a new set of offer price formulating rules are activated:

(1) Make your best offer on your first offer – Do not assume that the sellers will just make a counteroffer to try to get you to pay more money. When all the buyers' agents involved are aware that there are multiple offers, the buyers who really want it will generally offer the highest price (a) they can afford and (b) they believe the property will appraise for. (Obviously, you must stay within the price for which you are pre-approved or get pre-approved for a higher price range and make sure you are comfortable with the monthly payments at the new, higher price.) If your offer is $5,000 above the asking price and someone else's is $50,000 above, the chances that the seller will issue you a counteroffer are between slim and none.

BUT

(2) Don't offer above what the property can appraise for – Ask your Realtor to work with you to estimate the maximum price the property will appraise for. If this is not completely clear, and I know my client will be making an aggressively high offer in a multiple offer situation, I sometimes actually call one of my preferred appraisers and work through the comps with them to make sure my client's offer does not exceed what the property will appraise for. Unless you are putting more than 20 percent down, and you can afford to pay in cash the difference between the appraised price and the purchase price, your absolute cap for the offer price should be the maximum appraisal price.

Ultimately, no matter whether you are the only offer or one of 10, whether you are in a buyer's market or a seller's market, the final decision as to the price you should offer is up to you. The price you choose should reflect how badly you want the property and/or how high you would like to stack the deck in your own favor. In fact, I have had clients strategically decide to

Insider Secret

BEATING OUT THE COMPETITION

If you are competing with other wanna-be buyers for a property, your Realtor's prep work and presentation of your offer can be critical to your success. For the special report, 5.5 Things Your Realtor Can Do to Help Get Your Offer Accepted, visit www.REThinkRealEstate.com and enter "RealtorSellsOffer" in the Tara's Tips box.

make offers slightly above the asking price even when there were no other offers on the table, to induce a seller to forego another open house or to quash any hesitance the seller might experience at pulling their home off the market after only a day or so.

Many Savvy Women worry a lot about "overpaying" for a property, by which they usually mean offering to pay a certain price when the seller would have accepted less. The bad news: this risk can never be entirely eliminated, because no seller is going to tell you the truth about the least they will accept. The good news: so long as the price you offer is within the realm of the reasonable and the property appraises at that price, the risk of "overpaying" can be a risk well worth taking. Say, for example, you are going back and forth internally over a 2 percent difference in offer price on a property you really, really want—between $350,000 and $357,500. To put this in perspective, the difference in your monthly mortgage payment between these two purchase prices will be about $50 - $80 per month. So you offer the $357,500, and get the property.

Now, let's assume that you really didn't have to pay that extra $7,500, that the seller would actually have accepted the $350,000. Assume further that you are in a slowly appreciating market, where your property gains 6 percent of appreciation the first year. Your property will appreciate $7,500 within the first three months of ownership—to most Savvy Women, "overpaying" is a risk they would take all over again in order to secure the property they want, especially given that the property itself will compensate for that "overpayment" within a very short period of time.

It's Not All About the Benjamins – How to Formulate the Non-Price Terms of Your Offer

With the possible exception of price, the terms of your offer should mirror as closely as possible the terms the sellers' agent expressed would be preferred without impairing your important legal

Insider Secret

FINAL CHECK

Before you finalize your decision about how much to offer, have your mortgage broker run a monthly payment on your offer price, and estimate your property taxes and insurance. Often, buyers inch up in price during the house hunt and in the course of formulating their offer, so it's important to have a final check on the exact monthly and annual obligations you will incur if your offer is accepted.

Also, if you're seriously debating between offering two different prices, and are having a hard time making the decision, ask your mortgage professional to run the payment, taxes and insurance on both of the prices you're considering. You might be surprised at how small (or large) an impact a $5,000, $10,000, or $50,000 difference in purchase price has on your ongoing payments, and it may help ease your decision making between the two amounts you are thinking about offering.

protections and other common sense needs. A number of non-price terms don't necessarily impact you much cost-wise. For example, a quick close of escrow or allowing the sellers the option to rent-back may not cost you anything. Other terms, like offering to pay more than your normal share of the closing costs, might cost you a little chunk of change, but could seal a deal that will make you big bucks in the long run. If it doesn't cost you anything, or costs very little in the grand scheme of things, why not give the sellers what they want if it makes it much more likely that you get what you want?

The favorite non-price term of sellers, offering to accept the property in as-is condition, could cost you nothing, could run you a modest amount of money to do upgrades you might have done anyway, or might require you to expend a lot of money on repairs over your tenure as homeowner, depending on the facts of the specific situation.

As-Is Offers

To make an "as-is offer" is to state that you, the buyer, will take the property in the condition it is in as of the date you make the offer, and will not ask the seller to do any work or repairs to the home. You can see why these offers are so attractive to sellers; they love the idea of being able to mentally move on from this home to the next one as soon as they accept your offer. In the olden days, many states required that certain basic condition standards be met by every property sold, whether or not the buyer asked the seller to do any work: no broken windows, no termites, etc. Today, "as-is" is the default under the contract in many states; unless Buyer

and Seller specifically agree that Seller will do something, the property will pass to Buyer in the same condition as when the contract was affirmed. Other states have remained old-school and maintain standards that the Seller will have to—or is expected to—meet prior to closing. Before you spend time agonizing over whether to make an as-is offer, check in with your Realtor. In some markets, sellers expect to have to complete some repairs, so the issue is, well, a non-issue! We'll talk more about as-is contracts vis-à-vis inspections in the next chapter.

If You're Thinking of Making an As-Is Offer

The ideal property to offer to take in as-is condition is one where:

- The property is new or appears to be well-maintained;

- The seller has prepared their property-related disclosures and shared them with you before your offer (e.g., in a binder at the property or online); and

- The seller has had a pest or "termite" inspection (also known as a Wood Destroying Organism inspection or WDO for short), and/or property inspections prior to listing the home, has given you the opportunity to read the reports, and you feel comfortable taking on the responsibility for the repairs recommended therein.

Whether or not all the above-listed ducks are in a row, you'll need to weigh the pros and cons of making an as-is offer on a property- and situation-specific basis. Do you have cash to do repairs later? Do you not want the seller to do repairs so you can hire the contractors and choose the supplies yourself? Depending on the severity of needed repairs, are you okay with living in the home and taking care of those gradually over time? Or are you simply unable or unwilling to either have repairs done or live with items needing repair—period?

If you do make an as-is offer, make sure to have your inspections as early as possible and get repair cost estimates prior to removing your contingencies. This way you don't get yourself in over your head, and you will know whether or not you need to back out or renegotiate with the seller.

Making an as-is offer is essentially your promise that you won't ask the seller to do any more work to the property. That promise is not set in stone, though, because most sellers would prefer to close the deal with you than to put the property back on the market if major hidden repairs come to light after your inspections. However, you shouldn't make an as-is offer with

the intention to approach the seller and ask for repairs or credits later. Only make one if you're prepared to handle all obvious needed repairs and some degree of non-obvious repairs that your inspectors might uncover.

If you know from the first moment you see the place that you are planning to ask the seller to fix things or that you are unwilling to take the property if the inspectors find almost anything wrong, then don't make an as-is offer. (Realtors whose buyer-clients frequently make as-is offers, then try to renegotiate, lose credibility among listing agents. This sort of reputation makes it harder for their buyer clients' offers to be accepted in the future.) However, if you do make an as-is offer you also shouldn't hesitate, in the event the inspector comes back with truly major non-obvious and undisclosed items, to issue the ultimatum that you will either need Seller's help with the work (monetarily or otherwise), or to back out of the deal.

Always Have a Back-Out Plan: Contingencies You *Must* Have

When you're buying a home, Plan A is always to buy the home on the terms in the original contract. Plan B is to buy the home after renegotiating some of the terms. Plan C is the contingency plan: if there is an irresolvable flaw in the condition of the home, the home doesn't appraise for the purchase price, or your lender refuses to fund your loan for whatever reason, you can back out of the transaction with no penalty (other than the money you've spent on inspections) so long as you have the appropriate contingencies in place. Remember, contingency = the right to bail.

When you're in a hot seller's market, or there are multiple offers on a property, you might be pressured to make an offer with no contingencies, or one with no appraisal or loan contingency. DON'T DO IT! Personally, I wouldn't spend more than about $50 at a store that didn't have a 30-day return policy. It is insane to even consider having no back-out plan on a purchase in the hundreds of thousands of dollars! This is way too big a purchase to be without an escape route, at least until your due diligence into the condition of the property is completed.

The results of your home inspections will help you decide whether you need to bail out of a home purchase. For the most part, properties that look very well maintained have been very well maintained. People who tend to every nook and cranny of their homes and keep things well dusted and manicured, also often maintain their rain gutters and roofs well. Over the last decade, though, a wave of buying and rehabbing properties strictly for profit (not to live in) has swept our nation. Investors "fix" properties with widely varying degrees of attention to the fundamentals prior to "flipping" them. In an effort to maximize profit, some flippers pay all their attention to cosmetic detail, and very little to the structural integrity of the home. Others literally

tend to everything from the ground up, so don't dismiss these sorts of properties out of hand either. My point is that with any property, but especially a fix-and-flip, looks can be deceiving.

True Story – Looks Can be Deceiving

One of my Savvy Woman buyers was house hunting in a particular, 100-year-old neighborhood in Oakland. Very stroll-to-the-local-produce-market-esque. We found this lovely little Spanish style cottage—with all the charming detail of the 1920s, when it was built—but simply gleaming as though it was in brand new condition. We walked inside and saw that the home had been fully remodeled; new flooring, working fireplace, granite slab countertops, brand new stainless steel kitchen appliances and—get this—two full bathrooms with fixtures so new the shower and bathtub still had the energy efficiency rating tags on them!

We quickly made our offer, received an acceptance, and opened escrow. The seller's disclosures informed us that the place had been through a house fire during the prior tenant's occupancy and, thus, had been largely rebuilt from the wall framing out, with City permits. So the windows, roof, appliances—all were still covered under their manufacturer's warranties. The sellers even "suggested" that we might save a few bucks by foregoing the usual inspections, as virtually "everything" was new or warrantied in any event. Paperwork and conversations with the sellers also revealed that they were professional "flippers"—a couple of guys who drive around town picking up distressed properties, then rehabilitating and reselling them for profit. My buyer wisely elected to move ahead with inspections, even if for purely informational and peace-of-mind purposes.

The home inspector came and went, saying that she thought the interior of the house looked great, but that there were some drainage issues she wanted us to have looked at by the structural pest (termite) inspector and a foundation engineer. The next day, the termite inspector came out and determined that, as the home inspector said, the interior of the home was virtually new. About 75 percent of the concrete foundation and wood framing under the house, however, was totally shot from 80 years' worth of poor drainage and standing water sitting on the foundation. Our structural pest inspector gave a whopping quote of over $80,000 (!!!!) to remediate the damage.

"Let's not totally panic, here," I advised my client, who was still seriously considering buying the property and doing the work. "Obviously, we'll try to get the seller to help out with the repair bill. But before our contingency period runs, let's also call the foundation engineers out so that they can give a competing bid. Foundations are all they do, so it might be less expensive

to call them ourselves than it would be to pay the pest company to be the middleman. All the pest company will do is subcontract the job out to the foundation company, and then mark it up anyway." That sounded good in theory. When the foundation engineers arrived, they did indeed undercut the pest company's price per foot of foundation and framing that needed to be replaced. However, they deemed the entire foundation to be beyond repair. In fact, the engineer called me over to a particular spot in the crawl space under the house, grabbed my hand, and brushed it over the concrete foundation—which literally crumbled into dust under my touch. YIKES! So, their repair bid was over $110,000, plus an extra $12,000 for an under-house drainage system to prevent the problem from recurring.

Long story short—my client exercised her inspection contingency, backing out of the deal on grounds that she was not satisfied with the condition of the property per the inspection results. She lost nothing except approximately $1,000 in inspectors' fees, which she felt was a very small price to pay to save herself from the $122,000 "surprise" she would have had if she had closed escrow before realizing the extent of the foundation damage. Within a month she had closed escrow on another property, which was less showy, but in far superior fundamental condition. The sellers not only understood, but were more than a little horrified themselves. I kept in touch with them, and last I checked, they still hadn't (over a year later!) been able to find a buyer who would take on the property in this condition. (Now that the sellers know about the foundation issues, they are legally required to disclose it up front to all prospective buyers.)

Back to Contingencies

No matter how perfect the place looks to the naked eye, get a property inspection professional out there just to be sure. You might just save yourself the headache, heartache, and financial nightmare of a lifetime.

If you are competing with other buyers for the property, you can shorten your contingency or objection period so that the seller can gain certainty that you will close the transaction sooner, rather than later, if you get the go-ahead from your team. You should insist, though, on having at least two particular contingencies in your contract—two grounds based upon which you can back out of the transaction within the first days or weeks of escrow. The two contingencies you should insist on having in your contract are the loan and inspection contingencies. The loan contingency allows you to be certain that your lender's underwriter will approve of all your documentation and your property (including its HOA, if applicable), and make a final commitment to fund the

loan. The only hypothetical situation which eliminates the need for a loan contingency is one where you are paying cash for the property.

The inspection contingency is the one which allows you to back out of the deal if you are not satisfied with the results of your investigations into the condition and insurability of the property. Unless you are ready, willing and able to buy the property at the price and terms of the original property no matter what condition it is in (e.g., a brand new home with comprehensive builder's and home warranties, or a home you knew was a teardown at the outset), you need this contingency for at least as many days as it will take you to have the necessary inspections and read and review the inspectors' reports. In fact, I have even advised clients who planned to pay cash and to tear the existing home down against making non-contingent offers, so that they can have the City give an idea of whether the home they would like to build will be allowed on the lot, and have the contractors inspect the site, provide estimates and give opinions on whether the water and sewer capacity, soil stability, and other resources will be sufficient to support the home they plan to build—all before they have made the final commitment to purchase the property.

Your due diligence investigations into the condition of the property will take, cumulatively, a full day of your time. However, your inspectors may not be able to get to the property for a couple of days, or may recommend further inspections which will take some time. Or, the appraisal may take a week to be completed. Most mortgage companies have a 48 or 72 hour turnaround time on applications once you have a specific property address, after which the lender might come back with several more items of supporting documentation they require before issuing a final approval or commitment letter. These time frames are outside of your control, and make it somewhat foolhardy to set contingency removals for less than about eight days.

In some instances, like where your mortgage broker has an in-house bank, or where your inspectors can come out the next day, or where your sister is an appraiser, you may be able to cut down the time you need. However, you would want to run the proposed timetable by your Realtor and mortgage pro before you commit to a short contingency removal or objection period in writing.

True Story - The Breakup Contingency (One More Reason Not to Make a Non-Contingent Offer)

A couple of years ago I worked with a couple of Savvy Women, life partners, as they bought a darling cottage. The place was pristine and highly upgraded when they bought it, but they discovered that they shared a true life calling as habitual DIY renovators; on one visit I found

these two petite young ladies taking sledge hammers to the concrete patio and wiring the backyard for a lighted wood deck and hot tub!

About a year later, they decided to buy a second home as a fixer-upper project. I was oblivious, but this was really a last ditch effort to save their struggling relationship, like that whole pre-Oprah-era thing people used to do where couples on the verge of divorce would have a baby to "bring them closer" to each other. Well, my clients had decided, unbeknownst to me, to give birth to a house to try to save their relationship. The tactic was just about as successful as that whole baby strategy ever was. Not very. We looked at a couple of properties, got into contract on one, and then not more than two weeks into escrow (after inspections but before removing contingencies) the couple split up! For good.

They decided quickly that they would prefer to back out of the transaction by exercising their contingencies. In California, as in many states, you needn't specify the specific facts underlying why you are backing out of the deal, you simply specify the paragraph in the contract that provides the contingency(ies) you are exercising. We exercised the loan contingency (legitimately so, as the household income on which their loan approval was based was effectively being split), but amongst ourselves good-naturedly referred to it as the "breakup contingency." However, in consideration of the trouble they might have caused and out of the goodness of their hearts, my clients decided to allow the seller to keep their small earnest money deposit.

Even if you think nothing on earth could get in the way of your ability to close the deal, you should still not make a non-contingent offer. You never know what might come up that will make you change your life plan as it relates to the property, and you might be very glad you had a "breakup contingency" or objection period available to you, even for a short period of time.

Negotiating Terms Other Than Price – A Final Note

When it comes to non-price terms, stay flexible and look for the potential for a win-win situation. Be clear on your priorities and be sure you understand the impact of different terms you include or exclude for both you and the seller. Our On the Other Hand Decision Guide (see below) breaks down the most common non-price terms and how they affect you and the seller. Don't risk losing your dream home over items which are fairly insignificant for you in the grand scheme of things. But this is a fine line to walk—don't lose your head either. If a seller insists that you compromise your necessary legal rights—run, don't walk away from that property and that seller. Your real property is still waiting out there somewhere.

On The Other Hand: Pros & Cons of Non-Price Terms from the Buyer's & Seller's Perspective

TERM	IMPACT ON BUYER		IMPACT ON BUYER	
	PROS	CONS	PROS	CONS
Short escrow/ Long escrow	May impact move-in date, amount of prepaid interest and pro-rated taxes on closing costs.	May impact move-in date, amount of prepaid interest and pro-rated taxes on closing costs.	Short escrow – get cash sooner. Long escrow – able to stay in property longer.	Short escrow – must move out sooner. Long escrow – takes longer to get cash in hand.
As-Is	Buyer can have work completed to their satisfaction, by workers & with materials of their choosing.	Buyer might take property with known problems or non-functioning items	Minimizes work to property after acceptance.	Purchase price might reflect a discount for repairs needed.
Repairs	You don't have to do or pay for repairs after COE.	Seller may want you to pay a higher price for the property than if you took it as is. Seller may not complete repair the way you would like.	May be able to demand premium price from the buyer.	Cost and inconvenience of doing the repairs, sometimes in a rush to complete them prior to COE.
Closing cost credits	Keeps money in your pocket by reducing the amount you have to pay to close.	You are basically financing some of your closing costs.	Makes it cheaper and easier for Buyer to close the transaction, widening the number of buyers attracted to the property.	Some buyers needing credits are poor mortgage candidates, and may not follow through on deal.
Shortened contingency or objection periods	Brings certainty as to whether deal will close sooner, rather than later. Allows you to finalize your finances and moving plans sooner. Certainty is good.	Forces you and your team to get through inspections and underwriting faster – making the early phase of escrow a little (or a lot) more hectic.	Brings certainty that either deal will close or deposit will be forfeited sooner, rather than later.	N/A
Appraisal Contingency	Allows you to back out if the property doesn't appraise at the purchase price.	N/A	N/A	Creates uncertainty as to whether deal will close until contingency has been removed or objection period has expired.
Loan Contingency	MUST HAVE. Allows you to back out if your mortgage doesn't come through for whatever reason.	Some sellers dislike. Doesn't matter. You must have it unless you are paying cash for the property.	N/A	Creates uncertainty as to whether deal will close until contingency has been removed or objection period has expired.

TERM	IMPACT ON BUYER		IMPACT ON BUYER	
	PROS	CONS	PROS	CONS
Inspection Contingency (a.k.a. Buyer's Investigation)	MUST HAVE. Allows you to back out if property's condition is unacceptable.	Some sellers dislike. Doesn't matter – you must have it unless you are okay to buy property no matter what condition it is in.		Creates uncertainty as to whether deal will close until contingency has been removed or objection period has expired.
Included Personal Property	Don't have to buy or install items.	Cost and inconvenience of discarding unwanted items.	Don't have to move or discard unwanted items.	Cost and inconvenience of replacing items.
Excluded Personal Property	Higher chance that you don't have to discard items.	You don't get to keep them items. (Only a disadvantage if you wanted them in the first place).	Get to keep the stuff.	Have to move or discard of the items.
Earnest Money Deposit Amount	The higher the deposit, the more attractive your offer to the sellers.	Cash out of your pocket early in the transaction.	The higher the amount, the more serious and well-qualified the buyer. Raises likelihood that deal will close, and may provide recourse if Buyer backs out after contingencies are removed or objection period is up.	May limit the amount of recourse against the buyer in the event of breach.
Liquidated Damages Clause	Sellers like it and are more likely to accept an offer containing it. Reduces risk of lawsuit in the event you breach the contract.	You forfeit your deposit money if you back out of the deal after you remove contingencies or your objection period expires.	Provides instant recourse without lawsuit if Buyer backs out after contingencies are removed or objection period is up.	May limit the amount of recourse against the buyer in the event of breach to the amount of the deposit or whatever amount is specified in the clause.
Arbitration Clause	Avoids length and expense of litigation, in the event of a dispute.	Less predictable than litigation, Seller is forced to disclose less information. May waive right to appeal.	Avoids length and expense of litigation, in the event of a dispute.	Less predictable than litigation, Buyer is forced to disclose less information. May waive right to appeal.

Anti-Checklist #3

WHAT NOT TO DO WHEN YOU'RE MAKING AN OFFER OR NEGOTIATING TO BUY YOUR HOUSE.

✓ **Disparage the Property, Its Location, Its Condition, etc. –** Don't even bother trying to justify a lowball offer. (Believe me, the seller and their agent were well aware that there's an electric tower in the backyard when they set the asking price.);

✓ **Ask, or Care, How Much the Sellers Paid for It or How Long They've Owned It –** Fair market value is what it is, regardless of how much money the seller is making on the home. When you sell the home, you will not be willing to take less than your home is worth just because it has appreciated a lot. Why should the seller?;

✓ **Disregard the Seller's Wants and Needs –** Why mess around when you can create a win-win and get a quick "yes"? Especially if their wants and needs are non-monetary or within what seems fair for the property;

✓ **Lowball the Seller –** That is, don't lowball the seller of a fairly-priced property. Even if the property is overpriced, the seller is probably pretty unreasonable and chances are low that they will accept your lowball offer anyway (unless it has been on the market a long time or the seller is really broke!);

✓ **Be Rigid and Inflexible –** Seriously, does it really matter to you if the seller needs a rent-back or wants to close a little bit early? Does it matter enough to lose the home over?;

✓ **Disregard Standard Market Practices –** You'll signal your naiveté and turn the listing agent off big time. If you know your offer will be way out of the norm for your area, have your agent call the listing agent ahead of time to explain (a) that they understand the terms are unusual, (b) why you need the unusual terms and (c) why your offer should be accepted despite being somewhat unconventional;

✓ **Get Overly Attached –** It ain't over until your offer has been accepted, no matter how good the offer;

✓ **Become a Stalker –** If it is meant to be yours, it will be. So don't stalk the home, Open Houses, the listing agent, etc. If you need to stalk anyone, stalk your own Realtor. She'll understand, and she'll love you anyway!

Insider Secret

MANAGING BUYER'S REMORSE

I've heard it said that the last day either side—Buyer or Seller—is truly happy with the price and terms of the transaction is the day the offer is accepted. I would say that's the last *moment* either side is happy. That same night—or the next morning at the latest—the buyer sits wide-eyed in bed thinking they paid too much for the place. The seller gets their agent on the horn and complains that they were bamboozled into accepting way too little for the home. Whether you call it second guessing yourself, the 'hindsight-is-20/20' phenomenon, or Monday morning quarterbacking, the fact is buyer's remorse happens—and seller's remorse does, too.

You can't totally prevent buyer's remorse, though you can minimize it by having a strategic house hunt that is driven by your clear Vision of Home. Expect it to come, sit with it for a moment, know that your feelings are normal and watch it pass on as you dive into your escrow process and start envisioning yourself in the home. If it gets very severe or feels inescapable, pull out your Wants and Needs Checklist. Go over it with your Realtor and compare the house you got with the house you said you wanted. If it matches many or most of your wishes, I guarantee you that your remorse will subside. If it is completely different than what you said you wanted, first try to remember why you made those compromises and determine whether they still make sense. If so, you're good—do whatever you do to relieve stress (so long as it's legal) and keep on trucking! If the compromises you made don't stand up to your scrutiny, decide whether you still want the place and be grateful you made sure you had a contingency or objection period in the contract!

Contracts & Negotiations – A Successful Outcome Defined

I've had many clients express fear of negotiating the contract—ostensibly, a fear of failing in some way. In reality, it is tough to screw up miserably in negotiating a real estate sales contract. To my mind, the only real failure would be giving up the legal protections that will cover you through the rest of the transaction. Defining success can be much more productive—and lengthy! Getting the house you want is success—even if you had to pay a premium or compete with others to get it—so long as the house is actually worth that price (which you'll find out with your appraisal) and you can afford to make your monthly mortgage payments and the other costs of owning the home. Getting it at a fair price is success, getting it at a good price is success, and getting a bargain is even a bigger success. And what's more, not getting a particular home can be success if you would have had to pay a price you really couldn't afford, or agree to unreasonable or oppressive terms.

I lost two homes to competing offers before I got the one that became my first home, a little rancher on Prosperity Way in San Leandro, California that I bought before I got into the biz. That was really the street name. It was about one third less in price than the other homes I lost, and somewhat smaller, but had been built to maximize the incredible views of the San Francisco Bay. A couple of years after I bought that place, inspired in part by my decidedly un-fabulous homebuying experience, I quit my six-figure lawyer job and started helping women manifest their Visions of Home. That's a career move I couldn't have made had I purchased one of the other, more expensive homes I had bid on. The moral of the story (not to get all soy milk/yoga/ Serenity prayer-ish on you) is that the home you end up buying is the home you were meant to have. The corollary? If you lose a home at the contract phase, it truly wasn't meant for you in the first place, and your home is still out there. So go get it, and before you know it you will have moved from contract into escrow, then to closing—and beyond.

I lost two homes to competing offers before I got the one that became my first home, a little rancher on Prosperity Way in San Leandro, California that I bought before I got into the biz. That was really the street name. It was about one third less in price than the other homes I lost, and somewhat smaller, but had been built to maximize the incredible views of the San Francisco Bay. A couple of years after I bought that place, inspired in part by my decidedly un-fabulous homebuying experience, I quit my six-figure lawyer job and started helping women manifest their Visions of Home. That's a career move I couldn't have made had I purchased one of the other, more expensive homes I had bid on. The moral of the story (not to get all soy milk/yoga/ Serenity prayer-ish on you) is that the home you end up buying is the home you were meant to have. The corollary? If you lose a home at the contract phase, it truly wasn't meant for you in the first place, and your home is still out there. So go get it, and before you know it you will have moved from contract into escrow, then to closing—and beyond.

Chapter 8

Escrow Purgatory

My parents sent me to church schools most of my life: some Catholic and some Protestant. In addition to learning to say a quick, automatic prayer every time I see an ambulance speed by, I learned that Catholics and Protestants have completely opposing views of purgatory. The Holy Roman Catholic Church officially views purgatory as a temporary place where you serve out your punishment for earthly sins before you can move on to Heaven. Those Protestants who believe in purgatory see it as almost a detox session—a temporary place where you cleanse and purify your spirit before you enter the pearly gates.

Escrow is like purgatory. It is that process, that time period that extends between contract acceptance and your entry into the pearly gates, I mean, the front doors of your new home. Some see it as a sort of penance they must serve, with seemingly needless and strange hoops to jump through for the privilege of home ownership. Others view it as a delicious opportunity to perfect their financial and other lifestyle elements—automating their bill payments, cutting out extraneous spending, tossing those old college textbooks you know you will never crack open again in this life and the monogrammed LL Bean backpack with the big blue ink stain—for homeownership and to learn as much as possible about their home-to-be. No matter what your religion, even if you're an atheist or a Buddhist in real life, try to assume the Protestant view of escrow!

So what exactly happens during escrow? Three major things:

Deposits – Your escrow holder or closing agent collects a bunch of stuff from a bunch of people: money from you and your lender, the deed from the seller, documents from both agents, both parties, and both lenders, etc. and so forth;

Due Diligence – Your Realtor and you do everything necessary for you to be fully informed about the property and its condition, and to make sure that your lender gives a final thumbs up before moving forward. This piece is all about reviewing inspection reports and disclosures, and the process of making sure the lender's underwriter is satisfied with everything—about you and about the property;

Performance, Exchange & Closing – You and the seller both do everything you agreed to do in the contract, and sign a pile of papers. Once that's complete, the escrow or closing agent exchanges money for ownership, and you become the proud owner of a home!

Insider Secret

HURRY UP & WAIT

Many buyers experience escrow as two distinct phases. Phase 1 is a flurry of activity with documents and disclosures being exchanged with the seller and the lender, and inspections being conducted and reports reviewed. Then, you downshift into Phase 2, which is much more passive and preparatory—arranging for your home warranty, insurance, and moving; signing documents and waiting for escrow to close.

I don't know if purgatory exists, or whether all my church school education about it will do me any good in the afterlife. What I do know is that knowing what to expect from escrow "purgatory" and understanding how to make the most of each phase will help you utilize the process and its phases to your advantage. That way you won't feel like you've been made to write school rules on the blackboard a thousand times before you can get the keys to your new front door.

What to Expect From the Escrow Process

Escrows in different states, counties and even cities can unfold slightly differently, depending on the standard practices in your local area. For example, in some places, your Realtor may not schedule inspections and will simply provide you with the names and contact information of trusted inspection professionals. In others, an attorney may take on tasks that are completed by

escrow or title companies elsewhere. The steps below may not be a precise forecast of exactly how your escrow will progress, but no matter where you are, this should give you a good general understanding of what you can expect.

(1) Your Realtor "opens escrow" by sending your contract and earnest money deposit to the escrow agent;

(2) The escrow agent assigns an escrow number to your transaction, searches the history of matters affecting title on the property and issues the preliminary title report;

(3) You and your Realtor review the preliminary title report;

(4) Your Realtor submits the contract and preliminary title report to your mortgage professional, initiating the underwriting and appraisal process;

(5) Your Realtor schedules, at your convenience, the standard inspections in your area: pest, property, roof and/or whatever else is required by law or indicated as necessary by the property or the other inspectors;

(6) As we saw in the last chapter, the appraiser visits the property and measures it, visits and photographs comparable properties in the area that have sold recently. You do not need to be present for the appraiser's site visit. (Some appraisers actually avoid doing site visits when either Buyer or Seller will be there, to prevent being pressured as to the outcome of the appraisal.);

(7) Throughout, you and your Realtor review and sign seller's disclosures, as they come in;

(8) Throughout, as part of the underwriting process, your mortgage professional asks you and your Realtor for lender-requested documentation of various aspects of the transaction the property; and your employment, income, and assets. Don't be surprised if this process seems really inefficient and your mortgage pro calls you five times over three weeks to request documents—sometimes on short notice — that it seems like she could have asked for all at once. It helps to understand that the underwriter at the actual bank sometimes issues these new requests at the last minute, and they can't always be anticipated by your mortgage professional. Don't kill the messenger — just suck it up and roll with it;

Time-Off Alert #1

You should attend at least the pest and property inspections; plan to take a half to a full day off work for this.

(9) Throughout, you sign contractual documents, as necessary to document any changes and additions to your agreement with the seller;

(10) After making certain you are satisfied with the terms of the sale in light of the results of all inspection reports and disclosures, and after passing final underwriting approval by your lender, you remove contingencies or allow your objection period to run out without objection;

(11) You increase your earnest money deposit, if called for in the contract;

(12) You obtain a homeowner's insurance policy;

(13) You & your Realtor review the proposed final settlement statement—the escrow agent's balance sheet of credits and debits owed by and to each party and the lender, and listing all closing costs. You report any errors or disputes to the closing agent, and get them resolved;

(14) You sign loan & title documents at the escrow agent's office;

(15) A few days before closing, you and your Realtor do a "final walkthrough" of the property, making sure that (a) it is in the same condition as it was when you last saw it, and (b) that any work the seller agreed to do is done;

(16) Your escrow agent tells you the exact dollar amount of cash needed from you to close, if any, including any closing costs not covered by your deposit money and down payment. You go in person to your bank to make a wire transfer to the escrow agent's account;

(17) The lender funds your mortgage, wiring the mortgage funds into your escrow agent's account;

(18) Your escrow agent or Realtor orders you a home protection plan (a.k.a. home warranty);

(19) The escrow agent sends a courier to the County recorder's office, who records the deed for your home in your name. ESCROW HAS CLOSED, and the home is yours. That same day (or prior, or later, depending on the contract) the seller hands over the keys, either literally putting them in your hand or, more often, getting them to your Realtor.

Time-Off Alert #2

You cannot complete a wire transfer online or by phone at most banks. You must do it in person, so plan to take an hour off work to complete this.

Calendar of a 30-Day** Escrow

SUNDAY	MONDAY	TUESDAY	WEDNESDAY	THURSDAY	FRIDAY	SATURDAY
	1 Contract Acceptance.*	**2** Open Escrow.	**3** Inspections	**4**	**5**	**6**
7	**8** Receive & Review Inspection Reports.	**9** Receive & Review Preliminary Title Report, Seller Disclosures & HOA Docs, if applicable	**10** Ask Seller & Inspectors Questions, Obtain any further inspections recommended, Resolve, renegotiate or accept condition.	**11**	**12**	**13**
14 Provide requested documents to mortgage professional for final loan underwriting.	**15**	**16**	**17**	**18** Remove Contingencies or Issue Objections *** Increased Deposit, if any, Due. Contingencies or Issue Objections Increased Deposit, if any, Due.	**19**	**20**
21	**22**	**23**	**24** Final Walk-Through.	**25** Sign Loan & Title Documents at Closing Agent's Office.	**26** You Wire Transfer Funds to Closing Agent, if Necessary.	**27**
28	**29** Mortgage Funds Wired to Closing Agent.	**30** Close of Escrow!				

* All time frames in your contract run from acceptance.

** Your escrow length can be anywhere from a couple of days to a couple of months long, but 30 to 60 days is standard in most markets.

*** Contingency & objection periods are subject to negotiation between you and the seller – usually ranging from10 to 17 days.

Insider Secret

PRO-FILING

Unless you live in a minimally regulated state like Alaska, chances are you will end up with hundreds of pages of paper before this thing is over with. They'll either end up all over the place, or in some file you put together. Even if you're a pretty organized gal, it can be tough to keep everything straight. You only need two things to keep your homebuying paperwork organized: a Classification Folder with three dividers and a two hole punch (the kind that makes two holes at the top of a page). Your folder will have six different sections with brads at the top of each to fit into your two holes.

Label the sections as follows, and you'll always know where to find everything—for years to come:

- Correspondence – Letters, faxes, emails, etc.;
- Basic Information – Your escrow calendar, the MLS listing, and miscellaneous;
- Contracts & Addenda;
- Disclosures;
- Inspections & Reports; and
- Title, Escrow & HOA Documents.

Disclosures, Inspections, Reports – Your Paper Safety Net

My profession is a tree-killing business. I estimate that my average buyer client's transaction file is three to four inches thick and hundreds of pages long. The lion's share of these pages is comprised of disclosures and inspection reports. If you're a goal-oriented type of gal, it is tempting to attack that stack of paper like an unpleasant chore—to initial and sign away to get it out of the way as fast as you can. I'm here to tell you to fight that impulse—just this once!

When the typical Savvy Woman prepares to buy a $30,000 car, she goes to the Blue Book to research market values, goes to epinions.com to check out the feedback of others who already own the car, and maybe to the purchase decision-making gurus at Consumer Reports. She may also email a bunch of folks she knows to see if anyone has the type of car she's considering, and

how their experience has been with the vehicle. If she's buying used, she'll go to CarFax.com to get a vehicle history report, and take it to her own mechanic to get a professional opinion on the car before she buys it.

Well, homes aren't like cars in that there is no standard repository of information about your "model" of home, and no database that keeps track of the history of repairs done to individual homes. That thick set of disclosures, inspections, and other reports are the safety net that keeps you from buying a lemon of a house. The point of these documents is to equip you to make your final decision whether to buy the property only after you have full and unbiased information. Instead of looking at these papers like a stack of signatures you have to churn out, look at them as the final phase of a study project. Depending on the length of your contingency or objection period, you'll have up to about a three-week time period after you get into contract. In that time, your job is to research, study and familiarize yourself with the details of the property by attending your inspections and reading disclosure and reports. That's the only way you'll be able to say a fully informed 'yea' or 'nay' to the purchase, or to renegotiate the price or other terms if you need to.

General Rules for How to Read and Use Disclosures, Inspections and Reports

- Read them front to back;

- Keep a running list of questions, and present it to your Realtor. Then follow up and get answers—from your Realtor, the inspector(s) or the sellers. Feel free to call inspectors directly with questions, if you'd like;

- There is no such thing as a "bad" inspection report or an absolute "deal breaker," other than a home that needs repairs that you don't want (or can't afford) to complete;

- If the inspection results are surprising, you might be able to renegotiate your deal with the seller. For minor items, though, you should plan to use the inspection reports as the start of your long-term home maintenance/upgrade plan;

- Keep everything in perspective—even brand new homes sometimes have items that should be repaired, replaced, or installed differently: no home is perfect, and the older the home is, the more of a "history" it will have.

Disclosures

What They Are – Disclosures are forms, statements, and reports completed by the seller which tell you about the features, characteristics, and condition of the property you are about to buy. They are designed to (a) help you make a decision regarding whether you'd like to consummate your purchase, and (b) assuming you do move forward, give you as much detailed information about your new home as possible! There are also a few disclosures that the two Realtors involved will issue; these usually focus on advising you of your legal rights and obligations as a homebuyer, and legal issues that may affect you as a home owner. You'll be asked to sign the disclosure forms themselves or a receipt for them, indicating that you have read and received your own copy of the documents.

What to Look For – Start with the question being answered. When you are reading the seller's disclosures, it is CRITICAL that you actually read the question that the seller is answering. Many of the standardized disclosure forms allow the sellers to simply check 'yes' or 'no' boxes next to a list of issues that should be disclosed, like "flooding, drainage or grading problems," for example. So, for those of you who read by skimming, you might simply scan the topics and corresponding 'yes'es and 'no's, and think—oh, fabulous, there's no flooding, draining, or grading problem! What you might miss is the question that the seller was originally asked, which is often: "Are you aware of any of the following?" So a checked "yes" box means the seller is aware that a particular issue exists, but a checked "no" box means only that the seller is not aware of the issue—not that the issue doesn't exist.

Environmental or Health Hazards

- **Lead-Based Paint** – Properties built prior to the late '70s often have lead-based paint in their history. Lead-based paint can cause serious neurological damage if ingested. Fortunately, most homes that once had lead-based paint have had about four or five coats of paint over the offending coats. So, if you are told that your new home has lead-based paint, don't freak out, but make 150 percent sure that you keep your home well painted (no chipping or flaking), make 200 percent sure that your kids don't pick at the paint or eat paint chips, and make 250 percent sure that you test your soil before planting anything that you plan to eat near your house. (Soil testing kits are super cheap and can be purchased at your nursery or local home improvement store.)

- **Natural and Environmental Hazards** – Every state is different, but chances are that you're entitled to receive some sort of disclosure notifying you as to whether:

→ Your home is located in a zone that has been declared by state or local authorities to have a high likelihood of fire, flood, landslide, earthquake, hurricane or other natural "events."

→ Your home is located in or near any sort of commercial or industrial zone, a site where industrial chemicals or military waste have been disposed, an airport which might create excess noise, or an area which is known to be plagued with mold problems or radon gas.

It is rare that these sorts of disclosures will actually surprise you. Almost every home in the San Francisco Bay Area, for example, is deemed to be in an earthquake zone (duh!). And there's certainly nothing anyone can do to take a house in a landslide zone and put it in a non-landslide zone. Also, if the area in which your home is located works for your lifestyle, keep in mind that many or most of the other homes in the area will have similar natural and environmental issues.

Keep in mind the age of your home and how it has lasted over the years vis-à-vis the issues disclosed. Now, it's up to you to decide how important the various zones and potential natural hazards really are to you, and whether they make any difference to your decision making about whether to buy your home. Perhaps the best use of this information is to help you decide how to upgrade your home over time; an earthquake-prone home might need seismic retrofitting, while you might want to re-landscape a home in a high fire zone with fire-resistant, native plants.

Property History – Whether you are buying a detached home or a unit in a larger building, you should receive some document (or set of documents) listing:

○ *Features* – In some, but not all states, the seller will provide some sort of document that serves as a detailed inventory of all the characteristics and features of the property. Often, this inventory will be formatted as a sort of checklist, where the seller can mark the boxes corresponding with the items the property has. This is also the section where the seller will tell you things like the type of roofing material on the home and how old the roof is, what type of wiring is present where, etc.

○ *Problems* – The seller should disclose whether any of the features or amenities of the property are not in operating condition, or have significant defects or malfunctions. In short, this is how you find out about anything that is not working, from the garage door opener, to the garbage disposal, to the ceilings, sidewalks and foundations. Also, they should tell you whether the property has been affected by mold, used as a meth lab, or has a history of any other harmful substance being present on the premises.

- *Recent Deaths* - Because some cultures have religious and traditional issues around death and dying, many states also mandate that the seller inform you whether anyone has died on the premises during the period a few years prior to the sale. Many Savvy Women find that the idea of a law requiring sellers to disclose any deaths that have recently occurred on the property excessive. I mean, how frequently can this issue come up, right? More often than you think. People die at home (though less often these days than they once did), and it is quite normal for a home to be sold shortly thereafter. Because expected deaths usually occur nowadays in hospital or hospice, an ever-greater percentage of deaths at home are accidental or traumatic deaths. Note, though, that the seller's responsibility is to disclose that the death occurred on the property, not the cause or circumstances of the death. (Many times, especially when the death was from natural causes, the sellers will simply relate the whole story around the death as a matter of course.) However, if the decedent had HIV or AIDS, some states expressly prohibit the seller from disclosing the decedent's HIV-positive status to prospective buyers.

The disclosure of a death on the property is not meant to freak you all the way out. Death is just another phase of life—it happens, and in an older property, the chances are that it has happened at some point or other on the premises, whether or not this particular seller knows or is required to disclose it. The disclosure is meant to provide you with the full facts, as some cultures and spiritual traditions prescribe various remedies and actions to be taken prior to moving into a property where someone has recently passed away. You may not believe a recent death is a problem at all. Even if you do find it problematic, all sorts of things are believed to remediate the negative energy from a death—from lighting a candle, to saying a prayer, burning smudge sticks, or hanging crystals—pretty much every belief system has some prescription for this problem. The reality is that a recent death on the property does freak some prospective buyers all the way out (the door, that is). If you can get beyond it, though, a recent death can also create great opportunities for you in the way of less competition, more seller motivation and (sometimes) even a lower price!

True Story—Death Becomes Her

Recently, a Savvy Woman client of mine decided she wanted to make an offer to purchase a three-plex. I called up the listing agent for my pre-offer interview, and ended up in a verbal negotiation of some of the more complex terms. Around 10 a.m., my client and I prepped the paperwork and sent it over to the listing agent, who confirmed by telephone that I should expect the seller's acceptance in a couple of hours. By 6 p.m. that evening, I still hadn't heard anything, and didn't get a return call when I left the listing agent a voicemail. I had a great relationship with this agent, so this struck me as particularly strange. At 9 a.m. the next morning, I telephoned again, asking what had happened with my client's offer. The listing agent said, "Well, um, my seller did

accept it. I, er, still have it here but, uh, well, see, ahem we've run into a little problem." My mind raced through all the possibilities of things that could have happened, but never in a million years would I have come up with what she said next. "Tara, the tenant in Unit 3 committed suicide yesterday." I replied with lots of the normal condolences, "How awful? Poor soul. Was he unwell? That's just terrible!" She interrupted my expressions of sympathy, "Um, Tara, he killed himself at the property."

This set my Realtor radar off. Savvy sellers and agents, this listing agent included, usually disclose a recent death on the property on MLS, so they don't end up in and out of escrow with buyers who bail when they learn the situation. This poor seller was less than a day into contract with a buyer who hadn't had time to get emotionally attached to the property when the death occurred. The listing agent's silence on the other end of the line was deafening: she and the seller were scared that my buyer would run screaming from the property, leaving them to the morose task of finding a new buyer who wouldn't mind the new bad news.

Frankly, I had the same concern—and was doubly worried because this property was such a great fit for this particular buyer. So it was with great trepidation that I called my buyer to break the news. She, who had been expecting me to explain away the tardy paperwork with the tale of a broken fax machine or something like that, sat in silence as I related the sad story of how the poor tenant in the upstairs unit (yes! the man who was there during the Open House!) had parked his running car in another tenant's garage, closed the door, and fatally inhaled the exhaust. I told her that handling the necessary emergency arrangements had prevented the landlord from attending to her offer yesterday, but that he had accepted. As she sat silent, I informed her that the seller's agent was letting us know of this development verbally in anticipation of the formal, written disclosure that was required by law. With my buyer still silent, I told her that the listing agent had, effectively, asked me to gauge my client's reaction to this news, and to let them know whether the suicide would be a deal-breaker for the buyer.

"So," I asked with bated breath, "What do you think?" A moment passed, a pin dropped, and a cricket chirped outside. First, my client asked the astute question, "If I buy the place, will I have to disclose this to future tenants?" After we established the contours of her disclosure requirements, another moment passed until finally, my client said, "Hmmm, do you think we could get the seller to paint the guy's unit?" "Oh—I'm sure he will—no problem, let me give his agent a call," I replied. (The deceased had extensively decorated his unit in a southwestern motif, and every wall and ceiling surface had been painted an "interesting" shade of pink.)

Needless to say, upon hearing the news that my client was still interested, the seller almost instantly agreed to repaint the unit a neutral off-white, cleaned the carpet (without our even asking), and contributed toward an electrical upgrade recommended by our inspectors. The listing agent even offered to pay for a feng shui practitioner to come out and remedy the negative energy flow in the property! Note—my buyer didn't try to take egregious advantage by trying to lowball the seller or threaten to back out. She just asked for a couple of small items, received way more than she asked for, and now has actually developed a mentor-mentee relationship with the seller, who had been a landlord for over 30 years. My client is now living in one unit and renting out the other two, having turned tragedy into triumph for everyone involved.

Back to Disclosures

Property History, continued

o **Improvements & Repairs** – The seller will happily disclose all the updating, upgrading, and repairs that have been done to the property, to their knowledge. Some common, and very nice, upgrades/updating you should be happy to see if they show up on your disclosures are:

> → Dual Pane Windows – Cut down on noise and heat loss, lowering your energy bills;

> → Copper Plumbing – Newer, efficient and preferred by modern building codes because it can be bent and as a result doesn't require as many joints as other types of plumbing (fewer joints means fewer leaks!), and because copper actually kills many bacteria in water;

> → Updated Electrical – This usually means the house has been rewired, and you'll have more outlets and grounded outlets, which are necessary for computer equipment to be safely plugged in. This also means that outlets near water sources (kitchen, bathroom, garage and outdoor electrical outlets) should be equipped with Ground Fault Circuit Interrupter (GFCI) outlets, which will interrupt power to that outlet if someone is getting a shock;

> → Miscellaneous – New or new(ish) furnace, air conditioner, water heater, kitchen appliances, bathroom fixtures—any of these is a real reason for celebration if they show up on your disclosures!

HOA Disclosures – The seller, of course, will tell you if your property belongs to a Homeowner's Association ("HOA"). If it does, that's just the tip of the iceberg in terms of information you need to know. The seller will also provide—or your Realtor can request:

- *Rules & Regulations* – This is CRITICAL information that sets forth the rules you'll be expected to follow as a member of the HOA, including guidelines for using the common recreational facilities, colors you can paint your house (in a PUD), where you can and can't park, etc. If you are in a co-op or condo complex, the rules and regs will also lay out rules for modifications to your unit (e.g., no wood floors in upstairs units), which utilities are provided by the HOA, and things of that nature.

- *Minutes/Newsletters* – HOA disclosure packets often include a year's worth of minutes from the meetings of the HOA board of directors, and a year's worth of HOA newsletters, if the HOA puts one out. This is where you'll find out about plans to upgrade or repair the common areas, and increases in dues a year or more in advance. This is also the place to get the real dirt, like if your condo, co-op or PUD has a neighbor who deserves the title of Queen B (for Busybody); she'll make sure her name is all over the newsletter and she'll also report every infraction of the rules at the board meetings.

- *Finances, Reserves & Litigation* – The financial documents will include the HOA's annual budget, a balance sheet showing the HOA's financial assets, and income & expense statements—all indicators of whether the HOA will be able to afford the maintenance and upkeep on the buildings, unexpected repairs, etc. If the HOA is very small, or has too little money in reserve, then each time the property needs a new roof or new windows, the HOA will have to impose an assessment on each homeowner (including you!) for their share of the improvements. (These sorts of assessments rarely happen without many months' notice, but you do need to participate in the board meetings, or at least read the minutes, to make sure nothing of this sort sneaks up on you.)

School District – Many disclosure forms ask the seller to tell you what school district the property is located in. In some areas, it is very obvious, and the sellers will list the school district as a matter of course. In others, school district boundaries change frequently, and the schools which are geographically the closest to the residence are not always the schools your children will be able to attend. So in some areas, the common practice is to fill the school district blank in with a notation of "Call School District" or some such thing which shifts the burden back to you to ascertain the district of your residence. I always say that if you care about which school district your property is in—no matter what the seller's disclosures say—you should call the area districts and give them the property address, or go online and plug the address in, and make certain that you are okay with the school before you remove contingencies or your objection period elapses.

Pre-Contract Inspections – In some areas, the sellers will have their own home and pest inspections (or others) conducted before they even put their place on the market, and they'll provide the inspection reports to you as disclosures. Sellers do this to encourage as-is offers; buyers who have access to pre-contract inspection reports are much more likely to:

- Feel comfortable making an as-is offer;
- Not turn around and ask the seller to fix something or reduce the price after they get their own inspection reports; and
- Not freak out and back out of the deal if something major comes up in their own inspections.

When it comes to the seller's pre-contract inspections, caveat emptor is the rule. Pre-contract inspections were prepared by inspectors paid by and chosen by the seller, not you. Any warranty on the inspectors' work or insurance which covers the inspectors if they make an error will not extend to you, but only to the seller. (Sometimes, the sellers' inspectors are willing to come back out, at a reduced re-inspection fee, update the inspection and discuss the findings with you in person; such a re-inspection does serve to bring you under the umbrella of the inspectors' insurance.) Unless your Realtor also has a very close relationship with the inspection companies that prepared the pre-contract inspection reports and can vouch for their reputation for accuracy and integrity, you should absolutely hire your own pest, property and other inspectors (referred by your Realtor) and have your own inspections conducted. Read the seller's inspections before you go into contract, and be sure there's nothing horrifying there, but take it with a grain of salt; I recently had a situation where the seller's pest inspector found only $245 worth of work that needed to be done, but my trusty termite guru found over $14,000 in needed repairs.

Local Regulations – In some areas, there are city and county regulations which may affect you as a homeowner. Things like burglar alarm registration requirements, eco-friendly low-flow toilet and shower head requirements, permits you are legally required to get before doing certain things to your home, and rent control laws (which might kick in if you eventually convert your home into a rental property)—all of these things should be disclosed by the agents before your deal is closed. Information like this is usually not a deal-breaker, but not knowing it can cause you problems in the years after the deal is closed.

Insider Secret

INSPECTING THE BOTTOM LINE

If cash is very tight, ordering your own versions of inspections that the seller has already had can seem like a waste of money. At the very least, get your own property inspection and ask that inspector to review the seller's pre-contract inspection reports. If she agrees with them by and large, you might decide to pass on getting your own pest and roof and other inspections. If she finds things that the seller's inspectors missed, though, you should definitely bite the bullet and call your Realtor's whole team of inspectors out to get to the bottom of things.

Agency – Virtually every state requires Realtors to issue a written disclosure that clearly advises you of (a) which Realtor represents you, (b) which Realtor represents the seller, and (c) the legal duties each Realtor owes to you, the seller and to both of you. Just check to make sure you understand who is representing you, and what their duties to you are.

WEB TIP

If you don't receive information regarding local regulations which will affect you as a homeowner, ask your Realtor and also take charge—go on your city and county websites, and check their "Living In Your Town" section for information geared to homebuyers and homeowners. This is exactly where Realtors go to get local regulation disclosures; this way, you can get it from the horse's mouth!

Preliminary Title Report (a.k.a. "Prelim" or Binder)

What It Is

The preliminary title report is usually the very first "report" you'll receive during the escrow process, and it is the only "report" issued by the Title Insurance Company describing the property that you will receive.

The reason I keep using those blasted quotation marks around the word "report" is that, strictly speaking, the preliminary title report is not actually a report. It is actually an offer—the Title Company's offer to issue a policy of title insurance covering the ownership interest in the property you are in contract to purchase. The offer to insure is maybe a page long, and includes:

(1) The types of title insurance policies being offered. Usually this includes two policies:

- **Your state's Land Title Association Policy, which covers your interests in the event that:**
 - → There is no access to and from your property; or
 - → Later, someone discovers errors, falsifications, forgeries and mistakes on deeds, or in the process of recording and delivering them, as well as mistakes or omissions in interpreting wills over the long-term history of the property's ownership. (Note—in the olden days before title insurance, if the prior owner had his signature forged on the deed when it was sold to the seller, and no one found this out until after you bought the place—you were out of luck. Title insurance will cover you if this sort of thing were to later come to light. Awesome, huh?); and

(2) An American Land Title Association Policy, which covers your lender's interests against even more things—makes sense when you think that your lender would take the biggest hit if your title later turned out to be defective.

(3) The date and time the offer was made, and the guidelines for when the offer expires;

(4) The legal description of the property: its street address, city, state and Assessor's Parcel Number—the official number the county assigns to each and every property in the county;

The other four-to-ten pages list the exceptions to the insurance policy, things that the title company uncovered when it searched the history of title and ownership on your specific property. Most exceptions are non-problematic, but every once in awhile, that list of exceptions will include a vital line item which may impact the willingness and ability of the seller to close the deal. (For example, if the property is involved in a bankruptcy action or other litigation, the prelim will often show that a lis pendens has been recorded against the property, reflecting that the court may not allow it to be sold.)

The report part of the preliminary title report includes:

- **Name(s) of the current owners;**
- **Exclusions and exceptions to title;**
- **How the current owners hold title (e.g., as joint tenants, TIC, etc.);**
- **Matters of record which specifically affect the property or its owners (court judgments, liens and other debts which must be handled for the property to be sold);**

- Easements – rights others have to use or drive on your property (e.g., a shared driveway, the electric company's right to have their lines run under or over your land);

- An informational plat map showing the square of land your property sits on relative to the neighboring properties;

- Taxes – are they paid up & what the tax rate is;

- Informational notes;

- Covenants, conditions & restrictions (a.k.a. CC&Rs—rules for living in the property or subdivision).

What to Look For

As soon as you get it you should review the prelim and do the following checks:

- *Verify current owners' names* – The names on the title report must match the names on the purchase contract. If they don't, or if there are more owners listed than those who signed the contract, the disconnect must be resolved before escrow can close;

- *Verify the property address & check the plat map* – Make sure the address is correct and that the indicated spot on the plat map is the right property. (Count number of lots from an intersection or landmark on the map & in real life for ease of reference.) The current owner may own properties next door or across the street from each other, so pay attention to every numeral in the street address— you want to make sure you buy the property you think you're buying;

- *Read the informational notes* – Look for: city or county transfer taxes and homeowner's association fees;

- *Read the exceptions.*– Watch for:

 → Current property taxes (they will increase when you move in, but this will give your escrow agent enough to project any prorations you'll have to pay to close escrow);

 → Deeds of trust (items the seller will have to pay out of the proceeds from the sale;

 → Bonds & special assessments (you'll inherit these fees);

 → CC&R's (you'll inherit these rules for using your property or living in that subdivision); and

→ Easements (you'll inherit the people who are allowed to use, or drive, or park on your property—usually they are very unobtrusive, like the electric company's easement to run lines underground or in the air over your property, but they can be more burdensome, like a driveway shared with the next-door neighbors).

Inspections

In the back of the mind of every would-be homebuyer lurks the horrific possibility that they might pay hundreds of thousands of dollars for a house that turns out to be a lemon: a misleadingly cute place that turns out down the road to have surprise roof or electrical or plumbing or foundation issues. There's no way the average Savvy Woman (or Savvy Human of any persuasion) can look at a house and tell what condition its insides are in. Inspectors are your hired guns whose raison is to resolve this dilemma: building professionals with various specialties who have the technical d'être knowledge, skill, and tools to investigate and report to you on the condition of the home before you buy it. (Remember that fix-and-flip True Story?) The three basic inspections that are most frequently obtained in real estate transactions are pest, property and roof inspections. Read on for guidance on what each inspection covers, what to look for in the inspectors' reports, and when you should be concerned about their discoveries.

Pest Inspection Report (a.k.a. Termite or Wood Destroying Organism [WDO] Report)

What it is

If you are a fashionista at heart, it might be instinctive for you to deem a particularly sweet Spanish-style bungalow "delectable" or to describe a tantalizing Tudor as "tasty." There are a multitude of little critters who wholeheartedly agree—they quite literally see your next home as a scrumptious morsel that is theirs for the taking. Besides them, there are a number of other threats to the wood that makes up most of your home: Certain plants like fungus, algae and mold can literally eat wood away; and even simple water can rot unprotected wood to the place where it crumbles at the touch of your hand.

As such, the common name for the wood destroying organism report—the termite report—is a misnomer. In fact, this inspection looks for and reports any organism, plant or condition that has, or could, destroy the wood or structural integrity of your home.

What to Look For

Sections – Many reports are divided into two sections. Section I items are areas where there is active infestation, or the wood or the structure has already been damaged. Section II contains reports of conditions likely to lead to infestation, wood or structural damage if they are not corrected. Some states and lenders mandate Section I items be remediated prior to closing; in others, market forces predominate. In a seller's market, you might be stuck with all the work from both Sections to handle over the time you own the home, if you choose to. In a buyer's market, you might be able to get the seller to do some or all of the work, or to give you a credit for the work to be done. In some markets, known as "as is markets," the presumption is

Insider Secret

WORKING IT OUT WITHOUT ROCKING THE BOAT

If you write into the contract that the seller is going to complete any work to the property, your lender will not fund your mortgage unless and until they see some written proof that the work has been completed in its entirety. When it comes to termite work, if the contract says that the seller will provide the property pest-free, the lender will also demand to see a termite clearance: a new inspection report that declares that there are no wood destroying organisms or conditions present. Depending on the nature and extent of the work that is needed, and the time it takes to get the pest control company to come out and get started on it, it could take longer than your escrow period to get the work done. If your inspections indicate that there is work to be done, and the seller is willing to pay for it, consider accepting the property as-is and taking a cash credit that you can apply toward getting the work done. This can help you in three ways:

(1) It gives you time to get multiple bids (so you can choose the lowest price), and potentially have non-pest-related items completed by a trusted handyman or general contractor (at less cost than the termite company would charge to do non-pest work);

(2) It allows you to move on in, and take care of non-urgent matters over time, without having your home held hostage by the lender!;

(3) If there is painting to be done, or toilets or other fixtures to be replaced, you'll get to choose colors or fixtures in accordance with your tastes, rather than just getting the cheapest stuff available (which is likely what the seller will have the pest company do).

The one caveat is that on occasion, the termite report will caution that more damage might be concealed behind a wall or under the area mentioned in the report; if so, and you are considering taking a credit and having the work done yourself, get the termite company to drill "test holes" so they can see behind the wall. This is the only way to make sure you know the full extent of the damage before you agree to a certain amount of credit.

that you will take the property as-is and without credits from the seller, but that the seller has priced the property in consideration of the work that needs to be done, per a pre-contract inspection. However, the number one rule of real estate negotiation applies here, too—everything is negotiable. Work with your Realtor to craft a strategy on the WDO report that makes sense in your market, and with your seller;

Scope of Report – Because you're paying for this inspection and report, you get to say what all should and shouldn't be inspected. If the property has a deck, in-law unit, garage or outbuilding that is not attached to the property, you might have to specify that you would like to have it inspected. Same with fences. If, however, you know that the fences are falling over and that the deck is dilapidated, and you are already planning on replacing them after you move in, consider excluding those items from the inspection to avoid paying extra to have the inspector to tell you what you already know!;

Wood Destroying Pests & Organisms – The key here is to make sure you are clear on the extent of the infestation, whether the pests have affected the structural integrity of the home, and the cost and logistics of the inspector's recommendation for getting rid of the little buggers, who include:

- Wood-eating fungus, mold, algae;

- Termites; and

- Wood-boring ants (a.k.a. "carpenter ants") and beetles (a.k.a. "powder-post beetles").

Insider Secret

UNWELCOME HOUSEGUESTS

If your property is infested with any of these creepy-crawlies (which are actually more like crunchy-munchies), check the report to see whether the home needs to be fumigated or whether the infestation is limited enough that the infected wood can be cut out and replaced with surrounding areas treated with pesticides. If your new home requires tenting (you know, with one of those huge circus-tent looking jobs) or fumigation, it may need to be vacated for several days during and after tenting. If you are taking the property as-is, it might be a good idea for you to have the place treated before you move in!

"Conducive" Conditions – These are matters of circumstance, elements of the way the property is situated with respect to the environment that encourage the dreaded, above-described critters to move right on in, or are otherwise "conducive" to structural decay or deterioration. Sometimes the condition itself is all that is being reported, which empowers you to remediate it before any damage is done. On these occasions, you can often work with your inspector to develop a plan for correcting the situation gradually. Make sure you ask what must be done ASAP, and what items can wait a little while.

Other times, the condition is reported along with the inspector's findings of damage already been done. Then, you'll want to distinguish damage correction from damage control, the immediate fix from the long-term preventive. You'll also need to know whether or not the structural integrity of the building has been compromised.

The most common "conducive conditions" are:

o *Defective Grade* – This is where the lot slopes toward the home, causing rainwater or runoff from your roof to sit at the base of your home rather than drain away from the home, causing damage to the wood and foundation;

o *Water* – Poor drainage due to grade, soil, bad gutters, missing downspouts or any of about 15,000,000 other conditions can cause standing water against or under your house, that can, over time, literally eat through the concrete foundation;

o *Earth-to-Wood Contact* – Many wood destroying pests live in the dirt under and around your house, and can get into the wood in your home simply because the dirt was piled up next to it in the crawl space under your house or even in your flower beds! Also, moisture can leach from the dirt into the structure. If your foundation is tall enough, this fix can be as simple as taking a shovel and moving the dirt away from the building—a Saturday afternoon project for you and your pals;

o *Excessively Short Foundation* – This also causes earth-to-wood contact, but is way more expensive to fix than if the excessive earth can just be scraped away;

o *Firewood Stacked Against an Outside Wall* – The quickest way to invite termites and other woodland pests to a meal of "haume" cuisine (as in your home is on the menu for breakfast, lunch, and dinner) is to stack firewood against your exterior wall. Firewood is full of tree-munching fauna who would love nothing more than to be welcomed into your home—literally into the wood that makes up your home. This fix can be as simple as moving the stack, or as complicated as treating an infected area or fumigating the entire building;

The Quote—Realtors and house hunters often use the dollar amount of the pest control company's bid to complete the needed work as shorthand for the extent of work needed. So, for example, one home in my area might be referred to as having "$5,000 in termite" while another home might be said to have "$4,000 in Section I and $1,000 in Section II." These two references mean essentially the same thing—the latter is simply more specific about the nature of the problems found by the WDO inspector.

Whether a WDO report quote should cause you alarm depends somewhat on the average condition of properties in your area. If your prospective property is located in an area where most homes are older, or structural pest control issues are very common due to seismic or soil issues, you should not be horrified if your termite inspection uncovers items that require work. If your property is newer, or many of the properties for sale in your area have termite "clearances," you should be more concerned if you get a lengthy list of needed repairs back from the termite inspector. Also, if the lender and/or the terms of your contract require that the seller complete any needed WDO repairs prior to closing, and the inspection indicates the need for a long or expensive list of repairs, your real concern should be the time it will take to get the work done—escrow may need to be extended (and your move-in date postponed) in order to give the contractors time to do what they do.

Should You Be Worried?

Buyers often hear the pest inspector's quote and ask me, "Is that a deal breaker?" Ultimately, whether we're talking $1,500 or $15,000, whether a specific dollar amount should freak you out or kill the deal is up to you. It's all relative to the terms of your contract (e.g., whether the seller will be completing the work prior to closing), to the amount of work that the other homes on the market require and, most importantly, your financial ability and emotional inclination to have the work done after you take ownership.

If your WDO report comes back indicating a level of work beyond what you feel is "normal" for your market or acceptable to you personally, you have a number of options for how to proceed. (Though we've covered most of these in the last chapter, they bear repeating.) In such a case, you can:

- Decide whether you believe the agreed-upon purchase price is already appropriate, given the work needed and, if so, move forward with the deal;

- If not, negotiate an appropriate price reduction in consideration of the work (or some other fair exchange, like new windows or some other improvement that works out for everyone);

- Negotiate for the seller to complete some or all of the needed work;

- Negotiate for the seller to give you a credit to cover some or all of your closing costs (so that you can conserve that cash to do the work later on—some lenders disallow seller credits which are expressly made in lieu of repairs);

- Decide to accept responsibility for the needed work and move forward with the deal; or

- Back out of the deal, and get back to house hunting!

Insider Secret

WATER IS THE ENEMY

Sounds unbelievable, but water can literally destroy a foundation and eat through wood. Take your inspectors' drainage recommendations very seriously—if your property has water-related conducive conditions, but hasn't been seriously damaged by them as of yet, follow through and correct these conditions in your first few years of homeownership so you don't end up with foundation problems down the road.

Before you decide what route to take, keep in mind that if most of the work indicated on your WDO report is not pest related, if you elect to move forward, you may be able to hire a licensed general contractor or a reputable unlicensed handyman to complete the repairs at a much lower price than the pest control company will charge. When you hire a pest control company to do non-pest related work, they often simply call up a general contractor and have them do the woodwork or replace the toilet or whatever at a marked-up price to you. This is one time that cutting out the middleman can make a lot of economic sense!

Property Inspection Report (a.k.a. Home Inspection Report)

What It Is

Your property, or home, inspection report is the closest you'll get to a user's manual for your home. The home inspector will literally give your home a physical exam, noting both the basic information you'll need to know as a homeowner (e.g., where you can find the main gas, electrical and water shutoffs) and areas of concern. These folks literally go room by room through the home, flipping the light switches, flushing the toilets, testing water pressures and electrical outlets—and noting their findings in a very detailed report that can range up to 50 pages or more!

Generally, property inspection reports address the following areas (where applicable to your property):

- Emergency Shutoffs
- Roof
- Exterior
- Drainage & Grading
- Garage
- Electrical
- Plumbing/Water Heater
- Heating
- Cooling
- Interior (room-by-room)

- Doors & Windows
- Bathroom
- Laundry
- Kitchen
- Attic
- Insulation
- Basement
- Structure
- Crawl Space

For each of the above areas, your property inspector will first give a general description of the features and characteristics of the home. Then, he or she will provide observations and recommendations, if any, for each topic of concern. Often, for ease of reference the inspector will insert digital photos of problem items directly under the description of the issue in the report.

I like to tell my clients to use this report as a prioritized Home Depot/Lowe's/Ace Hardware shopping list for the first couple of years of home ownership. This document is equal parts (a) information and (b) advice specific to your property, and many inspectors also include a small bound home maintenance and repair guide or DIY manual along with their report.

What to Look For

There is a set of standard headings which property inspectors use to signal the nature of the observation that follows. Here's a decoder for those headings:

Exclusions/Not Included/Not Inspected – These headings indicate items that could not be accessed for inspection, either because the occupant's personal property was blocking the inspector's way (e.g., packing boxes in the garage blocking the electrical service panel) or because it exceeds the scope of the inspection you ordered;

Summary Page/Action Items Page – Seasoned Realtors flip directly to this section when they pick up a property inspection report. This page pulls out all the health and safety issues of any degree, action items, and significant findings and recommendations from the entire report, and consolidates them in one place. This is your shopping list for those weekend excursions to the home improvement store;

Health & Safety – Items flagged as "Health & Safety" include any and everything the inspector believes might affect the health and safety of whoever lives in the home. These can range from very cheap-and-easy to fix problems like a faucet which has Hot and Cold knobs reversed (free to fix by correctly re-installing the same fixture) or a non GFCI-protected outlet in the kitchen (a $10 fix even I could do—and that's saying something!), to more worrisome items such as gas leaks and unsafe electrical wiring;

Maintenance – This describes items which are working well enough to serve their purpose at the time of the inspection, but are worn and need normal maintenance or minor repair to prevent damage or dysfunction. A common maintenance item I see is the obstruction of rain gutters by leaves and other debris—they need to be cleared in order to keep functioning and to prevent cracking;

Note – Comments made purely for informational purposes, like a description of the inspector's general recommendations for how to select a repair tradesperson or a comment that the property's interior walls appeared to be freshly painted (which sometimes conceals cracks, etc. in the wall);

Insider Secret

INSPECT YOUR INSPECTOR

Unlike pest inspectors and roofers, home inspectors are not subject to licensing requirements in every state. To ensure that your home inspector has a high level of competence, knowledge and skill, make sure she or he is certified by one of the major state or national certifying bodies. The American Society of Home Inspectors (ASHI) is the foremost national group; most states have a similar organization or association that sets minimum standards of practice.

Not Serviceable, Not Functioning/In Need of Repair – A system, component or amenity that is not functioning as intended, but is also not posing a threat to the occupants' health and safety. For example, a dead electrical outlet is a bummer, but it won't hurt anyone. These items need repair to be returned to "serviceable" condition

Serviceable – Items described as serviceable are functioning properly and serving their intended purpose. They should continue to function properly and remain in usable condition so long as routine maintenance is carried out;

Upgrade – This most often describes items which are out of date and out of compliance with modern building codes and practices, but which were likely acceptable at the time they were built or installed at the property. For example, porch and deck steps in older homes were often not built with the hefty structural support now required. The status quo is not necessarily hazardous, but the steps could certainly stand to be upgraded. These suggestions can be especially constructive in helping you create a longer-term plan for remodeling or upgrading your home;

Investigate Further – These are super important. Home inspectors are generalists; they won't give you quotes for fixing anything, because they don't fix for a living, they inspect for a living. What they will do, though, is recommend further investigation if they see red flags which might indicate hidden damage or areas that that might need to be looked at in closer detail by a specialist in the appropriate field, whether it be foundations or plumbing or air conditioning. Pay attention to these—this is a huge part of why you hire a home inspector in the first place. An "Investigate Further" is not necessarily a cause for alarm. I once had an inspector recommend further inspection of a foundation, and the foundation engineer's eventual verdict was "ugly, due to multiple repairs over the years, but totally functional and bearing the weight of the house well."

Insider Secret

WRITTEN EXTENSIONS

When a property inspector recommends further inspections, sellers are often willing to agree to extend the contingency or objection period by a few days to give the buyer time to get the necessary information. If you are close to your deadlines and your home inspector recommends that you get a specialist's opinion, ask your Realtor to request an extension of time in writing.

You should always follow up and seek the recommended information, preferably prior to the end of your contingency or objection period. The urgency of the further investigation depends on how serious the issue might be (i.e., whether the worst possible outcome of the recommended specialist opinion would change your decision regarding whether to buy the home or what to pay for it);

On occasion, an inspector will make an "Investigate Further" recommendation when he or she wants you to collect more information about a certain aspect of a property, like an addition, from the seller. In these cases, your Realtor can prepare a written request for the information and submit it to the seller;

> *Monitor* – This is advice from the inspector "Watch this item." It may not need repair right now, but you need to keep an eye on it. For example, sometimes an inspector will see a water stain on the ceiling during the sunny season, but the seller appears to have repaired the roof leak. Still, you need to keep an eye on that area when the rainy weather arrives, so that your ceiling and walls don't incur extensive water damage before you finally notice a leak. This is the sort of item that gets a "Monitor" flag;

> *Not Present* – An item that is normally covered in the report which is simply not a feature of the property, like a garage or cooling system in some homes.

Insider Secret

YOUR PRESENCE IS REQUESTED. . .

Make every effort to attend your pest and property inspections. The inspectors will show you around the inner workings of your place. Besides, while they are in the crawl space, or checking outlets and water pressure, you can be measuring rooms and spending a few hours getting to know your home-to-be. The disclosure reports are riddled with legalese that can make a simple weekend DIY fix seem like a health and safety hazard on par with Chernobyl; in person, the inspectors can better help you gauge what is and what isn't a big deal in terms of repairs that need to be done. They can also help you create a prioritized list of what action items need to be handled immediately, which ones can wait, and for how long. Take a half day off work for this, and ask your Realtor to schedule the pest and property inspections at or around the same time.

Roof Inspection Report

What It Is

A licensed roofing contractor goes out to the home you're buying and looks at the roof—usually climbing the ladder and getting on the roof to get a close view—to determine its condition. He prepares a written report describing the roof, making recommendations and comments, and providing a quote for how much any needed repairs will cost (if you hire his or her company to do them). The report is usually no longer than one to two pages, and often these guys get on the roof early in the morning or at other strange times. Since you can't get on the roof with them, there's no real reason for you to be present at this inspection. If you have any questions about the written report, you can just ring up the inspector and ask away via telephone.

What To Look For

Material – The roofer will tell you what the roof coverings are made of—composition shingles, wood shake, tile, etc. You will not believe the number of times you'll need to know what your roof is made of throughout the time you own your home, so pay attention to this;

Effective Age – This is the roofer's opinion of how old the roof "acts"—based on how well it is performing compared to how a properly installed roof of that material should perform over time. For example, a three-year-old roof that is leaking because of extreme weather conditions or improper installation might be given an effective age of 10 years. This can be useful to know in terms of predicting how long this roof—and future roofs—will last, and in determining the urgency of recommended fixes. If the roof has aged excessively due to weather conditions, then this will be a consideration for any roof that is ever placed on the home, and might even impact the type of roofing system you will choose if and when you replace the roof. If excessive age is due to improper installation, you might want to get the problems fixed sooner rather than later, in order to avoid a premature and costly re-roofing;

Life Expectancy – This is the one you might care about the most: the inspector's estimate of how much longer this roof will last. (Read: how many years before you'll have to pay to get a new roof or start strategically placing pots all over the house!);

Repairs Needed & Quote – Mmmm, pretty self-explanatory. The inspector will specify any specific items that need repair, describe the repairs, and provide a quote for repairing them;

Warranty – A nice thing about some roof inspections is that some roofers give a one-year warranty as to the roof's watertightness if they find it to be sound. This means that if you get a leak six months later, they will come back out and repair the leak at no cost. If they find that the roof has leaks or other damage, and you hire them to repair or replace it, they will often give a longer warranty than just the one-year. Whatever warranty, if any, is included with your inspection will be clearly stated on the inspection report. Check it out and keep it in mind so that you'll remember to call them if your roof leaks next winter, instead of looking in the Yellow Pages and paying someone else to do the fix.

What Else To Ask – I think you should always ask your inspector what the cost would be to totally replace your roof, no matter how new or perfect the roof is currently. They'll give you a ballpark, but that will put the roofing issue in perspective for you. It will also prevent you from procrastinating on getting leaks fixed and your roof replaced when the time comes that it does need it—nine times out of 10, it does not cost anywhere near what you might think!

Does Size Matter?

Early on in your house hunt you'll gain clarity as to whether you're looking for a 1500-ish square foot place, or a 900-ish s.f. home, or a 2,500-plus s.f. property—generally, you'll like the feel of places that have about 15 percent more or less square feet than your target number. But once you are in contract and reading inspection reports and disclosures, my advice on square footage is to just stop caring too much about the exact numbers. If you feel that you (and/or your family) can conduct your life in the property's living space in the style you were aiming for, and the property appraises at the purchase price, then the precise s.f. number is really of little or no import. This takes the freak-out potential out of this issue because the chances that you will be given a perfectly precise number—from anyone—are between slim and none.

Insider Secret

SQUARE FOOTAGE

It is notoriously problematic to get a precise measurement of the square footage of a home or a lot. The public records often say one thing, the seller says another, and the appraisal gives yet another number. Truth be told, even if you ask two different civil engineers to measure the same home, chances are they'll come out with different numbers. Not drastically different, perhaps, but different.

If, for whatever reason, you still feel a need to have a very accurate to-the-inch opinion as to the square footage of your home, or your lot, or even your property lines, my advice would be to hire a civil engineer to measure your house, and a surveyor to measure your lot. Oh, and be prepared to do battle with neighbors if the fences aren't right on the line. And it may turn out that the fence has been too far on their side for 80 years, so be very careful what you ask for—accurate lot line surveys have probably caused more turmoil than benefit in this world!

Special Considerations When Buying a Condo or Buying a New Home

If you're buying a condo or co-op, you are still entitled to all the same disclosures as you would be otherwise, and maybe even more, if you consider all the HOA information. Your inspections will be somewhat different, though. As the owner of an individual unit, you won't be individually responsible for the exterior of your building, so some condo owners opt to completely forego the exterior section of the property inspection. (See HOA's: All for One & One for All?; below, for a caveat.) Unless your prospective unit is in a huge building or complex, the better option is to have the inspector look at the exterior of your unit or building, but for you to consider that section as largely informational. This way, if the inspector finds things wrong, you might want to get active in your HOA, and work to get some repairs done for the benefit of all the owners (including you).

Insider Secret

HOA'S: ALL FOR ONE & ONE FOR ALL?

When you buy a condo or co-op, the HOA usually bears responsibility for maintaining and repairing the buildings' exteriors. However, if your HOA has a fairly small reserve account, and the roof(s) need to be replaced or the whole place needs painting, the HOA may vote to impose a special assessment on every unit's owner for their share of the repair bill. Large special assessments are usually proposed fairly far in advance—a year or more is normal—so if your inspector sees a lot of things wrong with the exterior of the property, pay special attention when you are reviewing HOA newsletters and board meeting minutes to see if repairs have been proposed and, if so, whether the expense will be covered by the HOA's reserves or special assessments against individual owners.

Similarly, the pest inspectors often offer to split their condo inspection reports into sections based on whether the unit's owner or the HOA would be responsible for correcting the problem: under-sink leaks go under "Owner," and termites in the building's crawl space go under "HOA." And, unless your unit is a stand-alone townhome or in a building with only one other unit, it probably doesn't make sense to have a roof inspection. (The HOA is almost always responsible for the roof—double check your HOA disclosures to be sure!)

If you're buying new, there are different schools of thought about whether you should have your home inspected at all—especially given the fact that the builder's warranty will likely cover most of the things that could go wrong in the first decade of ownership. My argument is that without a home inspection, you might not recognize or detect defects until after a particular defect has caused more damage, or until the warranty coverage for that particular item has lapsed, so I recommend that new homebuyers also get home inspections. (Besides, the inspection report is a handy informational tool even if no defects are found at all.)

Miscellaneous Inspections

There are a huge number of other inspections that are available, but not necessary unless your home has a specific feature or a specific problem. Just so you know what's out there, be aware that if you need or want to, you can order any of the following special inspections:

- Survey (to let you know your lot's exact boundaries) or civil engineering measurement (to measure the square footage of the home);
- Structural engineering inspection (to find design or construction defects and overall structural soundness of buildings);
- Foundation inspection (a foundation or structural engineer checks on structural integrity of foundation);
- Geotechnical engineering inspection (to determine soil stability);
- Pool or spa inspection;
- Earthquake and flooding susceptibility (geotechnical engineer or geologist inspect the building and the land beneath it);
- Insurability inquiry (asking your insurance agent whether anything will prevent you from being able to obtain insurance on the property);
- Waste disposal (to check out the capacity and condition of your sewer or septic system components);
- Well systems and components (if the property has a private well).

Inspections – Check!

Your inspections are your safety net before the transaction. They help stop you from getting a lemon of a house in the first place, and empower you with full information about the property before you have to move forward and seal the deal. Inspections and disclosures can only minimize—not eliminate—all the risks that something will happen to your home while you own

it. Fortunately, before you close escrow, you'll be able downshift from the frenzy of attending inspections and reviewing reports and disclosures, and slow down to put in place at least two major safety nets to catch you once you own the home: Homeowner's Insurance and a Home Protection Plan.

They Got Your Back: What you Need to Know about Selecting a Homeowner's Insurance Policy & Home Warranty Plan

Think of your car. When you buy a car you get a manufacturer's warranty to protect it when systems or components break down. But you also get an auto insurance policy to protect you and others if your car is involved in an accident. Toward the end of the escrow process, you'll need to obtain parallel layers of protection for your home: homeowner's insurance (to cover the cost of repairing damage from "accidents"—fire and other natural events, burglary, and injuries others suffer in and around your home)—and a home warranty or home protection plan (to repair or replace systems or components that break down).

Here's what you need to know about both of these long-term safety nets.

Homeowners' Insurance

It is called homeowner's insurance, not home insurance or land insurance. Here's why. Homeowner's insurance protects you, not just your house, providing cash coverage of three different flavors:

> *(1) Property Coverage* – If your house burns down, your insurance company writes you a check. Most lenders require that you obtain and maintain a property coverage policy that will pay at least the replacement cost, should (God forbid) your home be destroyed.
>
> Time after time, I have gotten a call from my homebuyer clients who have recently received homeowners' policy quotes and thought they were being scammed when they saw that the replacement cost for their home was listed at less than half of the purchase price! They think, "I certainly couldn't go out and buy this house elsewhere for that amount. I must get more insurance than this!"
>
> While there is such a thing as being underinsured, in most cases, that seemingly low replacement cost is neither an error nor a scam. Replacement cost is a tricky concept; it is not the cost of buying another home like the one you have now. It is the projected cost of rebuilding your home on the lot of land it now sits on. In the vast

majority of cases, when the home is destroyed, the land is still intact and rebuildable. When you buy your home, the purchase price is for the house and the land. And the greater share of the purchase price/market value of our homes definitely lies in the land, not the building;

(2) Personal Property Coverage – Your homeowner's insurance policy also covers your personal belongings. If the contents of your home—your computer, TV, jewelry , etc.—are stolen or destroyed, that loss will be covered up to your policy limits. Some policies require you to list all your personal items in order for them to be covered beyond fairly low limits;

(3) Liability Coverage – If someone slips and falls at your place and breaks their neck, or your dog bites a passerby on the street, your homeowner's insurance policy has your back! Liability is your exposure to having to pay someone for an injury or damage for which you—or someone or something that belongs to you—might be legally responsible. Accordingly, "liability coverage" simply means that in the event you might be legally responsible for something, your insurance carrier agrees to pay so you don't have to. (If you got sued for anything, and a judgment was imposed against you which you couldn't pay (and your insurance didn't cover), that judgment could be recorded as a lien against your home—and the courts might even force you to sell your home so the plaintiff can collect. See - it does make sense for your homeowner's insurance policy to protect you against all sorts of liability, not just things that happen at your home.)

Types of Policies

There are only about five types of insurance policies that offer protection for you as a homeowner, and only really two or three that you should care about. But you need to be aware that the others exist to make sure that you don't end up with one of them:

Homeowner's (a.k.a. HO) – Described above, for owner-occupied properties only, the most coverage for your insurance buck;

Landlord – For properties that are renter-occupied, covers same as homeowner's plus lawsuits against you for wrongful eviction;

Condo – Covers the contents of your place (your personal property) plus liability, but not the actual building (your HOA dues pay for a policy that covers property damage to the building);

Special Form (a.k.a. SF) – covers a property that is either owner or renter occupied; low cost policy that offers much less coverage than the others;

Dwelling (a.k.a. DP) – in the trade, we call this a "junk property" policy, because investors use it to cover buildings that will be torn down; offers the least coverage and is the least cost effective of all policies (read: if you are offered a Dwelling Policy—run, don't walk, away from that insurance broker).

Supplements & Endorsements

Insurance policies tend to be fairly cookie-cutter, with several standard coverage configurations available at varying levels of cost. Supplements are additional policies that are available only to people who already have homeowners' policies. The most common supplement is an umbrella policy—which extends liability coverage up to several million dollars beyond what is included in your homeowners' policy, at a fairly low cost. Just think—if you own a $700,000 home, your replacement cost might only be $300,000, and your liability coverage under your basic homeowners' policy might be $100,000. But if you were involved in a lawsuit, and someone obtained a $500,000 judgment against you, you would obviously still have at least $200,000 in exposure. An umbrella policy covers you against liability of all sorts—wrongful death in a car accident, business lawsuits, you name it—up to the umbrella coverage amount. Generally speaking, umbrella coverage is extremely inexpensive. At the time of this writing, I was quoted the following rates for an umbrella policy for an average Bay Area first time homebuyer (whose high home value actually makes them a more likely target for litigation-type risks than in other areas):

Umbrella Policy Coverage Limit	Annual Premium
$100,000	No Charge
$500,000	$35/year
$1,000,000	$60-250/year
$2,000,000	$360/year

Obviously, these rates are not the precise rates you'll be offered—they were created for a hypothetical buyer, and your actual rates will be based on your history and projected future risk level. However, with rates anywhere near this low, if you are buying a home with a fair market value greater than the liability coverage limits of your homeowner's policy (which you very likely are), an umbrella policy is a very cost-effective must. Ask your insurance agency to provide you a quote for an umbrella policy with limits about the same as the total value of all of your assets (your home, cash accounts, retirement and investment accounts, jewelry and personal belongings, your business, etc.).

Endorsements (a.k.a. floaters)

Endorsements are like add-ons—specific, additional coverages you can purchase to bolster specific coverage limits on your homeowners' policy. Like everything else involved in homebuying, you should pick and choose your endorsements based on your lifestyle and the nature of your belongings. The most common endorsements selected by Savvy Women homeowners are:

How Your Premium Is Determined

Just like your car insurance premium (the payment you make monthly, every six months or annually), your homeowner's insurance premium is set based on the answers to a bunch of questions that help the insurance company predict how likely you are to file a claim they have to pay out, and how large that claim is likely to be. Your deductible—the amount of cash you'll have to pay out of pocket toward your own damages before your coverage kicks in (from $500 to $10,000)—is probably the single factor which has the most impact on your premium. The more you're willing to pay in the event you need to make a claim, the lower your annual premium (which is payable in monthly installments).

Beyond the deductible issue, there are tons of little questions and answers that have a tiny impact on your premium, and there are a few big issues that have a big impact—the inquiries which assess the risk of big losses: fire, dog bites, and burglary (in some areas).

The predictors are:

The Home – When you call your insurance broker or carrier to get a homeowner's insurance quote, they'll have a list of detailed, technical questions about the property for you to answer. You'll need your home inspection report, the MLS listing, and the seller's disclosures close at hand when you call so you can flip through and find the answers. Some of the items your carrier will certainly ask you about are:

- *Electrical* – What sort of protection do your main and electrical service panels have: fuses or circuit breakers? What wiring method(s) are present in your home: non-metallic sheathed-wire, old school knob-and-tube, or flexible or rigid conduit?;

- *Roofing Material* – Is your roof covered with wood shake or shingles, composition shingles, tile, or tar and asphalt/gravel? Wood covered roofs catch and spread fire more readily than other roofing types, and can cost you more on your homeowner's policy;

Homeowners' Policy Endorsements—What They Cover & How to Know Which Ones You Might Need

ENDORSEMENT	WHAT IT COVERS	YOU MIGHT NEED IT IF. .
Guaranteed dwelling up to value Inflation guard Ordinance & law	These four separate endorsements each guarantee that your carrier will pay the actual (vs. projected) cost of rebuilding your home to current codes/standards at the time of rebuilding—regardless of inflation of building costs and up to the market value of your home, even in excess of the limits of your basic policy.	You are a human being, you live in America, and you can afford the endorsement—especially if you suspect you might be underinsured. You don't need them all, though; probably just one—ask your insurance agent to discuss pros and cons of the individual riders and to help you pick the most cost-effective one of these.
Other Structures	The cost of rebuilding larger, more elaborate outbuildings—stables, gazebos, in-law units, in excess of the normal 10 percent of overall replacement cost limit (e.g., if replacement cost of home = $200,000, your standard policy limit for replacing outbuildings without this floater would be $20,000 and would have to be stretched to also cover fences, sheds, etc.).	You have a major detached structure on your property.
Sewers & Drains	Damage to your finished or storage basement from defective sewer lines, drains, flooding. Not otherwise covered under a standard policy.	Your new property has a finished basement (a.k.a. "bonus" or "rumpus" rooms) in the basement, and you are not 100 percent certain you have perfect drainage or clear sewer lines.
Scheduled Endorsement	Covers value of individual items of personal property that you specify as having greater value than the normal limits of your policy. For example, might cover your engagement ring at the value you list, which exceeds your policy's $500 per piece of jewelry limit.	You have a very small or very large number of personal items which have significantly higher than average value for that category of items (e.g., antiques, jewelry, etc.) and are willing to diligently inventory & document their value piece by piece, on an ongoing basis.
Blanket Endorsement	Covers a range of your personal belongings above and beyond the standard coverage provided by your policy, without you having to schedule a list of individual items of personal property.	You aren't up for keeping a running, formal list or schedule of your valuables, and many or most items of your personal property are worth more than the coverage offered by your standard policy.
Guaranteed Contents	Guarantees replacement of your personal belongings (home electronics, furniture, etc.) with the amount you paid for it or a comparable item, rather than the depreciated value of that item (the standard policy rule—if your computer cost $800 but it was two years old when someone stole it, you would only receive a reduced amount for reimbursement due to natural loss of value—depreciation—over the last two years, maybe $400).	Same as above.

ENDORSEMENT	WHAT IT COVERS	YOU MIGHT NEED IT IF. .
Special Computer	Covers replacement costs for computer equipment above and beyond the limits of the standard policy. Does not cover the costs of replacing lost data.	You have new, fancy or expensive computers, printers, etc.
Home Business/ Business Pursuits	Covers liability created by a small home business (e.g., piano lessons) or business pursuit (e.g., Avon or passion parties).	You have a small home business or sell some sort of franchise-type product from home. If you own a business larger than this, you need a general commercial liability policy outside of your homeowner's policy.
Personal Injury	Covers items outside the normal type of injury caused in a home—including libel, defamation, slander and other character assassinations.	You live on Wisteria Lane and happen to be the gossipy type. Seriously—if you hang out in a circle where folks sue each other for spreading rumors (real or imaginary), this is your floater!
Home Daycare	Covers liability claims arising from your operation of a daycare from your home. For example, if a parent sues you or a child gets hurt, this is the coverage that kicks in.	You operate a daycare at home.
Income Property	Covers liability for building damage and physical injuries arising from having rented a structure at your home for income.	You rent out a room, finished basement, poolhouse, coachhouse, etc. from the home you live in.

- **_Extraordinary Safety & Security Measures_** – Is your new home equipped with a burglar alarm, smoke or carbon monoxide detectors (especially the kind which are monitored by a security company), or fire sprinklers? Is it located in a patrolled or gated community? Any of these extraordinary measures may lower your insurance rates.

You –

- Do you have a history of making claims against your homeowner's or renter's insurance policy? If you have made more than one in a year or more than three or four ever, you might be seen as a high risk client, and be charged a higher premium accordingly. This should make you think twice before making claims when you buy your new home—if the damage is something fairly easy and/or inexpensive to fix, it may not be worth asking your homeowner's carrier to cover it and risk a ding on your permanent record;

- Are you a smoker? Your rates will be higher (another reason you should stop!). Smokers are much more like to—you guessed it—have a house fire. It's that whole fall-asleep-with-a-cigarette-in-hand-and-the-mattress-goes-woosh! phenomenon;

- Do you own a big dog? What kind? If you own an American Staffordshire Terrier (pit bull), a Rottweiler or a dog mixed with either of those breeds, your rates will be higher. The average dog bite results in a $30,000 homeowner's insurance claim, and the insurance company expects people who own the most dangerous breeds to pay for the risk that Brutus might bite little Timmy next door;

- Do you have another policy with the insurance carrier? Most carriers who offer different types of insurance policies—auto, home, renter's, commercial—will give you a multiple policy discount if you carry more than one type of policy with them. If your auto insurance company also carries homeowners' policies, call and get a quote on your home insurance from them. If your auto insurance policy doesn't have homeowner's insurance, find a homeowner's company that offers auto and ask them (a) for quotes on both policies and (b) what the multi-policy discount is.

Your homeowner's insurance covers accidental damage to your home and its contents, and covers you when you might be liable for causing damage to someone else. However it doesn't cover the unexpected, but expensive, home repairs and replacements necessitated by normal wear–and–tear, and the aging of your plumbing, heating, electrical and other systems. For that, you need a home warranty!

Home Protection Plan (a.k.a. Home Warranty)

In many markets, the seller will pay for you to be covered by a one-year home warranty, which will help you fix or replace many of the major systems of your home if (or, rather, when!)

Insider Secret

INSURANCE TROUBLESHOOTING

If you learn, during your home inspection, that your property has a fuse box for electrical service, knob and tube wiring, or a wood shake or wood shingled roof, you should call your insurance company sooner rather than later to start the insurance process. A few companies refuse to carry policies on homes with fuses, knob-and-tube, or wood roofing material, so you'll want to know this in plenty of time to find another carrier, if necessary. Also let your insurer know if you plan to replace any of these items shortly after closing—some insurers will give you credit for having made the change on the condition they can verify that the work has been done within 60 days after escrow closes.

Home Protection Plan (a.k.a. Home Warranty)

BASIC OR STANDARD COVERAGE	UPGRADED A.K.A. PREMIER, FIRST CLASS, COMPREHENSIVE	OPTIONAL INDIVIDUAL COVERAGES
Plumbing Stoppage or Leak	Expands coverage to include faucets, showerheads, shower arms, and hose bibs.	Central Air Conditioner, Evaporative Cooler, Window coolers (automatically included with Upgraded Coverage)
Water Heater	Expands coverage to include sounds caused by sediment	Pool & Spa Equipment
Oven/Stove/Range/Cooktop	Expands coverage to include rotisseries, racks, handles, knobs, dials, interior lining	Washer & Dryer
Dishwasher	Expands coverage to include dishwasher racks, baskets and rollers	Well Pump
Garbage Disposal & Trash compactor	Expands coverage to include compactor buckets	Sewage Ejector Pump
Built-in Microwave	Expands coverage to include built-in microwave lining, shelves, clocks, door glass	Septic Tank Plumbing
Electrical		Limited Roof Leak Coverage
Heating	Expands coverage to include heating & Cooling Filters, Registers, Grills, heat lamps	Built-in Refrigerator (Sub-Zero style)
Garage Door Opener	Expands coverage to include hinges, springs and remote controls	Home size over 5,000 square feet
Toilets		Guest home under 1,000 square feet
Ceiling Fans		Solar heating or pool/spa equipment
Attic, Bathroom & Kitchen Exhaust Fans		
Ductwork		
Pest Control Services		
	Expands optional coverage to include refrigerator ice makers	Kitchen or wet bar refrigerator
	Smoke detector coverage	
	Limited code and ordinance—covers a certain dollar amount for code violations and upgrades required by the government to comply with building codes when doing covered plumbing, electrical and heating repairs	

they malfunction. The home warranty companies all have a network of local contractors who specialize in every sort of home repair. When your water heater starts leaking or your garage door won't roll down, you just pick up the phone and call your home warranty company, and they'll send out their local plumber or garage servicing contractor. He or she will come out for a $40 or $50 service call fee (which you pay), and determine whether the item needs work or simply needs to be chucked and replaced. The repairfolks will submit their recommendation and estimate directly to the home warranty company, who will give them the go-ahead and pay them to do the work. (On more costly repairs, they may get a second opinion, at no additional cost to you, but rarely do they give you much hassle about authorizing covered items.) All you have to do is (a) pay the nominal service fee and (b) have someone around to let the repair contractors in!

What is covered?

Most home warranty providers offer two levels of coverage: basic ($260-$325 for most single family residences) and premium (a.k.a. premier or first class or comprehensive or something like that, $75-80 more than the basic). There are also a number of line-item type upgrades you can purchase for a fee to cover individual features or characteristics or risks that are not normally covered. Home warranties don't vary much state-to-state or provider-to-provider, so you can use this chart to reliably gauge what coverage you'll be able to get no matter where you are.

What Isn't Covered?

- Items you knew (or could have told by looking at them that they) didn't work at the time you bought your house. So, if your home inspector tells you it doesn't work, then it's not covered. You might either want to negotiate a resolution with the seller or be grateful for the information and plan to fix or replace it yourself. However, if your home inspector just tells you something is old or near its usable life span, but is still functioning properly, it should be covered under your home warranty if it breaks or dies while your policy is in effect.

- Secondary Damage – Your home warranty doesn't cover the damage that can result if one of your covered appliances or systems breaks. For example, if your refrigerator breaks and the food spoils, or your dishwasher breaks and destroys your linoleum, your home warranty will replace the refrigerator or the dishwasher, but not the food or the linoleum. Your homeowner's insurance might cover that sort of secondary damage, but you will have to assess whether the extent of the damage warrants putting the claim on your risk record and paying the deductible.

When and How Do I Order It?

Ask your Realtor – in many markets, the home warranty is a standard line item in the contract and either your Realtor or your title company will order it for you as a matter of fact, sometimes without you even knowing it until you get your policy after closing! If a home warranty is not standard in your market, or it is not referred to in your contract, do a Yahoo! or Google search for "home warranty" and find a company who provides them in your state; just make sure to do this before closing. In this case, you might have to pay for it yourself, but it is money VERY well spent.

If you are building a new home, or buying a home that is fairly new, be aware that new home builders usually cover their handiwork with a comprehensive builder's warranty that covers many, but not all, of the same things as a regular home warranty. The builder's warranty also covers structural defect, as well as defects in the materials used to build your home. If your home is less than 10 years old, make sure to ask your builder or seller for a copy of the builder's warranty—you may decide not to get a home warranty at all! (A home warranty can cover refrigerators, laundry appliances, water heaters and other items that a builder's warranty may not cover, so it is up to you to compare and contrast all the coverages available to you and decide what makes sense for you. For example, if your appliances are new, they'll be covered under manufacturer's and/or retailer's warranties.)

Selecting and ordering your homeowner's insurance and home warranty are finite events. You make the call (or maybe a couple of short calls) and you're good to go. By contrast, the underwriting process stretches out from the moment you open escrow until the moment the loan funds land in the escrow company's account a day or so prior to closing. A representative of your lender called, the underwriter will collect items from you, your Realtor, your mortgage broker, title insurance company escrow holder, the appraiser, and even your homeowner's insurance company, until their company's requirements for funding your mortgage are 100 percent satisfied. A lot of this will happen without you even knowing it, but here's a heads up about how you can expect this element of the escrow period to affect you.

Insider Secret

THREE STRATEGIES FOR MAKING THE MOST OF YOUR HOME WARRANTY COVERAGE

(1) Who ya gonna call?

If and when something in your house breaks, leaks or otherwise fails—anything—call your home warranty company FIRST. If you call Roto Rooter to fix an emergency leak, and then later you realize that a bigger plumbing problem was the real cause, your home warranty company might refuse to cover it because they were not able to have their plumber look at the original problem. The home warranty companies all have service reps available by telephone 24 hours a day, so they are well-equipped to handle your emergency home repair calls.

(2) Cash is good

If you would prefer cash to having a repair completed, ask your home warranty company. Say, for instance, that you wanted to upgrade from a standard water heater to a tankless, on-demand system. Your home warranty company will replace broken items with similar items, but you might be able to get the equivalent of the replacement cost for your old water heater in cash that you can apply toward the installation of your new system.

(3) Renew, renew, renew

Your home warranty is renewable for as long as you own your home (though some providers won't allow you to re-up if you have had a gap in coverage), usually for about $350 to $500 per renewal year. A single major repair can pay for years' worth of coverage—if your home warranty provider pays to replace a $7,000 furnace, that policy has paid for itself for as long as 20 years! Of course, big repairs aren't needed every year, but when they are needed, they always seem to come at Christmas, or when you have just had a new baby, or started a business—times when cash is tight. So, it is a no-brainer to just keep on renewing your home warranty when it comes due—that $400 check will be a lot easier to write than the $5,000 one you'll have to write if the air conditioner breaks after you let your coverage lapse.

Underwriting Process

Most of the underwriting process goes down without your input. Your mortgage professional will go back and forth with the lender through several rounds of collecting and submitting requested documents—from you, your Realtor or the escrow agent—and waiting for the next set of requests (which are not always as predictable as you'd think). Sometimes, the mortgage program itself even changes during the actual escrow process, requiring a bunch of different or new documents than those you've already produced. It bears repeating that you should just be prepared to: (a) get multiple and last minute requests for documents, and (b) to produce them quickly to keep the process rolling along.

Some of the items lenders are notorious for asking for at the last minute are:

- An updated credit report (if your pre-approval was based on a credit report from more than 45 or 60 days before you got into contract);

- Social Security Cards (not just the number);

- Green card(s) or visa(s), if not a citizen;

- Driver's license (can't be expired, and must say exactly the same name as on the purchase contract!);

Insider Secret

DON'T SWEAT THE SMALL STUFF

Don't dicker with the seller to get a new water heater or a new furnace if the items are old, but working. Just make sure you get a home warranty that covers the items of concern, and call them if and when that appliance or system stops working or dies. Focus your negotiation energies on other matters of concern.

- A letter from your CPA verifying that you've filed income taxes as a self-employed person for at least two years (if you qualified for a self-employed loan),

- Your business license (if you qualified for a self-employed loan);

- The last 12 months' bank statements;

- The last two months' statements from all asset accounts (401K, IRA's, securities, etc.);

- The last month's paycheck stubs (the month closest in time to close of escrow).

True Story: Don't Change Mortgage Pros Midstream

Two Savvy Woman clients of mine, buddies who were buying a two-family home together—one unit for each—searched and searched before finding their dream duplex. Individually, each of these ladies was a mere mortal. Together, these two comprised a meticulous, if insatiable, house hunting machine. One was an attorney with a legendary attention to listing details; the other was an architect who could visually dissect a property and detect its engineering and condition strengths and weaknesses at a glance. For about nine months, these two chewed up and spit out every duplex listing in the $600,000—$800,000 price range in each of about four different cities. They were super-prepared financially—ample down payment and near-perfect credit. Before we even started the house hunt, I connected them with the most experienced and

prolific mortgage broker I know, who quickly got them pre-approved for the best rates anywhere, kept them updated on rates and loan programs and answered two million questions over the nine months of house hunting. Before we even got into contract, she had run 44 different loan scenarios at their request!

When they finally found the place they wanted, I was committed to going above and beyond to get it for them. And their home-to-be was a hot property. I saw it on Craigslist two days before it was to be listed on MLS, waged a persuasive-aggressive battle to convince the sellers to even look at our "preemptive" offer, and still had to compete with another offer to get the victory for my clients. The sellers were also savvy—the owner was the elderly father of a respected local Realtor, the latter of whom was actually the primary decision maker. We ended up offering the same price as the other prospective buyer—both offers were for the highest price for which the property would realistically appraise—but we prevailed, because (a) my clients were owner-occupants and the other offer-writer was an investor, and (b) we offered to close escrow in a lightning-quick 18 days, while the other offeror needed 45 days.

To meet our end of the bargain, we had our pest, property and roof inspectors crawling all over that place within 36 hours after the seller accepted our contract. When the results of all the basic inspections came back all thumbs-up, we still had a foundation engineer out to craft a long-term plan for implementing drainage and earthquake precautions. The seller was building a new deck on the place, and we got contractor quotes to remodel one of the kitchens. The loan sailed through underwriting and all was in place with plenty of time to spare. Birds sang, all was well with the world, and I detected not even a whiff of buyer's remorse.

And then it happened. Buyer's remorse finally reared its destructive head in the insidious, but not uncommon, form of second guessing their choice of mortgage providers. I got the call 15 days into our 18 day escrow: "Hey, Tara. Well, I was walking through my office building and noticed that there's a mortgage company in the building. Imagine that! So, just out of curiosity, I stopped in and asked them to give me a quote on our mortgage, and they say that they can beat the payment X quoted us by, like $200!!!" I said, "Do you know these people?" She said, "No, but $200 a month could really add up!" I agreed, but also said that I happened to know beyond the shadow of a doubt that the rate they were getting was absolutely the best on the market based on what they were paying for mortgage costs (i.e., the only way they could get a lower rate anywhere would be to start paying discount points, which they did not want to do).

When my head stopped spinning, I started rattling off my list of (a) reasons the buyers would be nuts to change mortgage providers period, but especially at this juncture, and (b) questions they should ask this dark horse to flesh out the purported quote:

- You don't even know these people, and they didn't give you a good faith estimate. They could be pulling a bait-and-switch—luring you in with a low quote that surprise (!) is much higher once you seek to lock it in;

- They haven't even seen your credit and they are quoting you an interest rate—not very professional. How do we know what their level of professionalism and customer service is? Do we know 100 percent that they can or will even close the loan? Will they take three days to return phone calls or disappear entirely?;

- Did they have all the information about your loan? Did they know it was a duplex? Does that quote include a point? What are they charging to do the loan?;

- We only have three days to close escrow—it will take them that long just to get a lender to review and approve your application!

Discounting my concerns about timing and customer service, my clients cut straight to the chase and tried to firm up the quote, (a) telling the lender that the property was a duplex (which usually raises interest rates at least .25 percent), (b) asking whether the price they had been quoted included any discount points, and (c) asking for a good faith estimate. Well, they didn't even get too far into this Q&A session before they realized that they had been quoted an interest rate and monthly payment they could only get if they paid a discount point, which they had already decided against doing. In fact, my lender had quoted them an even lower rate and payment with a point than the new broker had. Once the initial rush of perhaps having found a better deal had worn off, my clients were able to see this flight of fancy as exactly what it was: a last minute, oh-my-gosh-our-monthly-payments-will-be-what?!?!? flash of buyer's fear, buyer's remorse, and cold feet all rolled up into one. Having explored—and exhausted—this option, though, I think they felt even more appreciative of their original lender, and more certain that they were getting the best deal out there.

Fortunately, these folks were able to go through this entire process of second-guessing, but staying with, their original lender within the course of a couple of hours. Had it taken even an additional business day, it would have thrown the entire escrow calendar off, holding up signing, funding and closing so that COE rolled into the next month and their closing costs would have gone up several thousand dollars. Make sure you are comfortable, confident and committed in your choice of mortgage brokers before you get into escrow on a home. Trying to change this influential ship midstream can cause your transaction to get slightly off track at best, and completely derailed, at worst.

Closing Without a Bang

Don't assume that once your final underwriting approval is in, you're totally off the hook. Underwriting continues up until the time the deed has recorded. As I've stated before, many lenders, for example, will verify your employment on the day they fund the loan, or the morning the escrow agent plans to go record the deed in your name! Check out Anti-Checklist #4: Things Not to Do While You're In Escrow, at the end of the first chapter for tips on how to avoid last minute issues with your lender.

Ironically, after all you've gone through to get the house, if all goes well it will close with a whimper, not a bang. I recently sold a home to a woman who hadn't bought real estate in over 20 years. The sellers signed at home the night before she and I went to the title company for her signing appointment. I explained that the mortgage would fund the next day, and that the day after that the sale would close. The seller would leave all the keys and garage door opener on the counter, and I would access the front door using the lockbox, which the listing agent would later remove.

Well, my client was sorely disappointed at how anti-climatic her closing was. In her imagination, she pictured a momentous event with both parties, both agents, and some other distinguished-looking folk all dressed to the nines, and seated around a mahogany table in a mahogany paneled room. After everything was signed, a trumpet blast would sound and the Handing Over of the Key would take place.

In real life, any celebratory climax around closing escrow is something you'll have to create by going out to dinner or having a housewarming soiree.

Closing can be around-the-conference-room-table formal or around-your-dining-room-table informal, as the circumstances of your case and the standard practices in your area require. Your escrow agent will drive this phase, keeping your Realtor constantly apprised of any and everything that is required of you. One day during the last week of your escrow, you will be asked to sign the final documents. Ideally the signing will take place at the escrow agent's office, but you may request to do it at your home or office with a mobile loan signer, who is also a notary public in your state. At this signing, you will sign a huge stack of documents:

- *Title documents,* which allow the property to be placed in your name on the public records and which secure your mortgage lender's interest in your property (e.g., the grant deed from the seller and the deed of trust you sign for the benefit of your lender). These make up a small fraction of your closing documents;

- *Loan documents,* which set forth every last detail of your mortgage loan, and constitute your agreement to repay the lender and the lender's various legal and corporate disclosures to you (e.g., the note which evidences your agreement to repay the lender); and

- *Escrow documents,* which constitute your final authorization of the escrow or closing agent's disbursement of all the money and property in your escrow account (e.g., your settlement statement or HUD-1).

Most of these items vary dramatically state-by-state, county-by-county, lender-by-lender, and even transaction-by-transaction. However, there is one important element of closing that has been standardized nationwide—your closing, or settlement, statement. The federal Department of Housing and Urban Development has created a standard form, called the HUD-1 (check out a sample HUD-1 on www.REThinkRealEstate.com by going on our blog and typing keyword "HUD1" into the Tara's Tips box), for use by closing agents everywhere in disclosing to buyers and sellers in line item format:

- All the debits to both Buyer and Seller, including every penny of closing costs;

- All the credits to both Buyer and Seller;

- All deposits that have been made to the escrow account; and

- All monies which must still come in to close the transaction.

At closing, you will receive a preliminary or proposed HUD-1 statement, because some items, like property tax prorations or prepaid interest, cannot be determined definitively until the day of closing. This is because if the lender funds the loan a day early or a day late, these amounts will change. Usually, the closing agent will very slightly overestimate the cash you need to bring in to close, so that they don't have to ask you to come back in with a cashier's check for $13.25 before your deed can be recorded. Your final HUD-1 will be sent out the day of closing, and often a week or so later you will receive a refund check with the overage left in the escrow account, if any. This final HUD-1 will do double duty as a tax document the following January 1; mortgage discount points and pre-paid interest are fully tax deductible (in addition to your regular monthly mortgage interest) for the year in which you paid them. Don't forget to give your tax preparer your HUD-1 with your W-2's or 1099's the next year!

Insider Secret

THE FINAL WALKTHROUGH

You can do your final walkthrough right up to the day prior to closing. If you wait that long, though, chances are that any problem you find will not get rectified before closing. (Tara Says – If it doesn't happen before closing, chances are it ain't happening.) Personally, I think you should do your final walkthrough about five days before closing. Of course, the purpose of the walkthrough is to make sure the house is in the same shape it was when you got into contract, and to verify that the sellers have done any cleaning, work, or repairs they promised to do. While you're there, though, scope out the seller's progress in getting their stuff out of the place. I've had situations where the seller simply wasn't out when they were supposed to be, then we had to wrangle daily payments out of them until they finally got out. If you don't see a whole lot of boxes or a vacant house on the day of your walkthrough, ask your Realtor to please call the listing agent and apply gentle pressure until the house is vacant!

After Closing: The Afterlife

When your stay in purgatory is done, the story goes that trumpets blast, and St. Peter hits the "Open" button on the remote control for the pearly gates. Very grand. At the end of escrow, the best you can hope for is a housewarming par-tay where your well-dressed friends exchange witty banter and bring chic gifts, including a new set of 600 thread count Frette "linens" and plush, spa-quality Egyptian cotton towels. Oh—and a Krups espresso machine. The worst case scenario could mean an interminable pile of cardboard boxes, a year's worth of painting, weeding, and scrimping by eating those turkey stuffed bell peppers from Trader Joe's half at a time (the grown up girl's nutritionally superior version of Top Ramen). But whatever your post-escrow experience turns out to be, your internal sense of accomplishment and ownership and of being at home should be, simply put, heavenly.

Anti-Checklist #4

WHAT NOT TO DO DURING ESCROW

✓ **Buy large dollar amount items –** including a car or furniture—that create new credit accounts or lower your account balances.

✓ **Buy anything on credit – period.** Freeze your credit cards in an ice block if you have to, and ignore those 10%-off-if-you-open-an-account-right-now in-store offers.

✓ **Close credit accounts –** All of these items can dramatically reduce your credit score and screw up your debt-to-income ratio. If a lender requests an updated credit report, you could end up unable to qualify for the mortgage rates and terms you were originally quoted!

✓ **Quit your job –** The lender may verify your employment as late as the morning the deed is recorded.

✓ **Freak out about having spent X hundreds of thousands of dollars –** I know, I've said this before. But since you'll freak out anyway, I'm going to say it again. Believe me, no one will ever ask you to write a check for the full purchase price of your home. All you need to do is to cover the monthly payment.

✓ **Assume that your questions are stupid –** If you don't know something or don't fully understand a question someone asks you, ask somebody, preferably your Realtor, mortgage professional or escrow agent. This is too big a deal to have surprises later, so make sure you understand now.

✓ **Travel anywhere you can't be reached by cell or email –** Equally bad is traveling anywhere without letting your Realtor know your travel plans and how to reach you. And during the last week of escrow, don't travel anywhere there is no fax machine or where they don't have notaries. For more hints on how to have a smooth escrow while you're out of town, visit www.REThinkRealEstate.com and enter "TravelingBuyer" in the Tara's Tips box.

✓ **Pack the moving truck before you've been given the go-ahead by your Realtor –** Last minute problems come up on occasion, and having your stuff on the truck puts you in a tough spot—negotiation-wise—if the sellers decide they don't want to finish the promised repairs, or you discover on your walkthrough that they have taken something that was supposed to be included in the sale. It is seen as the ultimate sign that you have no bargaining power, to have your every earthly possession sitting on a truck outside of the house.

PART IV: The Plan: Now & Later

Chapter 9

Execution Essentials:
The Action Plan & How to Coach
Yourself Through It

Dreaming, thinking, and learning about buying a home are all important pieces of the homebuying puzzle. But all the dreaming, thinking and learning in the world – without action – will leave you the dreamiest, thinkingest, most learned non-homeowner in the world. If you are thinking that "action!" is easier said than done, then it is time to {RE}Think that sentiment! The {RE}Think way is to marry thought and action by using our Mindset Management technology to coach yourself through a strategic action plan and straight through the door to your new home.

Think of homebuying as a life goal similar to getting fit. There's a whole industry of mental and physical technologies designed to help you get—and stay—activated toward your fitness goals. I'm a self-styled fitness buff, so when I first moved to Oakland, I thought I'd check out a bunch of different gyms before I settled on one. At the time, I had no idea that Oakland held the distinction of being the birthplace of fitness as we know it. In 1936, one of my personal heroes, Jack LaLanne, opened the first modern health club in downtown Oakland filled with the first weight machines, which he designed. When I was gym hunting, I visited a place that had been opened in 1940 by a LaLanne prodigy. This place was like looking at a fitness evolution chart – there were literally weight machines dating from 1940 next to cardio machines from 1995.

Walking into this historic health club was like seeing a snapshot of how fitness advice had changed over time. At the time the club opened, doctors all over the area exhorted their clients to stay away from the gym, at all costs. They warned that vigorous exercise was the root of all manner of evil and illness, including heart attacks, hemorrhoids, sexual dysfunction, and more. Even the apparatus that people thought would help them get fit was very different than it is now; there were photos on the wall from the club's early years showing a row of women on treadmill-like machines with a wide, vibrating rubber belt wrapped around their rear-ends. Instead of walking on the machine, you just stood there and jiggled while you waited, wished, hoped and prayed for the belt to shake the flab off!

Just as fitness technology has evolved over the past 60 years, so have the self-improvement technologies which have promised to help us set and achieve goals. In the '50s, someone who wanted to learn how to swim was simply thrown in the pool and told to get out! Even in the '80s and '90s, goal setting and attainment advice was largely devoted to self-assessment quizzes that would help you figure out what was wrong with you, and correctional strategies to fix, bribe, threaten, or punish yourself into (or out of) a particular behavior. Want to stop smoking? Snap yourself with a rubber band when you get an urge. Want to lose 25 pounds? Visualize your favorite foods making you sick. Trying to put yourself on a spending plan or meet certain career targets? Book yourself a dream vacation and make a deal with your friend that she gets the trip if you don't follow through.

Many of the goal attainment strategies from the past helped people achieve very short-term, very concrete, very simple goals, like drinking eight glasses of water a day for a week, or working out four times a week for a month, but:

- They were unpleasant and negative – intended to threaten you into making changes by capitalizing on your fear of artificial negative consequences if you failed to do the desired thing;

- The changes they helped you create usually didn't last long term; and

- They tended not to work well at creating life changes that (a) were complex, or (b) took a long time to reach.

In focusing on the negatives, they often reinforced the negative self-talk that makes so many of us have problems achieving our goals in the first freaking place!

Homebuying as a Goal & Coaching as the Technology for Attaining It

Some people see buying a home as nothing more than a transaction – a dry, business exchange of money for property. When the cost of homes was a much lower percentage of the average household's earnings and the transactions were much simpler, that view might have been closer to true. These days, though, buying a home is a long-term, complex goal that requires many people to fundamentally change their mindsets and their lifestyles in exchange for the prospect of a better lifestyle and financial prosperity. You may know women (and men, for that matter) who have dreamed of buying a home for years, but are still renting and wishing and dreaming. That's because the essential nature of buying a home is not transactional. It is, at its core, a process that requires commitment, introspection, strategy and prolonged action in order to develop and manifest a vision of your home and your lifestyle as a homeowner. Snapping a rubber band just won't create that – a much more sophisticated technology is needed.

Having undergone several intense periods of massive personal change, and having worked with people as they change their lives every single day, I know that most people – especially women who see themselves as savvy and competent – don't struggle to achieve their lifestyle goals because of a lack of discipline or a lack of negative consequences for failure. They struggle because of:

- Fear of the unknown;

- Fear of being taken advantage of;

- Fear of failure and embarrassment;

- Fear that someone will ask them to do something they can't do;

- Fear that someone will ask them a bunch of questions they can't answer, and worse than all of these fears;

- Fear that if they do succeed, life will change in a way that is beyond their comfort zone.

How Coaching Can Help You Execute Your Vision of Home

Fortunately, self- and life-improvement technology has evolved dramatically, as evidenced by the fact that coaching is the most popular and effective success strategy being used today. I myself have had a business coach, a finance coach, and a writing coach at various times in my life, and most other highly successful people (defined as people who accomplish the things they set out to) also utilize coaches to help them progress in various aspects of their lives. I don't know if the word "coach" is the most appropriate handle, though; the relationship is much less motivational-talk-in-the-locker-room and much more about applying structure and accountability to otherwise nebulous and slippery objectives.

Having now been through coaching several times around specific life issues or goals, I am much more effective at creating change in all areas of my life, because I have incorporated some basic coaching strategies and solutions into the way I approach every problem I confront and every step of my lifelong evolutionary process. Now I can coach myself on all but the most complicated, long-term, or novel goals. Coaching services are not cheap! I'm not suggesting that you necessarily need to hire a coach to help you achieve your homeownership goals, though if you work with a life coach, this is certainly an issue they can help you incorporate into your life plan. What I am suggesting is that you, too, incorporate some basic tenets of coaching into your homebuying journey in order to maximize your chances of success without losing your sanity. I have structured this book—and the Action Plan contained in this chapter—with a liberal, but strategic, sprinkling of the coaching tools which have been proven successful in my own life and the lives of my homebuyer clients. If you utilize these coaching tools, you will coach yourself right through the front door of your new home!

Rather than trying to capitalize on and motivate you with the fear that bad things will happen if you don't buy a home, coaching will galvanize you by making your objective much more concrete, systematic and do-able. Breaking the complex goal of buying your first home or moving up into a system of less-complex action steps:

- Inspires you to action, by letting you know what you need to do right now;
- Deactivates the fear and sense of overwhelm created by the daunting and unknown nature of the homebuying process by breaking the vague, looming process into specific, smaller to-do list entries; and
- Empowers you to do what you need to do at any given moment to move toward your objective, no matter what your emotional state.

But applying coaching insights to ensure your success at homebuying involves much more than simply breaking the process down into easier-to-digest bites. Think of it as transforming a complicated transaction into a system for action, with the following elements:

- **Self-Knowledge & Self-Assessment** – The goal of this foray into self-knowledge is two-fold: (a) defining the contours of your own goal and figuring out what exactly you want, and (b) indicating the sorts of tools and supports you'll need to seek out in order to guarantee your success. This is the phase where you cultivate a clear Vision of Home. You'll also want to ponder such questions as:

 → Which kind of fear (if any) comes up for you when you consider buying a home? How is it manifested – negative self talk, self-sabotage, shut down or procrastination?

 → What is your self talk around buying or owning a home?

 → What is your family history around property ownership? How does that impact your ability to see yourself as a homeowner?

 → How do you like to be motivated or accomplish things? How have you accomplished big goals in the past? Are you a list maker? A team player? Are you more of a lone ranger? Do you thrive on pressure? Do you thrive on chaos? Do you prefer files, labels, and extreme organization?

- **The Plan, Action Items, Timelines & Deadlines** – These items, together, paint a very clear picture of: (a) exactly what you need to do, (b) by what date, and (c) what you'll be doing next, so that you can know where the different action steps and phases fall relative to one another, and have a good idea of how to expect the process to unfold;

- **Accountability** – Accountability simply refers to a system for making sure you stay on track throughout the process, and do what you have committed to doing. In traditional coaching, accountability is often a weekly phone call during which you and your coach check in, and you run through the list of the action steps you committed to for that week and check off which things you did or didn't complete before committing to the next week's action steps.

If you are going to coach yourself down the path to homeownership, you'll need to create an accountability system that works for you:

- If you are driven, self-disciplined, and prefer not to work in groups, and you have a history of success at accomplishing goals you take on alone, your accountability method might be as simple as taking the Action Plan here and entering the action steps into the pda, electronic or handwritten calendar system you already use. Ideally, you would set up one or more standing appointments with yourself (for example, every Saturday morning from 9 a.m. to 11 a.m. and Sunday afternoon from 2 p.m. to 4 p.m.) to work on your action items, calendar any tasks you need to handle during the week, and review your progress on the overall timeline;

- If you like to work in groups and draw inspiration from others, visit www. REThinkRealEstate.com and create or join a Savvy Woman Homebuying Group in your local area, so you can all work through your action steps together, keep each other accountable, and share experiences and referrals along the way. There is a guide for how to form and conduct a Group on the site.

- If your busy lifestyle prevents you from in-person group work, but you'd still like to connect with other Savvy Women Homebuyers, visit www. REThinkRealEstate.com, and mix the two accountability approaches discussed above. You'll need to commit to setting those standing appointments with yourself in order to complete the action plan, but you'll also be able to connect online with your fellow Savvy Woman Homebuyers and create relationships to help keep each other accountable;

- If you prefer to have a coach vs. trying to coach yourself, but would like that person to have some real estate expertise, visit the {RE}Think Real Estate Referral Network online and find a Realtor in your area. Ask her to meet you for coffee or at her office, and let her know that you are looking for someone who is willing to work with you on a longer-term basis to coach you through the initial phases of the Action Plan in exchange for your eventual business. If you're comfortable, set up a standing weekly or bi-weekly appointment to touch base with her by telephone in order to share your action steps for the next week or two, as well as the progress you have made since your last check in;

- No matter what your personal style, your accountability plan should incorporate relatively inexpensive rewards for staying on track – or getting back on track – as you make your way through the phases of the Action Plan. Whatever floats your boat – a small, but coveted, item you'll need for your home; a massage; a couple of hours to yourself for a hike or a nice dinner out – pick something to reward yourself for your discipline and to inspire further progress. Then, remember to actually give yourself the reward, once you've earned it!

Remember, the goal of this self-coaching odyssey is to have a homebuying experience that is focused on determining what you want and staying accountable to that from start to finish. In life, you will be accountable to someone's hopes and dreams. Make sure they are yours (not your landlord's, your Realtor's, or anyone else's) by following this program.

The {RE}Think Real Estate Homebuying Action Plan

This Action Plan is a Three Phase system that guides you through the execution of your homebuying goal – from dreaming and thinking about it, to learning about it, and through the concrete "to do"s involved in securing your mortgage, house hunting, and getting your offer accepted. Throughout, the Plan refers you to the appropriate places in the book where you'll need to go for preparation or for reference at various steps. To maximize your focus and minimize procrastination, each phase of the Plan comes with these self-coaching aids:

Should Take No More Than – This is an estimate of how long this phase should take. Use this as a double check—if it takes you much longer than this estimate to get through this phase, you might be procrastinating;

Start & Completion Dates – Right now, you should set these dates for the entire Plan. Then, note them here or in your workbook {RE}Think Real Estate Homebuyer's Journal and in your regular calendar;

Completion Reward – Create custom rewards to which you can look forward once you've done the work of each phase, and build them into your Plan by documenting them here and in your calendar on Completion Dates of the phases. If your reward is something that needs to be scheduled—a massage, vacation, etc.—go ahead and schedule it, and write that down, too!

Phase One: Get Your Mind Right!

🕐 Should Take No More Than: One day to two weeks

📅 Phase One Start Date: _____ Phase One Completion Date: _____

🎗 Phase One Completion Reward: _____

Notes:

Action Step	Reference Pages	Date Scheduled	Date Completed
(1) **Buy a journal or notebook** you love for your writing assignments (order our customized Homebuyer's Journal at www.REThinkReal Estate.com) or create a dedicated document on your PC or laptop;	23-33		
(2) **Click into conservation mode –** Set a goal to collect at least 3 percent of the purchase price of the homes you like. Start saving and stop making large purchases unless absolutely necessary. Cut unnecessary expenses as much as possible, and funnel the money you save into your homebuying fund;			
(3) Review **Chapter 1: Estate of Mind;**	15-33		
(4) **Determine which Frequently Expressed Qualms** (FEQs) you have been telling yourself;	16-19		
(5) **Writing Assignment – Commitment:** Record the time and date you committed to buying your home;	23		
(6) **Writing Assignment - Your Why:** Delineate the reasons you want to buy a home, the inspiration underlying your intention to buy;	23-24		
(7) **Writing Assignment – Identity:** Detail the attributes of the person you have decided to be;	24-28		
(8) **Writing Assignment – Your Vision of Home:** What will your life look like once you are in your home, on a daily basis? Make sure you address all the considerations listed in Chapter 1 (including your Values) and more, if necessary to paint a complete picture of your Vision;	28-33		
(9) **Double Check:** Check your Vision against your Values, and make sure they are consistent or resolve any inconsistencies;	33		
(10) Review **Chapter 2: The Process Primer.**	35-73		

Phase Two: Handle Your Business – Money Matters

⏱ Should Take No More Than: 30 days to six months

🗓 Phase Two Start Date:_____ Phase Two Completion Date: _____

🎗 Phase Two Completion Reward: _____

Notes:

Action Step	Reference Pages	Date Scheduled	Date Completed
(1) Review **Chapters 3 and 4: Money Matters;**	75-151		
(2) Order your credit reports and FICO scores from all three bureaus at www.AnnualCreditReport.com. Review all reports and initiate the process of disputing all erroneous entries with all three bureaus;	121		
(3) Gather up all your checking, savings, retirement and securities (stocks, bonds, mutual funds, etc.) account statements from the last two months.	121		
(4) Decide how much cash you are able to devote to getting into your home;	122		
(5) Gather up all your bills and/or statements from accounts that require a monthly payment;	123		
(6) Use the IRS withholdings calculator to determine how much more you can bring home monthly once you have purchased a home;	120		
(7) Complete the Personal Statistics Worksheet;	123-124		
(8) Do the quick work and the easy work;	125-130		
(9) Review **Chapter 5: Creative Homebuying;**	154-197		
(10) Create or revise your prioritized spending plan;			
(11) Decide how much you want to spend every month on housing;	120		
(12) At least 30 days after you initiated your credit reporting disputes, if any, check your FICO scores again. If they are below 580, commit to raising your credit scores using the resources in the Credit Tool Shed at www.REThinkRealEstate.com. If they are above 580, continue;	130		
(13) Revise your Personal Statistics Worksheet to take account of the changes you have made;	123-124		
(14) Review the Loans and Lives Chart from Chapter 4 and prepare a list of any questions you have about what type of loan is best for you;	132-133		
(15) Collect the items on Chapter 4's Items to Bring to Your Loan Application list.	134		

Phase Three: House Hunt & Team Building

⏱ Should Take No More Than: 30 days to six months.

📇 Phase Three Start Date:_____Phase Three Completion Date: _____

🎗 Phase Three Completion Reward: _____

Notes:

Action Step		Reference Pages	Date Scheduled	Date Completed
(1)	Spend a Sunday afternoon – or two or three – visiting Open Houses in your area;	226		
(2)	Review **Chapter 6: Master the Art of The House Hunt**	199-235		
(3)	Prepare your Wants & Needs Checklist, working from your Vision of Home;	232-235		
(4)	Find a Realtor: Email or call one or more supportive friends and/or family members who own homes for a referral, and/or visit www.REThinkRealEstate.com for a referral to a Realtor in your area;	50		
(5)	Call the Realtor(s) you are considering, make appointment(s), and attend your initial consultation meeting(s). Take your Wants & Needs Checklist with you, and share it with them!;	50-52		
(6)	Commit to working with a particular Realtor, at least on a trial basis. Ask your Realtor to set you up to receive automatic emails of new listings that reflect your search criteria. Request a referral to a mortgage professional from your Realtor;	55-56		
(7)	Contact the referred mortgage professional and ask to be pre-approved. Present them (in person, via fax, or via email) with your Personal Statistics Worksheet, the items for your loan application and make certain to tell them [a] the maximum amount of money you are willing to spend on housing monthly, [b] whether that monthly amount is to include taxes, insurance, and/or HOA, and [c] how firm or flexible that amount is;	120		
(8)	At the end of the pre-approval process, make sure you know what your: ○ Maximum purchase price is; ○ What your monthly payment will be at that purchase price; and ○ Which of the following that payment includes: principal, interest, taxes, homeowner's insurance, and/or HOA dues.	137		
(9)	Communicate your maximum purchase price to your Realtor;	137		
(10)	Review **Chapter 7: Contracts and Negotiations;**	237-274		
(11)	Schedule your first Buyer's Tour with your Realtor, and compare properties listed at or below your maximum purchase price against your Wants and Needs Checklist. Stay open and flexible and be prepared to compromise and adjust your wants and needs to stay at the monthly payment range you know makes sense for your lifestyle;	222-224		
(12)	Review **Chapter 8: Escrow Purgatory**	277-325		
(13)	Set a standing appointment for Buyer's Tours on a weekly or bi-weekly basis and keep your eye on your listing emails and make appointments to see individual properties which look promising. Continue this process until a particular home speaks to you, and you can see yourself living there. Then, inform your Realtor that you would like to make an offer to purchase the property.	222-228		

From Offer to Eternity – Shades of Gray

The day you decide to make an offer is the day the black-and-white action items end. From here, you will need to write an offer, negotiate your contract, and proceed through the escrow process in the manner and sequence that naturally unfolds based on:

- Your specific situation;
- The local standards of practice;
- The facts surrounding the particular property; and
- The needs and psychology of the particular seller and listing agent with whom you are negotiating.

Once you have inserted yourself this far into the process, the momentum of the transaction will literally suck you in and carry you through. You won't need an action plan per se, because your Realtor, mortgage professional, and escrow or closing agent will call you up and tell you where you need to be, what you need to bring or send, where to send it, and by when. Make sure you make yourself—and the documents your real estate professionals need—available to them and make sure you review and refer to Chapters 7 and 8 through the last phases of your homebuying experience to stay on top of what to expect and how to prepare.

Since I can't break the contract to closing process down into a list of action items any more specific than the What to Expect lists in Chapters 7 and 8, let me give you two overarching comments about how best to prepare for the last push of the homebuying process: expect the unexpected, and roll with the punches. Stay oriented toward your goal—don't get irritated or disgusted with little inefficiencies, seemingly repeated requests, or the build-up of petty frustrations you can't control in the homebuying procedural process. That's the nature of the beast, and every homebuyer goes through them, to some extent. So don't allow these annoyances to render your process unpleasant, or to cloud your focus on manifesting your Vision of Home. Handle them with a smile, send over whatever the lender or your Realtor requests—no matter how many times they request it—and know that at the end, your home will be your ultimate reward!

Conclusion

You've Got the House – Now What?

Because I had my children at such a young age, many of my friends are just now having their first children. Recent years have dramatically transformed the sophisticated Ladies' Lunches we used to have at chic eateries all over the Bay Area into at-home potlucks where we spend half the time running around grabbing potentially life-threatening items out of the reach of various munchkins, and the rest of the time sniffing tooshies to determine which of them is emanating that pungent baby-poo zing!

You should have witnessed the scene when one of these gals brought her first baby, Sophia, home from the hospital. The players: my friend, an attorney; her husband, a cardiologist; her Nobel-candidate scientist father; and her concert violinist mother. These four, exceptionally self-possessed and gifted adults were completely focused on—and controlled by—every whimper and mew of a six pound, foot-and-a-half long infant who, sweet as she was and brilliant as she surely will become, couldn't even hold her own head up at the time. Parenthood changes people—big time.

Your life transforms when you own a home in many ways that parallel how life changes when you have a child. On one hand, your home doesn't smell as bad as a child does when it's little. (Hopefully!) And you can leave your home unattended without the neighbors phoning C.P.S. On the other hand, you will need to protect your home, care for it, and plan for its future (and yours) in just the same way you would do for your child. But way less intense. And without the stink—did I mention that?

Protecting Your Crib from the Cradle Robbers

By now, you probably won't be surprised to know that I keep a list entitled Tara's Collection of Helpful Life Proverbs. I want to share two with you.

No. 17 – From my hygienist, on dental health: You only have to floss the teeth you want to keep.

No. 33 – From my Abnormal Psychology professor, on mental health: Just because you're paranoid doesn't mean someone's not out to get you.

So how do these relate to homebuying?

Like your teeth, your new home is an asset you must protect. If you want to keep it, that is. The majority of American homeowners think their homeowner's insurance policy is all the protection they need. That's because they are blissfully unaware of how paranoid they should be—there are about six different dangers and pitfalls lurking out there in the world that are "out to get" your new asset. The good news is that you can protect your new home from most of these dangers fairly simply and inexpensively relative to what you have to lose if you do nothing. The biggest cost to you is a modicum of effort and energy, so scrounge up a little, and go this final mile to make sure your hard work in getting your home doesn't go down the drain.

Tara's Top Six Things from Which You Need to Protect Your Home (and How to Protect It!)

Misused Equity

Remember how, in college, those credit card companies would set up table on campus and virtually stalk you to open an account in exchange for a T-shirt and a bag of M&Ms? That was nothing compared to what will happen once you close escrow and move into your home. You will get offer after offer in the mail for home equity loans or home equity lines of credit—banks will literally beg you to allow them the honor of lending you hundreds of thousands of dollars for a bizarrely low-sounding monthly payment, with tax deductible interest! The envelopes that don't contain these offers will contain offers to refinance your mortgage at extremely low interest or an extremely low payment, allowing you to skip payments, and/or offering you large amounts of cash while reducing the monthly payments you make now. And don't even get me started on the telemarketing calls you'll receive; if you aren't on the Do Not Call list, you'll definitely want to get on it ASAP.

Don't get me wrong; the ability to build—and borrow against—equity is one of the most compelling reasons to buy a home in the first place. Many Savvy Women, myself included, refinance their mortgages regularly (every few years or so) to obtain better terms or to pull cash out for worthy reasons, mostly those that enhance the value of the home, generate new or increased income, or in some other way reflect a real investment in the future. Smart things on which to spend home equity funds include:

- Starting a well-planned business;
- College tuition for yourself, your spouse, or your children;
- Home improvements, including landscaping, major repairs, additions, upgrades, and updating;
- Emergency funds—for medical emergencies and interruptions in income; and, especially;
- Buying a second home or investment property(ies).

Many homeowners, however, are also tempted to use these large sums of cash borrowed against their home equity to purchase items that depreciate or have no meaningful financial value to begin with. Not-so-smart or, ahem, stupid things to spend home equity funds on include:

- Buying a new car;
- Taking a vacation;
- Buying clothes, shoes, home electronics, or other personal property;
- Buying furniture; and
- Buying a computer, among many other non-appreciating, depreciating or value-less things (if you need one to start your new business, save up the $500 bucks a good PC costs these days and buy it that way—you don't want to still be paying for that computer 15 years later, when it's been obsolete for 14 ½ years!).

Cash "pulled out" of home equity is not free money. It is money you have to make a monthly payment on, money that you must pay interest on, and money that is secured by your property (i.e., if you can't keep up with the payments, your house can go into foreclosure). Don't use your home equity to buy a depreciating asset like a car—if you get an auto loan and can't make the payments, the car gets taken, not your house! Vacations, clothes, etc. fall into this same not-so-smart investment category. It makes no sense to increase the payments you have to make every month, year-after-year for an experience you'll only get to enjoy for a week!

Even with refinancing, keep in mind that there are always costs to obtaining a new loan, and these will often be added or "rolled into" your loan balance, so that you owe a few thousand dollars more on your home for the privilege of that lower interest rate or skipped monthly payment.

No matter what those mailers say, your home equity will always be there to use for good (vs. evil), unless you use it all up! Imagine how it would feel to have purchased a home that has doubled in value, sell it, and have nothing to put down on your next home because you have secured loans with your home equity on items that no longer have any real worth. To avoid this situation, think twice or thrice before you take equity out of your home, and have a logical plan for putting the cash to good use. If you don't have such a plan, then don't take the cash out in the first place.

Divorce

Maybe it's that whole church school thing I mentioned earlier, but I'm a big believer in cautionary tales. As I've mentioned previously, when it comes to understanding why women who own homes before marriage should get pre-nuptial agreements, there are real life cautionary tales a-plenty, involving everyone from the upper echelon of society to celebrities to the everyday woman on the street. And these same sorts of stories indicate that some married women should consider post-nuptial agreements, depending on the facts of their situation.

Take Tamara Mellon (founder of the Jimmy Choo shoe corporation), who married banking heir Matthew Mellon before her company became synonymous with high-end stilettos and strappy sandals. When they divorced, he sued her, claiming that his family name was key to her success. And remember Jessica Simpson? She refused to sign a pre-nup before her marriage to Nick Lachey who, at the time, was much wealthier than she. The millions she made during their marriage are still hers, but only because he graciously agreed to take less than he was legally entitled to. Almost every social circle of professional women has at least one woman in it who wishes she had asked for a pre-nup, having come out of a divorce with much less than she brought into the marriage.

If you buy your home before you get married, without a prenuptial agreement it is highly likely that at least some of the value of your home will become marital or community property, subject to a 50/50 split between you and your husband if (knock on wood) you should split up. If you buy your home while you are already married, and there is some reason you don't feel a

CONCLUSION : YOU'VE GOT THE HOUSE

346

50/50 split of the property would be fair in the event of a divorce (e.g., your husband is habitually unemployed or refuses to contribute to household finances, you pay a disproportionately high share of things, or whatever), then a post-nuptial agreement might be in order.

I know, asking for a pre- or post-nuptial agreement seems like planning for your marriage to fail. All a pre- or post-nup does is let you and your spouse decide for yourselves how property and money maters will be handled, instead of letting the state decide for you. It no more causes the end of your relationship than writing a will causes someone to die.

If you are in a relationship where you feel completely comfortable splitting all of your assets 50/50 with your mate, then this information is not for you!

If not, though, to refrain from asking for one is to live in denial of the statistical truth that 50 percent percent of first marriages, 67 percent of second, and 74 percent of third marriages end in divorce. If you even think you might need one, the exercise of creating and executing a pre- or post-nuptial agreement with your mate can settle the entire issue and eliminate the drama and turmoil created by obsessing over it. How many hundreds of thousands of dollars is it worth to you to avoid a few uncomfortable conversations?

If you think you might need to talk with your mate about a pre- or post-nuptial agreement, talk about it with a family or estate planning attorney, and ask for some pointers on how to bring the issue up and structure the conversation productively.

Unexpected Interruptions in Income

Many homebuyers have a momentary freak-out once they start making mortgage payments. "What if I lose my job?!?!?" I always wonder right back at them, "Well, what if you lost your job when you were renting?" Either way, you would have a tough time meeting your monthly obligations. If you own, though, you have at least three things working in your favor that wouldn't otherwise be available to you: (1) you can get a roommate to help contribute to the mortgage payment, (2) if push absolutely comes to shove, you can sell your place and collect the equity you've built up, and, most importantly (3) you qualify for insurance to cover your payments in the event of certain interruptions in your income.

- ○ **Disability** – There are insurance policies you can buy specifically for the purpose of making your mortgage payments in the event you become disabled and cannot work. The insurance company will actually want to see your mortgage statements, and will determine how much coverage you can purchase by the amount of mortgage you need to cover monthly. Also, if you have a standard disability insurance policy, you might be able to qualify for more coverage based

on the amount of your mortgage payment—check with your insurance agent or HR Department. I recommend that all homeowners consider purchasing disability insurance or disability mortgage insurance, to make sure that a car accident or several months of illness doesn't create the additional tragedy of losing your home;

o Death – Besides disability, death can create a major interruption in income. Major. As a new homeowner, especially if you co-own your property with a friend, loved one, or even strangers, you and your co-owners should obtain life insurance policies that designate the other (or whoever will inherit your ownership share in the property—and your share of the mortgage payment, too) as the beneficiary. Ideally, each of you should obtain insurance in an amount large enough to pay off the entire mortgage, but consult with your insurance agent and, if you have any doubts, with an estate planning attorney to make sure you obtain an appropriate level and type of coverage.

The Capital Gains Tax

As renters, we're most familiar with income tax and sales tax. Then, when you buy a home, you quickly become acquainted with real estate transfer taxes and property taxes. Only when you sell a house do you become subject to capital gains taxes. Essentially, Uncle Sam taxes you on the appreciation or profit (a.k.a. capital gains) you make when you sell your home. If you are the sort of gal who likes to avoid paying taxes unnecessarily (and who isn't?), the tax code offers two strategies you can use to avoid capital gains taxation.

Here's how the capital gain tax works:

o The purchase price you paid for your house + money you spend on home improvements = your tax basis;

o The sales price you receive when you sell your house minus your basis = your total capital gains;

o Your total capital gains minus your capital gains tax exemption = your taxable capital gains. You will be taxed on them at the rate of 15 percent—yes, you can kiss 15 cents of every dollar of taxable capital gains (profits) goodbye.

Avoiding Capital Gains Taxation: Stay, then Move or Improve

As you can see, maximizing your exemptions is the key to avoiding the capital gains tax. The first thing you need to know is that you only obtain an exemption if the property at issue is your personal residence, meaning that you have actually lived in the property for at least two of the

last five years. So, if you (a) sell your home before you have lived there for at least two years, or (b) live in your home for two years then rent it out for three or more years before you sell it, you will not qualify for an exemption, and you will automatically pay the 15 percent capital gains tax on every dollar of capital gain when you sell. For this reason, you should make every effort to live in your home for at least two years before you sell it, or risk losing most or all of the equity you've built up to the tax man. If you are forced to relocate before two years for work, or you convert your home into an investment property, talk to your CPA about what you need to do to qualify for tax forgiveness or deferment.

If you do live in your home for two years, you are allowed to have $250,000 (if you are single) or $500,000 (if you are married) in capital gains on your home before you incur the tax. This is why the capital gains tax exemption is known as the $250,000/$500,000 rule—if you sell your home for over $250,000 or $500,000 more than your tax basis, every dollar you receive over the exemption amount that applies to you will be taxed – 15 percent of it will go to Uncle Sam. So unless you plan to live in this home forever, make sure you keep track of what your home is worth, especially if it is a higher priced home or if you live in a rapidly appreciating area. Keep an eye on those Realtor postcards you get that tout the recent sales prices of homes in your area, and use the sales prices of homes similar to yours to keep track of how much your home is worth. You'll want to notice as the value of your home approaches $250,000 (if you are single) or $500,000 (if you are married) more than you paid for it. If you are dead-set against paying the capital gains tax, before your home appreciates past the $250,000/$500,000 mark, you'll want to sell and move on up, or improve the place significantly (have an addition, replace the roof, or otherwise remodel so that you can add the costs of the work to your tax basis).

Lawsuits

Owning a home makes you a much juicier target to people who would like to sue you because they see your home as a resource they can drain if they win a case against you. (Before you joined the landed gentry, litigious folk probably saw you as broke, a.k.a. "judgment proof." Attorneys don't like to pursue broke people with lawsuits, based on the can't-squeeze-blood-from-a-turnip theory.) Your homeowner's insurance policy may or may not be enough to cover the neighbor kid's injury when he gets bitten by the dog, and may not cover your dispute with your business partner at all. An umbrella policy, however, will. (See Chapter 8 for more detail on what an umbrella policy is and does.) They are very inexpensive relative to the coverage they

provide, and they often provide coverage in increments of millions of dollars (e.g., $1 million, $2 million, etc.), so most folks in the know maintain an umbrella policy with coverage equal to or slightly greater than the value of all their assets.

Probate

Yes, death again. Sorry, but it is a fact of life. If you own your property in any manner that does not specify that your co-owner has the right of survivorship (i.e., joint tenancy or community property with the right of survivorship), you must deal with the question of who will inherit your ownership interest when you pass away. (And, if you own your home jointly with someone else, you need to bring up the issue of whom will inherit your co-owner's ownership share in your home.) But "who" is simply the first question. Equally important is "how" the interests will pass after the death of you and/or your co-owner.

If you don't have a living trust, and your home is not co-owned in a manner that gives the right of survivorship, when you pass away your property and other assets will be distributed by a judge in probate court. One common misconception is that if you write a will, your stuff, your estate, won't have to go through the probate courts. A huge part of the probate court's jurisdiction is hearing and adjudicating wills. Probate is reeeeeallly undesirable: the details of what you owned and who gets it become public, the judge and the laws of your state decide who inherits your stuff (instead of you), it takes about a year for your heirs to get anything, your estate is heavily taxed, and the court and attorney take a big chunk of your estate for fees. Properties that are owned in a living trust are automatically and immediately dispersed according to the terms of the trust on death, with no court involvement.

A living trust is similar to a company—you form it, and you direct it, then you stick your house in it. You actually sign the deed over to your trust, which then "owns" your home. You can form a trust yourself (kind of hard, depending on how complicated your arrangements and what kinds of stuff you own), use an online service (less hard, but still kind of tricky to get it done right), or hire an attorney to do one for a fee that is infinitesimal compared with the estate taxes, fees, and drama you will spare your loved ones. Your trust will lay out exactly who you want your belongings and investments to go to. Even if you don't have kids, a mate, or living relatives, my guess is that you don't want your stuff to go to pay fees and taxes—leave it to your alma mater, your local charity, or your Shar Pei, but get a living trust and leave it to someone or something of your own choosing.

Care for It

In middle school, I was fascinated by the scientific concept of entropy. The idea that order deteriorates over time unless something stops it, the theory that the entire universe is slowly evolving into maximum disorder, and the image of melting ice cubes in a glass of water that was used to illustrate the concept left me a little obsessed with the idea that we all need to constantly run around patching up the universe, or it will spiral slowly out of control.

If you ask me, an even better example of entropy would be your home. Condo or single family home, co-op or PUD, without continuous maintenance, your home—interior and exterior—will fall into disorder and disrepair. You've been house hunting recently, so undoubtedly you've seen those houses that stick out of a well-manicured block like a sore thumb: paint barely hanging on in big flakes, cracked windows, sagging front porch, and a roof covered in moss that has become the home to a family of not-so-friendly critters. People drive by these homes and wonder what sort of abuse the inhabitants inflicted on the home to create that dishevelment. The fact is, they probably didn't do anything; an eyesore house most often results from years and years of deferred maintenance and plain old neglect.

As with everything else in life, continuous maintenance will minimize the need for big repairs, certain major items like roofs, water heaters, exterior paint and rain gutters will definitely need to be totally replaced on a regular schedule. How often depends on the type of materials used (e.g., a tile roof might have a 50-year lifespan, while a composition shingle roof will last 15 years) and how intense or mild the weather extremes are in your area (e.g., snow, hail and extreme heat take a major toll on your home's exterior, and temperatures impact how much wear and tear will be placed on your heating and cooling systems). If you live in a condo or co-op where the HOA handles exterior maintenance, you can devote yourself to interior maintenance, making sure your kitchens and bathrooms stay updated and in good repair, that your interior paint is always fresh, and that your floor and window coverings are well-kept.

Also, if you own your home a long time or your home is an older home that hasn't been fully updated, you'll want to plan for upgrades: single paned windows to dual, a wood shake roof to composition or tile, that '50s kitchen to a more convenient and functional one, galvanized plumbing to copper, a fuse box to circuit breakers. Eventually you'll want to ditch that bulky, leak-prone water heater for an energy-efficient, tankless/on-demand system. (And who even knows what the future will bring in terms of new technologies for upgrading the major systems of your home?)

To maximize the livability and the resale value of your most sizeable investment—both for purposes of actually selling it or for purposes of borrowing against your home equity—you should proactively set up a maintenance, repair and upgrade calendar or system for your home. This is a major departure from life as a renter, so you may need to be pretty strategic about incorporating home repairs and maintenance into your life as an ongoing concern—whether you decide to do-it-yourself or prefer to delegate.

Here's a two-step strategy for figuring out what all needs to be done and when, and setting up a realistic schedule for handling it:

Step 1 – As soon as you buy your home and get yourself moved in (or even before!), page through your home inspection report. Use it to figure out what items need to be repaired and what items are good candidates for upgrades. Depending on whether you are DIY-oriented or more inclined to outsource, calendar a weekend to make a run to Home Depot/Lowe's/ACE Hardware (with your inspection report in hand) or interview and hire a handyperson (preferably, by referral). Start pricing out how much the various repairs and upgrades will cost you, and then—that day—enter into your pda or calendar the various dates throughout the year when you will attend to the various repairs; then

Step 2 – Go to www.REThinkRealEstate.com and enter keyword "MaintenanceCalendar" in the Tara's Tips box. The {RE}Think Real Estate Maintenance Calendar will give you a month-by-month breakdown of the items you should maintain or evaluate on a monthly basis—from mechanics to cosmetics. Spreading home maintenance and repairs throughout the year converts the prospect

Insider Secret

HIRING THE RIGHT HELP

Don't hesitate to ask your Realtor or home inspectors for referrals to home improvement professionals. Just so you know, a licensed pro is known as a contractor, while an unlicensed person who does all sorts of small jobs around the house is called a handyman (or handywoman, for that matter). Usually, contractors are preferred if you are doing a major upgrade or a job which requires a permit from your city (check the city's building and permits website to figure out whether your repair or upgrade requires a permit). Of course, their services are generally more expensive, too, so for things like putting up a ceiling fan, a handy person with strong references from past clients can often do the job for a fraction of the price!

of caring for a home from daunting to do-able. Then pull that pda or calendar out again and select—and commit to—a day each month when you can devote at least three or four hours to your home maintenance regime. (And if you have any discretionary income left over, also schedule yourself for a mani/pedi or massage at the end of those home maintenance days! It's always easier to get through your chores when you have a nice treat waiting at the end of the day.);

Step 3 – Pay attention to your house, and keep a running list of the little things that need to be fixed. When you can, fix them—or have them fixed—immediately. Whenever you can't do that, attend to "the list" on your regularly scheduled home maintenance days.

Plan for the Future

When you make plans for your children, almost everything you plan is tied in some way to preparing them for their separation from you. These days, people pick preschools, spouses and even sperm and egg donors with deliberate forethought about how their decision will impact their child's higher educational and career options—20 years down the road! There's no need to be quite so obsessed with the future of your home. In fact, when asked about the whether the cost of a particular home improvement or added amenity will yield a dollar-for-dollar return when the home is sold, I often remind the homeowner that even if they recoup only a fraction of the cost in the future, it might still be a prudent investment if it increases their enjoyment of the home in the right now!

Enjoy yourself in your home; don't start out obsessing about what comes next. But in your quiet moments, allow your mind to drift toward your new Vision of Home. It might be a picture of yourself and your current family still living and thriving in the house you just bought, only 10 or 20 years in the future. It might be an image of a family or children that don't yet exist in a home that is bigger, better, nicer, or in a better town or school district than the one you just bought—a move up. Or, maybe you dream of downsizing—sending the kids off to school and buying an elegant nest that is very grown-up and sophisticated—with or without a life partner. Perhaps in your new Vision of Home—your vision of life down the road a ways—you see yourself owning more than one home. Your life vision might include having investment properties, or even a second or vacation home (e.g., the beach/winter/mountain/island house—you know the one).

Protecting your equity, as I've described above, is especially critical if you'd like to move up or down, or buy more properties for your family or for income. At {RE}Invest, the{RE}Think Real Estate Investment Consultancy, we coach and consult women nationwide who have decided to

explode their wealth development and create financial prosperity through real estate investing. Over 90 percent of {RE}Invest members started investing in properties using cash they borrowed against the equity they had in their personal residences. When you are ready to start thinking about investing in real estate, visit us at the Investment Center at www.REThinkRealEstate. com, and start learning how you can use your home to launch a future of financial security and prosperity for yourself and your family.

{RE}Think Homebuying—Redux

{RE}Thinking homebuying is about approaching the process from a totally different perspective than the way it has always been done—demystifying it entirely. It is about having:

- A basic knowledge of what to do and what to expect;
- A state of mind characterized more by control, power and responsibility than by fear;
- Insider secrets and strategies; and
- Some sense of the things you need to ask, and know, and think about when you make the 40 plus decisions involved in homebuying.

If you can take these four things away and let them be your companions during the homebuying experience, you will have escaped the traditional experience of real estate as an excruciating, stressful means to an end that results from the average homebuyer's sense of cluelessness and lack of control. This book—and our web community—are your always-available homebuying companions; refer to us and connect with us throughout your homebuying process—whether it takes weeks, months or even years. Having us as your insider industry "connection," and connecting with others who are undergoing or have recently undergone the homebuying odyssey will deactivate the avoidable drama and equip you to proceed through the process with your usual Savvy Woman-esque fabulosity!

{RE}Thinking homebuying is also about viewing the process of homebuying not as an isolated business event, but as an opportunity to evolve and grow beyond fear, beyond procrastination, beyond excuses and into the phase of your life where you move boldly and decisively to create the life you envision. Think back over the phases you might have progressed through over the course of your path to home ownership:

- {RE}Thinking the whole concept of buying a home from something you must do simply to financially survive into an odyssey during and after which you can THRIVE;

- {RE}Setting your priorities and {RE}Configuring your mindset—achieving clarity on your Vision of Home and moving into the mindset of a homeowner;

- {RE}Allocating your time & energy – committing to take continual, concrete actions consistent with your goal of homeownership and your Vision of Home; and

- {RE}Inventing your persona in progressively more powerful phases, until you have {RE}Invented yourself right into the owner of your new home:

 → From fearful renter—or accidental homeowner—to fearless house huntress;

 → From money and finance novice to mortgage maven; and finally

 → From contract beginner to prosperous proprietess!

May the end of your journey to homeownership be the beginning of a life lived at the very edges of possibility and filled with growth, passion and wellness.

Au {RE}Voir!